PATIENCE WRIGHT

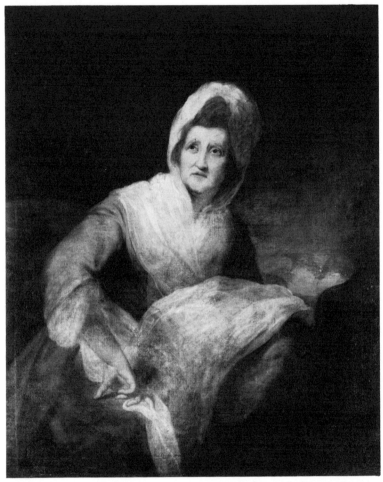

"THE SIBYL"

Portrait of Patience Wright, c. 1781–1783, attributed to John Hoppner. This is the inspired modeling observed by William Dunlap and others, the wax under the apron on her lap, but here the right hand withdrawn in a gesture that points to a mysterious encircled symbol in the lower left corner of the painting.

PATIENCE WRIGHT
American Artist
and Spy
in
George III's London

by

Charles Coleman Sellers

WESLEYAN UNIVERSITY PRESS

Middletown, Connecticut

Copyright © 1976 by Wesleyan University

Library of Congress Cataloging in Publication Data

Sellers, Charles Coleman, 1903–
 Patience Wright: American artist and spy in George
III's London.

 Includes index.
 1. Wright, Patience. 2. Wax-modeling—United
States. I. Title.
NK9582.W74S44 736'.93'0924 [B] 76–7193
ISBN 0–8195–5001–9

Book design by Jorgen G. Hansen
Manufactured in the United States of America
First edition

Dedicated with Love
to
Susan and Paul

CONTENTS

ILLUSTRATIONS

FOREWORD

I have found Patience Wright, to say the least, an engaging subject for study — first encountered during the research for my *Benjamin Franklin in Portraiture,* published in 1962, and through subsequent years pursued intermittently but always with pleasure. In her art she is an authentic genius, and in her life she has all the charms of the visionary, the dreamer of apocalyptic dreams. Her solution for the imperial crisis — to unite the republics of Britain and America — stirs emotions of admiration and surprise. A final reward has been the historian's satisfaction in penetrating some of the mysteries with which she surrounded herself, and relating bits and pieces of her spy work, here and there, to real fact. At first, there was almost nothing tangible from which to make a biography. A continual gentle shaking of the tree, however, brought down more and more until we have at last a presence, vociferous and sure, downright in a wholly American way, and yet also clearly a spark of England's seventeenth-century fervors, blown back across the wild Atlantic into the England of a more temperate age.

Her character comes through best in her letters. Only thirty of the hundreds she wrote have survived, and in quoting from these I have tried to retain their original flavor. The impetuous thrash of her quill is lost in the transition into printer's type, and occasionally I have had to capitalize and punctuate in order to keep one sentence from treading too hard upon the heels of another, but beyond this the words come straight from the wax-work.

Among the many who have ministered in one way or another to the gradual unfolding, through the years, of the Patience Wright story, particular acknowledgments are due to Marjorie Akin of Dickinson College; Robert C. Alberts, biographer of Benjamin West; Stephen S. Bank for help with Lon-

don research; Whitfield J. Bell, Jr., Librarian of the American Philosophical Society, who has observed and contributed throughout; Eugene Charlton Black, author of *The Association;* Dorothy W. Bowers, Martha C. Slotten and others of the Dickinson College Library; Edwin B. Bronner of the Quaker Collection at Haverford College; Lyman H. Butterfield of the Adams Papers; Barbara Butturff and James H. Maroney of Sotheby Parke Bernet; William P. Campbell of the National Gallery of Art; Ian R. Christie; Anna Jarman Cooper and other friends with the research collections of the Museum of Early Southern Decorative Arts; Thomas Imlay Corddry; John F. Crosfield; Lillian de la Torre for valuable comments complemented by J. R. T. Bueno's critical and meticulous editing of the manuscript; Milton E. Flower, biographer of John Dickinson; R. P. Howgrave-Graham and N. H. MacMichael of the Muniment Room and Library, Westminster Abbey; Donald Castell Kelley of the Boston Athenaeum; Caroline Heath Kennedy; Wilmarth S. Lewis and the Lewis Walpole Library; E. J. Pyke, author of the definitive *Biographical Dictionary of Wax Modellers;* Edgar P. Richardson; Susan S. Siemianowski for research in the field and editorial help; Malcolm Thomas and Lesley J. Webster of Friends House, London; John A. Vickers; Maud Wilcox of Harvard University Press; William B. Willcox of the Papers of Benjamin Franklin at Yale; and Henry J. Young. As also to Barbara Sellers, who has held a protective wing over biographer and subject.

Charles Coleman Sellers

Carlisle, Pennsylvania
February, 1976

PATIENCE WRIGHT

Amazing Art and Deep Design

PATIENCE WRIGHT stepped boldly into fame and history in London in the early spring of 1772. Down from the clubs of Westminster, out of the great houses from St. James's to Portman Square, up from the City by the Strand came the courtiers, gentlemen and ladies, Parliament men of Lords and Commons, merchants of the livery, actors, artists, wits, and connoisseurs to see for themselves this strange new genius blown in from across the ocean in winter mist and storm. There were those anticipatory half-smiles from the men alighting at her door, handing the ladies in, the ladies wide-eyed, lips parted, whispered asides in the rustle of silk and taffeta — then the shrill notes of surprise, clasped hands, light laughter as they came in among the portraits in wax, standing or seated, dressed like themselves, persons sometimes whom they knew well, mirrored here to the last detail with all the familiar air and bearing and only that motionless silence to mark them as unreal.

The artist had her greeting for each new arrival, loud and sure. She strode among them, large, straight, and vigorous, plain white cap and apron, plain dark dress, white fichu carelessly about her shoulders, a wild energy in her dark compelling eyes, the rapid step, and a flow of words that was at once quaint and commanding, artless, spontaneous, oracular. She was quick to guess the thoughts and character of each, startling many as much by doing so as by her handiwork. She seemed to possess the living people as if of her own making too. They marveled. They laughed. They loved her American gusto and blunt speech, the same for quality or commoner. Of all the art-

ists clustered near the Palace, here was an experience quite
new.

Her art was portrait sculpture, life-size — just that, but a
world away from what was to be seen at the popular waxwork
exhibitions of before her day, or after.[1] To her mirror image of
each subject, so superbly detailed, she added also, subtly, deftly,
that light of expression in which character is revealed and the
work stands irrefutably as fine art. Others of the waxwork
fraternity — or sisterhood — have depended much on casts and
have used costumes and accessories to make the whole convinc-
ing. Not Patience Wright. She sought a life mask only once,
George Washington's, at the end of the Revolutionary War,
when there was no other way of bringing his likeness into her
oeuvre. Otherwise, she modeled only from the life.

To see Patience Wright in the act of creation was itself
worth her fifty-guinea price for a portrait. With those olive-
green eyes fixed upon her subject or roaming the room with a
mettlesome intensity, with every muscle of her sallow face taut as
a harp string, all the while her hands would be busy with the
wax, unseen, under her apron. It must be kept warm, and where
better than there between her thighs? A modern waxworker
would use a photographer's bulb and reflector, but this was the
eighteenth century and a woman with her own warmth of body
and light of mind. Practiced fingers out of sight, eye and voice
holding all entranced, and then — dramatic surprise — the
apron whipped aside and a likeness, newborn, lifted into view.[2]
One must assume that it returned to the apron and re-emerged
intermittently, and that finishing touches were added with the
head on her lap as a well-known London print shows her. Last of
all came the points of minute perfection — the delicate skin tex-
ture and coloring, glass eyes characterized by lids, lashes, and
brows, veins introduced under the waxen skin of face and
hands, and on a man's hands even the fine hair. But for all that,
the inspired touch, out of sight, was best remembered, and it was
believed that she could bring forth in this way a vivid likeness of
one long dead, from memory alone.[3]

Surprisingly, Mrs. Wright's under-the-apron performances

inspired no *double entendre,* though a piquancy the eighteenth century could well appreciate. London wits were in stitches when Benjamin West painted stout William Penn under the Treaty Tree with the Indian chiefs, one of whom is wearing a headdress of horns, the long-established symbol of a cuckold. The only humor they found in Patience's *oeuvre* came from the puzzlement of not being able to tell image from living presence, in speaking — one thought — to an old acquaintance only to find him laughing at you nearby, or in laughing again to see a shilling dropped into the hand of the waxen housemaid at the door.

Patience, moreover, did not follow the others in creating a show simply of famous figures. If a celebrity offered to pose, well and good. But she saw herself as a portrait artist taking private commissions, with a studio exhibition like any other portraitist's. One found there, duplicated in wax, people one met in their homes or saw in the street, and the rendering of likeness and character was all the more impressive. Some were at full length, wearing their own clothes. A larger number were portrayed in "busto" — Mrs. Wright used only the vigorous Italianate form of the word. Her private commissions seem to have been, understandably, only in that smaller size. Her rooms were crowded, but her art never became popular as home portraiture. Realism can go too far. The face watching one from its glass case could bring a shudder, touch a nameless apprehension, shadowy, elemental. Awe of the image is as old as humanity itself. Past ages felt that fascination as fear — and a fear of the image-maker too, who dared to rival the divine creative power. London *cognoscenti* might not be troubled so, but common folk in England and America still listened to tales of the witch's control by waxen double of the one she watched, for good or evil.

Patience was well aware of the witchery of her art. That mystique of under-the-apron modeling was like crystal ball to clairvoyant, bringing the counterfeit presence into being like an utterance of truth. Such a mind sees no boundaries. She was ready to reshape the whole world around her. Here was a quick, bold intelligence, ready, sharp, no nonsense, yet all the while

held and impelled by what she called "the old Quaker truths," that inner light of inspiration.

"Hearty" was one favorite word, "love" another. She was responsive to firm, fair-minded men, but her love splashed over and beyond them into a protective mothering of all the weak, meek, suffering, and oppressed. All through the terrible years of war her heart went out alike to the plain people of "Old England" and of "Dear America." There in London in the eye of the storm, she dreamed, plotted, and contrived, not for the victory of one, but for them both. Overthrow the King and let the republics of Great Britain and America join hands. That was this woman's solution for the imperial crisis. She would be a Deborah, a prophetess of Israel, denouncing the tyrant, mustering her followers, readying London for the coming of her great friend, Franklin, to lead a peaceful revolution.

And, almost, dimly almost, it might have happened, though never in the single apocalyptic convulsion of her dream. Others, among them British intellectuals far more informed and logical than she, had hopes and forecasts much the same — and today one fascinating aspect of the inspired activities of Patience Wright is that one can see in them a distilled reflection of the swirling undercurrents of those times. It might have happened. There were stirrings of revolt in an England sickened by the disastrous American war. King George at its end did draft a message of abdication. Many foresaw a "Glorious Revolution" like that of 1688. A reformed Parliament and a mollified Congress might, in time, have revived old ties and common interests.

Patience was a conspirator like no other, and a nova in the dark world of wartime espionage. She cultivated an air of mystery, undercover contacts, secret sources, and inspired perceptions. She delighted in obtaining private information both military and political; sending it covertly to Franklin in Paris or — concealed in wax bustos of her own making — to well-connected friends in America; trying by this means to tilt the balance of opinions and events. But her operations were a world away from those of military spies. Her cousins, the Townsends of the "Culper Ring" outside New York, were among

Washington's most effective secret agents — precise information sent through with speed. Patience knew them well, yet only the wildest surmise can link her doings to their dangerous work.[4] Her information from London was inevitably too late, too often wrong, and generally accompanied by hortatory directions as to how it must be used. And yet, while the war hung in crisis, they listened. One cannot brush aside one with whom liberal leaders of the day willingly exchanged information and ideas. If Benjamin Franklin refused to be her co-conspirator in a British revolution, he nonetheless held her in affection and respect. He could observe the visionary side of her nature with understanding and sympathy. He knew it well, that strange admixture of blunt truth, mystery, and inner light.

The defiant laughter, the bold, free-voiced assertion in wax or word, were of one piece with a predilection for hidden paths and subtle maneuver. Artist and prophetess — both roles reached their climax in unison and would fade together in the sad, untidy twilight of her life. For those London ladies and gentlemen, "romantic" held it all in a word, the genius and the fantasies. British sophisticates delighted in these confrontations with natural talent unadorned — the ploughboy poet of Scotland, the shy-smiling Polynesian "prince," the artist whose gifts had first flowered in woodland shadow. Friendly, polite, amazed, amused, they loved to hear her tell of her childhood and how this consummate skill began, there between the forests and the great river. The story must surely have revealed to them also how Patience the wartime spy came into being, as over and over she told of her father's dreams and proclamations, of stealthy revolt within the family circle, of furtive, joyous image-making in the secret world of the nine little sisters in white.

Wisdom's Dictates

THOSE nine little girls, cut off from the world and practicing secret arts and mysteries of their own, fitted into a pattern of family life that was itself as strange as anything in that strange world of pioneers and prophets. The story begins at Oyster Bay on Long Island — a wild, low country with slowly expanding farmlands along the northern shore and an enclave of Indians not far away. There were marsh and forest and sandy barrens. Oyster Bay was one of a line of villages, like beads thinly strung, between Setauket and New York. A traveler could lose his way between them. But they had one great open highway at their side, the Sound. It was thirty miles westward to the wharves and markets of New York, and eastward one hundred and fifty to Newport and Rhode Island Plantations, with the steeples of the Connecticut towns shining white in distance on the opposite shore.

The people there were mostly Quaker families driven by persecution from New England, and Baptists from Roger Williams' Rhode Island. The turbulence of early English Protestantism was still strong among them, mystical, Biblical, intense. So it was with John Lovell, who first appears in the town records of Oyster Bay as a farmer, 1711, and two years later as a miller.[1] He was a private in Captain Samuel Dickinson's "Company of Soldiers" in September 1715, and his father before him, another John Lovell, had carried a musket in King Philip's War, over the Sound, 1675 and 1676.[2] It may have been in the summer of 1713, when he added the house and lands "between Musketacove and Matinacock" to his holdings, that he married Quaker

Patience Townsend.[3] The Townsends were well rooted in the place. Many years later, the children of Patience Wright would inherit valuable lands from Townsend aunts and uncles whose names read like an echo of sombre footsteps trudging onward toward a heavenly rest: Joshua, Noah, Deborah, Ruemourn, and Restore. The Fekes of Oyster Bay were in-laws and cousins. When Robert Feke joined the Baptists it had been a grievous day for his father, a Quaker elder. But his son, Robert Feke the mariner-artist, married a Quaker as John Lovell had done, and then reared his family as Friends.[4] The two groups had much in common and, on occasions of special interest, would attend one another's meetings. Both favored simplicity of dress and manners, and frowned upon wars, lawsuits, or quarreling in any form other than theological disputation. The Baptists, one of the smallest of the Colonial sects, were commonly looked upon as a menace to social order and sound politics, and so had drifted into the Quaker communities, where their own principle of toleration was shared.[5] In Oyster Bay the God-given inspiration of each individual could have free play. Everyone possessed a voice from Heaven, privately cherished and socially respected. Miracles could happen in this interesting milieu. Life was hard, death was near, but there was always a breath of magic in the air.

John Lovell had his own preserves of truth, his own sacred books and fount of inspiration. Patience Wright loved to tell how this father of hers had lived his life and reared his family, though she never gave his credo, and let it be seen only as an abstruse form of Quakerism.[6] He would not eat the flesh of any creature, cattle or game, fowl or fish. He would not profit from their deaths by using leather in shoes, gloves, saddles, or harness, or in any other way. All the beasts and birds of the farm were to be nurtured as friends in return for drawing the plow and wagon, for giving him milk, cheese, and eggs. Cleanliness and innocence were the cardinal principles of his life, and, as a public testimony to them, he and all around him must dress entirely in white. As a final singularity, John Lovell's commanding eyes looked out upon the world from above a patriarchal beard. Assume that his daughter favored him in appearance,

and you have a large-bodied man, active and dark, with her roving, searching glance, her light step, and always the ready word of one whose mind is fixed and sure.

This much we have from what she used to tell, over and over, to English visitors when they paused in astonishment before the wax figures of John and Patience Lovell. But by a rare good chance, we have a nearer view, dating from 1725, the year when she was born. It comes from one of those lonely, saintly wanderers who held the Quaker communities together in thought and practice by spending their lives in a long pilgrimage from meeting to meeting, England, America, West Indies. At the end, under the burden of years, they might gather the whole adventure into a book. So did Thomas Chalkley, "that Antient, Faithful Servant of Jesus Christ," whose *Journal, or Historical Account* was published in Philadelphia soon after his death — the neatly written manuscript still preserved there.[7] It is a chronicle of the communion of souls by day and by night, interspersed with the psalms that he himself composed and sang along the lonely road:

> Thou art all Faire and Richly RAIRE
> Full Beauty is in THEE.
> To the Great LORD none can COMPARE,
> Oh allways Dwell in MEE.
> My heart is Glad may I be CLAD
> With Garments of High PRAISE,
> My Soule Rejoyce and bee not SAD.
> May I so End my Days.[8]

So he was riding on the wintry Long Island roads in 1725, short days and bitter cold. At Oyster Bay, for all the icy sharp wind, he found crowds of neighbors filling the rooms to hear him, and among the folk "many who were not of our society, who steadily gave attention to what was declared."[9] It is here, though Chalkley does not give his name, that John Lovell appears:

> . . . after meeting wth Divers others I was a little fainty in my
> Bodily Spirits after this servis but resting a little I soon Grew

better so that we had an Evening meeting at James Cocks where one came who toulds us wee must not Eat any flesh and produced Tho: Tryons Works for his proof. But I took the Bible and shewd: him a proof for the Contrary and tould him that wee were Resolved to beleve our book before his and shewd. him from the Apostle that the Kingdome of GOD did not stand in meats nor Drinks nor Divers Washings but in Joy and Peace in the holy Gost, Tho at the saime time I was for temperance in meats drinks & Apparell the wch also Christ his Apostles the Scripturs and the Gospell Recommended.[10]

This was at "Matinicock," the Indian name for the hills overlooking the Sound between Oyster Bay and Hempstead Harbor, and the home of James Cock on the Piping Rock Road lay midway between the two.[11] James Cock's sister Meribah was the wife of Patience Townsend Lovell's brother, and he himself would soon be marrying Deborah, sister of Robert Feke. All kinfolk and neighbors would be there. As for the book which John Lovell brought forward to where the candles burned on that bitter wintry night, it was, almost certainly, Thomas Tryon's *Wisdom's Dictates, or, Aphorisms and Rules, Physical, Moral and Divine, for Preserving the Health of the Body and the Peace of the Mind. . . . To which is added a Bill of Fare of Seventy-five Noble Dishes of Excellent Food,* a little volume, pocket-size, printed in London, 1691. Here, succinctly set forth in numbered passages, are all the precepts on diet, cleanliness, and costume which Thomas Chalkley then and there brushed aside. One can sense John Lovell's finger upon Number 491 and moving on beyond. Let worshipers worship not upon the mountain, or in any other place, but only "in the inward part of the Heart in loneness and silence." In loneness and silence let them depart from all uncleanness and superfluity.

495. And remember that he that lives as he ought needs but a few things, and those easie to be procured, a small Cottage, a little Garden, a Spade, Corn, and Water, white Garments, a little Wood, a Straw-Bed, which are the

most useful and necessary, and will support Nature to the highest degree, and a little labour and less care will procure them.

496. Straw-Hats will serve instead of Beavors and Castors.

497. Wooden Shooes instead of Leather, for their Journeys are but small.

498. White Linnen and Woollen instead of rich Colours, for there is no need of rich Garments to cover the outside, when the inside is arrayed with Virtue.

Thanks to Tryon's precise rules of life, we can step through the Lovell door and watch the family from dawn to dark. John Lovell was expounding them in the year of Patience's birth, and one of the last acts of his own life was to reprint a Tryon work "for the good of Mankind." Tryon could be warmly persuasive in a mild, rational way — on the value of abstinence in stimulating the mind and saving money, on the benefits of light clothing, cool rooms, pure water, and fresh air ("The pleasant and friendly Nature of the Air"), on the evils of alcohol and tobacco and the "great Mistake" of slaughtering "gentle and friendly" fellow creatures in order to eat them. Let us be content "with the innocent and natural Food." No fanatic, he admits that he attacks established custom in vain. People will continue to eat meat, and so he gives them good advice, at least, on cooking it.[12]

Diet is the central theme of the most widely read of Tryon's books, his *Way to Health, Long Life and Happiness, or, A Discourse of Temperance and the particular Nature of all things requisit for the Life of Man, As All sorts of Meats, Drinks, Air, Exercises, &c. . . . The like never before Published. Communicated to the World for the general Good by Philotheos Physiologus*, first put out by Andrew Sowle, London, 1683. Whatever the book, there is always a good seventeenth-century vigor in Tryon's style. War he condemns as "the Whole-sale Murthering Art," and he traces religious bigotry to those who think like "some bloody, sottish, Belly-cod, devilish Priest."[13] He had made a voyage to Barbadoes, and his *Friendly Advice to the Gentlemen-Planters of East and West Indies* was in-

tended to open their eyes, among other matters, to the poor Negroes' own sensation of what it is to be a slave.[14] His *Countryman's Companion* gave instruction in the friendly care of horses and sheep.[15] He found women in general more intelligent than men, and addressed them in *The Good House-Wife made a Doctor; or, Health's Choice and Sure Friend,* 1692. Even his *Treatise of Dreams and Visions,* 1695, stated its case in the same clear and logical way; and to this, in one of the Lovell children at least, we can trace her preoccupation with the idea of guardian spirits, revealed in dream, watching over men and nations.

But in America *The Way to Health* stood first. William Penn's learned friend Isaac Norris treasured a copy, as did Dr. Benjamin Rush, leading physician of the later generation.[16] John Lovell may have become a convert at about the same time as the sixteen-year-old printer's 'prentice in Boston, Benjamin Franklin. Benjamin set out to pattern his life on that *Way to Health,* and it was soon putting money in his pocket and ideas in his head.[17] "Poor Richard," with his *Way to Wealth,* owes much to Tryon. Tryon's combination of religious zeal with thrift and plain practicality made him more of an influence in our western world than has been realized. His full-scale regimen, to be sure, was not easy. He himself had had some backsliding before the ascetic life took hold, and his wife, Susanna, was never able to follow him all the way into simplicity and innocence. Franklin's vegetarianism soon yielded to the sweet smell of frying cod. Deep religious convictions eluded Ben, and yet he would always feel a genuine sympathy, gentle and amused, for those who held them — as it would be long years later and half the world away when the great issues of war and peace hung balanced and Patience Wright was sounding the trumpets of Armageddon in his ear.

In 1729 the Lovells sold their Oyster Bay plantation to Daniel Cock and moved south to the Quaker and Baptist settlements of West Jersey.[18] Mother Patience signed the deed of sale with her husband, evidence of mutual rights and in line with Thomas Tryon's strong assertion of the full equality of women with men in the management of affairs. Tryon, indeed, ranks

them superior in all matters of intricacy and fine skills, and here John Lovell could count himself blessed — the father of nine girls and one son. Little Patience, four years old when they moved to their new home by the Delaware, was his fifth daughter. Of the brother, John, little is known. It was the girls who made history: Rachel, Deborah, Rezine, Anne, Patience, then Sarah, Martha, Mary, and Elizabeth.[19]

We know from Patience's own account that the sisters were taught only "the Arts of the Dairy, of Agriculture, and every Branch of such useful and Pastoral Knowledge."[20] Yet Tryon had decreed that daughters were not to be drudges. "All robustickal labour shall be done by man: The fair sex are naturally unfit for dirty mugling imployments. Besides, the preservation of mankind principally depends on the good education and discret conduct of women."[21] Women were precious. According to the "principles, maxims and laws" laid down in the *Some Memoirs* which John Lovell later had reprinted, they must have almost oriental protection from defilement. From the age of seven they were to be veiled when in public. Picture Lovell's daughters in their white dresses and veils, straw hats, and wooden shoes. See their world through that veil. A move to a new home can change the life of a child. That bond to the place where first steps, first words, were made, as much a part of one as the mother's arms, is broken. There is bewilderment, hostility, and then, as the new scene grows familiar, more independence and readiness to wander.

The Lovell farm was near the little cove where Crosswicks Creek flows into the Delaware. The river, rolling by, wide and smooth, flows straight south to Philadelphia, twenty miles. Ships of four hundred tons could come up this far and farther, riding with the tide and wind, a ripple of flags to point the way. The Farnsworths, first settlers, ran the ferry there, a big flatboat moving out toward the manor lands of the Penns on the farther shore. One was told of the great brick mansion of the Manor, with chimneys towering high and a paradise of gardens spread out below. The Lovell house was low-roofed and built of forest timber, fronting the highroad and looking across it to the river

beyond. Soon after they came, the Lovells saw "Farnsworth's Landing" change its name to Bordentown, with Joseph Borden's ships moving in and out, his big house rising not far from theirs. There was a village street of plain and sturdy houses set along a trampled grassy road, the road that led away, northward to Perth Amboy and New York, southward to Burlington, the West Jersey's little capital so spruce and proud. Trees here did not stand in neatly planted aisles with branches meeting overhead. They were survivors of the forest, magnificently straight and tall, each holding its flutter of foliage at great height against the blue.

Travelers moved by unheard, unless it were a heavy wagon with its six-horse team and bells. Indians of the Crosswicks tribe came shyly and watchfully in from time to time. Big John Pombelus, their chief, would glide into John Imlay's store and throw down his pack of deer, fox, and coon skins to trade for powder and shot, knives, cloth, and rum.[22] Imagine little Patience staring at him through her veil, for later he would come to life again in London, as proud and reserved as here. Out around the village, around the fields of barley, wheat, and corn, great remnants of the forest remained, trees like cathedral columns up to a vault of green, and on the soft old mold below flowers blooming where the long shafts of sunlight could mark them out. Everywhere, in a new country, there were places of silence, mystery, and expectation.

Joseph Borden gave land for the village's Quaker meeting in 1740, when Patience was fifteen. That was the year of "the hard winter." The Delaware was frozen and even, as the word came back from Oyster Bay, so was Long Island Sound.[23] Long Island families, Townsends, Ludlams, and others, had come to these new lands, but they were keeping in touch with the old. At Bordentown the new Quaker meetinghouse was built next year. See the Lovells seated there on First Day, a thin line of white scored across the black and gray. It would be as dim and quiet as the woods, until, suddenly, some voice would break the silence with words that came like small waves lapping on the eternal shore. Voices uttering inspiration and command, voices speak-

ing even within the harbor of one's own thoughts, did not break that sense of stillness and great distances which one felt in field and forest here, reaching beyond life and time.

At home there was the overtidily patterned life of a household with two circles of religious commitment, Quakerism and Tryon, and these lay within the larger monotony of farm life, varied only by the seasons. Weather, a gift or a stern imposition from on high, was the most changeable factor, watched, studied, bringing blessings, sudden terrors, magical beauty and surprise. Twice daily, morning and late afternoon, the family gathered at table. Half an hour before and half an hour after, as Thomas Tryon had prescribed, they would all sing together, praising God in a psalm tune. In this way "Philotheos Physiologus" prepared them to receive their simple nourishment and settled their digestions afterward. More Quakerlike, they would silently "read their plates" for three minutes, after which, before eating, it would be the part of the head of the house to speak a few words on the wisdom and mercy of the Creator.

The food was simple, plain, and quite free of all the meaty delights which other families enjoyed. The "Bill of Fare" in *Wisdom's Dictates* is seasoned with zestful adjectives, and these may well have been on John Lovell's lips as he looked up and around him into the circle of faces:

> Apple-dumplins eaten with Butter, or Butter and Sugar, hath the first place of most sorts of Puddings, they are easie of Concoction, and afford a friendly nourishment.
>
> Plain Dumplins made very small, viz. with good Flower, Milk, Eggs, and a little Butter mixed or work'd up in them, and made thin like small Cakes about as large as a Crown Piece, and put into boiling Water, which will be boiled in a little time, this is a noble substantial Food, very sweet and pleasant, of a warming nature, of an easie friendly operation.
>
> Apple-pies made with Fruit that is neither too green or unripe, nor too old or far spent, are a very good Food, especially for young People, they afford a good nourishment, and are friendly to Nature. . . .

Take good white Pease boil them, when near done, add green Sage and Onions cut small, then season it with Salt and Butter; but in the Winter, when green Sage is not good, then take that which is dried according to our Directions in *The Way to Health, long Life and Happiness,* which is to be preferred before green; This is a brave strong substantial Pottage, very grateful to the Pallate, and agreeable to the Stomach.[24]

Frugality, as Ben Franklin observed so well, has a double reward, health and wealth. John Lovell prospered. His singularity brought him fame and respect. It is quite clear that he looked back upon his life and forward to the future with satisfaction. For his daughters it was not at all the same. Self-denial should be self-imposed to work its hidden powers. White clothing may signal both innocence of life and a long washday. To each soul its own inner light and voices, and let no one be surprised that the Lovell girls, growing up, moved into a covert, singular world of their own. It could only have been in these years that Patience developed her taste for doing what authority forbade and the community disapproved — a foundation for all that was to follow.

In his little book of 1695, *A New Method of Educating Children,* Tryon tells us that "Females . . . are of a quick, penetrating Fancy, apt to comprehend anything that is fine or curious, as the Art of Housewifery, Needle-work, Painting, Musick, Writing, &c. In these things no man can exceed them, if they have both timely and proper Education and Instruction; being both by their Genius and Complexions naturally adapted for all easie Employments, and curious Arts."[25] Tryon was no enemy to the arts. *The Way to Health* contains a little treatise on colors, introduced to illustrate his idea that in diet as in painting all depends upon a right mixture of basic elements. It is easy to see how suggestive to bright young eyes his words might have been:

. . . for Example, take *Indigo, Ultramarine,* or any *Blew,* and mix it with *White,* and it makes a *Skie* to what degree you please; but then put in a third, *viz.* mix a *Pink* Colour, and makes a *Green,* which is a fourth Colour, of a contrary Na-

ture to both the first, second and third; also mix *Verdigrease* and *Pink,* and it makes a *Green;* take Lake and *Ultramarine,* and it gives a deep *Purple;* mix *Lake* and *White* together and you have a *Pink* Colour; and if you would have the deepest *Black,* take the *whitest Ivory* you can get, and burn it, and the Ashes will perform your desire; so also *Copporas, Gauls* and *Logwood* dye a *Black,* though none of them are so.

Furthermore, it is to be noted, that there are but seven perfect *Colours* in the World, which have their original form from the *seven Constellations,* viz. *Black, Red, Yellow, Blew, Lake, Green* and *White,* each of which does contain the true Nature of all the Seven; but that Quality that predominates dominates the Colour, and all the other lie as if hid or captivated; but when another or contrary Colour is mixt or incorporated therewith, then both those Colours lose their right in Nature, and thro' an inward strife and contention, there is a *Third* awakened, which before the mixture lay hid and captivated, and this *third* is of a contrary Nature to both the first; and so you may by continual Additions of other Colours, alter it into a fourth, a fifth, a sixth, and so on: for in an apt Commixture of these seven Colours, an ingenious Artist in Painting can imitate and represent the Colours of *all things* in the whole Universe.[26]

The Lovell girls made dyes from herbs and paints from the colored earths the Indians used, mixing them, for binder, with the gums of trees. They painted pictures, and with increasing skill. Then Patience, as more daring, more satisfactory, took to modeling with the clays they had found. The others joined her. Little figures of clay or even of flour dough came into being, were tinted in flesh tones, and then dressed in proper clothing. As they grew older, likenesses of people they knew were attempted, and with recognizable success.[27]

We do not know in what year their mother died, nor how far John Lovell would have stood with his wife in Quaker disapproval of picture-making, or whether he would have leaned toward Tryon's toleration of it. Their neighbors would certainly

have looked askance, and when it came to recognizable images of people, themselves included, most darkly and fearfully so.

"Thou shalt not make unto thee any graven image, or any likeness of any thing that is in heaven, or that is in the earth beneath, or that is in the waters under the earth. . . ." It was all in clear defiance of the second of the Ten Commandments. Quaker doctrine condemned it part and parcel. Any country-bred American father would have felt anger and alarm. Perhaps the girls did not "bow down" and "serve them," the ultimate sin of that Commandment, but they came close to that. They could feel very near to these new companions who would never laugh at white clothes, veils, and wood or canvas shoes, and from whom one could always feel an answering affection.

The thing could never have gone as far as it did under Father Lovell's eye. Perhaps he never knew. Perhaps he came suddenly upon the truth — a Moses descending from the mountain to find the Children of Israel adoringly around a golden calf. What then could the Tryonite, dedicated to innocence and kindliness, do? In a time and land where imagery of any sort was rare indeed — tavern signs of Guy of Warwick, Indian Queen, or Blazing Star, or sometimes a stiffly posed portrait such as cousin Robert Feke was making — it was a staggering thing to come upon little shapes of people, dressed to the life, and some the spirit-and-image of neighbors and kin. It was a mockery of God, bringing old stories of blasphemy and witchcraft to mind, things told at night among the elders beside a winter fire. Benjamin West's biographer, John Galt, tells us of Quaker neighbors condoning his artistic bent as a gift from God. More likely, it was a gift from Thomas Tryon. Certainly, the story of a formal approval voted by the Meeting owes much to Galt's imagination.[28] Quakerism had deeply influenced both Benjamin West and Patience Wright, though neither was a member of the Society and their activities — those of Patience particularly — could not have been acceptable to it. Yet in England that Friendly aura enhanced the reputations of both.

John Imlay's accounts show only two Lovells trading at his store, John and Patience — presumably the joint heads of this

remarkable household.[29] Patience the younger is there, a presence undefined. The wonder is, from all we know of her, that this young woman could have endured the Tryonite regimen all through the teens to twenty, even though secret image-making supplied escape and compensation. There can be no doubt that her youth had set the pattern of visionary intrigue, spy-play, the bustling authority, the voice of a prophetess in Israel. The rule of an aging parent, however benign, would have had less and less regard. It was at twenty that she became, as she told an English friend known among the wits as "Dr. Viper," "a little disobedient." Philadelphia, where the arts flourished and the free, good life was lived by so many, lay before her down the shining river; and to Philadelphia she must go.

A Husband, Rich and Old

I T is from "Dr. Viper," otherwise Captain Philip Thicknesse, Lieutenant Governor of the Landguard Fort, that we have a condensed version of Patience's own story of her life as she had rattled it off a thousand times at her waxwork in England. Soldier, traveler, amateur medico, scribbler, and gossip, born 1719, died 1792, he had made himself notorious as the most querulous and quarrelsome man in all Britain.[1] Thomas Gainsborough the painter was one of his few friends (till it ended with the usual wrathy recriminations), and Patience Wright the sculptor another. There was a whimsical, obstinate, do-or-die contrariness in his nature that had its match in hers. He flew with an instinctive zeal and sense of righteousness to the defense of the underdog, whether it be poor Dr. Dodd, sentenced to hang, or the whole of rebel America. She the same — and the two of them partners, later on, in a risky business.

He vacationed, in season, at Bath. She followed her aristocratic London clientele to that city, and there it is that she receives particular mention among the artists in Thicknesse's *New Prose Bath Guide for 1778.* Allow a little, as you read it, for the bias of the writer:

Mrs. WRIGHT, CHURCH YARD.

Among the Artists we must not omit to mention Mrs. WRIGHT, a Lady (*though born in the wilds of America*) who has a just Claim to the Notice of every Encourager of Arts, for her Talent in modelling Likenesses in Wax. Nor are her *Waxen* Figures the only Object worthy of Notice in her

Apartments, *when she is present.* The Simplicity of her Man-
ners, her strong, natural Sense, her Vivacity, and the open
and honest Manner in which she indiscriminately discloses
her political Sentiments, to Persons of whatever Rank, Con-
dition, or Party, they are of, shews her to be a Native of the
NEW WORLD, where she was taught, by virtuous Parents, to
acknowledge no Distinction between Men, but that which is
produced by superior Virtues, or distinguished Merit. This
extraordinary Woman's Father was (for that part of *America*
where he lived) esteemed among his Neighbors to be A VERY
RICH, AND A VERY HONEST MAN; *i.e.* He had large Tracts of
Land, Houses, Horses, Oxen, Sheep, Poultry, and, in short,
every Kind of living Thing, and earthly Grain (*beside Ten
Children*) which Man can really want, for the Support and
Comfort of Life; but being one of that Sect called *Quakers (I
would to* GOD *we were all so).* He became so singularly con-
scientious, that he could not bring himself to believe, that
GOD permitted Men to spill the Blood of Animals for their
daily Food. He therefore neither eat Flesh himself nor
permitted it to be eaten by any one within his Gates. His ten
Children were twice ten Years old before they tasted Flesh.
Instead of the modern Boarding-school education of *Brit-
ain,* the Daughters of this good man were instructed in the
Arts of the Dairy, of Agriculture, and every Branch of such
useful and Pastoral Knowledge as tended to make them
good Wives to Men in the same humble and natural Way of
Life their Father set before their Eyes.

 The good Man of this *Arcadian* Family, nor any of his
Household, ever appeared in any other Dress, from Head
to Foot, than in white Apparel; and they became not only
the Objects of Admiration and Love, of their surrounding
Neighbors, but the Fame of his singular Manner of Life, his
virtuous Actions, and the general Ingenuity of the whole
Family, was spread over ALL AMERICA. The Genius of his ten
Children (*though they never eat Meat*) broke out in a Variety
of Shapes; for though they were denied earthly Masters,
they had the GREAT MASTER OF ALL NATURE FULL IN VIEW,

and their imitative Powers burst forth like Fruits in their Season, and by the same hidden powers. They expressed Juice from the Herbs and Flowers of their Garden, and extracted Gums from the Trees of the Forest; with these they made Colours, and vied with each other, which should excell most in the Line of Genius they pursued. In short, the Sister-Arts in *America* were THEN *Ten in Number*. The fifth Daughter, our present BATH Artist, became a modeller in Clay, and at length, almost *made Man*. Her Desire of going to *Philadelphia* (where *she then conceived* all the Arts of the known World were to be seen) was so violent, that, for the first Time, she became a little disobedient, and got herself privately removed to that *Now City* of Sorrow and Sadness, but which, then, was the QUEEN of all the CITIES in AMERICA: But being very straitened in Point of Circumstances, she soon after gave her hand to a substantial *Quaker,* who had nothing but *Age* and *Money* to *recommend* himself to her Favour. This Connection, however, enabled her to buy such materials as she wanted, and to pursue the Bent of her Genius; and while the old Gentleman produced her four living Children, she modelled him an hundred in Clay, but not one to his Goût. At length, Misfortunes befel him, and he died, leaving his ingenious Wife, at the age of 35, little else to maintain her Family, but the Ingenuity of her Head, and the cunning of her Finger.[2]

Here is the artist's personal history in a nutshell, from the beginning to her marriage, and with some of the directness, phrase, and emphasis with which she herself had told it. When Thicknesse wrote, Philadelphia, the "*Now City* of Sorrow and Sadness," had just been captured by a British army, Washington defeated and Congress in flight. Philadelphia was in all minds, a symbol of woe to some, of triumph to others.

Here let us take her narrative back to that time when Patience had been "a little disobedient" and had broken away from home to seek her fortune there. The date must have been between 1745 (since Patience was twice the age of ten before she

ever "eat Flesh") and 1748, when her problems were solved by a rich old husband. Since she had not yet begun to work in wax, we may assume that she came to town as "a modeller in clay," and that she met with no success, or, as it is put, became "straitened in Point of Circumstances." In 1746 Robert Feke came down from Newport to Philadelphia, stopping en route at the home of his parents in Oyster Bay and painting some portraits there. That he stopped also with his kinfolk at Bordentown is not at all unlikely, since one traveled in this day from friendly door to friendly door. If so, his presence could have had much to do with Patience's departure.

"Philadelphy" — in Patience's labored letters, freely and phonetically spelled, in her sister's too, one hears a slurring vernacular with something of the New England speech in it ("dea" for "dear," "govone" for "governor," "Mannah" for the Pennsbury Manor lands across the river) — "Philadelphy" had all the allure of freedom, all the excitement of the times. Britain and America were at war with France and Spain, and winning. There were tall ships of war at anchor there, rowdy sailors roving the streets, and soldiers on parade or guard. Hawkers cried their wares. Fine gentlemen in gold-laced velvet strolled between counting house and coffeehouse, with an answering glance for any watchful girl. George Whitefield had been preaching to tremendous crowds — with witchery in his words, they said, for his outdoor sermon on Society Hill could be heard clear as a bell at Gloucester Point, two miles down river.[3] Echoes of holiness, long after, would tremble in the air. Benjamin Franklin gave Whitefield and his idea of founding an academy the *Pennsylvania Gazette*'s solid support. Franklin was for military strength, setting the Quakers at defiance in his sturdy, reasonable way, a man of rising influence in public affairs. He was just beginning his experiments with electricity, dabbling deep in that dangerous mystery and preparing to snatch away, for mankind, the weapon of vengeance that had belonged before to Jove and Jehovah alone.

A French *Géographie Moderne* of the time tells us that this great and beautiful city had been built *"par les Quakers ou*

Trembleurs, sur le modèle de l'ancienne Babylone."⁴ To the Quakers living there it must have seemed as if the taint of Babylon had come in with the others of alien creed and character now sharing their prosperity, borne in on every tide, from Europe, the islands, the American coasts to north and south. Plain Quaker dress and broad-brimmed hats and "plain language" were everywhere, and if some Babylonish pride had taken hold among them, voices were not wanting to decry it. Patience, escaping from the Tryonite way of life at home, would find it present here. Savoring her first meat and fish at tavern table, wearing her first bright colors over the white dress which had always been (this from Tryon's *The Planter's Speech to his Neighbors & Country-Men of Pennsylvania, East & West Jersey*) her "emblem of Innocence and Temperance," this liberated Patience might have been confronted at any time by some familiar and accusing eye.⁵

Philadelphia's most conspicuous expounder of Tryon was the little English sailor, Benjamin Lay, and in times past he must have known her father well, the two long beards wagging together over the woes of the world. Just four feet tall on his spindly legs, a small misshapen figure, he lived with his small misshapen wife in a cave house cut into a hillside. Into town, to meeting or to marketplace he would come, denouncing slavery and other evils in his shrill voice. Ben Franklin had called him "the Pythagorean-cynical-christian Philosopher" in the *Pennsylvania Gazette*'s news story of how, after his wife's death, he had publicly smashed her china in protest against the vice of tea-drinking.⁶ Ben Lay expressed his convictions best by the *coup de théâtre*, or, in today's parlance, the demonstration. Once (taking his cue from Tryon) he had kidnapped a slaveholder's child, keeping the little girl pleasantly captive in his cave until he felt sure her father knew the distress of the poor bondsman when his child was sold away.⁷ The Lovells may have seen and certainly had heard of his act at Burlington Yearly Meeting, women swooning and everyone in an unforgettable uproar.

That had been in startling contrast to John Lovell's modest protest at Thomas Chalkley's meeting in 1725. The little man

had come in wearing an old overcoat and carrying a book, unnoticed by anyone until suddenly he arose and commanded the attention of all. For a while he discoursed on love among all people, then in one quick gesture shed his coat and stood before them in the uniform of an armed soldier, shrill voice rising in climactic phrases as he slashed his sword into the book. The book had been hollowed out and filled with red pokeberry juice (*Phytolacca decandra,* as one chronicler of the occasion is careful to record) — truth destroyed in a welter of blood — Tryon dramatized in a way the West Jersey meetings would never forget.[8] When another old sailor, William Williams, painted Ben Lay's portrait for Ben Franklin, he posed him at his cave's mouth holding a book, "Trion on Happiness," obviously the famous *Way to Health, Long Life and Happiness.*[9] That this God-given oddity had its effect on John Lovell's rebellious daughter we cannot doubt, for it will be seen again in her own ready, swinging defiance of the mighty and the proud.

We cannot know whether she found love or lovers in this first taste of freedom. At home, she might never have escaped from virgin singularity. By Tryon's "Principles, maxims and laws," children are to be married at the age of twelve — "but they shall not be suffered to cohabit, nor bed together, till the man be 21, and the woman 17 years of age." We can only guess how John Lovell may have dealt with this bold rule. All we know is that Patience, daughter of a now well-to-do family, went unwed much longer than one would expect. Here was a young woman with emotions as strong as the tides and as unsubmissive. She had too commanding a nature for softly amorous feelings. Hero worship, yes — John Dickinson, John Adams, the Earl of Chatham, Franklin, Washington — but never tame surrender to a man. The fullness of her love was spread over all, that intimate, affectionate, ready fellow-felling which made her at home wherever she might wander. This is what the Quakers in their way prized as a "unity," and what bound Ben Lay to the whole world, "my Joy and my Crown . . . your Unity, in the holy spotless eternal Truth."[10] Patience sought the same, with greater freedom and zest. Friends she found at a glance or word.

Children in revolt often retain much of what they have been at pains to cast aside. Tryon remained. *The Planter's Speech* tells parents to create by example a "Habit of Love, Compassion and Concord," and so the Lovells had. Patience would be her father over again in seeking love, compassion, concord, and in declaring God's will. She would fit herself, her friends and enemies, into the shadowy shimmering framework of the Scripture stories — always, be it noted, the Old Testament rather than the New — and, with her friends, always ready to seal the unity with a warm embrace and buss.

If Patience Lovell and Robert Feke were together in Philadelphia in this runaway sojourn, they would have made a striking pair, and with a certain Old Testament aura over them both — she, dark, sure, straight as an Indian, with the light, quick stride, the warmth and energy; her cousin with his long pale face framed in shoulder-length black hair, his dark, searching eyes, and slender tapered hands. They were alike in the intensity with which each moment was possessed. They would have been seen at Christopher Marshall's color shop in Chestnut Street, under the sign of the Golden Ball, where not only all sorts of colors were on sale, ready-mixed with directions for use, but things for the body and spirit as well, "Royal Patent Snuff," "Greenough's Tincture for Tooth-ach," "Hooper's Female Pills," liquorice balls and sugar candy.[11]

From Philadelphia she may have gone back with Feke, perhaps as far as her mother's family at Oyster Bay. Or she may have made the journey alone, for we know that, through the rest of her life, from time to time, she would be out a-roving through the American, the British, countryside. Two years later, she was married at last, and William Wade Hinshaw's *Encyclopedia of Quaker Genealogy* gives the place as Oyster Bay.[12] Yet this is unsupported by the Westbury Monthly Meeting records, and Hinshaw mistakenly identifies her husband, Joseph Wright, as one of the Oyster Bay Wrights, some of whom, like the Lovells, had moved south. The date, at least, is sure: March 20, 1748.[13]

Patience's Joseph Wright was a West Jersey neighbor, a native of Burlington County. His father, Richard Wright, was a

large landowner of the county with a home in Burlington city. His brother, Richard, was the most prosperous shipbuilder of the region, with shipyards on the Delaware at Kensington, in the Northern Liberties of Philadelphia. His sister, Elizabeth, had married John Imlay of Bordentown, and would be the namesake of one of Patience's children.[14]

John Imlay, background figure in this tale, is worth a second look. He first appears as a young storekeeper and trader at Bordentown. One would like to think that there is a flash of wit in his entering Patience's father in his books as "John Loveall."[15] By the time of the marriage, Imlay was branching out into larger affairs — a land broker, with mercantile operations of a general sort extending as far as New York. When the Revolution came he would become Judge of the Court of Admiralty in New Jersey, the same eminence that his friend, Francis Hopkinson, held in Pennsylvania. His life ended in 1792 at the age of seventy-three, in a new-built mansion in Allentown, New Jersey, parts of which may now be seen at the Metropolitan and Henry Francis du Pont Winterthur Museums.[16] The Judge's nephew, Captain Gilbert Imlay, swung out into history on a wider orbit. He saw service with the New Jersey Continentals, then turned, as his uncle had, to land speculation. His promotion of western development took him to England in 1792, where his three-volume novel, *The Emigrants,* was followed by a career of political intrigue in revolutionary France. Gilbert is best remembered now for his liaison with Mary Wollstonecraft, on his part cruel and inglorious.[17]

It was through John Imlay that the newlyweds of 1748 bought a home in Bordentown.[18] The house, a neat brick edifice still standing, was at the crossroads center of the growing village, right across the street from Colonel Joseph Borden's mansion. Nearby, as the *New Prose Bath Guide* tells us, old Father Lovell had been prospering. He would be investing, 1754, in a fine plantation in Bristol, north of Philadelphia.[19] Then, at Bordentown, out on Crosswicks Creek, he bought another for himself, cleared the fields, planted an orchard, and began the building of a substantial mansion. He planned a grist mill on the creek, recalling his young days as a miller at Oyster Bay.[20]

Family interests had been expanding toward Philadelphia. On October 23, 1750, Patience's sister Rachel had married James Wells, a Philadelphia shipwright.[21] Their home was in Southwark on the southern fringe of the city, at the corner of Swanson and Queen Streets, near the wharves and boatyards. They had bought it from Thomas Penrose, him whose name the painter William Williams borrowed for the hero of his novel of seafaring adventure.[22] Sister Deborah married one of the Eyres, a Yorkshire family which had become numerous and successful in New Jersey (Eayre in her estate settlement, but also Ears, Ayres, Ayre, and a dozen other forms).[23] In 1760, two brothers, Manuel and Jehu Eyre, married daughters of shipbuilder Richard Wright and so became nephews-in-law of Patience and Joseph.[24] They took over the management of the shipyard soon after, and, joyfully romantic, named the first large vessel they built *Truelove.* The barque *Truelove* sailed on her maiden voyage in 1764. She would, to the wonderment of all the city, return to Philadelphia one hundred and nine years later, bringing a cargo of oil from the whale fisheries of Greenland.[25] Manuel and Jehu, with a third brother, Benjamin George Eyre, have places of note in the military and naval history of the American Revolution.

Others of the Lovell brood stayed nearer home. Sister Rezine was married to Ephraim Anderson of Trenton, who also became an officer in the Revolution and died in the fighting in northern New Jersey, 1777.[26] Sister Sarah was comfortably provided as Mrs. Samuel Harker.[27] Sister Anne had been the widow, since 1749, of Nathaniel Farnsworth of the old Bordentown family, with a son and a daughter, Amariah and Rachel.[28]

Old John Lovell, white hair and beard matching his garments now, saw his family comfortably settled around him, though perhaps not altogether in the pattern he had set. Respected and renowned through all the countryside, he turned his thoughts to the founding of Tryonite "Societies in Cleanness, Temperance and Innocency." On September 10, 1761, the *Pennsylvania Gazette* announced his publication of *Some Memoirs of the Life of Mr. Thomas Tryon,* first issued in London, 1705, and the only work in which directions are given for forming a society to perpetuate the Tryon doctrines. It is a tiny book, six inches by

three and a half, bound only in gray paper — something to pass out among family and friends in the year of life remaining to him.[29] He died in September, 1762.[30] The *Memoirs* closes with an "Epitaph" on Tryon, some lines of which might stand as well for this faithful follower in a distant land:

> Such refin'd Notions to the World he gave,
> As Men with Angels entercourse might have;
> Shewed how to live on cleanest Food,
> To abstain from Flesh, and Fish, and Blood.
> Harmless his Life was, as his Food,
> Both Patriarchal, Primitively Good.

John Lovell's only son, to whom he had given the house in the village, did not attempt to finish the mansion by the creek or develop the plantation and mill.[31] Of John, Jr., little more is heard. The girls, however, stand out in such records as remain, and most particularly the one whom Joseph Wright had taken as the companion of his declining years.

Patience and Joseph, living in Bordentown, brought into the world a family of their own. Mary came first, and then Elizabeth — or "Betsy," until the dignity of young womanhood in London forbade it. Joseph, their only boy, was born on July 16, 1756. A third daughter, Phoebe (until London days always "Phebe" or "Pheby"), came on August 22, 1761. The last child, Sarah, or "Sally," was born after her father's death, probably in 1770.[32] As for Patience's collateral family of modeled figures, we have only "Dr. Viper's" broad estimate of this activity, "an hundred in clay," along with his smirking comment on her husband's distaste for it.

In saying that she "gave her hand to a substantial *Quaker,* who had nothing but *Age* and *Money* to *recommend* himself to her Favour," he certainly reported what Patience had told him. The suave hint of other affairs within the marriage bond, however, may come from him rather than from her. Patience was one to cut her own course, and it can only be said that there was nowhere in her career any stir of *"fama clamosa,"* the churches' onomatopoetic phrase for breath of scandal.

The *Bath Guide* mentions the decline of Joseph's fortunes, and this may have begun with the death of his father in 1756. Some time later, he took a small house in Philadelphia, his family remaining at Bordentown. His will describes him as "cooper," and his business was probably concerned with the kegs and barrels needed at the Richard Wright shipyard, now owned and operated by the Eyres. Patience was apparently not with him when he died, and she probably disliked the terms of his will, though actually it reveals him as a thoughtful and kindly man. It was drawn May 7, 1769, at the Philadelphia house by Peter Thomson, a cousin of the painter Benjamin West. Dr. Stephen Wooley was in attendance. "Sick and weak in Body, but of sound disposing Mind and Memory," he was able to sign only with his mark, and that a feeble scratch as someone held his hand. He died soon after, for the will was probated on May 25.[33]

The inventory of the contents of the Philadelphia house includes no portrait sculpture. It takes us through the small home room by room: In the Front Parlor a cot bed, an old maple desk, a pier looking glass with a gilt frame (broken), six leather-bottom black walnut chairs, and a joint stool. In the Back Parlor a walnut dining table, mahogany card table, cherrytree tea table, a large pier mirror, and brass andirons on the hearth. Here also were a "Tea Board & a parcel of China, Stone & Glass Ware," with two japanned trays. In the Front Chamber a bedstead, feather bed and bedclothes, six old "stuff bottom" maple chairs, and a joint stool, with "2 Setts of red Durant Window Curtains" (a woolen material, pressed and glazed). In the Back Chamber another bedstead, a walnut chamber table, two iron stoves, and an old musket. Upstairs, in the Front Room again a bedstead, a chamber table, a small looking glass, another set of window curtains, and "25 bound books upon various Subjects." In the Back Room upstairs, used for storage apparently, a feather bed, coverlets, bedding and bed curtains, six rush-bottomed chairs, and a leather trunk. To grace the walls around the house there were five "India Pictures," presumably engravings. The Kitchen had a walnut table, a Windsor chair and stools, a corner cupboard, a brass kettle and saucepan among the many other im-

plements, and, as its final convenience, "A Negroe Woman named Coba, aged upwards of 40 years" and valued at ten pounds.

Under the terms of Joseph Wright's will the proceeds from the lands inherited from his father were to go two-fifths to his son Joseph, one-fifth each to Mary, Elizabeth, and Phoebe. Patience, in lieu of her dower right to one-third of the whole, was to have the Bordentown home and all it contained — but upon a certain condition: "She my said wife Patience, maintaining and bringing up my Three youngest Children, namely, Elizabeth, Joseph, and Phebe, in the best manner she may be capable, according to her Ability, until they do respectively attain to the Age of twenty one Years or Day of Marriage, which ever shall first happen, without any Charge on her part to be made for the same."

There was no provision for the unborn child, of whose existence the father was unaware. The eldest daughter, Mary, was already married.[34] Her husband, Benjamin Van Cleve of Hunterdon County, New Jersey, was named an executor, as was Manuel Eyre of the shipyards, both men of business, resolute and precise. Was that "in the best manner she may be capable, according to her Ability" a recognition of her strong character or a challenge to display it? Was it an answer to some boast of hers that she could support herself and family without him? Perhaps, though more probably it was simply the act of a man who hoped to keep this woman of the free and roving disposition safely at home where her kindred round about would make sure that neither she nor the children were ever in want.

Patience on her part took the injunction literally. She would meet the conditions fully, but had no intention whatever of living out her life in the village. She was entering a new freedom, and meant to maintain it upon the terms prescribed. Here it may as well be confessed that in telling her English friends of her bereavement "at the age of 35," a decade had been brushed aside. She was forty-four. And she was carrying not only those years, but that last child, not mentioned in the will and born, we must suppose, sometime in 1770. She could give the newcomer,

Sarah, to one of her sisters for safekeeping. The other three, on whom her inheritance depended, she would keep securely with her as she went out to seek her fortune in her own special way. She would show those executors, the whole family, and the world what "her Ability" could do.

The American Waxwork

How to support herself and the children "according to her Ability" was now the problem. In such a place as Bordentown it would have been the thing to take boarders or lodgers, or open a little shop. But modest endeavors of that sort were not to the lady's taste. As she would frankly and gratefully acknowledge, it was her sister Rachel Wells who found the answer.

Rachel had also kept up with their childhood image-making, but had turned from clay to wax, and in the years of her widowhood had made great strides with it. Dr. William Shippen, Jr., had had high praise for her talent three years earlier. He had employed her to copy in wax "A very extraordinary Lusus Naturae, two female children joind firmly together from the breast bone as low as the navel, having therefore but one body." He sent the copy to Benjamin Franklin, then in London, for transmission to the savants of the Royal Society. "This preparation of wax was made by a Gentlewoman who is a great tho unimproved genius in this way. Tis the exact semblance of the original which I have in spirits."[1]

But such work was not what Rachel had in mind, and with a reason. It was at just about this time, 1770, that Dr. Abraham Chovet, physician, wit, and wag, came to Philadelphia from Barbadoes. He was a man of sixty-six, a teacher of anatomy as well as practitioner of medicine. In London at the outset of his career he had been one of the first to lecture from wax models, made by himself, rather than actual anatomical specimens.[2] Now, in this new milieu, he created others, both for medical students and

as a diversion for the public. In 1774 the *Pennsylvania Gazette* would be advertising his "Anatomical Museum in Videl's Alley, in Second street."[3] The chief attraction here was a pair of figures, male and female, with the external parts removable for separate examination. It would remain for many years one of the little city's major attractions. George Washington, on July 4, 1787, the Constitutional Convention year, "Visited Doctr. Shovat's anatomical figures" before strolling on to the Independence Day oration and dinner.[4]

Let the Doctor go his own way. What Rachel proposed to her sister was portraiture in wax, a final chapter in the childhood game. Patience tried her hand at the new medium and quickly mastered it. Portraits could be made with a speed and ease she had not found possible in clay, and features shaped more readily into any desired nuance of expression. Best of all was the realism imparted by hair and eyes and by color, tenderly or boldly applied. A veritable duplicate of the living individual could be created. The value of portraiture, as Dr. Samuel Johnson had declared, lay "in diffusing friendship, in reviving tenderness, in quickening the affections of the absent, and continuing the presence of the dead."[5] Here was an art that could do that as no other. These two sisters, well into middle age, could startle the world around them, worry the clergy, frighten the superstitious, and set everyone agog.

What, however, of practical, pecuniary success? Patience had a new neighbor who should know. Francis Hopkinson had recently married Colonel Borden's daughter, Ann, and had come to live in Bordentown. He was not only an artist and connoisseur but a lawyer, and thus well qualified to counsel a widow with a legal obligation to support her family. Patience's house was on a street corner, with the Borden mansion opposite on one side, and the tall Hopkinson mansion opposite on the other. Perhaps, for this occasion, she had made portraits of Francis and Nancy themselves.

Mr. Hopkinson was then just thirty-two years of age, a surprisingly little and lively man who painted pictures, wrote poetry, played and composed music. He is best remembered

now as a Signer of the Declaration of Independence, but quite possibly would not have made that his own first claim to fame. He might have given primary place to having designed the American flag, or might have called your attention to some of his verse, his comic pieces, an air for the violin, or even his opinions as Judge of the Court of Admiralty. In 1770 he had just returned from England, where he had hobnobbed with Benjamin Franklin, Benjamin West, and other Americans in London. He had put himself on friendly terms with the affable and eminent Lord North, a family relative; and the British ruling class, like everyone else, had found him pleasantly engaging. He was, like his own music, alive with tenderness and intelligent laughter. One might hardly notice him, small as he was, in a room full of people, and yet his presence would have brought it to life like a pool that ripples and bubbles over a spring of fresh water.

Mr. Hopkinson could see at a glance the difference between this woman's work and Mrs. Salmon's waxwork show, so long one of London's most popular attractions. The success of wax sculpture as a private portrait art was too much of a novelty to predict. But work of such quality was sure to make a stir in the American towns, might even hold its own in London.[6]

So the widows Wright and Wells set out on tour as their cousin Robert Feke had done, and as all American limners for many years must do. Seeking the patronage of the prosperous and elite, they did not advertise. Gentlemen and ladies were invited to their rooms. There would be no admission charge, but those who did not commission a portrait might be expected to leave an appreciative gift. Waxwork shows had drifted through the colonies before. Boston had had one since 1733 when John Dyer had shown, price sixpence, "a lively Representation of Margaret, Countess of Heininburg, who had 365 Children at one Birth, occasioned by the rash Wish of a poor Beggar Woman." This was accompanied by a figure of the beggar woman in the act of wishing. Dyer was followed by Mrs. Abigail Hiller with an assembly of kings, queens, and lesser notables, and far to the south, the while, Charleston was enjoying similar excitements even to an overflow from Mrs. Salmon's London

wonders — King, Queen, Princess Amelia with attendant cour-
tiers and a drummer drumming.[7] But waxwork as contempor-
ary portraiture was something else again, striking home as such
stuff could never do.

Slender as the evidence is, it becomes apparent that with
Wright and Wells the exhibition was more profitable than the
individual commissions. Their effigy of "a dead child" may have
brought more private orders than the busts and figures. With
the high rate of infant mortality such pieces were much in de-
mand from artists and the utter realism of wax, surely, was
something to keep fresh the mourning parent's tears. Wax is an
art for summertime or a warm climate, and so the two moved
south in winter as far as Charleston, ranging north again with
the return of spring. But wax sculpture, bulky and hollow, is not
easily moved about, and this led as their collection increased, to
the establishment of two fixed exhibitions, one at Rachel's home
in Philadelphia, the other in Patience's chosen milieu, the city of
New York.

They still traveled, each looking after the other's interests as
well as her own. Rachel brought back from the South head and
hands of the bell-voiced evangelist, George Whitefield. The rep-
lica sent to Patience may have become the model from which
Staffordshire and other Whitefield likenesses were made in Eng-
land. Both Rachel and Patience set up the full figure, seated, in
black ministerial gown, looking at you with that round, kindly,
energetic face. Patience modeled a bust of lean, gentle, long-
nosed John Dickinson, the "Pennsylvania Farmer" whose news-
paper articles had posed determined, legalistic logic against the
encroachment of King and Parliament on American liberties.
She modeled also the head of Lieutenant-Governor Cadwal-
lader Colden of New York, author of respected medical works,
internationally known as a botanist, and one of Benjamin
Franklin's closest friends. Dr. Colden was in the opposite politi-
cal camp from Franklin or Dickinson, but Patience was attracted
by eminence and strong character. In Colden — aged eighty-
three, straight nose between sagging cheeks, small mouth
pinched firm — she had both.[8]

Rachel showed a taste for subject pieces, sometimes of several figures, with emphasis on dramatic action and strong emotion. Her Philadelphia rooms would become a regular exhibition with admission price.[9] Her work won praise, and yet, strangely, no personal impression of Rachel Wells herself has come down to us. Patience, in contrast, made portraiture her thing, and in the vis-à-vis interplay of artist and subject she was magnificent and memorable. Her subjects became her friends. Boisterous and loud as she was, they nonetheless enjoyed and respected her rough, right-to-the-point intelligence, reading her scribble-scrawl letters with attention and answering with frankness and freedom of their own. Patience became a famous personality, while Rachel is a mere shadow in the past. We see Rachel filling her stage with vigorous action while playing no part herself, and Patience creating actors in wax to support her own stellar role.

The New York waxwork was at No. 100 in the upper end of Queen Street. It was nearer the wharves and Merchants' Coffee House and center of town than its only competitor, Samuel Francis's "Vaux Hall," where there were seventy wax figures in miniature including the Queen of Sheba and King Solomon, "with a view of his Palace," not to mention "the great Roman General Publius Scipio" standing by his tent attended by his guards.[10] One could enjoy these spectacles and then move out into the garden for tea or coffee with hot rolls. Queen Street offered no such excitements or polite relaxation as this. There one found a fresh, contemporary scene, enlivened by talk of the characters — who were so marvelously reproduced — and of related affairs. The waxwork became a place for discussion of people and the times, with its proprietrix, pithy and plain, presiding over a sort of 'change of anecdote and information. One sees here the beginning of Patience the famous London "spy." The newspapers, as they would do in England, praised her art in literate phrases foreign to Patience herself, yet an echo of the talk at her rendezvous.

As was later the way in London, she was by no means a fixture there. She would leave the children in charge and fare up or down the coast, back through the Jerseys or off among her

cousins around the old home at Oyster Bay. Near Oyster Bay lay "Spring Hill," Cadwallader Colden's farm, where he now spent most of his time, and she had probably made his portrait there.[11] Samuel Townsend, merchant of Oyster Bay and Jericho, was now the chief figure of the clan — a well-read solid citizen, he and his wife so tall and proud as they came together into Quaker meeting followed by their sons and daughters, Samuel, Robert, Audrey, Sarah, Phebe.[12] It was Robert who, seven years later, would come on stage as "Culper Junior," playing opposite Abraham Woodhull's "Samuel Culper" in General Washington's secret service.[13]

Plain country folk may well have been shocked at what they heard, or even, coming in on market days, beheld at the waxwork. Those who saw it as a thumb-to-nose at Scripture must have thought it a judgment of God when disaster struck. It struck on June 3, 1771. *The New-York Gazette, or the Weekly Post-Boy* of June 10 has the story:

> On Monday Evening about 8 o'clock, a Fire was discover'd in the House of Mrs. Wright, the ingenious Artist in Wax-Work, and Proprietor of Figures so nearly resembling the Life, which have for some time past been exhibited in this City to general Satisfaction. The Accident happen'd when Mrs. Wright was abroad, and only the Children at home, and was occasion'd by one of them accidentally setting Fire to a Curtain enclosing some of the Figures: The Child for some time in vain endeavor'd to extinguish the Fire; which was soon communicated to the Clothes of the Figures, and the Wax of which they were composed. The Neighbours immediately assembled, and with the greatest Care and Expedition, gave all possible Assistance in removing and preserving the Household Goods. The Fire Engines play'd into the House and soon extinguished the Flames, with little Damage to the House; but, tho' most of the Wax-Work was destroy'd, together with some new pieces which Mrs. Wells (Sister of Mrs. Wright) had lately brought from Charlestown: the whole amounting it is said to the

Value of several Hundred Pounds; yet she was so fortunate as to save the curious Piece of the Rev. Mr. Whitefield, the Pennsylvania-Farmer and some others, which she continues to exhibit, and we hear that she proposes to repair the loss sustained by this Fire, as soon as possible, by making some new and curious Pieces.

This news is to be found also in the *Pennsylvania Chronicle* of June 10–17 and the *Boston News-Letter* of June 20, and may well have been picked up by other papers. The sisters were newsworthy now. Publicity would take care of itself. Rachel hurries up from Philadelphia and together they repair the damage:

> It is said that Mrs. Wright, with the Assistance of her Sister, Mrs. Wells, has been so assiduous in repairing the Damages done to the Wax-Work by the late Fire in her House, that the Defect is not only supplied by new Pieces, the Subjects of which are interesting and well chosen, but they are executed with superior Skill and Judgement, as the Performers have improved by Practice and Experience: To both these extraordinary Geniuses, may without Impropriety be applied what Addison says of Kneller, a little varied.
> By Heav'n and Nature, not a Master taught,
> They give to Statues, Passion, Life and Thought.[14]

The replacements winning this praise for the two artists were, as the article went on to say, in the field of Biblical illustration, Rachel's métier — "The Murder of Abel by Cain, and the Treachery of Delilah to Samson, are two principal Subjects of their last Performance."

Whichever child may have started the fire when Mother was away — fifteen-year-old Joseph or his elder or younger sister — seems now to have learned a proper lesson, for Patience and Rachel were soon on tour again. They arrived in Boston early in September, and here the news as reported in the *Pennsylvania Chronicle* of September 9–16 reads a little as if it might have been penned by one of the sisters, in part at least:

> Last week arrived in this town Mrs. Wells and Mrs.

Wright, widow daughters of the celebrated Mr. John Lovell of Long-Island, who between the years [i.e. ages] of thirty and forty engaged in the formation of figures in wax-work, which they readily brought to such perfection, as have amazed spectators in all ranks where they have been exhibited. The figures they have brought here, shew the return of the Prodigal Son, the celebrated Mr. Whitefield, and the beloved Farmer of Philadelphia. Gentlemen acquainted with those admired personages confess their obligations to the skill and industry of these Ladies for reviving the former from the grave, and presenting his numberless friends in Boston, with the living image of John Dickinson, Esq.

In Boston the Ladies had found a congenial friend in Mrs. Jane Mecom, Benjamin Franklin's favorite sister. When Patience brought out that she might go even to London in search of new subjects for her talent, Jane offered to write a letter of introduction to her brother, who was there as official agent for the colonies of Pennsylvania, New Jersey, Massachusetts, and Georgia. Jane was herself a widow who had had to cope with hardships, and Benjamin would surely respond to this other determined woman's need. World-famous now as an electrician, he could persuade the eminent of Britain to pose for portraits in wax which all America would come to know.

London! The fire in Queen Street seems only to have warmed the enthusiasm of Mrs. Wright. The children, sure to be careful with candles now, would remain in charge in New York until her return. She had no thought at first of remaining. Yet her letters of introduction reflected a hope that she might match in sculpture all that was being told of painter Benjamin West. West had not expected to stay long in London, but was now a fixed and rising star there in the greatest city of the world.

It would have to be a winter voyage, since she must be settled in time to have all the warm weather for her work. The passage, too, was cheaper in the stormy season. On February 1, 1772, surrounded by leave-taking children and friends, she

boarded the little two-master *Nancy,* rocking at her New York pier with a cold wind from the outer sea slapping the lines against her masts. Not until then did she feel that chill of premonition, of never, maybe, returning to the friendly faces, the towns and highways of home. So there in Captain Dillon's cabin she wrote out her will, and friends stepped forward to witness it. As in the later reports and bulletins she would be sending out through the years, it was a highly personal document, well seasoned with admonition. Her hurried, worried words are still on file in the Surrogate's Court of the County of New York:

> Mrs. Patience Wright being about to leve my native country and Embark for England in Ship Nancy Captn. Dillon Comander as my busness I trust is lawful both in the sight of God and man I now leve my worldly afairs as followeth: I leve my daughter Elizabeth Wright the whole and sole Exectress of all my moveball estate in New York to pay rcive and do justice to all men as far as in her power and to take care of her broth. Joseph Wright now at Philadelphe at school to send him money if any can posable can be spared from keeping of herself and sister Pheby Wright at home in New York to always live in love and tender regard to each other the younger to obey the elder and elder to behave becoming and with love to speek and act towards each other and in order the better to regulate thir condoct I do opint Mr. Jeams Bowne, Mr. Wm. Goforth my landlord, and Mr. Linley Murrey to asist and to be always consulted by them my Children on all afars of importance and to re[cei]ve thir advise and obey them in all ther reasonable demands they being men I love honour and esteem my friends &c. . . .

With this preamble, the Bordentown house was willed to little Sarah, "as she was born after her father death and not mentiond in his will but said house was gave to me for my legacy or dowerey. . . ." "Sally," now being "in the care of her aunt Anderson I order my daughter Elizabeth to Remember her and to as often as posable to send to know how she is in helth and to send all posable opertunty's money and a part of all profitts arising from my waxwork. . . ."

Aunt Rachel Wells, whenever she might come to New York, was to be honored and obeyed as having been "the means under god to permote my wellfare and instruct me in waxwork to enable me to maintain my famaly and I order Betsey Wright to keep a regualor book of all proffts that arise from my waxwork And to pay a quarter part to her aunt Wells after the rent is paid. . . ." Sister Harker, then in South Carolina — whether with a waxwork show is not known — was to be summoned north should need arise.

The three loved friends whom she had named are worth a second glance. Brilliant young Lindley Murray had just returned from a tour of England and had begun what was to be a remarkably successful law practice in New York. Later, returning to Britain to live, he would write, among other books, his *Grammar,* long definitive throughout the English-speaking world. She could scarcely have left behind her a better friend, to be ready with advice for the children and keep an eye on her affairs. She may have had a wax portrait of him among the few she took with her to the ship — high forehead, Roman nose, a sharp cleft chin, and those large, friendly, understanding eyes.[15] Lindley's mother, living on Murray Hill (near today's juncture of Park Avenue and East 40th Street), would become a heroine of sorts, September 5, 1776, when she entertained General Howe and his officers so engagingly in her home that they missed their chance to cut off old Israel Putnam's Yankees from Washington's army.

William Goforth, the Queen Street landlord, was a young man too, and would go forward into a distinguished career — commandant of a military post in Canada during Benjamin Franklin's mission there in 1776, and still later a judge and outstanding pioneer in the history of Kentucky and Ohio.[16] As for James Bowne, he was a solid figure from among the Oyster Bay cousins, a direct descendent of the seventeenth-century Quaker leader, John Bowne, under whose oak trees by the Sound George Fox had preached in 1672.[17] John Bowne had married a daughter of Lieutenant Robert Feke, great-grandfather of Robert Feke the mariner-painter, and both "Jeams" and Patience may have been thinking, as the *Nancy*'s sailors made ready

to cast off, of how Robert had sailed away from Newport and never been heard of again.

The trio of advisers to her children reveals again the readiness with which Patience won the friendship of men whose learning and sophistication far surpassed her own. A second trio named in the will shows us another side — the two witnesses, Hercules Mulligan and his brother Cooke, and Captain Dillon, all plain, bold, adventurous souls. Hercules, brightly Irish, lover of religious music and pleasant words, was New York's most popular tailor and would long continue so. It becomes clear that in dressing her waxwork Patience sought out the best. In this year 1772, a lonely boy from the West Indies, Alexander Hamilton, would find a friend and protector in Hercules Mulligan.[18] Mulligan would stay with his shop when war broke out, and Hamilton would suggest him to Washington as a source of information.[19] He became as successful in fitting British officers as he had been with Colonial gentry — learning all he could by a watchful eye and glib tongue and passing it on to the young men of the "Culper Ring."[20] An appreciative General Washington, entering the city at last on November 25, 1783, would invite Mulligan to join him and his staff at breakfast on the town's first liberated day.[21] Moreover, back in this year 1772, when Captain Joseph Dillon was elected a member of The Marine Society of New York for the Relief of Distressed Shipmasters or Their Wives and Children, Cooke and Hercules Mulligan came in as honorary members.[22]

She sailed, New York for London, February 3, two days after that will had been drawn. The news was being echoed up and down the continental coast, partly because this was a new packet line from city to city, and partly for the distinguished passenger on a maiden voyage. The *Boston News-Letter* picked it up from the *Pennsylvania Chronicle* as it had come to Philadelphia from the New York papers:

> The Snow Mercury Packet, lately built here, Captain Dillon, Commander, is ready to sail for London, to which place she is bound this voyage as a merchant ship, and is

thence to proceed to Falmouth, and sail to this place as the 5th packet boat, for which purpose she was built.

Among the passengers is the ingenious Mrs. Wright, whose skill in taking likenesses, expressing the passions, and many curious devices in waxwork, has deservedly recommended her to public notice, especially among persons of distinction, from many of whom she carries letters to their friends in England.[23]

Strange times and great times lay ahead as the little craft saw spires and rooftops grow small behind her, disappear at last, lifting her prow to the first long combers, plunging forward, tight and hearty, to meet the winter gales.

CHAPTER V

London by Storm

Americans, sailing up to London on the Thames' strong tidal current, found themselves drifting into a forest of masts, reminding them of forests at home where the trees had been girdled to clear new land for planting. All around them rose the city, crowded roofs and smouldering chimneys, spires and towers and the great dome of St. Paul's upon its hill. London was vast, maternal, the mother of all their own little towns from which the stricken wilderness shrank away. London was the heart of an empire reaching out to America on one hand, to India on the other. This was the seat of wealth and power, of wisdom and the arts.

Once ashore, the numbers and variety of people seemed beyond belief, hurrying or idling, steady tradesmen, haughty gentlemen and ladies, the plaintive poor. Jonathan Boucher, who had brought a young American wife home from Maryland to London, used to tell laughing how the poor girl had shrunk back from going into the street on her first day, begging that they wait "until the crowd went by."[1] Patience Wright, bolder than that, may well have loved London as much at the first as she did at the end. A newcomer, an American arriving alone, must needs look to the sturdy red-faced chairmen waiting with their poles in hand, and to the porters with their badges, all watchfully alert among the clop of hoofs and rumble of wheels. Here were men who would meet her eyes and match her wit, word for word. Patience would become a part of London, just as her older compatriot, Benjamin Franklin, had done. It was Franklin at his home in Craven Street whom she sought out first of all.

She brought him Jane Mecom's letter, the wax portrait of his friend Cadwallader Colden, and, since we know that she felt this to be the right greeting among Americans far from home, a hearty kiss. Benjamin wrote his answer to Jane on March 20, 1772, showing that Patience must have been nearly two months at sea, a stormy crossing. He wrote letters, as Jane had promised he would, to persons of distinction who might be pleased to see themselves mirrored in wax.[2] Patience on her part must needs make a portrait of him to add a cheerful lustre to the opening of her exhibition.

This was a fateful meeting, and the beginning of a friendship full of strange passages. Her art of vivid and precise realism was of the sort he could most admire, and one can imagine the expression on his broad, mobile face as, in the midst of that flow of ready utterance which Patience was wont to call "the old Quaker truths," her first impression of his likeness came suddenly out from under the apron. He liked this art and he liked this woman with her boldness and brio. Human oracles — Tryon, Keimer, Ben Lay, Whitefield — he had always observed them with interest and perhaps some inner sense of rapport. Here was the stuff of prophets, perception from beyond the conscious self — sureness of utterance, sureness of fingers on the wax. Yet this woman's mood was not sorrowful or solitary in its yearning for goodness and truth, but dispensed in a torrent of earthy vehemence that captured and delighted him.

The bust of Colden was not a gift. Her friend was to keep it to show to visitors until she had found lodgings, could open an exhibition room and invite patronage. Young Henry Marchant, visiting Franklin on April 6, was greatly intrigued by this strange art. He went next to Mrs. Salmon's show near Temple Bar, and there he would be one of the first to note the contrast between waxwork as London knew it and as it was practiced by the American woman.[3]

Mrs. Salmon had died in 1760, aged ninety, but her show continued to prosper in Fleet Street under the sign of the Golden Salmon, with a figure of a beefeater to watch you pay your sixpence at the door, and another of Old Mother Shipton

to give you a smart kick from behind as you came away. Inside, floor upon floor, there was everyone from Biblical prophets to Dick Turpin —

> Tall Polygars,
> Dwarf Zanzibars,
> Mahomed's Tomb, Killarney's Lake, the Fane of Ammon,
> With all thy Kings and Queens, ingenious Mrs. Salmon,

as a "Probationary Ode for the Laureateship" expressed it in 1785. She had created a group of Charles I "on the Fatal Scaffold" with executioner, guards, and the Bishop of London; "The Rites of *Moloch*," with the Canaanitish women sacrificing their first-born; and, equally startling to mothers, that same Countess Margaret of Mrs. Hiller's show in Boston — in bed with the 365 newborn infants and, for proof of the prodigy, the actual basins from which they had all been baptised with the names of John and Elizabeth.[4]

Mrs. Salmon's catered to all tastes, one room full of shepherds and shepherdesses making love, another a shop with toys and goodies for the young. She had advertised "all sorts of molds and glass eyes" and offered to teach "the full art" to any seeking it for business or pleasure.[5] London was far more aware of the comedy potential in waxwork than of its possible status among the arts. One's first thought was of such pranks as that played by the madcap Duke of Montague in 1746 with the help of Mrs. Salmon and her daughter. A mask had been taken of the face of John James Heidegger, Swiss co-manager with Handel of the Opera House in Haymarket, "while dead drunk," and from this the ladies had made a mask to be worn by an impersonator. Heidegger, well known to all as "the ugliest man in England," was also director of the royal masquerades, and as such was now made to appear in duplicate. In comes His Majesty George II with the Countess of Yarmouth on his arm, and as the real Heidegger gives the signal for "God Save the King," the other is out front shouting an order for "Over de Vater to Charley" — that is, to Bonnie Prince Charley, the young Stuart Pretender whose Scots clansmen had but lately been defeated at Cul-

loden — with confusion and delight as the two come furiously face to face.[6]

Before Mrs. Salmon there had been Mrs. Goldsmith of Green Court in Old Jewry who had made the effigy of the Duchess of Richmond for Westminster Abbey in 1703, and Mrs. Mills of Exeter Change with an assembly of royalty from Cleopatra to Queen Anne — and others before that.[7] Trace them back through all the ancient craft and mysteries of image-making, tenuous and far. But Henry Marchant, stepping up to the door of Patience's rooms at No. 30, Great Suffolk Street, the Strand, early in July, had learned that something new was come to town.[8] That very location proclaimed it. The Golden Salmon, Rackstrow's Museum, and the rest were in the old city. Mrs. Wright had taken her stand in Westminster, near the Palace, the center of fashionable life. She would move three times in succeeding years, but always within the same area. The patronage of art was centered there, and other artists' studios clustered around her, among them that of Benjamin West.

Her career and his would now be intertwined. He had come to the capital nine years before, similarly hailed as a prodigy of art from the far wilderness, "By Heav'n and Nature, not a Master taught." Though neither belonged to Meeting, both enjoyed the high repute in which Quakers had stood ever since Voltaire had extolled them in his *Letters Concerning the English Nation,* 1733. But he was the soul of tact and Patience its opposite. He had won the admiration of the connoisseurs of "high art" and was on the threshhold of his years as laureate "Historical Painter to the King." Patience, with almost as promising a start, would follow her star in a very different fashion. How she stood at the first we learn from an item sent to the *London Chronicle* of July 4–7, 1772, by some early admirer:

Sir:
 I doubt not but many of your Readers will receive pleasure by being informed that the ingenious Mrs. Wright of New York, who is remarkable for expressing the exact likeness of the human face and passions of the soul, in wax

work, is arrived in London. She has modelled the late Rev. Mr. George Whitefield in a sitting posture, as large as life, which is thought by all who have seen it to be a striking resemblance. She has also modelled the present Lieutenant Governor of New York the learned Cadwallader Colden, Esq., and another of that excellent and public spirited philosopher Dr. Benjamin Franklin, of Philadelphia. She is now forming a likeness of Mr. Garrick.

So in London, as in America, she was attracting "public notice, especially among persons of distinction." Famous names were announced at her door. John Wilkes of *North Briton* No. 45 was there with his daughter Polly and his friend Lord Temple. Wilkes' defiance of the King had set the sporting men of New York to betting on his chances for a seat in Parliament. "All the bawdy is wiped off the walls," had been the news from London, "and in its place we see nothing but *Wilkes and Liberty*."[9] Polly Wilkes, with her father's strong nose and chin, bright sense of humor playing about the mouth, would return often to the waxwork, bringing friends. The great Lord Camden, who had stood with Pitt against the Stamp Act six years before, stepped in. Colonel Barré, his dark and scowling face scarred by the wound of Quebec, stayed to be portrayed in a "busto." So did Franklin's friend Dr. Fothergill, gentle, amused, benign. Pious and precious Dr. William Dodd, the King's Chaplain and author of the watery *Beauties of Shakespeare,* flitted about. The comedian and playwright Samuel Foote was conspicuous in the crowd — conspicuous anywhere — and feared, too, for his satiric wit.[10] It was Foote who had turned the laughter on Philip Thicknesse as "Dr. Viper" in one of his pieces. David Garrick must have seen it all as a dramatic presentation — Mrs. Wright playing the lead, blunt, irreverent, loud and declarative in a voice that seemed to English ears to echo from some rocky cliff beyond the surrounding seas.

Horace Walpole had been one of the first to come, suavely amused among his friends, writing afterward to the Countess of Upper Ossory that, along with Lord Chatham and Mrs.

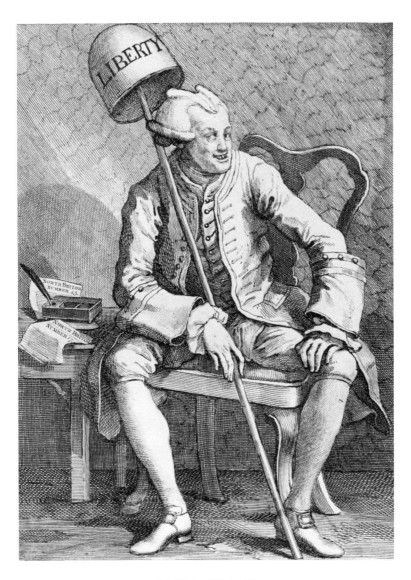

JOHN WILKES

William Hogarth's popular caricature, "drawn from the life" in 1763, brought Americans a glimpse of the stormy figure who was to become Patience Wright's friend and ally in London.

BENJAMIN WEST

Self-portrait of approximately the time of Mrs. Wright's arrival
in London.

Macaulay, Lord Lyttelton, author of the *Dialogues of the Dead* and now on the verge of his own demise, was expected soon to be reproduced in wax. Lady Aylesbury, he added, "literally spoke to a waxen figure of a housemaid in the room, for the artistress has brought over a group, & Mrs. Fitzroy's aunt is one of them." Mrs. Fitzroy's aunt was a New York lady related to the Coldens, Anne De Lancey, now Mrs. John Watts.[11]

Patience had written at once to Jeffrey, Lord Amherst, stating that she had crossed the ocean especially to take his likeness and bring it back for exhibition in America.[12] To the celebrated William Pitt, now Earl of Chatham, she wrote with the same urgency. She was in town for a term only, her mission to bring home to the American public true images of Britain's great.[13] Amherst apprently declined. Chatham, always reluctant to pose, would hold off for two years but then yield as a return for Patience's favors to him. For, with success running high, the idea of the voyage home was constantly deferred. Great and important people were coming, day after day. Mrs. Wright, the object of their wonder and admiration, would be made to chatter through the story of her life, over and over — how it all began in the village, the farm, the long-bearded father, the whole family robed in white, the little girls busily filling a secret world with people of their own.

Of course it turned her head. Visionary and intuitive to start with, this adulation from the great of the empire seemed to confirm all that she herself would willingly believe. They credited her with instant perception of character and, amused, suggested insight into hidden motives and foresight of coming events as well. They handed her self-importance on a platter. An "exotic prodigy," a sibyl, they called her, smiling, and a sibyl she must be.[14]

Benjamin West, always the soul of generosity in promoting the career of any other artist, was almost certainly the one who brought her to the favorable notice of the King. To portray royalty from life was the highest recognition a portrait artist could attain in this place and time, and a guarantee of further patronage. The news splashed like a transatlantic wave into the

pages of the *New-York Gazette* — probably by way of a letter from
Patience herself to the three children waiting at No. 100 Queen
Street:

> We hear from England that the ingenious Mrs. Wright,
> whose surprising Imitations of Nature, in Wax Work, have
> been so much admired in America, by a diligent Application
> and Improvement in the same Employment, has recom-
> mended herself to the general Notice and Encouragement
> of Persons of the first Distinction in England, who have
> honoured her with peculiar Marks of their Favour: and as
> several eminent Personages, and even his Majesty himself,
> have condescended to sit several Times, for her to take their
> Likenesses; it is probable she will enrich her Collection, and
> oblige her Friends in America, with a View of the most
> remarkable Persons of the present Age, among which will
> be the immortal, inimitable Garrick, whom she had began;
> she has already compleated, and sent over to her House
> in this City, where they may be seen, the most striking
> Likeness of the celebrated Doctor Benjamin Franklin,
> of Philadelphia, now in London, and of Mrs. Catharine
> M'Cauley, so much admired for her great Learning, Writ-
> ing and amiable Character.[15]

Catharine Macaulay of the great Learning and amiable
Character held opinions very far removed from those of George
III, and Patience Wright would come to share them in time. She
had just brought out the fifth of the eight volumes of her *History
of England from the Accession of James I to that of the Brunswick Line*,
in which she sought to prove that Britain's traditional liberties
had been invaded or corrupted from the first by just such royal
power as her new young king of the Brunswick line was now
wielding. It had made her popular in America, especially with
such legal minds as John Dickinson and John Adams. Adams
thought her "one of the brightest ornaments not only of her Sex
but of her Age and Country."[16] To both Abigail Adams and
Mary Wollstonecraft, very different ladies, she was the feminine
ideal.[17] Ben Franklin ranked her with the great historians of

past and present, Livy and William Robertson,[18] and it may well have been on Franklin's initiative that her full-length was standing there in Patience's rooms. Now Patience and Catharine were firmly linked in popular imagination — two bright stars among a falange of brilliant women enlightening the London scene, Sarah Siddons on the stage, Angelica Kauffmann a master in painting, Mrs. Montagu, Elizabeth Carter and Fanny Burney in literature. Both were widows of elderly husbands, both naturally gay of heart, but otherwise they were made of very different stuff and never became close friends. Both would be whole-soul for American resistance to the crown, but Catharine's cerebral and legalistic approach could never find common ground with Patience's mystical gusto.

Second thoughts may have cooled the royal willingness to pose. Some show of deference to rank was needed, a quality lacking in Mrs. Wright. She, who breathed love and spoke her mind to all, saw such matters as Thomas Tryon had. Take, says he, "a hundred of those Genteel Sparks" and mix them "naked amongst an equal number of *Tradesmen* and *Artists* and he must be a Cunning Man indeed that could distinguish those of the Noble from those of the Mean Birth."[19] It was an attitude which her visitors at the waxwork found refreshing, while aware at the same time that she was treating them with a rough sort of respect of her own. Patience knew very well the value of keeping her affairs on a high level with persons of "first Distinction."

Soon after the turn of the year she moved to better quarters in Chudleigh Court, a little byway between the Palace gardens and Pall Mall at St. Alban's Street.[20] This put her only a short walk or ride from St. James's Palace, down the wide thoroughfare with its long parade of glittering and fanciful signs — the city's center of luxury and pleasure. Here the three children, Betsy, Joe, and Phoebe, arrived to join her. Little Sarah (not mentioned in her father's will) remained with her aunt in Bordentown.[21]

As in America, the exhibition had become the thing, and yet Patience still held herself to be a portrait artist seeking private commissions. Very soon one came her way, offsetting the anti-

monarchical color that Mrs. Macaulay's image had given her affairs. A hint of it appears first in the *New-York Gazette* of February 15, 1773, with a London date line of December 1: In addition to her "inimitable Wax Figures" sent to New York, "she is now making (to go by Captain All for Philadelphia), another of a well known character in America, as a present to the American Philosophical Society."

In bits and pieces the story comes out. Philadelphia's *Pennsylvania Packet* prints a London item of November 20, 1772: "Yesterday —— Penn, one of the Proprietors of Pennsylvania, was presented to their Majesties at St. James's and was most graciously received." Thomas Penn had come to London with his wife, Lady Juliana, daughter of the Earl of Pomfret. Lady Juliana had, it seems, visited the waxwork and determined to enlist the talent of this American woman in improving her husband's somewhat equivocal position as a Colonial dignitary. It is apparent also that whatever arrangement was made included the removal of the wax portrait of Benjamin Franklin from its place of honor at Chudleigh Court.[22]

Franklin had not been on good terms with the Lords Proprietors, nor they with him. Thomas Livezy, back in 1767, had written Franklin from Philadelphia, expressing his quizzical hope that Thomas Penn, largest holder of the family rights, "could be prevail'd on to Die for the good of the people," adding that in doing so he might "make his Name as Imortal as Samson's Death did his, and gain him more applause here, then all the acts which he has ever done in his life." Franklin in the same spirit replied that he would celebrate such news with a glass of London wine.[23]

Pennsylvanians were strongly divided on the virtues or the meanness of Lady Juliana's spouse, and the American Philosophical Society of which Franklin was founder and president may well have been considered an unsafe repository. The wax portrait was dispatched instead to the care of the Reverend Richard Peters, Rector of Christ Church, as her gift to the people of Pennsylvania. Mrs. Wright's accompanying letter,

dated June 24, 1773, is quoted in the minutes of the Pennsylvania Assembly. September 24:

> I send you by Captain *Sutton* the Busto of the Proprietor *Thomas Penn*, Esq. It is a Present from Lady *Juliana* his Wife to the People of *Pennsylvania*, to be lodged in the public library. Lady Juliana ordered me to send it to you, and to inform you she thought it a most excellent Performance, and that it was admired by the King and Queen and most of the Nobility in *England*. If any accident should happen in the Passage, or it may want anything done to the Drapery, be pleased to apply to my Sister Rachel Wells, who has orders from me and Lady Juliana to inspect it and keep the key of the Case, until she hears further from us, as a few alterations are intended to make it keep for Posterity, in memory of the *Penn* Family and of Mrs. Wright's Ingenuity.[24]

"The public library" was taken to mean the Assembly's library room in the present Independence Hall, not the Library Company (founded by Franklin).[25] As for the Franklin effigy in London, no further mention of it appears in visitors' descriptions until after Patience had made a new one eight years later. Lady Juliana's patronage seems to have brought a temporary rift between the friends. Franklin wrote his wife, April 6, 1773, that he did not know how he had displeased Mrs. Wright. He had done his best to help her, but she never came near him any more.[26] Deborah Franklin may have known Patience well, for the two women were cut in the same no-nonsense American pattern. Their direct approach is apparent when we find them quill in hand — orthography no obstacle — Patience bursting with "Inthusazm," Deborah signing off as Ben's loving "Yf." The coolness continued until the British ministry's ponderous umbrage was turned squarely upon Franklin himself, rekindling all the fires of friendship in Mrs. Wright.

At last, late in the summer of 1773, the "bustos" of the King and Queen were made. They had seen and admired that of

Penn, and no doubt Lady Juliana had spoken a word. But policy was in the picture too. This king meant to have an empire firmly united in obedience to the crown. Force would be used if rebellion showed its face, but first of all a wise monarch inspires loyalty. To recognize and honor American genius would turn the eyes of all Americans toward the throne. So it had been in bringing West into favor, and he had been accepted only after careful scrutiny, with due note of his having declined the patronage of Lord Rockingham, whom the King disliked.[27]

So Patience Wright was summoned to Buckingham House, seat of royal domesticity, the drafty Palace of St. James being reserved for court functions. Here, by all accounts, she made herself at home, trudging in and out of the great mansion at will, striding through the rooms, always hearty and familiar to everyone. As in his relationship with West, the King liked to think of himself as enough of a connoisseur and man of taste to advise the artist. A surprise from under the apron would not do. Of course it took time. The royal pair posed repeatedly in order that their portraits might be perfect. Patience was a new experience for them. She would have no truck with forms of address. They were "George" and "Charlotte" to her.[28] He, with his full red lips, florid face, blonde eyebrows, and bulging eyes, the Queen with her prim little face like a Meissen figurine, watched and listened spellbound. His Majesty's sense of humor, gently pompous and derisive, would enable him to enjoy the situation.

London gossips, to be sure, would have their own ways of seeing it. Some, taking note of the royal favors granted to "Quaker" West and "Quaker" Wright, may have recalled the tales of the teen-age George's infatuation with "the fair Quaker" of St. James's market, Hannah Lightfoot. Then there were the stories of Patience as an adviser to the King. Quaker William Forster, keeping an interested eye upon the waxwork, wrote to his sister on October 7, 1773, "Patience Wright has lately been sent for by the King and was with him near two hours. They had a deal of discourse (she says) on politics &c. & the distresses of the People."[29] His letter, part of which has been torn away, seems to have gone on to imply that His Majesty had responded

with sympathy and encouragement. It brings a modicum of support to a legend which Patience herself did nothing to discourage—that he repeatedly sought the waxwork "sibyl's" counsel on American affairs, and that she, busking in and out of the Palace, obliged.[30]

She would tell of their meetings with a gusto and irreverence which would have been inconceivable in Benjamin West — West, whose portrait in "busto" was appropriately on display in Pall Mall near those of George and Charlotte. West would remain throughout his life, as the painter James Northcote phrased it, "an American royalist."[31] But he remained also a steadfast friend to the Americans in London, the artists most of all, and thus, indirectly, Patience benefited from his favored position under the crown. He entered young Joseph Wright in the schools of the Royal Academy. Phoebe, the younger and prettier of the girls, would be called in to pose for nymph or angel in his huge canvases of biblical-historical-mythological drama.[32] The fact that he and Patience made portraits of some of the same individuals at about the same time — Lord Lyttelton for one, General Robert Monkton, or John Sawbridge — suggests that he invited her to share sittings in his studio when the subjects were willing. Isaac Gosset, modeler of small wax profiles, had done much of his work in that way, and Patience, chattering along, hands busy under the apron, would have been a godsend in lightening the slow tedium of posing.[33]

So far, but no farther. Though other women won rank in the Royal Academy, there would be no "Patience Wright, R.A.," bearing a diploma signed by the King. No breezy tittle-tattle of "George" and "Charlotte" would ever have been countenanced in that charmed circle.

She might have exhibited at the Academy — the royal "bustos," perhaps — but did not. Prosperity had come without it, and there was good reason to keep her own exhibition unique. Visitors' gifts were generous. Her price of fifty guineas for a private commission was equal to what the best portrait painters of the time were receiving for a three-quarter or full-length.[34] Duplicates emerged easily from under the apron and were sent

overseas to Rachel, a grateful return to the sister who had launched her into this new life.

Along with the King's and Queen's, a "busto" of Frederick, Lord North, Prime Minister, was added to the Pall Mall collection. It enabled her public, with a close scrutiny impossible otherwise, to compare his features with those of King George — both stoutish, blonde, and bulbous-eyed. The resemblance was often attributed to an intimacy between George's father, Frederick, Prince of Wales, and the Countess of Guildford, Lord North's mother.[35] A bloc of faces from the opposite camp now confronted Catharine Macaulay, Wilkes, and Barré. Lord North, a man of eloquence and charm for all his heavy lips and ungainly figure, was on his way to becoming, in the eyes of American patriots, the deep-dyed villain of the political drama. Franklin would later twit Patience upon her having replaced his own portrait with this one.[36] However, his old friend Governor Thomas Pownall had also been added, a man with an experienced and liberal view of colonial affairs, and influence over them in Parliament. The *Pennsylvania Gazette* of March 9, 1774, would carry a news item taken from the *London Chronicle* of December 4–7, 1773:

> Mrs. Wright, of Pall-Mall, the ingenious North American Artist, has lately finished three admirable busts in wax, viz, One of his Majesty, one of Lord North, and one of Governor Pownall, which surprise all who see them, so finely is life imitated. Our principal Painters and Sculptors have paid her great compliments on these performances.

William Forster in this season of 1773 had brought a flock of Quaker visitors, young and old, into town to see the waxwork and the public buildings.[37] Mrs. Philip Lybbe Powys, coming in from Oxfordshire and paying a first call at Chudleigh Court, confessed to that sudden tremor which shook some people when they came face to face with images so breathtakingly true to life — "went to see Mrs. Wright's waxworks, which, tho' exceedingly well executed, yet being as large as life, if of one's particular friends, 'tis a likeness strikingly unpleasing."[38] Not so the gay

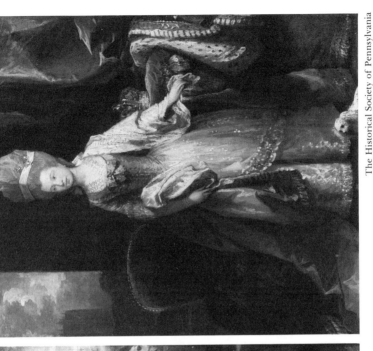

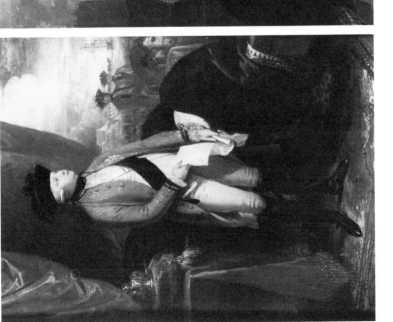

"GEORGE" AND "CHARLOTTE"

Small studies of the King and Queen by Benjamin West, 1778. The King's background reflects the expansion of the American rebellion into a European war.

LIBERTY I ask, and Liberty is my RIGHT
And Slavery do disdain, with all my Might.

PATIENCE WRIGHT, 1777

Drawing by John Downman, A.R.A., whose drawings of Benjamin West, "my most beloved teacher," date from the same time.

bachelor Fitzmaurice, who, as Dr. Franklin told the story, when urged by all his friends to marry and settle down, swore that he would make everyone happy by "getting Mrs. Wright to make him a waxwork wife to sit at the head of his table."[39]

That disturbing emotion felt by Mrs. Powys recalls a curious apprehension touched upon in the opening words of Patience's will: "My business I trust is lawful in the sight of God and man" — an admission that Americans did not always look upon the making of images in that light. So Patience was now at pains to let them know that King and nobility and even the sainted Selina, Countess of Huntingdon, approved. An item from London, January 10, 1774, printed in the *New-York Journal* of March 17 and *Pennsylvania Gazette* of March 23, gave them, gives us, a glimpse into the rooms at Chudleigh Court, highborn and courtly company, a flow of conversation and light laughter, and everywhere in and out and around them the creator of the scene, tall and broad and heavy-breasted, all energy and "Inthusazm," familiar, sure, and loud:

> Mrs. Wright, the ingenious American, continues to have a great resort of company of the first distinction, among whom are some of the principal nobility. Her performances are greatly admired; she has as much business as she can possibly go through, and is in a fair way of making an ample fortune. Her frankness and humour are generally pleasing, and without giving the least offense to the greatest people she indulges herself in the utmost freedom of speech, especially in defense of the rights and liberty of the American colonies, and in advantageous representations of them and their inhabitants. She has been much favoured by the King and Queen, who have frequently honoured her with their presence and familiar conversation; and his Majesty has several times sat for her to take his likeness. The figures of General Monckton and the Countess of Huntington, lately sent over for New York by Captain Winn, are allowed to be striking representations of their present likenesses. The first of these personages is entitled to the

highest esteem and respect of the colonies, on account of his warm and steady attachment to their interest; and the last is remarkable for her piety and general benevolence of heart.

Patience was speaking out for rights and liberties. Warm and steady attachment, alike to King and colonies, was honored at the waxwork along with piety and benevolence of heart. Yet already the curtain was rising on great changes and grand events. The full storm was about to break. When Captain Winn sailed down the Thames with those wax figures in his cargo, January 10, 1774, London had not yet learned of Boston's rough riposte to the tax on tea, more than three weeks before.

"Women Are Always Usful In Grand Events"

ALSO on January 10, 1774, Benjamin Franklin became aware that his part in the publication of the private letters of Thomas Hutchinson, Governor of Massachusetts, was about to bring down upon him the wrath of British officialdom. It did not help matters that he had been tweaking the ministry's nose with his "Rules by which a Great Empire may be reduced to a Small One" and other squibs. The attack came on January 29, public and vituperative. Two days later he was dismissed from his postmastership under the crown and, as the crown saw it, abandoned to disgrace. It was in the aftermath of these events that Patience dreamed her dream.[1]

In her mind, like light across dark waters, she saw Franklin rising again in triumph over the King and all other enemies. It was Franklin who would bring peace, unity, and renewal to the troubled empire. The vision would stay with her through the years of war, fostering hopes and determining action. Chatham's ideal of equality among Englishmen everywhere was in it. Person-to-person issues, diamond-sharp and clear, aroused that sense of inner power, of knowing and uttering God's will. Her letters show how the dream changed in detail in response to events, and how it was strengthened by a growing belief among British liberals that only Franklin's wisdom could restore harmony and revive old loyalties. Somewhere along the line she set it down in writing, probably in the pages of her "Jurnal of material Events," a document that still eludes the search for it.[2]

Thomas Tryon had studied the matter of dreams in his

forthright way, and his findings would certainly have been discussed in her father's circle at Bordentown. A dream carried you in whole or in part beyond yourself, over that final boundary and into the vast forevers of time and space.[3] Quakers and other burning hearts had set a pattern of consciously seeking to pass that boundary, and she would often have heard such voices raised in meeting, strangely intoning as if from within the clouds between life and death.

With such inner light she may have felt little need to trace the background of the swirl of events around her, but Catharine Macaulay could well have told her how George III had now brought the long encroachment of royal upon popular power to a climactic point. Catharine could have explained how the young King, encouraged by a self-serving peer, the Earl of Bute, had set out to unite all parties, all parts of his realm, in subservience to the throne. He had not needed to pose royal against parliamentary authority, but only to do as the old Whig aristocracy had been doing before his time — create majorities of his own in the two houses by a deft expenditure of money, offices, and titles. In such turbulent spots as the twin cities of London and Westminster elections might go against him, but there were pocket boroughs and miniscule electorates enough to take care of that.

In the past, Parliament's control of the purse had limited the King's prerogative. But now, if he could tax America whose rising prosperity was plainly seen, the royal power might have no limit. This was the prospect which made the King so determined to enforce, the average Britisher so complaisant in the thought of his pecuniary advantage, and those small bands of liberal protest with whom the exuberant waxwork artist allied herself so vibrant with alarm.

That opposition, of which Mrs. Wright was to become a magic-mirror reflection, was small but stout. In seeking to abolish parties the King had created them in a truer sense than before. Public meetings of inquiry and protest had emerged not long before her arrival and had grown into a reform movement in which women and others not qualified to vote were taking

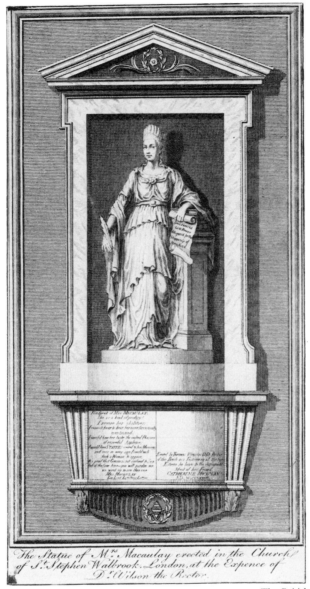

CATHARINE MACAULAY

Dr. Wilson's controversial statue. In the inscription beneath, Lord Lyttelton declares, ". . . I would have STATUES erected to her Memory, and once in every age I could wish such a Woman to appear, as a proof that Genius is not confined to Sex . . ."

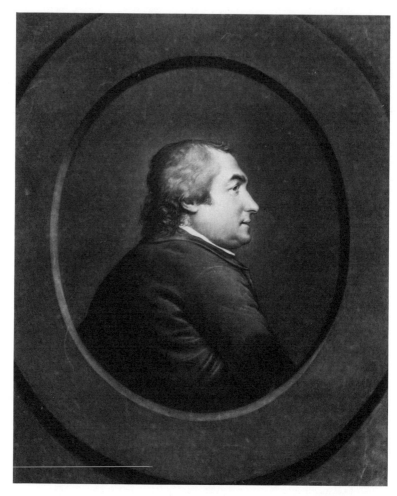

THE RIGHT HONORABLE COLONEL ISAAC BARRÉ

Veteran of Chatham's wars and champion of the Chatham policy, he esteemed Mrs. Wright as "a sensible woman." Engraving by Richard Houston, 1771, after a painting by Hugh Douglas Hamilton. His face in profile to conceal the scar of Quebec.

impassioned part. A Parliament, incorruptible and truly representative, must be the ultimate power. The American colonies must be free and equal partners, as Lord Chatham so resoundingly demanded — the "Great Commoner" who had turned defeat into victory at the end of the last reign, humbled the French, handed the new young monarch a newly created empire. Catharine Macaulay's brother, John Sawbridge, reformer and republican, was a stalwart among them whom Patience knew well. His motion for annual parliaments, raised and defeated each year, would become a ritual of the movement, threatening the bribers with unbearable expense in regaining control each time. Thomas Pownall, advocate of a unified, reformed colonial administration, was less staunch. He would lose his borough in 1774, unable to put up the cash, and in an artful move Lord North would find him another, conditioned on a pledge that he vote with the court party. Closer to Patience and sharing her readiness to anger was the blunt old soldier, Isaac Barré. Colonel Barré declared Mrs. Wright to be "a sensible woman" who "wou'd have shone more eminently" had her "education been equal to her natural abilities."[4]

It was a tight, loud opposition, yet without the martyr heroes of Cromwell's day. Only if the King's policy led the nation to disaster could it win. And now, March of 1774, Lord North brought into Parliament for the King the first steps toward just that. Boston was to be harshly punished, Massachusettts ruled by a military governor and army of occupation, and, most sweeping of all, Quebec made a crown colony with boundaries expanded southward to take in all the western country claimed by the seaboard provinces. That the Quebec Act also protected the Roman Catholic faith of the French population was a sound administrative measure and yet, coming as it did, it added the cry of "No Popery!" to Protestant America's "Appeal to Heaven." Patience Wright was there in the gallery of the House.[5] She saw it done, and one can imagine her eyes, remembered by so many, flashing from face to face along the benches as the votes were given.

The "Intolerable Acts" left the colonies only a choice be-

tween complete subservience or war. War it would be — a civil
war at first, with the King's opponents cheering American resis-
tance, clinging more and more desperately to a hope that it
would remain a civil conflict only. The King played a game of
winner-take-all. If he lost, many saw America as a model of
sturdy, open democracy for Britain to follow, while others stood
in dread of having English life infected by "the Leaven of Re-
publican Principles."[6] Mrs. Wright's prophetic mind foresaw
American victory in the field, and the Leaven of Republican
Principles to follow.

Chatham had moved promptly for repeal. Hopeless as his
case might be, he had with him not only such men as Sawbridge,
Barré, and Edmund Burke, but the merchants in the American
trade who, as Patience's Quaker friend William Forster put it,
were now "very severe against Lord North."[7] Chatham, as was
always his method, was searching out information from every
possible source.[8] Depending much on Franklin, he turned also
to Franklin's friend at the waxwork. The eagerness of her re-
sponse can be imagined. She flew about town — to John Saw-
bridge, then to Robert Murray of New York, father of her
friend Lindley, then to William Lee of Virginia and his partner
Stephen Sayre (College of New Jersey at Princeton, Class of
1757), a Long Islander like herself. These two, Americans with a
foothold in British politics, had been elected Sheriffs of London.
She dashed off letters to friends across the sea, to everyone she
knew who might be helpful, and in the midst of it a first report
to the Earl. He had wanted to know more of the shipments of
tea, for they had sparked the crisis. Her handwriting is atro-
cious, her sentences obscure, but in this day such things as that
did not lessen the credibility of a writer.[9] Do not pass lightly over
what the great Chatham read with gratitude. It enlarged upon
what she had told him in conversation:

> Wendsday
> Mrs Wrights Duty to Ld Chattam and has Informd her
> self of the true facts of the Merchnts offer to Lord
> North, — mr Robert murrey Late from new York and now
> a merchnt in London was in Company with three of the

most Principal merchnts traiding to Boston who Declard to him they was the men who waited on Lord North to offer a sum of money to Pay the India Company the Loss and Damage of thir tea Destroyd at Boston Praying in behalf of the traid and Peopel of Boston to have a Short time to Descover who was the offenders; that they Should be Brot to Justice and ampel Satisfaction be made to the India Company — Ld Norths Refusial was in the words Related by mrs Wright to Ld Chattam and the Perticulars the Same as she Related. Enquire of the sd Robert Murrey the Sheriffs of London mr Lea and Sear [Lee and Sayre] or any of the gentlmen whos names are here Inclosd, — a long List will be Sent to the Inspection of Those to home it may Concarn a few Pappr which Paradventure may be some hint.[10]

And enclosed with this, the following:

Hagley & hopkings
Champargion & Dickerson
Lane Sone & Fraiser
Mr Brumfield
mr Harison[11]

} ofird in behalf of them Selvs and in behalf of town Boston and as merchants £1900 to stop or put off the Bill to be Brott in &c. — Begd time to Bring the ofendrs to Justice not Punish the Inocent with the gulty that Boston did not aprove of the tea being destroyd But

would Pay the Loss of the India Companys tea and the damages. A numbe of gentlmen have heard the above namd merchants since the Passing the said Bills against Boston Declare Lord North had diceved them also, that they had Informd Ld North the tea was Damage tea 3 years old not merchantable facts can be Proved true. Mr. Colings Packer of the India tea at fench Street Ware house Declares the tea to be old some 3 years some mouldy unsailable, Been put up to sail and Refusd as Damagd tea not fit for merchants &c. Many of the off[ic]ers in the Company Service Say the tea was Extream Bad —

Ld North told the merchnts Boston was a Spot must be

Punishd, that he was determind to make them submit to the athorety of Parlement, had Began and should do all he could to Bring them to Proper Submision &c. But as those men have declard ther Busness to Lord North and mrs Wright with mr Lee [and] Mr Sear Sheriffs of London, mr Green, mr Delly, mr Sawbridge, mr Murrey,[12] all which men will Inform Ld Chattam the facts they have Related to mrs Wright and with a hearty thanks to Ld Chattam for his willingness to be Informd by them they think themselvs happy to be calld on.

See the Earl's long, thin face with its lofty Roman nose and imagine a lift of the eyebrow and twitch of the lips as this was scanned. But the state of the tea and willingness of the merchants to pay for it were important. She had given her sources and he turned to one of them, Stephen Sayre, for verification. Sayre, responding warmly and sending a copy of his reply to Mrs. Wright, became himself a friend and protégé of the great man.[13] And, in the light of all this, Chatham at last consented to pose for his likeness in wax. Patience's note of May 11 to the Countess implies that the work has been begun and needs only a short sitting from the life:

Thursday May 11th 1774
Mrs Wright has Waited on Ld Tempel to Enquire Lord Chattams health and was advisd to write to Lady Pitt as the most Scartain way to be Informd what day or at what time it would be agreable for Mrs Wright again to wait on Ld Chattam. She only wishes to see him a few moments, at the Request of meny men of Emenence in America who all look up to mr Pitt as ther gaurdin angel and in gratatud to him Insist on mrs Wright to send over to them a Bosto done in Wax of her Best Performan, that they may therby have a Prope[r] Likeness to moddel in Merbel &c.

as the Season is now Come that Encourags mrs Wright to work and waits only for to Se Ld Chattam to finish it[14]

Lady Pitt seems to have had a primary part in this addition to the Pall Mall gallery, and also in adding the bust of her

brother, Lord Temple. As for the "Prope Likeness" in marble, there was already a marble statue of William Pitt on Wall Street in New York, another as the principal ornament of Charleston, South Carolina, and Patience must have known them well. Both had been carved in London by Joseph Wilton, and it hardly needs saying that in this day a wax model would not have been sent to America for translation into marble.

But the memorable phrase in this letter is that hearty epithet for the Earl himself — "gaurdin angel" of America. So he would be in Mrs. Wright's regard as long as he lived. He had come to her for help and — first taste of truth in her dream — had turned to Franklin too. Franklin, derided in the papers as "old dotard" and "American polecat,"[15] was recognized by the great Chatham as holding the key to peace, and upon his invitation the two met openly to discuss high policy. Here is the beginning of Patience Wright the spy, the one-woman committee of correspondence with Franklin as her closest confidant — her quill scratching furiously to bring him each new clue or shocker in the unfolding story, and young Joe with the paper in his pocket scampering out of the waxwork to Pall Mall and around the corner into Cockspur toward Craven Street.[16]

A brief item in the *London Chronicle* of June 16–18, 1774, gives us a completion date for the Earl's portrait: "The celebrated Mrs. Wright has just finished a busto of Lord Chatham which is soon to be sent to Philadelphia."

During the sittings His Lordship had expressed a wish to visit America, and Patience, already alert to the drama of messianic entrances, was eager to prepare the way. But first there was important information to transmit:

June 27th 1774

Mrs Wrights Duty to Lord Chattam

this day Mr Grear from Boston Recvd a letter from his Father gives him an ac[coun]t that the Congress had meet at New York and come into the Resolution that a ship be sent Imeadatly the west Indies to all the Islands to Inform them that all those who joyne the Coloneys in a Plan of non Im-

portation to England should be alowd the advantage of thir Provisions and staves, flowr &c. But that all those Islands who Refuse to agree with the Coloneys should be deamed Enemies to trad and to thir Contry and should be starved out by a Resolution that was Past that no sort of Provision should be sold to any who did not come into the agreement and that no ships do sail to the southward of Carolina from the middle of octob &c nor any vesel admitted into the harbor of Philadelphia or new York without the Consent of the Comittee apointed for that Porpose to Inspect into the Lading &c. After the sd middl of octobr and in consequence of this news the merchnts are now Laying up ther vesels unRigging them — The sailors are to be Employd in asisting Building of Bridges and usful Employment. A new Bridge is to be Built across from Boston to Charlstown Equal to London, as wide as the tames ten thousand Pounds is already put into a stock fo[r] the use of the Poor traiding Peopel who may be hurt by the stoping traid. Some men have subscribd five hundred Each and those merchnts who Refuse to Comply will be oblige to flye the Continent as the Dutch have ther own Languge and the Printing Press, ther own news Paper and are nearly conected with Canady the news and Bad Effects will be very soon sent them.

the French a[nd] Canadens are not so Religious as to give up all ther Priviledgs and the Proclamation and the Kings oath. The Capatulation they are determind to Keep Sacred. Your Lordship has Spoke So Well so Wise So Exelent on the sd Bill that a Copy of which is to be translated and Publishd and sent out Emeadetly amongst them — Provdenc Sent you into this World to be on the Earth, that Sattan should be not able to distroy the Protestant Religion nor Ruin all america. May the same Providenc Keep your Life Long a Blessing to your Contry and a Patren of wise Counsil and the name of Pitt be Remembred for Ever is the hearty Prayr of

P. Wright.

Some Friends to america Wish to be favord with leave to

Inform thir friends in the difrent Coloneys to make the
Reception of Ld Pitt agreable by a Early Inteligenc to them
of his Intended visit to them &c. Virginia wishes to be
favord with his Landing thir first.[17]

This last bit has confimation in a letter from Stephen Sayre to
the Earl on his plan to visit the colonies. Sayre, on behalf of the
Lees, urged priority for Virginia, where they felt sure that their
brother, Richard Henry Lee, could be more helpful to him than
any other man in America.[18]

Patience, meanwhile, sensing keenly the importance in
London of direct information from her homeland, and in Amer-
ica of news picked up at her post of observation between Palace
and Parliament, was trading news for news, splashing ink on
paper. Government agents, just as eager to be informed, were
busy rifling the mails. It is at this time that the papers of Lord
Dartmouth, Secretary of State for American Affairs, begin to fill
up with intercepted letters, many of them of more interest to the
historian of today than they could have been to the noble lord.[19]
Mrs. Wright was quick to learn of the danger, and her portrait
head of Chatham may have been the first to go out stuffed full
of dispatches from the waxwork to the Continental Congress at
Philadelphia, per Rachel Wells.[20]

So also, her letter to the Reverend Dr. John Rodgers of New
York may have come over in that way. He was a Presbyterian
dominie of the liberal "New Side" faction of his church, a man
with whom she must often have discussed the ups and downs of
politics in Queen Street days — perhaps church politics too, for
there was the matter of his petition, sent to London, seeking a
charter of incorporation for the United Presbyterian Churches
of New York.[21] She wrote:

London Pall mall Sept 3d 1774

Revnd Sir

I wrote all opertuntys and had no anser. I fere the lettrs
did not Com to hand as the Contents was of such a Natur to
defie atention. All my corospondanc have gladly Embracd
my Intelegenc.

Pr Mr Murry you must have Recd my Last wherin I freely stated the afair of your Pettition &c. No sort of hope of Sucksess as yet, nor will Eve[r] more the Intrest of the Religion of the Gospel be Encouragd by Present ad-mistration —[22]

My Love to my dea Ms Rogers and all the famaly. I hope new york will all behave so as to give Pleasure to the othr Coloneys. Poor Boston is truly in a State of Pity. Take cear you are not decived with a Complyanc of the horred s[c]heeme of the Wicked Enemies of govrment. England all begin to be alarmd for you, and depend on you to help your selves out of this troubl by a Stedy Joyning with Boston and the othe Coloneys. The News Papr will Inform you that no good is Intended toward you. Sir [William] D[r]aper is Com-ing.[23] Take cear of your own Peopel. Be cearful — 5 of your Yorkr are to Exept of a Contract for goverment. Money is the Rote of all Evil. I am sorry to say your Enemies Expect to get great advantage by your own Peopel —

Mansfld and Bute and Hilsbrah is Determind to Drive you into the Sea by the new Canady Bill.[24] Take cear of deception and Providen will work all for good. Dont you Expect Mercy of the once Mother Contry. All them times are over and Past.

the two thousand Pounds given to the Departing minis-try has made them all Silent.

Prayer and Providenc must do [for] you. Nothing on this side the water can help you. Your own good Condoct must [help?] you. Be all hearty in your own C[ondoct?] and England will fight for you soon.

Ld Chattam is still your friend.

dartmouth is not your Friend — a courdly spirit is sezd him — our Worthy K — g is deceivd. A most foolish set of men have acted wrong and now ashamd to own thir fault.

tryon is in the gaurds again Silent and only a few act for your ondoing.[25] I hope to Return in the Spring and Injoy the Blessings of a free goverment of Peace and Plenty and set down to Injoy the Comforts of america. May the great god direct you to act wisely and Keep up the Blessing you

Injoy and be thankful. Let not Pride or Love of Powr do you mischief. The Parlement meet soon and then some New act of Regulation to be Past that will be more dredful than you Can Imagine. Coroption and Pride has ovr turnd all ther scheams. All the scheams is to Inslave you all. Dont be decevd. No honesty nor Honor is to be Expected from ths side the watter — Stuped Ignorance is taken Place, the Poor opresd, the Rich Proud and Impedent and [no] fear of god or man. Altho I am well [with] the Best of friends and great Encouragment [and am] Honord as a Ingenous Woman, can have access to any of them, talk freely and have all the advantage I wish or want, my Pride and my vanity gratified, my health good and Busness Plenty, friends of the Best Rank all Pay great atention to me. Meny men Visit me that in time Past I should [have] thought it a honor to speak to me, and as Solomon saith all is vanity and vexation of spirit. I find by Experence that to live by faith is the most happy life and this World is a Mad house, a Place of sin and sorrow. Money is no means of hapyness But love and Peace of mind is the only Blessing —

P: Wright[26]

A few words have been obliterated by water at some early date. That may have happened two years after the letter was written, when Dr. Rodgers' house was destroyed in the great fire of September 1776. He, with many other Whig families, had fled the town before the British army occupied it. A month later, the letter was found by an American agent of the crown, who seems to have regarded it as highly suspicious, adding an unsigned docket before passing it on to his superior:

This letter I found open in the street new york
20 Oct. 1776, the day on which I arrived in town,
(from West Point) where my duty as well as Loyal
principles called me.

Dr. Rodgers was then in the field as chaplain of an American regiment. P. Wright, far from returning to "Injoy the Blessings of a free government of Peace and Plenty," was still in

London, a famous figure — famous enough by that time for headquarters at New York to take a second look at anything that bore her name.

Yet if her letter of September 3, 1774, be contrasted with another of precisely the same date from an unknown London Whig to a friend in New York, Mrs. Wright's deficiency as a spy is sadly apparent. Both must have come by the same ship and both reflect London news and rumor of the same day. But where she announces "Sir Daper is Coming," the other states clearly that Sir William Draper is said to have been offered a governorship, probably of New York, and where he touches on the wilder sort of rumor — such as that of a plot to bring in the Stuart Pretender to replace King George in a coup that would be blamed on the Americans — it comes as rumor only.[27]

Uncertainties indeed were rife in that September of 1774. Parliament was dissolved and a new election called to test the ministry's strength. The price of seats rose sharply, but the King brought his secret service funds into play and gained an increased majority. John Wilkes did come in at last as both Member of Parliament and Lord Mayor, but this success would mark the end of his prominence as an opposition leader. Lord North's administration was now secure against anything Chatham could bring against it. Now the King, if successful in America, would have the British taxpayers with him, whatever the intellectuals might say or do. Mrs. Wright, appalled by her first close view of electoral corruption running rampant, appealed to the "gaurdin angel" of the land:

Pallmal octobr 19th [1774]

Most Worthy Sir /

I canot be silent any longer. I must troubel your Lordship with a few hints on this unhapy Confused ocasion. I see the whole Island of England in a uprore, and america the same by the unhapy Condoct of a few week and Ignoront onworthy men, who have deceived the Peopel and are Indeavoring to Deceive them a few months Longer. Our letters from america are stopt and all Posable means usd to

THE EARL OF CHATHAM

Patience Wright's memorial figure of 1779, wearing the robes in
which the Earl had delivered his last oration. Her only work
surviving in its original form.

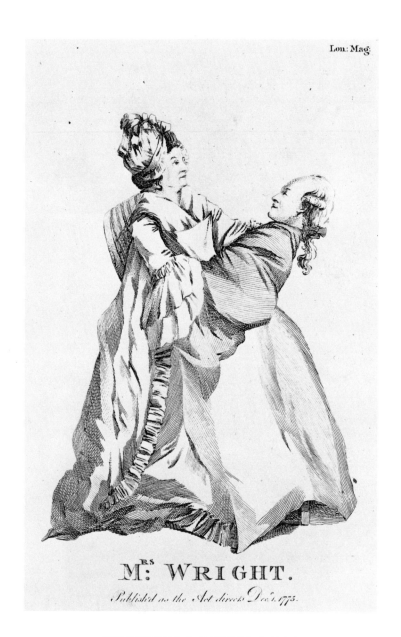

Lon: Mag:

MRS: WRIGHT.

Published as the Act directs Decr 1. 1775.

FINISHING A "BUSTO," 1775

Mrs. Wright in a news engraving from the *London Magazine*.

keep the true Intrest of the Peopel from being known, and
by false and undue Influance are now set the Powers of Hell
to work to get votes for the City of Westminstr. to chuse
L[ord] Percy a membr of the new Parlement.[28] I with my
own Eyes have seen, my own Ears have heard such methods
usd to get the Ignorant to give a vote for Percy or to Prevent
a free Election, that my heart akes for the unhapy Nation.

My Lord — we look up to you for you to help us —
Providence has gav you such great abilites. The Earl of
Chattam has done great and worthy things for His Contry
and the English Nation Both in Europe and America ows all
Posable gratitud to him —

Ld Chattam the great and glorious Pitt must continue
his usfulness to this unhapy Peopel — Genl. gages condoct
at Boston is such that it will Bring on a Dangorous Resistanc
in the Coloneys. The Quake[r]s have Raisd 1500 men to
asist the town of Boston to defend that Provience against
opresion and all the othe Coloneys have got the Melitia in
Readiness to march to thir asistence. If a speedy stop is not
sent to that Roman Catholick Leader a Sivill Warr will most
scartainly take Plaice.[29] Depend on the most dredful Conse-
quences to Insue. Human nature will not be governd by
Persecution and america do one and all Beleve themselves
undr a heavy Persecution the same as England thought
themselvs in Charls Reign and they Believe it ther Duty to
Protect the Inocent Inhabitents of Each Coloney when
opresd —

the new Parlement is likely to be the old over again and
the same unlawful Counsil will be folowed.

the Peopel in England are in a surprise. They know not
who to chuse to Protect them. Your wisdom may Point out
to them wise and honest men to stand for them, and by a
wise honest Parlement the unhapy uprore may be Pre-
vented from a sivil Warr.

Captn. Tompson [is] well know[n] for his good heart
and wise head. He is thought a very Proper man to be a
membr for some of the Countys or Bouroughs and if your

Lordship would Pleas to signifie your aprobation of him, the Peopel would gladly Chuse him.

at a meeting of worthy freeholders it was Perposd to Chuse him for Hull But the Court Influanc has all ovr Ruld. Some Buroughs have wrote to London to Call on ther friends to send a honest man to Represent them But will not take any But those who are Recomendd by Ld Chattam or those whos Judment they Can Rely on. A letter from Ld Chattam will be a good Recomendation for the honest tompson. His abilities have been tryed. His love to his Contry, his Knowledge of the laws, and Inclination to serve the Peopel makes him a Proper man and will Recomend him to the Choice of the Peopel if Properly Known to them by your Lordship Recomendation. Pardon my overfondness for a Ingurd Peopel, dont think me Impertinent. I am with all Posable Respet Yor Lordships most dutiful and most hearty well wisher a friend to England.

I shall take the Liberty to send a few lettes Rcvd from New York as soon as they are Returnd from those who are orded to Read them.[30]

Captain Edward Thompson of the Navy, whom she presented for Lord Chatham's endorsement, had had his portrait made in wax, and one cannot escape the surmise that he thought its presence in the exhibition a promotional advantage in his campaign. He was a comrade of Wilkes and close to a less witty but steadier liberal whom Patience also counted as her friend, Dr. John Jebb. The "honest tompson" was a sailor with a literary turn. His *Demi-Rep, Courtesan,* and *Meretricious Miscellanies* had been collected in 1770 under the title of *The Court of Cupid.* He had had a resounding theatrical success, *The Fair Quaker, or The Humours of the Navy.* He might have enlivened the waxwork with one of his rousing songs, such as the long popular "Sailor's Farewell":

> The topsails shiver in the wind
> The Ship she casts to Sea,
> But yet my soul, my heart, my mind,
> Are, Mary, moor'd with thee.[31]

Honest heart, however, did not bring votes to overcome Lord North's opposition, and he would lounge about London on half-pay until, under the urgency of war, command of the frigate *Hyaena* was given him in 1778.

Another naval officer, a retired lieutenant only, did win a seat from which, six years later, he would become a living terror to the King's party and a leading figure in this chronicle of the artist in wax. Lord George Gordon, aged twenty-three, a sweet, pale face framed in long locks of rust-red hair, was a younger son of the Dowager Duchess of Gordon, who had found a second husband in Staats Long Morris of New York. As a boy, neglected and forlorn, Lord George had conceived a passion for the relief of oppressed humanity. In the Navy he had championed the common sailor — extinguishing all hope for his own promotion. On the West India station he had been a partisan of the slaves, and in North American waters of the Americans. He was charming, kindly, gracious, and a devout reader of the Bible. Women, easily moved by him, were his chief pleasure. His love for the common man had made him popular in his constituency, just as his long speeches on the subject would make him unpopular in the Commons.

When the new Parliament met on November 29, 1774, Lord Chatham moved for recall of the troops from Boston. He spoke not only to the benches but to the throngs beyond, at home and over ocean — "The Americans are a brave and united people, with arms in their hands and courage in their hearts, three millions of them, the desendants of a valiant and pious ancestry, driven to those deserts by the narrow maxims of a superstitious tyranny."[32]

The benches' new majority sat unmoved. The might of England would now decide the issue. The Americans, having refused to pay the light taxation imposed, must be kept in submission and pay the charges for it. If they attempted a war they would pay for that, and the garrisons too. War was in the air. The far-away Congress at Philadelphia prepared for it. William and Arthur Lee talked of enlisting a great European general to head American resistance, Prince Ferdinand of Brunswick or Prince Victor Claude de Broglie, Marshal of France. It was at

this dramatic moment of great power poised to strike that a young man arrived in London from guilty Massachusetts to plead for peace. To many he must have seemed the very symbol of a lost cause — dying of consumption, driven alike by the hectic fevers of patriotism and disease. Josiah Quincy, Jr., had, with John Adams, defended the soldiers charged with murder at the Boston Massacre. He now came upon a sudden personal impulse to speak for America before the King's ministers — to make a strong and clear rebuttal to the charges and statements of Hutchinson and other refugee Loyalists.[33]

Josiah had tried to keep his plan a secret so that none could be prejudiced against him on arrival. The result was that a cloud of rumor came with him. Some thought him a secret agent of Congress with power to sue for mercy. General Gage sent a warning note via the same ship that brought him.[34] Coming into town on November 17, 1774, he was at once in a whirl of activity, meeting the American protagonists, among them Patience Wright, interviewing the ministers and opposition.

Lord North received him on November 19, suave, affable, kindly, but immovable. America must be punished. Submission must be absolute.[35] Back among the Americans at coffeehouse and dinner table he found an equal but more stormy determination — in all but Franklin, before whose temperate advice for firmness in one hand, readiness to be reconciled in the other, the young man's belligerency melted almost into tears.[36] Between these moods, November 25, Mrs. Wright "spent the evening with me, and afforded much entertainment by her account of what [is] said and conjectured about me, my views and business."[37]

Josiah Quincy's brief diary jottings tell much of Patience Wright beyond that single entry. She who responded so eagerly to Lord Chatham's plea for information was here confronted by an attractive young man in the role of secret intermediary, engaging upon his own initiative in a mysterious activity portending great things. She would henceforth be casting herself in a similar part as she conceived it. The diary, furthermore, shows Josiah in intimate contact with the same persons who are more obscurely mentioned in her letters, and reveals William Lee in

particular as a source of her excitement, fears, and warnings. It gives us a quick, intimate glimpse into the heart of the Pro-American bloc, the mercantile firms in the American trade — Alexander Champion and Thomas Dickason, Thomas and Henry Bromfield, and, on a more memorable side, Charles and Edward Dilly, to all of whom Mrs. Wright had come. The Dillys, bookseller-publishers, figure brightly in the literary history of the times. It was at one of their dinners that James Boswell contrived by artifice to bring Samuel Johnson and John Wilkes together. Boswell was of one mind with the Dillys on the American question, Dr. Johnson emphatically not — though he and Wilkes somehow found common ground in a jocular upbraiding of the Scots. Arthur Lee, whom Boswell had known as a medical student at Edinburgh, was there, and Alderman William Lee joined the group later.[38] William Lee's later warnings to Josiah, March and April 1775, against the De Lanceys of New York, and that "Dr. Smith in Philadelphia should be watched," reappear in Patience's letters of the same time to John Dickinson.[39]

Josiah talked with Lord Dartmouth and others, as adamant as Lord North; and on the other hand dined with the Lees, with John Alleyne, a friend of Franklin at the London bar, and had long conferences with Lord Shelburne, Catharine Macaulay, and the Countess of Huntingdon. He met Mrs. Wright again, perhaps at the waxwork, and she gave him a letter which she must have received late in December from the Reverend Samuel Stillman, filled with the latest news from Boston.[40] Quincy was at Craven Street on January 17, 1775, with a merry group celebrating Franklin's birthday, and three days later he heard Lord Chatham in the House of Lords, "like an old Roman Senator, rising with the dignity of age, yet speaking with the fire of youth," denouncing the ministry and declaring himself, no less than his fellow-subjects across the sea, an American.[41]

Prostrated twice by his illness, Josiah broke away from Dr. Fothergill's care to take ship for home — fearful of the voyage but fearful also that a written report would be intercepted. He died as his ship approached the New England shore, dictating what he could of it to a sailor.

Franklin had sailed for Philadelphia only a few days before

Quincy. As Chatham had consulted him openly, so had the ministry secretly, holding out a lure of financial gain in return for his influence. His departure on March 20 was noted in the *London Chronicle* with a hope long to be cherished in Britain. Let "the great American philosopher" now work to reconcile Congress and King — a hope echoed in strong letters of appeal from Franklin's old friend, William Strahan.[42]

Franklin carried with him a letter from Patience Wright to John Dickinson, a reply to one she had just received from him. Dickinson had written, as many did in this day, in awareness that his letter might be shown to others, passed about, even printed. It brings us, in his own clear terms, an American version of Lord Chatham's view. In the "Pennsylvania Farmer's" conservative legal mind the King was the radical innovator:

Madam,

I now gratefully acknowledge the Receipt of two Letters from you, and intreat you to pardon my not answering them sooner. The Business in which I have been involved by the unhappy Affairs of our native Country, and a great deal of Sickness, have occasion'd so long a delay in writing to you, which I hope therefore you'll be so good as to excuse.

I heartily thank you for the Intelligence you have been pleased to give me, and shall be obliged for as frequent a Correspondence as will be agreeable to you.

America now waits for the Decision of Great Britain resolved at every hazard to resist Force by Force, with a *probability*, at worst, a *Chance* for Success; and, that, your Share of public Spirit must satisfy [you], is better than the *certainty* of Poverty, Slavery, Misery and Infamy, that must overtake us and our Posterity by a tame submission.

Nothing less than an assurance of these Calamities falling upon us, and our Descendants, could have reconciled your loyal and dutiful Countrymen to the thoughts of bearing Arms, against the powers of our Sovreign & parent State. But the Schemes agitated against us are too evident

for Men of the least Sense and Virtue to hesitate on the part they ought to take. Where our struggles will end, what strange Revolutions will take place, no human Creature can guess, if once the Sword is dipt in blood, for drawn it already is. For my part, I can only say, there are two points on either of which I shall esteem it my duty, when called upon, to lay down my Life. First, to defend the Liberties of my Country, against their meditated Destruction. Secondly, To preserve the Dependance of these Colonies on their Mother Country. May God Almighty bless and prosper her and them in a subordinate Connection with her, till Time shall be no more. I sincerely rejoice in the Success that has attended you in England. I have mention'd to several of my Brethren in Assembly, the propriety of sending for Ld. Chatham's Bust, done by our ingenious Countrywoman; But the public Distresses render them too inattentive to the fine Arts; I will remind them of the Proposal at another Sessions.

<div style="text-align: center">

I am with great Esteen

Madam

Your much obliged and
</div>

Mrs. P. Wright	very humble servant
Pall mall	John Dickinson
London	Fair Hill Jany 30th 1775[43]

Her reply shows that she was beginning to see her own role in the conflict as something much more vital than merely transmitting information — though that remained a major part of it.

<div style="text-align: center">

Pallmall March 10th, 1775
</div>

Sir /

I had the Pleasure to Read your lette and very glad that your sentiments Continue so firm in the great Cause of american Safty — The Bills now in agitation are still worse and pr the Worthy Bairr dr Frankling you will be Informd of the undue Power that is to be Exerted against your Coloney, and all the Southern govements — Now is the time

Come that Calls for the utmost wisdom of all the honest
men in america.

this day I waited on the worthy desenting ministers to
Know if any advise could be sent to the Congress to Inform
them what method will be Best for the Coloneys to
Proceed — and they all agree that the Wisdom and Pru-
dence of the Congress must save themselves, and not look
for any asistance this side the Watter.[44] All depends on your
own Courage and good Condoct — The Ministry is deter-
mand to Cary thir Point and Bring the Coloneys into a
Compliance by force. They Expect to oblige you into a
Compliance by the Necessity of traid or the want of Provi-
sions in Each Coloney from the Suplies that they get from
Each other or to divide them amongst themselvs if thir
Starving will not do then fighting Blood and murder is to be
the scartan fate of all who will not submit

thir horred Scheem is thought so dredful that all the
honest men in England are alarmd and all with one voice
Cry out against it and most heartly wish you Courage and
fortitud and Publick as well as Privet Vertue to hold out and
shew the World that the wisdom and honesty of the Con-
gress and the Coloneys all to Joyne in one heart to Improve
your Land and to atend to the Improvement of the Land
and Blessing god has gave you and Keep america a Land of
Refuge to fly unto from opresion and tyroney. England is
now Lost if you Submit — I waited on admral muntague.[45]
He think the time Calls for the utmost Ceare and Prudance
and Refuses to take the Comand of any other station on the
Contenant untill a Spirit of Peace or Reconcelation takes
Place. But he and many others thinks that Prid and Luxory
will make you submit, with the desgrac of an atempt to hold
out and then be forced to submit at Last — with the des-
agreable agrivation that you have a standing armie &c.

may the god of our father Keep you and Bless you and
give a union amongst you is the most hearty Prayer of your
old heart fieling

friend and humbl srvt
Patience Wright

a Bishop is to be Sent to new york, new Charter is now in agetation new Charters for all the Coloneys and a military Power is to work great things.[46] It would take a quir of Paper to write all the Evils Intended against you. Pride and Power with Ignorance and tyraney is all you are to Expect.

take Cea of Smith, galoway &c. Gv. Penn is to be Employd to decive you. Youl see pr the Paper the fate of the Peopel is to be Intirly on thir own good Condoct.[47] Hapy Pennsylvania who have a John Dickison to advise them.[48]

A month later she had even more alarming news for Dickinson, and information which gives a clearer hint as to how she may have been gathering it. She mentions, too, a return to America, as she had to Rodgers in the autumn before. But the issues were becoming too great, the game too exciting to leave now. She would not think of departure again until four years had passed, war had closed in around the island, and the only sea routes left were long and dangerous. Captain McCulloch was entrusted with the letter.[49]

Pallmall april 6th 1775

Sir

I have the Pleasure to Recomend meculah to you to be Inform of the agreable news of our worthy Ld mayor Wilks and Comon Counsil and Livry of LONDON have Pettition the King of which is sent a Copy &c.[50]

The Ld Chamberlin and Comon Counsil have a desire to asist the Congress and wish you god Speed a Blessing to the world and to Keep america as an asalum for all lovers of Liberty and Publick vertue to flye unto from tyrony and opresion.[51] The fleat is any moment to sail and a new Constructed Cannon, lite, Portable on horse Back, 32 Inches Long, wide muzzel to fire at the Inhabitants and kill many at a shot.[52] Meny thousand fire arms sent out of the tower and shipt on bord the transports at dedford. Meny hundrd Cags of flints marked BOSTON on Each Cagg with all Implements of WARR. But this is all well known to you in america I much wish to asist you in giving you the Early Intelegenc and a

few Hints may be usful — mr Gilbert Barkly son in Law to John Ingles who was Long waiting for some place, is at Last taken into Pay. Ten days agoe he was desird to hold himself in readiness to sail at a hours warning to america — On the 3 inst he saild from Dover in a vesel bound to Maryland. He Expects to be at the Congress. He told a Confident before he set out that he had a Comision from the ministry to make overturs to the americans, But this was rather a *Bounce* [i.e., a boastful lie] for it is known that he is perticerly directed by Lord Sandwich who hates the americans in his heart to watch thir proceedings of peopel at the Congress, try to learn if there is any devisions amongs them any Parties, and to send the Earliest intelligence of evry thing to the ministry who is to try by what means the americans can be devided —

Betts are already oferd that Phila. will prvid him with a new Suter of Cloathes for its aprehended he must fly and want *fethers*.[53] It is astonishing the low arts made use of amongst the ministry. If you was sencable of the weekness of the men and the wickedness of your Enemies you would Despise ther fleet and armies.

How[e] is to land at new york. The Delancy Breed is marr[i]ed in England and, by that means the names of the inhabitan in new york are Known to the ministry and they Expect to bribe them with Cont[r]acts and Places and ther port left open to devide the Coloneys and to deceve the peopl, But I depend on the Vertue of the Peopel.[54] Pray take cear of Jo galoway, dr Smith, Jo Read, delancy &c. Ther lettes are seen in dartmouth offic — depend on my Informat is a undeniable fact.[55] Colnl fitzroy, g. Pownill, aldman Sawbridge, Colnl Barry I have good Reason to think some one of those membs of Parlement have seen Cause to Caution the Congress against those american Hyprocretes (as they Call them).[56]

by the pape[r]s youl see how well the City and Livry of London behavd and I make no doubt but you will act with a politeness toward them that will do honor to america.[57] The despute is not betwen England and america, but against a

wicked ministry warring against both. The peopel of Eng-
land are opresd more than they cane any longer bare and
the day you declare yourselves free men England will do so
likewise. They look up to you. You gentlemen of the Con-
gress are the means undr god to set free the whole English
nation on both sides the Water. Glorious Busness highly
honored by the Peopel in England as well as america. The
Eys of all Urope are opon you. I rejoyce in beng Born and
Educated in America and hope soon to see that Land of
Blessings and Enjoy the free undefilld air of a Blessed
Climat and a Virtious peopel — farwell poor old England.
The sins of the Rich have Brot on the Curse of Babylon on
the Island and before next octobr Either a Revolution or
Ruin will most seartainly take place with out the spirit of
prophesie and america will flourish and be a Blessing to the
Whole World

I am hapy to live in the days when I see with my own
Eyes, I here with my own Ears, and Know the wicked Coun-
sel that is against you, as also to be so Hapy to Know meny
of the gentlemen in the Congress and am not a silent spec-
tatr on the grand works of provedenc. I charge you dont
faint or give Way in the Least article — Stop the actt of the
stoping the port of Boston. Take a Estemet of the Loss of
traid and Bring in your Bill agains the India Company tea
and demand the Damage. America has so much sufferd.
Keep your act Ready — very soon —

Pleas to speak to the gentlemen from Boston to send
me a Corect Copy of a Impeachment aganst g. Huch-
ingson.[58] The grand Jury of middlesex will Indite Him Im-
eadally and Bring to Isue the Horred plott. Likewise draw
up a papr Copy of a Impeachment against Lord fredrick
North, prime minister of the tresary and membr of Parle-
ment. I saw him Bring in to the house [of] Parlment, the
Boston Port Bill and now the other Bills Blocking up all the
other Port. The English Nation will not bare this unlawful
ministry any longer to keep ther Places. Send Copys of facts
properly suported and I warent the suksess. By good au-

thority I write you this. Women are always usful in grand
Events. Lay this before such of the worthy gentlemen of
your Bretheren. Keep a Corospondanc with Ld Mayor. I
will give you a Compleat List of the names of all your frends
and Enemies. Direct your lettrs to proper men. We have 26
men in London who make your afair all their study and are
Impatient to be Employd. Take this Hint from your old
friend and devotd humbl srvt
Patience Wright
as for new york here pr the new[s]paper[s].
my hearty love to Mrs Dickerson and famaly[59]

This letter of April 6 brings us as close to Patience Wright in
her role of spy as we shall probably ever come. It raises provoca-
tive questions. "Ther letters are seen in dartmouth office —
depend on my Informat is a undeniable fact." Undeniable it is,
and confirmed in the Dartmouth papers. She had not seen them
herself, apparently, but relied on her informant. Was he some
clerk or undersecretary sympathetic to her or to her cause? Or a
humorist teasing her with alarming tidbits? Or one who, with the
knowledge and approval of the noble lord, was deliberately
using her to mislead the rebels?

From one viewpoint, this last is the logical conclusion. The
genuine news of "all Implements of WARR" would abash but not
help the rebels, while lending credibility to the one major piece
of misinformation. What has been given her on the naming of
an American Bishop will add spice, and stir the blood of the
many Americans who, like Mrs. Wright, are highly sensitive to
religious impositions. The light cannon, "32 Inches Long, wide
muzzel to fire at the Inhabitants and kill many at a shot," would
add thrills of terror and outrage. There is a freshness, too, about
this news from Dartmouth's office. Amherst's list of ordinance
was written only the evening before Patience launched her letter
seaward with Captain McCulloch for safe delivery in the rebel
capital. Yet all this supports the statement that Howe "is to land
at New York," which was not true at all. The flotilla was bound

for Boston, where General Sir William Howe would command at
Bunker Hill. Here we sense that art of misleading the enemy
practiced by the British with such success in World War II.

And yet one cannot be quite sure. There it is that the kegs of
gun flints are marked "BOSTON." She may simply have picked up
at the waxwork some chatter on Sir William's known preference
for a New York objective.[60] He had a soft place in his heart for
the people of Boston, who had raised a monument in Westmin-
ster Abbey to his brother, killed at Ticonderoga in 1758. It all
reminds us of Patience's happy boast to Dr. Rodgers, "Honord
as a Ingenous Woman can have access to any of them talk freely
and have all the advantage I wish or want." After the retirement
from Boston it was Howe who moved against New York in con-
cert with his brother the Admiral, but that was a year after the
letter of April 6, 1775.

William Lee was certainly one source of Patience's informa-
tion and anger, even her words sometimes echoing his — as
"junto" for Lord North's cabinet — but here that link is clouded.
In February he had given the whole armament's destination as
New York, but by March was naming both New York and Bos-
ton.[61] Less meaningful now, but far more explosive then, is her
statement that "the wicked ministry" is at war with both England
and America — "and the day you declare yourselves free men
England will do so Likewise." An English uprising was very
much in the hopes of Lee and his circle, and even more real in
the fears of some of the King's party. As troops embarked for
America, the Americans in London were watched with finger on
hair trigger in a dread that some new Guy Fawkes might be
preparing to strike — to strike, as of old, on the day when the
King came to open his new Parliament.

That would be in October, and Patience would be there,
sounding her trumpet, ablaze with the faith of a leader just as
she was now, in April. "Women are always usful in grand
Events," she assures John Dickinson, and then, ignoring his firm
profession of loyalty equally to American rights and the empire,
urges him to "declare yourselves free men." That would bring

England promptly to her senses, to compromise and peace, and it is true that many in Britain, some in America, would long continue to see independence as a forceful threat rather than a finality. Follow it up, she cries: Levy damages against the East India Company. Bring Governor Hutchinson to trial. Impeach Lord North.

All this with religious zeal, and William Lee's cadre was quite as ready as she to stress that side. He also had been sending copies of the London Common Council's resolves to America, and one of these came to Lord Dartmouth in the stream of intercepted letters accompanied by a printed "Address to the Soldiers." The "Address" was for distribution in barracks and embarkation ports throughout the isles. It was signed "An Old Soldier" and began, "Gentlemen, You are about to embark for America, tó compel your fellow subjects there to submit to Popery and Slavery. It is the Glory of the British Soldier, that he is the Defender, not the Destroyer, of the Civil and Religious Rights of the People." The argument that followed dwelt significantly on the intolerance and downfall of James II. There was a note in Lee's hand: "This has been sent to Ireland to be publish'd there. London, March 1775."[62]

Four days after writing to Dickinson, Patience sent off a letter to New York, again warning that Sir William was coming "to hoist the flag" over that city. This missive is known only through a long excerpt printed in a newspaper and later republished in Force's *American Archives.* No writer's name is given but, making due allowance for editorial clarification, its content and style mark it plainly as Mrs. Wright's. The King, she says, refuses to see any adviser who differs from him in opinion, yet wastes time and money in "publick diversions, plays, operas, and has given fifteen hundred pounds to an Italian singer. . . Several gentlemen called on me, and desired me to write to you to arm immediately. Get ready to receive ten thousand men and four hundred sail, and you are to find provisions and pay them yourselves. New charters are ready now; for your money, the soldiers have orders to fight; new cannon, guns, powder and ball, for war and blood! The cry of blood is gone out against you." She

deplores the passing of "the glory of old England," and we have her first references to King George as Pharaoh — "the greatest tyrant that ever yet was seen, who is now hardened Pharoah like."

> The Quakers are the most hearty in the cause, and see the dreadful consequences of a civil war. Our forefathers did not think that ever a King of *England* would break his oath, and murder his subjects in cold blood, and take their money, or rob his people without giving them any opportunity to defend themselves but by the sword. This is dreadful, and dreadfully true. May the *God* of our forefathers direct you so to defend your rights and property, as will teach us to depend on the justice of our cause, and the hearty love of our country, in full confidence of a complete victory. This is the hearty prayer of thousands.

And it all leads up to a final prophecy as to the fate of the iron-hearted monarch — "As *Pharaoh,* he will drive his chariot into the *German* Sea, not without a host of his Nobles to attend him."[63]

Both letters denounce the wasteful extravagance of Britain's rulers. "Farwell poor old England. The sins of the rich have brot on the curse of Babylon on the island and before next Octobr Either a Revolution or Ruin will most seartainly take place." Benjamin Franklin had felt the same thing, moodily, in his own way, without Patience's prophetic exuberance and without Dickinson's full dedication to union: "When I consider the extream Corruption prevalent among all Orders of Men in this old rotten State, and the glorious publick Virtue so predominant in our rising Country, I cannot but apprehend more Mischief than Benefit from a closer Union. I fear they will drag us after them in all the plundering Wars which their desperate Circumstances, Injustice and Rapacity may prompt them to undertake; and their wide-ranging Prodigality and Profusion is a Gulph that will swallow up every aid we may distress ourselves to afford them. . . . However, I would try anything, and bear anything that can be borne with Safety to our just Liberties, rather

than engage in a War with such near relations, unless compelled to it by dire Necessity in our own Defence." To this, ever hopeful, he adds a list of "preliminary Articles" toward reunion, considerably more temperate in character than those proposed by Mrs. Wright to Dickinson.[64]

Many, and among them many who knew him well, would continue to look to Franklin for compromise. He was a man for reasonable solutions, and he himself would continue to watch for those fundamental changes on the other side which would make it possible. War, if America could hold her own, might bring them.

War came. The news of Concord and Lexington reached London on May 29, 1775. "The horrid tragedy is commenced," wrote Stephen Sayre to Lord Chatham on that day.[65] But Mrs. Wright — and the story was current for too long to be lightly brushed aside — spoke out to the King himself. This was the King's war. He could no longer be seen as a "worthy" monarch ill-advised. Out into Pall Mall she marched, past St. James's, across the park and into Buckingham House, and there she gave him the true picture of his wickedness and due warning of what would surely follow. As young William Dunlap heard the story in 1784, "She once had the ear and favour of George the Third, but lost it by scolding him for sanctioning the American war." To this he adds from personal recollection, "Her manners were not those of a courtier."[66]

CHAPTER VII

"The Promethean Modeller"

PATRIOTISM is a feminine quality, full of pride, hope, and all the defensive mettle of motherhood. At the waxwork it lifted the large bosom, lighted the bold eyes, breathing faith that "dear America" would never yield, never be conquered. But Chatham's leadership had been beaten down. Franklin was far away upon the sea. Around her the mustering forces of the King were everywhere ascendant. She would be both direct and devious. She at her end of Pall Mall would be watching the Palace at the other, just as ready as had been Paul Revere at this same time to sound the alarm.

The exhibition was now a base of operations. Courtiers, the elite, were still attracted to it, teasing the "Sibyl" for predictions, trying to shake her confidence, playing a game that she could play as well. William Forster stopped by in January and found her busy enhancing its attractions:

> I was to see P. Wright a few days since. She is still very warm against the ministry, yet conceives great hopes of a Change of them & consequently of their measures soon as Parlt. sits again. She was finishing her Fathers figure. He was a singular Character, a long white beard adorns his face which is very expressive, & not unlike Jno Woolmans, and a large white hat on his head. She has done an Indian man & Squaw in their proper dress and Attitude extra: well, I think also the D. of Gloucester.[1]

Quaker saint John Woolman of Burlington, New Jersey, had come to England in 1772, not long after Patience's arrival,

and it may well have been he who told Forster of the Lovells and
the workers in wax. John Woolman, like John Lovell, wore the
undyed clothing commended by Thomas Tryon, though not,
apparently, the patriarchal beard.[2] John Lovell's figure was
joined soon after by that of his wife, seated near him, book in
hand. They served to illustrate Patience's oft-recited story of her
childhood. The "Indian man & Squaw" also satisfied curiosity
and identified the artist more firmly with the mysteries of nature
in a primitive land.

Her new pieces in portrait sculpture may have been replicas
of privately commissioned works, but also seem to show the
waxwork becoming a sort of personal hall of fame reflecting the
artist's sympathies and admiration. Such, for instance, were the
portraits of Robert Dingley and Jonas Hanway, who in 1758 had
founded the Magdalen Hospital as a haven for seduced women
and repentant prostitutes. Hanway's philanthropy had gone fur-
ther, with a hospital for the "Exposed and Deserted Young
Children" of the poor, after which he had forced through Par-
liament a series of intelligently conceived acts for their protection.
He could write touchingly of freedom in his own way:

> The genius of Liberty never shines with more tran-
> scendent brightness than in those laws which are calculated
> for the preservation of the common people, particularly the
> poor, and of these the infant part, who are under the more
> immediate care of heaven.[3]

Dingley, a member of the Dilettanti Society of wealthy amateurs,
had proposed and promoted an early plan for the establishment
of a British academy of art.[4]

More — the waxwork was now reaching out on tour as it
had in America. With the arrival of the children their mother
could once more roam afield. The girls could receive company
and work on the costumes, and Elizabeth took up modeling as
well. When the London season ended Patience could follow so-
ciety out to Bath for a stay, and from Bath move on to Bristol,
not too far beyond. Bath was all gaiety and gossip. Bristol was a
solid little trading city, a place where Americans felt more at

home than anywhere else in England. To these outings, profitable and pleasant, we may also trace some of the strong feeling she would express for the plain people of "Old England."

She was at Bath in the summer of 1775.[5] Mrs. Macaulay was living there now in a house provided by her elderly and infatuated, but platonic, admirer, the Reverend Dr. Thomas Wilson. There at this time Catharine published her *Address to the People of England, Scotland and Ireland on the Present Important Crisis of Affairs*. The fairest part of Britain's empire will be lost, she warns, unless the steady advance of despotism can be turned back and ancient liberties restored:

> Rouse, my countrymen! rouse from that state of guilty dissipation in which you have too long remained, and in which, if you longer continue, you are lost forever. Rouse! and unite in one general effort; till, by your unanimous and repeated Addresses to the throne, and to both Houses of Parliament, you draw the attention of every part of the government to their own interests, and to the dangerous state of the British empire.[6]

Here is a more literate rendering of what Patience was proclaiming in her own way as she moved across England on her self-appointed mission. Lawyer John Baker, who had visited and admired the London waxwork on May 1, on July 27 drank tea with Mrs. Norris, who "told me of the odd manner of her getting acquainted lately at Bristol with Mrs. Wright, the waxwork woman in Pall Mall."[7] Just that in his diary, but we may guess why she had been there. Bristol, long in the American trade, had more ships and more news coming in from the west than London, news of Congress, Boston, Bunker Hill, news that should make all England turn in fury against the King. Both Catharine and Patience looked forward to a massive peaceful protest, but the men on both sides talked of war and of dark conspiracy in ferment.

Back in London, late that summer, a new figure moved covertly from one camp to the other. Pierre Augustin Caron, who figures in the arts and statecraft as Caron de Beaumarchais,

was on stage in Act I of that drama of Franco-American alliance
of which he was both an author and a star performer. His cover
was a matter between the French government and the notorious
transvestite the Chevalier d'Éon — his true errand to report ac-
curately upon the rift between King and colonies. He was well
acquainted with Lord Rochford, one of the Secretaries of
State — they had sung duets together in Spain a decade before.
On the other side, he was well established as a bon-vivant com-
panion of Lord Mayor John Wilkes.

Rochford now regarded Caron de Beaumarchais with an icy
suspicion, but that being well founded lent credence to a deeper
suspicion which the Earl at last, with a sigh, revealed: *"I am much
afraid, Sir, that the winter will not pass without some heads being
brought down, either among the king's party or the opposition."* John
Wilkes foresaw much the same, but proclaimed it openly: "The
King of England has long done me the honour of hating me. For
my part, I have always rendered him the justice of despising
him. The time has come for deciding which of us has formed the
best opinion of the other, and on which side the wind will cause
heads to fall."

At Wilkes', Beaumarchais met "Monsieur L.," certainly
either Arthur or William Lee, eager to place French arms in the
hands of the enormous armies arising in America. All this was
reported to Louis XVI on September 21, with an opening state-
ment that "War is kindled with more strength in London than at
Boston."[8]

On October 23, the day before the King would come to
open Parliament, Rochford struck against the man he saw as
mastermind of a latter-day Gunpowder Plot — an American in-
sinuating himself into government with Chatham's help and
now conspiring to seize the whole. This was no other than Mrs.
Wright's Long Island and New Jersey compatriot, handsome
Stephen Sayre, who had first met Chatham through her. He had
been William Lee's partner in the tobacco trade, and that the two
should have been elected sheriff and alderman of London had
seemed to bode well for a democratic union of the empire. Brit-
ons in the main were not yet ready to stomach such a thing. It

had been with the endorsement of the left-wing Society of Supporters of the Bill of Rights that Sheriff Sayre had become entitled to war the white and silver livery and gold chain of office.[9] In February 1775 he had achieved a more conventional success by marrying an English heiress. Then, proprietor now of a London bank, he had stood for Parliament with Lord Chatham's endorsement.[10] Here was Americanizing with a vengeance, and others had moved quickly to thwart it. Sayre had chosen an easy borough. Forty-seven votes made a majority — but he polled only one. That was the immediate prelude to the sudden invasion of his home by officers of the crown and his lodgement in the Tower upon a charge of high treason.

Lord Rochford's indictment outlined a plot to seize the person of the King as he passed through a certain corridor in the House of Lords, take possession of the Tower of London, and hold the monarch a prisoner there while disbanding Parliament and rallying up a government of Sayre's own.[11] It was to have been accomplished with a force of soldiers believed to have responded to that appeal which William Lee had been distributing, and who would act under the command of a retired officer of Royal Marines, Major Peter Labilliere.[12] This is our earliest glimpse of the mad Major, who reappears later in this chronicle hand in glove with Mrs. Wright in continuing plans for a determined but peaceful overthrow of George III.

Rochford presented a detailed conspiracy, but his evidence was not strongly supportive. Mr. Sayre, after dining well and perhaps in a mood of some exasperation after his failure at the polls, had ventured a rather free opinion as to how His Majesty and other problems of the moment might be dealt with. A young military man, an American, had repeated his recollection of this to the Earl, who had hoped, taking Sayre by surprise, to find full proof in his private papers. Locks were smashed, the house ransacked, but the rigorous search yielded only two documents of a suspicious tenor. One was a letter from Catharine Macaulay. The other was an anonymous communication signed "Bernard's Ghost," in apparent reference to Sir Francis Bernard, unpopular governor of New Jersey and Massachusetts. "Scraps of

paper" from Mrs. Wright, though certainly there, were not reported. Sayre accepted calmly his brief imprisonment in the Tower and soon after easily won damages of a thousand pounds from Rochford. Yet he had learned with finality that there would be no place for an American in British politics.

Sayre soon left for the Continent and a career of undercover intrigue in which Patience would hear from him again from time to time. As for the undercover work at Chudleigh Court, it was protected by the very eminence of the visitors who came to see the waxwork and who found its creator amusing. That concept of art as a supernal gift also protected her, as it did West. West, however, was following the course of discretion that "prudence and the times" demanded.[13] He kept both his strong American sympathies and the friendship of the King. Patience did not. After the Declaration of Independence she would receive no more fanfare in the press as an artistic prodigy. Two articles, one in the *London Magazine* of November 1775, and another in the ultra-respectable *Gentleman's Magazine* April 1776, would be the last she would have of public acclaim until, a decade later, the obituary writers tiptoed into print with the legend of the politician and spy.

The *London Magazine* glowingly depicts "the Promethean Modeller" as one "reserved by the hand of nature to provide a new style of picturing superior to statuary and peculiar to herself and the honour of America." The writer, obviously, is a friend of the embattled colonies.[14] He brings us, with only a few inaccuracies as to past background, a picture of a pleasant family of four immersed in art, and it is accompanied by an engraving of the mother holding a newly created "busto" in her lap:

> The arts and sciences long flourished in Europe, before they even travelled into this island; but the natives of England can boast they never diminished by crossing the waves. When persecution in the reign of Charles the First, thirst of exploration, adventure or despair, winged away from these kingdoms a variety of emigrants, mechanics and artists of all denominations mixed in the ships that sailed for America,

amongst those were the progenitors of Mrs. Wright, who has been reserved by the hand of nature to produce a new style of picturing, superior to statuary, and peculiar to herself and the honour of America. For her compositions, in likeness to their originals, surpass paint or any other method of delineation: they live with such perfect animation, that we are more surprized than charmed, for we see art perfect as nature.

Amongst the group of her characters there are some large as life in conversation, and so natural that people frequently speak to the dumb figures; the most familiar of these is Mrs. Maucaulay, who may live by the fingers of Mrs. Wright as long as in her republican history, wherein she has given us a picture of her mind; but Mrs. Wright has preserved to us the person of this celebrated and patriot female. There is also a Scripture story, inimitably done, of Queen Esther, Ahasuerus and Mordecai; a dead child, and an Indian family: but the two most striking figures are her own mother and father, so immediately living, that human nature is shocked to find that really dead, which is so much like life. Among the busts, the most capital characters for elegance of execution and real representations of the living, are the king and queen; her majesty particularly expressive. Lords Temple and Chatham, Mr. Barre, Hanway, Dr. Wilson, Mr. Wilkes, Captain Edward Thompson, Mr. Dingley and many others; and so well executed that it is impossible to see the busts without immediate acknowledgements of the similitude. This surpassing genius, in itself so novel, drew Mrs. Wright from America where she had met with every applause and encouragement: but it was the mart of the world that so rare a genius should explore, where the artists of Europe bring their compositions to view. About three years ago she left her native America with her family and came to England. She was born in the nighbourhood of New York, where her parents were celebrated for honour and integrity, being Quakers of pure and upright manners. In her very infancy she discovered a striking genius, and

began with making faces in new bread and putty to such excellence that she was advised to try her skill in wax; and by labour she arrived at the amazing perfection we see her admired for at this period. To do that justice to every rank of people which they merit, Patricians and Plebeians have given every encomium to her productions; and the former have shewn her an attention worthy her deserts and their good sense.

She has been particularly honoured with the notice of Lords Chatham and Temple; and many of the most illustrious characters of this country visit her repository to converse with the Promethean Modeller. Her natural abilities are surpassing; and had a liberal and extensive education been added to her innate qualities, she had been a prodigy. She has an eye of that quick and brilliant water, that it penetrates and darts through the person it looks on; and so amazing has her work made her capable of distinguishing the characters and dispositions of her visitors, that she is very rarely mistaken, even in the minute points of manners; much more so in the general cast of the character. As an individual she is great, for she is good: as a woman she hath done honour to human nature in the qualities of mother and friend. For integrity, virtue and a pure heart she is an ornament to her sex; and so sound is her sense and argument on public subjects that the most learned men may draw instruction from the keenness of her observations, and the satire of her language. She is a kind of exotic prodigy, and appears, like Pallas, to have come forth complete from the head of Jove.

She has one son and two daughters, all inspired with geniuses similar to their mother, and all excellent at working with their fingers. The son has an amazing turn to the liberal arts, and from a most promising beginning he gives assurances of arriving at great perfection in painting. In some families you find one child excelling, but then it appears by the small share remaining with the rest, that he has

bankrupted the others: in these children I have seen this observation fully and only contradicted, for they are all ingenious and ingenuous. I have enclosed you a drawing of Mrs. Wright, which I shall be proud to have inserted in your magazine.

N.

Patience might be "the Sibyl" to others, but sensible and sensitive Horace Walpole disagreed with that "capable of distinguishing the characters and dispositions of her visitors." She had seemed to mistake him for a clergyman, and the inference rankled. Mild-mannered and soberly dressed, he had probably looked the part. If he had been a restrained admirer of Mrs. Wright when she first appeared on the London scene, he was no longer so when he wrote in 1781, "I remember five years ago that madwoman who works in wax told me when I went to see her raree show, 'that if there was a God and a Providence which she firmly believed there was, and hoped (as I seemed to be a parson) that I believed the same, that the Americans would never be conquered.' "[15]

The *Gentleman's Magazine* of April 1776 had a briefer notice, which would be reprinted in London's *Morning Chronicle* in May.[16] Here the *Magazine's* editor, "Mr. Urban," is informed by a correspondent:

As it is now the general season for exhibition, give me leave, through the channel of your Magazine, to recommend to the notice of the public the performances of a lady of very singular genius.

Mrs. Wright, of Chudleigh Court, Pall-mall, is one of the most extraordinary women of the age. As an artist she stands alone; for it is not in memory, that there now exists a person possessed of her abilities as a modeller in wax. In her present exhibition, if the busts of the King and Queen, the Duke of Cumberland, Lord North, Lord Chatham, Lord Effingham, Lord Temple, Jonas Hanway, Dr. Wilson, John Wilkes, and others, were not sufficient proofs of her skill,

that of the Rev. Mr. Gostling*, of Canterbury, lately finished, would be an incontestible evidence of her happy talent of preserving an admirable likeness, and coming the nearest to a representation of life of any artist that ever attempted modelling. This gentleman is well known as a learned, agreeable, and intelligent companion, and as a worthy friend to society in general. Tho' now at a very advanced period of life, he is in full possession of his faculties, and bears in his countenance the ruddy emblems of health and content. Mrs. Wright, in the opinion of all who have seen it, has acquitted herself incomparably in the bust of Mr. Gostling, having given his immediate image, without the smallest deviation from the original

*Author of the Walk in and about Canterbury.

This surely was written by some friend of the eighty-year-old William Gostling, antiquarian and recluse, since he can assure the public so confidently of the accuracy of the new portrait. Gostling's *Walk in and About the City of Canterbury,* published in 1774, was attracting many readers and would reappear in successive editions through the next half-century. Patience's art seems to have been new to the reporter, which also suggests a Canterbury man. His mention of another new portrait, that of twenty-nine-year-old Thomas Howard, Lord Effingham, touches the wider aspect of affairs.

Effingham had resigned his commission in the army in April 1775, an act involving heavy financial loss, rather than serve against the Americans.[17] Congress had responded by naming one of its new frigates *Effingham* — among the last of its acts appropriate to a civil war rather than a conflict between nations. Reconciliation was then still an eager hope of many, and Effingham, like Franklin, would have been prominent in it, conciliatory, trusted by both sides.

As for Patience Wright, something of her view may be seen in that Scripture story of Queen Esther, Ahaseurus, and Mordecai, dramatized at the waxwork and singled out for praise in the *London Magazine.* This is the sort of thing that Rachel Wells

had been doing, but here the theme is clearly Patience's own. King Ahaseurus, as every Bible reader knew, had conspired under the influence of an evil councillor to destroy the Chosen People. Esther and Mordecai had foiled their plot — beauty and wisdom united on the side of the Lord. In a way, this was "high art" on a level with Benjamin West's — "sacred history" — but pointed toward the moment as no work of West's would ever be. One can guess from some later pieces in the Wright *oeuvre* that portrait likenesses may have reinforced the allegory. Did her Ahaseurus resemble George III? Had she cast herself as Esther? Had her Mordecai the nose and lean dignity of Chatham — or the wide mouth and weighty benevolence of Franklin? Chatham was the "gaurdin Angel," but powerless now. Franklin is perhaps a shade closer to the *Book of Esther*'s Mordecai, "seeking the wealth of his people, and speaking peace to all his seed." Franklin was closer to Patience in friendship and hearty affection, and Franklin, as London was learning, dimly, from afar, was now a figure in great affairs.

He had been to the camp at Cambridge, a Congressman consulting with Washington. He had gone still farther north in the spring of 1776, trying to persuade the Canadians to join the United Colonies. He had returned, old and weary, to sign the Declaration of Independence, as John Dickinson, true to those principles of his own, refused to do. In September he had met with Lord Howe in a fruitless last attempt at reconciliation. Then, in that same month, he was named a commissioner to negotiate, if it could be done, a treaty of commerce and friendship with the court of France.

He went on board the small armed brig *Reprisal,* this indomitable old man of past seventy years, bringing his two young grandsons with him. Five weeks later the little vessel came fluttering into Quiberon Bay on the coast of Brittany, followed by two British ships she had overtaken and captured on the way. On December 3 the great news spread through France — Franklin, the sage, the tamer of the lightning, the apostle of human liberty, had come. The *philosophes,* the ladies, the public, all thrilled to the heroism of the thing, to America, to freedom.

More coolly, suavely, France's statesmen nodded over the pros-
pect of avenging the defeats inflicted upon her by Pitt, fourteen
years before.

Over Channel, in the England of Lord North, officialdom
nodded and stirred with plans to checkmate whatever the recal-
citrant old man might do. English liberals, the world of
Chatham, Macaulay, Sawbridge, Effingham, the ever hopeful
intelligentsia in London and the provinces, all felt the nearness
of a returning promise of reconciliation. Only Franklin could
now initiate a reunion of British nationality. Franklin would be
working for a French alliance and recognition of the United
States, but he would also, they thought, balance the threat he
would hold there with proposals to the crown. Franklin must be
won over, persuaded. In England every friend of Franklin had
importance now — a place in the game of statecraft where peace
and harmony might still be within reach.

That was a fact not lost upon Mrs. Wright, whose former
closeness to the great American was well remembered. She
could be Queen Esther now. Her prophetic dream began to
blaze with expectation. It had shown her a messianic coming, a
grand entrance before which the wicked would take flight and
all evils dissolve. He would come. It would be. Franklin was in
France, only a heartbeat away.

CHAPTER VIII

"Hearty Love and Confidence"

Y OUR excellent friend in Pall Mall is in perfect health, and as much yours as ever."
This reassurance came to Franklin from his old friend of the London years, William Strahan, on May 27, 1777.[1] Franklin had by then received three letters from Patience, vibrant with hostility to King and court, and he had reason to be concerned as to how well she was holding her own. Strahan had come into Parliament in the election of 1774, a supporter of the ministry. He was very far indeed from the radicals from whom Mrs. Wright drew inspiration, and yet the two had now one similar objective. His letters urging initiatives toward peace and reconciliation had followed Franklin to America and were now coming to Paris in stronger terms. She on her part had begun to press the same appeal, though in a very different temper. Strahan was canny, controlled, a Tory. She was a Chatham Whig, and more — ready to wipe the nation clean of King and Tory alike — and would pursue that idea with an ardor gathering and rising into prophetic obsession.

Franklin in France and the tumult of enthusiasm meeting him there had sent a shock through England. He had come as if from a sovereign nation, raising the threat of a European war — Franklin, on whom England had poured contempt and abuse. Edmund Burke, envisioning a constructive role of mediation for the Whig Party, thought seriously of going to Paris. Franklin had long been his friend. The American defeats around New York might be persuasive. This had been in January 1777, before the news of Trenton and Princeton ar-

rived.[2] Yet the Whigs themselves were divided, public opinion was strong for beating the Americans into submission, and he did not go. Someone, however, similarly hopeful, had a bronze medal struck in Franklin's honor, a conciliatory gesture — the face a vigorous portrait and on the reverse a tree assailed by lightning, with the legend *"NON IRRITA FULMINA CURAT,"* or "He withstands the thunderbolt." That was to declare how futile the ministry's attack of 1773 had been. Radical printer John Almon matched the medal with a print and a motto for all liberals and reformers: *"Ubi Libertas, ibi Patria,"* "Where Liberty is, there is my country."[3]

Dr. John Fothergill, another old friend, wrote to Franklin in strong appeal as the threat of war with France loomed large — "Save this devoted country from ruin if possible." He outlined in detail terms acceptable, he thought, to almost all. There was, he declared, only one man who "refuses his consent to any change of measures."[4] That, of course, was the King. The King was ready to cajole, to bribe, to counterplay, but not to yield. He had captured New York, turned back the rebel surge into Canada, and was about to send General Burgoyne from Canada in a campaign to tear the rebellion in half. That should end the threat from France. This was the King's war, and now Franklin was seen as holding the cards for America. It had become, almost, a duel between the King and the philosopher.

And, within the narrower scope of this chronicle, it was a duel between the King and Franklin's old friend Patience Wright. "As I been 8 years faithfully Employd in doing all the good I can . . .," she would state in 1785, and that marks Franklin's arrival in France as the start of her long approach to the mighty climax presaged in the dream of 1773.[5] The letters from the waxwork to the Hôtel Valentinois at Passy move from helter-skelter information to resounding dream and prophecy. Franklin would steadily ignore her plans for his entrance into London, there to be hailed by the adherents she would muster. When an answer did come, it was full of good sense and the healthy, bantering humor they had shared before.

Yet in this winter of Franklin's arrival at Paris there were

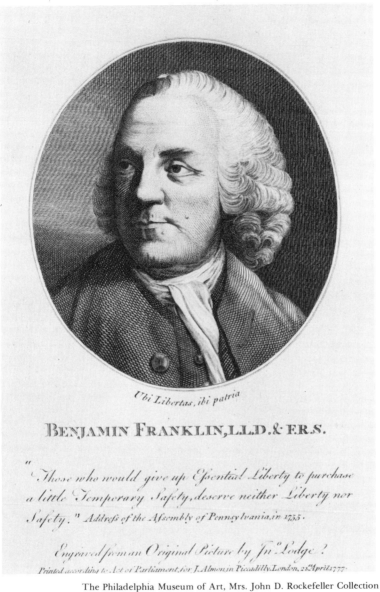

Ubi Libertas, ibi patria

BENJAMIN FRANKLIN, LL.D. & F.R.S.

"*Those who would give up Essential Liberty to purchase a little Temporary Safety, deserve neither Liberty nor Safety.*" *Address of the Assembly of Pennsylvania, in 1755.*

Engraved from an Original Picture by Jn° Lodge?

Printed according to Act of Parliament, for J. Almon, in Piccadilly, London, 21st April 1777.

FRANKLIN IN ENGLAND

The engraving that signaled Franklin's emergence as a hoped-for champion of both British and American liberty, April 1777.

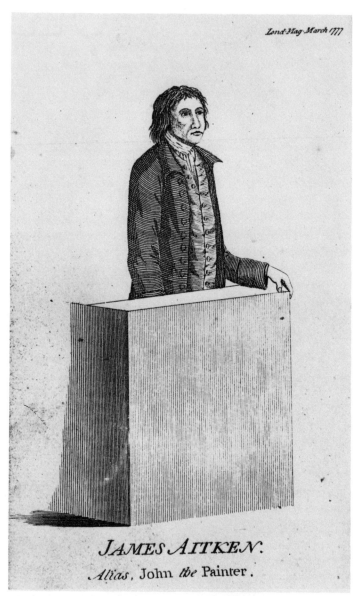

Lond: Mag: March 1777

JAMES AITKEN.

Alias, John the Painter.

"JOHN THE PAINTER"

News engraving from the *London Magazine,* March 1777, at the time of his trial and execution.

not only hopes that he might work some great reversal of the war policy, but dark fears as well. England groped and trembled through a murky terror of hidden enemies lured to desperate deeds by French gold. A single spy or saboteur can strike fear into the heart of a nation, and this was true of the flaming trail blazed along the British coast by John the Painter.

James Aitken, alias John the Painter, short and thin, red-haired and freckled, reared in an Edinburgh orphanage, had seen something of Virginia and the Carolinas as a gentleman's servant. Resentful, ambitious, he found in the war a dream of attaining wealth and a place in history by a bold stroke for America. He had devised an "infernal machine," a simple contraption in which a candle, burning down, would suddenly set everything around it in a blaze. He had taken it to Paris in the summer of 1776. Franklin had not yet arrived, but Silas Deane and Arthur Lee were there. Mr. Deane looked doubtfully at the shabby, hangdog little figure who was gently offering to set fire to all the British naval dockyards and pulling plans of them from his pocket to prove that he was ready. But the idea interested him. John the Painter went back to England with a small sum of money in hand to show what he could do. He was to burn the Portsmouth shipyard first, moving on to others as seemed best. This done, he was to make contact with Dr. Edward Bancroft, American chemist and naturalist, in London.[6]

The fire at Portsmouth, December 7, was a roaring success, though it fell short of destroying the whole area or reaching the ships. It was judged accidental, but others followed at Bristol and elsewhere, and with the discovery of one of the "infernal machines," Bow Street was in hot pursuit of the unknown arsonist. John the Painter crept into London and met Bancroft, whispering and mysterious. Bancroft, whom Patience Wright knew and trusted as an American eager to serve his country, was actually in the pay of the crown and would have betrayed the saboteur but for the fact that word from Deane had failed to reach him, and the frightened little man slipped away without revealing more than that he was an enemy of Great Britain.[7]

The reward of five hundred guineas was upped to a

thousand pounds. Lord North's cabinet was meeting in special sessions of alarm. Then, out of the culprit's own lack of coolness and guile, came capture and confession. "He shewed," the *Gazetteer and New Daily Advertiser* reported, "some signs of a clear head, but more of a fixed enthusiasm."[8] In the biography printed at the time of his trial, March 6, 1777, we are told that he had been led into crime by reading radical books — "Voltaire was his favorite author, and anti-monarchical writers."[9] So it may have been, though he had not, as the *London Magazine* darkly alleged, joined in the destruction of the tea at Boston. Hanged at the scene of the Portsmouth fire, the little body was left to rot in chains on a gibbet sixty feet high — a traitor's fate, but to the waxwork woman a pitiable martyrdom.[10]

All Americans in London were now sharply suspect as never before. Dr. Bancroft, named in the confession, fled conspicuously to France, thus adding authenticity to his American credentials. He became confidential secretary to Dr. Franklin, thereafter skillfully betraying all of the American commissioner's secrets to the ministry. Arthur Lee also had a spy as secretary.[11] All the Americans in Paris were watched with an efficiency far beyond that attributed to Mrs. Wright. Franklin, repeatedly warned, answered blandly that he had nothing to hide. "If . . . my *valet de place* was a spy, as probably he is, I think I should not discharge him for that, if in other respects I liked him."[12]

When Mrs. Bancroft followed her husband across the Channel she carried a letter from Patience to Franklin. Here the Reverend John Vardill, late Professor of Natural Law and Moral Philosophy at King's College, New York, enters the scene. Eager to win royal approval, he arranged that her papers would be "carefully opened, & without any apparent alteration return'd to Her." Nothing of great moment was found, and only a brief excerpt of Patience's reported:

The wicked Ministry have endeavored to propagate that 5000 provincials had come over to Govr. Tryon & Genl. Howe. The reason is that they had heard of a large addi-

tional number of foreign troops — but as soon as they are convinced they are imposed on they will return again.[13]

Only that, and as the letter never reached Franklin we know no more. The rest of it probably touched on the plight of another martyr to American liberty, as young and almost as insouciant as John the Painter.

In January, at the height of the spy scare, Ebenezer Smith Platt had been brought to London and arraigned upon the charge of high treason. Patience, hearing the name and knowing it well, was to the fore at once. Seeing him in his cell at Newgate, loaded with chains, wan and weary after a year in prison ships and jails, she "felt the mother." Her daughter Elizabeth, equally moved, fell heart and soul in love with the unhappy youth.

He was a Long Island boy who had grown up only a few miles from Oyster Bay, a teen-ager in the days of the New York waxwork, a son of Jonas and Temperance Platt and a nephew of Judge Zephaniah Platt, now a Member of Congress and later a founder of Plattsburg, New York. An older brother, Richard, had been aide-de-camp to General Montgomery and Montgomery had died in his arms at the storming of Quebec.[14] In 1774, aged twenty-one, Ebenezer had advertised for an apprentice in the watch and clock business in New York.[15] Soon after, however, he was off to Georgia, where his father had invested in a plantation of five thousand acres. There Jonas died and the young man, not fancying the life of a planter, drifted into Savannah and became conspicuous in the Revolutionary activities of 1775 — all being duly reported to the authorities in London.[16]

He took a leading part in forcing a ship captain with a cargo of arms for St. Augustine to sell them to the Georgia patriots instead, and this adventure brought his arrest while on a trading voyage to the islands. He was tried in Jamaica for high treason, the charge all American prisoners faced in the early days of the conflict, and acquitted for lack of evidence. There followed a social occasion among sea captains "heated with Liquor," at which Ebenezer refused to drink "Damnation to all Americans."

This recalcitrance — and an uncle in Congress — brought him, in the irons he would wear for more than two years, to the prison pen of a ship of war bound for England. At first, recourse to habeas corpus was evaded by hurried transfers from one ship to another.[17] Then, pending the suspension of the act and with the crimes of John the Painter shaking the nation, he was brought to Newgate and told that only submission to the King could save him from the terrible traitors' death. Patience and Betsy were turning to everyone who might help, including the traitorous Dr. Bancroft. Bancroft had written Silas Deane on February 7:

> There is a Mr. Platt here, who was arrested in Jamaica, and has been brought here as an agent of the Americans. He is laden with irons in Newgate. The Ministry has not sufficient proof to convict him but in accordance with the proposed Act it will detain him in prison. Would you and the Doctor think it desireable to give him some pecuniary assistance?[18]

Then followed Bancroft's pseudo-flight to France, and the appeals to Paris were continued by the ladies of the waxwork.

Elizabeth wrote to Franklin on February 13, 1777, giving her lover's history in a more coherent form than her mother could have done.[19] Patience splashed out a missive on March 7, saying little since it was to go by the regular mails, but carrying the hope of a more fruitful correspondence to follow:

> Pall-mall　　March 7th
>
> My much Honourd Friend
> 　Sir /
> 　　your thorow knowledg of me and my Principles and actions makes it not necessary for me to apologize for writing to you —
> 　　I was very anxious for a opertunity to be of som use in the great work of doing good to mankind. But now I see and behold god orderth all thing by His wise Provedenc and things are all in the universal Course set in order by him — and all I can do is only Pray for you as the means to bring about a Wise and Safe Peace.

My daughtr wrote to you informing you of the case of mr. Platt now in Newgate for Rebelion comitted in Savannah in georgia in year 1775, 4 month before the Coloney was declared Rebels the wondeful method taken to convince us of our safe situation. I make no doubt but your great knowledge of human nature and human temper with a desire to do all the good you can you will so ordr that Either Platt be Imeadetly set at liberty or Exchangd for another prisoner or som money be sent to support him in this unjust confinement. A Letter from you to the alldmen of London or to some other of those who have Power it will spirit up those good honest men (for Some thir are) who will see that justice be done if he be Brot to trial. We are now impatient for your advise how to proceed, as youl see by the news paper his case and the proceedings against him.[20] We [are] keept in the dark with all the movements of govrment and hope light to brake in upon us by some divine spark kindled in you or those provedence makes his agents.

Mr. Seayr is now at Liberty to atend your Comands and if you think prope[r] will see you. My vanity prompts me to think I can Entertan you if permited to write. Pray Sir suffer me to troubel you with my scraps of papr as I formely did in Craven Street. Small beginning and some times a slight hint to a wise man from a honest heart may do wonders. Our stocks is a material object to our leading People and to save ther money they Let go ther Contry

Ld Dunmore spent much time to convince me of the week and wicked american Rebelion this day — and the Impudence of Captn Wccks to take the Swallow sloop [of] war, the Kings Packet, and to sell the Kings ship at Public sail in France is a thing he dont Like[21] — He tells the King, "america will very soon be tired of doct Franklings Condoct" as also that they now wish for Peace most heartily. May the great Ruler of the Earth give you health and continue your life a Blessing to all mankind is the most hearty Prayr of Sir

yr faithful humbl svt

Patience Wright

I keep a Jurnal of material Events and wish to here from my
Relations and Friends in Philadelphia. Pray favr me with a
line. My children Joyne me in duty and good wishes

And then follow six lines heavily scratched out but still
barely legible. Franklin may have paused here, adjusting his
spectacles, holding the paper to nearer light, sensing the emo-
tions with which the offer — a mother's of her only son — had
been made and then withdrawn. One reads:

> my Son is a Exelent Portrait Painter Equal to
> mr West in taking likenesses. I wish you would
> admit him to [meet?] you and Paint you and
> your Friends and make him usful to you
> in any way you think most likely to serve his
> Contry, my heart is full &c.

Below which, as if in excuse for having so marred the page, she
wrote:

> all lettes are said to be opend at the Post office so it is
> not material what I write.[22]

Franklin, knowing her well, would have been touched by
that, "My heart is full &c.," aware of its fullness. One may won-
der also how long his mind lingered on her news of Lord Dun-
more, there in the waxwork protesting Captain Lambert Wickes'
seizure of the King's ship. Wickes had reported the capture to
Franklin on February 14, and here, only three weeks later, it is
common talk in London.

In the incident we have, too, a glimpse of Mrs. Wright's
elicitation of news. His Lordship, aquiline nose and small dis-
dainful mouth, was renewing an acquaintance, for he had come
to New York in the fall of 1770 as "Captain General and Gover-
nor in Chief in and over the Province." It may not have pleased
him to find the waxwork woman a greater celebrity here than
there, vaunting her friendship with Franklin and the invincibil-
ity of America. Her method was to throw out facts that "he don't
like," and then gather her harvest from the angry rebuttal.

A few days later, with a friend to deliver the letter in person,

she turned to Franklin with more precise news and more in-
spired guidance upon the course he should follow. She still
foresees a British revolution, as she had written Dickinson in
April of '75, and now it comes out for the first time that two
active bands of supporters have been making ready. We begin to
glimpse the preparations for a peaceful overthrow like that of
James II, to be spurred along by Mrs. Wright's "congregation"
of five hundred souls, and the seven hundred "Christian sol-
diers" of Major Peter Labilliere.

March

My Honoured Friend /
With the most hearty Love and Confidence in your
Friendship — Mr S[ayre?] has deservedly Recomendd him-
self to his Contry and to your Service —
things are now in a fare way of coming into a self pre-
serving and self cure *way*. They will now with a littel of your
asistance soon work their own *way*. The Spirit of honest
English men seem to get the art of thinking Properly and
much *now* desposed to act so — if they knew what was best.
Ther is wise and great men in England who are Ready to
serve their Contry with your wise council and some few
other. In a few months you may have Peace and happiness
Restord to both our unhappy contrys. The gentlemen of
Property from the Island of Jamaca have com to a Resolu-
tion to stand by america in consequence of which gov Keath
and the admiral Gayton are calld home —[23] and now is the
time today before the People in England that Express order
went out to them at Jamaica to Seze the vessels belonging to
america and take ther Property — some Months before any
actt of Parlement was made for the same. The ordr went out
in feby 4th 1775. The Actts past the season after the mete-
rial circumstances has not allarmd the Court. What makes
the ministry keep Platt from coming to a triall [is] for fear of
those pro[o]fs coming out to the merchants and Peopel of
England.
I have the Honor to be Informd by one of the gov

Council whos Intrest and health Both oblige him to own truth. You Sir are humbly Requested to urge this matter by a lette to him. Letters Importing what your wisdom shall think Best. Truth Careys the Victory. The People have been told that america sezd the west India Property first, which was not so. But — facts Properly to be stated by you to the merchents with a demand for those Prisoners will stop the Bosted Pride of taking up Sylas Deen and Doctor Frankling for treason. As John the *Painter* is to give Dignity to great Britain by his Discoveries, he is to live to confess crimes never comitted.

But as the Barer may Properly be said to come to you as an asistanc sent from god to Releeve mankind and to carey on the great work of his Providence ——

Your arival at Phila was in good TIME. Your arrival [in France] is in good TIME ALSO. My dream is out now. This 1777 will Bring the ways of god more clear to MAN and Prove that women are usful and may be admitted into the Bond of usful Frienship wher the good of all men is concernd.

Inclosd is a pamplet Intitld a Patrott KING which Pleas to Read, as also a news Pappe[r] with mr Wilks Speach wher mr Platts Case is taken up in the house Comons by him and the Peopel now begin to feal their fooly in so long shamefully looking upon one [an]other.[24] A letter to Sir Charls Asgall on the afairs of STOCKS —[25] a letter from the Emperor Germany on some truthes, Properly stated to the Alldmen in London, and a Letter to Ld Temple or gorge germain would at this time have a blessed good effect.[26] Your own head and heart will direct you to write to me Enclosd with propier directions which way I cane the most honestly and most heartly serve you by serving old England. We both know London and wish well to mankind. We have had meny agreable chatt on Publick afairs. We well know what we can do and know of a truth that the great god has made us usful to our Contry.

Majr Labilear has seven hundred men who have not

bowd down to *Baäll,* and I have nere five hundred in my
Congregation — whose weight in the scaile and properly
directed will turn the balance of Power much in old Eng-
lands favour yet.[27]

you will find our Friend the Barer of this a stedy well
Informd man whose prudence and th[o]row knowledge of
England and america will most seartanly make him a object
of your cear and confidence. You want such a man. We send
him to you. We send him with head and heart evry way
qualified to be useful in your traid, in your counting house
or at your desk in almost any capacity. He will most faith-
fully serve you and as you have Business very Plenty we beg
you for your own sake as well as for us that the moment he
arives you put a penn in his hand and a few gunies in his
Pocket, and in 3 weeks time you will see the good effects of
his Politicall Skill — which from undeniable Proffts is good.
I need not urge any thing to you, who I am so well convincd
want no spur to great actions. Only I wish to shew you our
good will and help the glorious Cause which may god Bless,
and Bless you with long life and meny happy years to live
and Enjoy the Blessings you have so gloriously defended
and assisted to Posterity. Our hearts are warm for you. We
are tiptoe to come to you and we Expect in July to see you
Come in the name of the Lord of host and gidion —[28]

there is 23 more unhapy Prisone[r]s at Portmout and
gosport and [in] the same perdiceterment of mr Platt. They
wish to know what to hope from you. For gods sake have
compasion on those strange[r]s whos Property is all taken
from them, and they in Irons, no one to Comfort them, and
it is not in the powe of the People to help them without you.
You must be our Delivrer. Our salvation depends on you
and you Sir have it in your Powr to set us all in order. You
may set us all to work in evry mans own way to help Each
other to the good of the whole

which is the Prayre of your old faithful
Servant Patience Wright Lovell
the Barer will enform you how the Prisoners, or any that

shall be [taken] hereafter may be set at Liberty by a
Letter — from some Publick Man — to Publick Men in-
forming them that they may depend on Retaliation.[29]

Aware, perhaps, that her letter sent by Mrs. Bancroft had
been intercepted, she here, on second thought, takes a new iden-
tity, knowing that Franklin would recognize her maiden name.
It is a thin disguise. The name in the opening paragraph is well
inked out except for the initial S, but her own can still be
read.

It all leads up to that final summons. He is to "Come" in
July — a "Delivrer . . . to set us all in order." When Patience's
vision is lifted on the historian's steely forceps, component parts
can be discerned. Liberals listened and talked freely with her.
She saw much of those prominent in the Society of the Support-
ers of the Bill of Rights, among whom Franklin stood in high
regard, and she was known as Franklin's friend. They spoke of
his wisdom and humanity and of England's great need at such a
time for such a mind and voice — Franklin, whom the war party
had denounced and attempted to destroy! Franklin could speak
to his own people with temperate good sense — and to the
British on necessary constitutional changes ending that long
pre-emption of power by the crown which Catharine Macaulay
had chronicled. Others, less moderate, would give her that
counsel on how Franklin could force an exchange of prisoners
by the harsh threat of retaliation. Franklin in France could
threaten far more than that. He held tremendous power for
England's weal or woe.

Such thoughts in the warm crucible of Mrs. Wright's mind
raised her vision of a day of triumph for all plain good men and
women on both sides the water. Franklin would lead a peaceful
revolution, welcomed into London by the hearty cheers of
"Christian soldiers" and "congregation." She, a Deborah in Is-
rael, would bring it about.

What messenger carried that first urgent call we do not
know. "Traid" and "counting house" touch John Greenwood,
her own and Franklin's friend, formerly of Boston, painter and

engraver and now a dealer in art, furnishings, curiosities. But Greenwood was not unemployed or in need of a few guineas. He did, however, cross from London to Paris at just this time, and on his return in April wrote jubilantly back to Franklin from Dover with news of the success of American privateers along the English coast.[30] Secret political correspondence was often disguised as commercial, and Mrs. Wright's flurry of counting-house terms may have had merely this intention.

On May 7, 1777, another plea went out from the waxwork to Paris, short, urgent, stressing the dreadful fate still threatening the American prisoners. Franklin's old friend, John Alleyne, F.R.S., was one lawyer who could surely arrange for bail:

> We consider you our Comon Father and we all look up to you for, and in behalf of Mr Platt whose Case calls on all america to se Justice done to a Inocent young man now Lying in Irons in Newgate for no other Crime than being Born in america . . . Let England see you atend to the Rights of all us american who are now under the opresion of warr or the tyrony of those Ignorant men that believe thir is none to help, and are not afraid to opress all who have the misfortune to fall in their way. Tyrants are also Cowards. They are Cowards and a letter from you would Relieve and Comfort us — you are now the most happy Instrument and cane save Both Contrys by your wisdom and Power. . . .

She adds a postscript for three men who may have been visiting the waxwork at the time:

Majr Carteat
Doctr Price } all Send their hearty love &c[31]
Major Labiliere

Of the three, only the Reverend Dr. Richard Price was an old friend of Franklin. His *Observations on Civil Liberty and the Justice and Policy of the War with America* had just appeared. He had long been prominent among the liberal intellectuals, first introduced into their circle by Elizabeth Montagu. He stressed

ethical values, and looked to the Americans for a great renewal of English moral fibre. His warning of an apocalyptic doom brought on by luxury and the decay of British liberties had an affinity with Mrs. Wright's more emphatic inspiration.

Major John Cartwright's long political career had begun too late for a close relationship with Franklin, though they would have been wholly congenial. He was a sturdy, practical reformer, a Nottinghamshire man, brother of Edmund Cartwright, inventor of the power loom. He had served in the Navy, as a magistrate in Newfoundland, and in the English militia. In 1774 he had published *American Independence the Glory and Interest of Great Britain,* and in 1776, *Take Your Choice,* a manifesto for universal suffrage and regularly re-elected Parliaments, the cause that would become his life work.

In contrast, Major Peter Labilliere stands firmly upon the lunatic fringe. The scion of an ancient Huguenot family, he had once been a spruce officer of marines. The old Duke of Devonshire had found pleasure in his company and had settled a small pension on him. A disappointment in love had changed his life, leading to the decisive moment at which, in his own phrase, he had "commenced Patriot."[32] He became a disciple of Cartwright as well as of earlier writers such as Hugh Blair, Sidney, Locke, William Penn, and John Mason, author of *Self-knowledge,* a treatise which enjoyed a popularity similar to Thomas Tryon's works. He wrote letters to the press. His pamphlets had few readers, but early in this career he had been able to gain access to the soldiers in barracks, whom he exhorted not to take up arms against their American brethren. His "seven hundred" followers were probably soldiers who had been in some vague way so pledged.[33] He may well have been the author of that broadsheet signed "An Old Soldier," which William Lee had been distributing in the spring of 1775, and at the time of Stephen Sayre's arrest in the fall of that year he had been accused of spending £1,500 to hire a force of fighting men to carry out the seizure of the Tower and the King.[34] This was a reckless charge indeed, and it savors of an effort to show that only bribery could induce men to be accomplices in treason. It does argue, how-

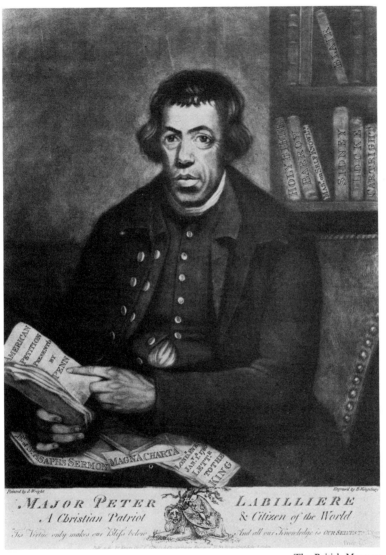

MAJOR PETER LABILLIERE

"Christian Patriot and Citizen of the World," painted by Joseph
Wright. Mezzotint by H. Kingsbury, December 1, 1780.

"DR. VIPER"

Captain Philip Thicknesse in a relaxed mood, painted by Francis
Hayman, an artist with a matching love of adventure.

ever, that Labilliere must have had supporters of some sort in considerable numbers. Again, the fact that in 1780 young Joseph Wright's portrait of him was engraved in mezzotint and on sale in the print shops points to a popular following.

The Major felt that "a dirty shabby appearance" was the best uniform in which to promulgate liberal principles. As time went on he would become increasingly forlorn and unsettled in his mind. His most enduring fame would come at his death in 1800 when, by his own directive, he was buried on Box Hill in a perpendicular position, head downward. He was leaving a topsy-turvy world but, in this way, when it righted he would be on his feet again.

But what of Patience Wright's "congregation," those "nere five hundred" souls? The word itself implies some sort of regular assembly. Public meetings were becoming a commonplace of English life. It was also commonplace for political leaders to have their own nonvoting cohorts. These were generally rough-and-tumble bully boys, but there were also peacefully demonstrating pressure groups such as is here implied. If Mrs. Wright's "five hundred" met together, it could have been in the "Great Room" of John Greenwood the auctioneer, used later by Lord George Gordon's Protestant Association in the build-up to the great riots of 1780.[35] Greenwood had a background of adventure from Boston to Surinam to Holland and to London, where now his business, like Patience's art, brought him into touch with all classes. Benjamin West, an old friend, came to him in search of bargains, and found them.[36] A memorial print engraved at the time of his death is inscribed, "The Friendly Mr. Jno. Greenwood."[37]

In the meantime there had been silence from France, and Mrs. Wright, as the only link between this formidable array in London and her great friend over Channel, was not bearing it well. It implied doubt, distrust, and her next letter dealt with that. A French lady and gentleman had stepped into the waxwork and offered to carry a message on their return. Polly Wilkes had been there and had helped with the language barrier. Patience flew to quill and ink:

London Pall-mall Nov 10th 1777

Honord Sir /

As much depends on seartain and Early Inteligence I send you a Copy of the letter sent out to the ministeriel myrmedons about the meeting of Parlement —

"Sir you are requested to attend at the Cockpit on Wendsday at 7 oclok being the nineteenth Instant." Notwithstanding the Circulating letter the Runners [were] orded to say the parlement will not meett until more Explicit acount comes from Ld How, by a vesel sent for that purpose to bring Inteligens &c.[38] This deception has gave meney of the wise English membir to go on ther pleasures, some one way some to ther Contry seats, that by this means only about 50 membir will attend at the Cockpit nor be ready at the House to apose the renewal of the acursed act that keeps poor Platt confind in Newgate with other of our Contry men — For god Sake and for the Honor of human Nature dont suffer Ld Stormont or any other tools in power to prevent that exchange of prisoners that you so nobly and honourable did perpose to him — The people of England now are caut in ther own net. Pray Have mercy on them — Shew them that America is Blessd with wisdom, Power, mercy and those godlike atributes that will convince the whole world it is better to joyne them — A number of men of fortune are getting their afairs Ready to Embark to America to bye land and settle ther.

I the moment have had the favr of a visit, a french gentlman and Lady who Informd me pr a Interpreter that they would be much Pleasd to Carry a lette to doctr Frankling — At the same time Miss Wilks Desird that I would send her Fathers most hearty wishis and a ofer of his best services to go to america if he could serve the glorous Cause of human nature — which is now in destress. Ms Wilks presents her respectful complents to the doctr and wishes this Hint to be laid before Ms Wright's friend now in France — *and will be very glad to have an anser.*

Ther is a Number of worthy young men now waiting and looking out to serve ther Contry.

My not having the pleasur of a line from any of my honourable Contrymen, now in France gives me no small mortification, as I say with truth my asistanc has been more matereal than they can possable Imagine — but TIME the great unfolder of Secrets will set my condoct in a Light that will make it a favour to corospond with P. Wright

This is the 5th letter I have wrot to dr Frankling and many other to mr Seayer, Banckroft &c.

none of which I have recd any anser

Mrs Wrights most respectful complents to dr Frankling and hopes he is well, and most humbly begs some directions how to proceed concerning mr Platt as his situation is now dredful. He has no money. He will very soon suffer. His letters to america are not yet ansered. His friends in London have not in ther power to aid him. Some hundreds are now in the greatest Poverty.[39]

The governor of Newgate, urged by John Wilkes to strike off the young man's irons, protested politely to the prisoner that he would incur the enmity of others by doing so. "I cannot but think his excuse rather frivolous," Ebenezer wrote to Wilkes, July 23, "though I acknowledge his treatment to me in other respects has been very Genteel."[40] In August the Georgia delegates in Congress secured a resolution that the commissioners in Paris advance money for Platt's relief and demand his inclusion in an exchange of prisoners.[41] But Franklin meanwhile had sent money, apparently from his own purse. He was always responsive to old friends, always moved by the appeal of a woman in love; Platt's case had a part in giving the plight of the prisoners a central place in his diplomacy.[42] Mrs. Wright acknowledged his aid, though belated and lacking the threats of reprisal she had wanted, in a cool note from Bath, December 23, 1777:

To the Right Honorble Dr B: Franklin
 at Passy near Paris
 The barer of this is mr. George Searle at whos request I gave him this your address. He is the Person that has advanced the twenty guineas for my Bill on your other late drawn for the use of mr Platt and is otherways our good

Friend, and I have once more the honour to subscribe my-
self your honours

> most obligd humble servant
> Patience Wright[43]

Already, in London, the Whigs of the opposition had taken
up the cause of the prisoners as a humanitarian effort that might
smooth the way toward British-American reconciliation. At a
meeting on December 24, £3,700 was raised, with Wilkes the
leading contributor.[44] Accounts of the fund were published
regularly in the papers thereafter, but with Ebenezer Smith
Platt, recipient of "cloathing, subsistence and necessaries," the
only beneficiary named.[45] Franklin had reinforced the work
with American public money, and sent the mysterious Major
John Thornton to England as his agent in the prisoners' be-
half.[46] Ebenezer, released at long last in March 1778, was mar-
ried to Betsy and the two set out for home by way of France,
where Franklin gave them his blessing and further aid.[47] They
appear next at Philadelphia, petitioning Congress for help,
March 6, 1780, and, we may assume, warmly welcomed by their
Aunt Rachel Wells.

The story of the prisoners goes on, but clouded in mystery.
Formal exchanges met little success, but escapes proved easy and
frequent. Given clothes and money, the fugitives could pass as
English and find their way to France. English friends of Franklin
helped them, one supplying as many as forty in a single week.[48]
Mrs. Wright was in a conspicuous position that would have
drawn them to her, yet would have posed dangers as well. That
they came is attested in an obituary note in New York, 1786,
with information that must have come from Betsy or Joe —
"Those brave fellows, who during the late war were fortunate
enough to escape from the arms of tyranny and take sanctuary
under her roof, will join us in lamenting her loss."[49]

A Guardian Angel Laid Away

FROM Aunt Rachel's, Elizabeth Platt would begin her brief career as an independent waxwork artist of America. Mrs. Wells herself, with her gift for histrionic subjects, can be seen at this time through the eyes of John Adams, a careful observer. He had visited her rooms in company with a New Hampshire Congressman and wrote home about it to Abigail, May 10, 1777:

> The Day before Yesterday, I took a Walk, with my Friend Whipple to Mrs. Wells's, the Sister of the famous Mrs. Wright, to see her Waxwork. She has two Chambers filled with it. In one, the Parable of the Prodigal Son, is represented. The Prodigal is prostrate on his knees, before his Father, whose Joy, and Grief, and Compassion all appear in his Eyes and Face, struggling with each other. A servant Maid, at the Fathers command, is pulling down from a Closet Shelf, the choicest Robes, to cloath the Prodigal, who is all in Rags. At an outward Door, in a Corner of the Room stands the elder Brother, chagrined at this Festivity, a Servant coaxing him to come in. A large Number of Guests, are placed round the Room. In another Chamber, are the Figures of Chatham, Franklin, Sawbridge, Mrs. Maccaulay, and several others. At a Corner is a Miser, sitting at his Table, weighing his Gold, his Bag upon one Side of the Table, and a Thief behind him, endeavoring to pilfer the Bag.
>
> There is Genius, as well as Taste and Art, discovered in this Exhibition: But I must confess, the whole Scaene was

disagreable to me. The Imitation of Life was too faint, and I seemed to be walking among a Group of Corps's, standing, sitting, and walking, laughing, singing, crying, and weeping. This Art I think will make but little Progress in the World.

Another Historical Piece I forgot, which is Elisha, restoring to Life the Shunamite's Son. The Joy of the Mother, upon Discerning the first Symptoms of Life in the Child, is pretty strongly expressed.

Dr. Chevot's Waxwork, in which all the various Parts of the human Body are represented, for the Benefit of young Students in Anatomy . . . were much more pleasing to me. Wax is much fitter to represent dead Bodies, than living ones.[1]

Rachel had fused her religious feeling and her art in a way quite different from her sister. *Elisha Restoring to Life the Shunammite's Son* was a subject painted by Benjamin West, and she may have borrowed the composition from a copy which her neighbor, Charles Willson Peale, had brought back from London. The only portraits named by Adams had been sent over by Patience. All had been made by 1774, and this suggests that the wax heads with messages for Congress concealed inside had ceased to come after open hostilities began. Otherwise, Lord Effingham's, 1776, would have been there, and the fact would appear also in Rachel's statement citing only "Hancock & others of our oldest members" as those who had praised the sender's information.[2] This, again, makes it unlikely that wax heads with hidden messages came to Robert Townsend of the "Culper Ring," flitting in and out of New York from Oyster Bay. We do not know whether a waxwork continued at 100 Queen Street, though Betsy Platt would be there with one after the peace. Mrs. Wright, moreover, was too busily occupied with nearer matters. Even as Mr. Adams was observing Mrs. Wells' handiwork with a critical eye, she on the other side of the ocean was conspiring to rob her royal enemy of another victim. "To shame the English king," as she later affirmed, "I would go to any trouble and expense."[3]

Her trips to Newgate in behalf of Ebenezer Platt had brought her suddenly close to an even more pitiable prisoner, one for whom she could make no appeal to powerful friends, for his fate lay in the hands of the King alone. In January 1777, the Reverend Dr. William Dodd had attempted to defraud his former pupil, the Earl of Chesterfield, of a large sum by forging his name to a bond. Brought to trial on February 2, he was condemned to death. The Chaplain to the King and author of *The Beauties of Shakespeare* had been in trouble before. An attempt to get the rich living of St. George's, Hanover Square, by bribery had brought him into temporary disgrace in 1774. Foote's comedy, *The Cozzeners,* had lampooned him as "Dr. Simony," and the tag had stuck. He was an ecclesiastical dandy, a writer of flippant light verse, and yet at the same time a preacher of great emotional power. Now respectable London householders, twenty-three thousand of them, signed a petition in his favor. A great wave of sympathy flowed up to the throne itself. After all, Dodd had returned most of the money, and had embezzled it only in order to publish a de luxe edition of Shakespeare, to illustrate which he had been recruiting artists in France. Queen Charlotte, to whom he had dedicated his private chapel as if to a saint, was in tears. But the King, never a man to yield to popular clamor, withheld his pardon.[4]

Dr. Samuel Johnson became the most eminent spokesman for Dodd, though the two had always disliked each other. But Philip Thicknesse, Foote's "Dr. Viper," was the most resourceful. He had recently returned from a tour abroad, where he had been one of the first to welcome Franklin to Paris — simultaneously pledging allegiance to the American cause and soliciting a subscription to his forthcoming book of travel.[5] Literary annalist John Nichols assures us that "Mr. Thicknesse was a man of probity and honour, whose heart and purse were always open to the unfortunate. None were his enemies, but those who were unworthy of being his friends; for he was as severe in his censure of the infamous, as he was friendly to virtue and merit."[6]

To Captain Thicknesse, with his sharp eye for virtue and merit, Mrs. Wright was "a crazy-pated genius." They became

friends and collaborators in a rescue of Dodd. For Patience it was a chance to trump the King and settle a score with Isaac Akerman, Governor of Newgate, who had refused to remove Platt's chains but had done that and more for Dodd. She had ready her wax head of Dodd, the kindly clergyman who had preached so touchingly in support of Hanway's and Dingley's Magdalen Hospital for fallen women. Yet authorities agree that it was Thicknesse who first hatched the plan — though in his account of the affair, published soon after Mrs. Wright's death, he lays the whole of it at her door — while at the same time quoting contrary evidence in the condemned man's anguished note of thanks to himself. He had known Dodd far longer than she, and had been one of those "trusty" friends among whom the Doctor found social relaxation. Furthermore, when Thicknesse had been in prison for his famous "wooden gun" libel on Lord Orwell, Dodd had visited him there and tried to straighten the matter out. The Lieutenant Governor of the Landguard Fort would now visit Dodd and, if it could be done, spring him free.

The *Memoirs and Anecdotes of Philip Thicknesse, late Lieutenant Governor of the Land Guard Fort and Unfortunately Father to George Touchet, Baron Audley,* London, printed for the author in two small volumes, 1788, is not so much an autobiography as a series of personal "Anecdotes" by a ready-tongued raconteur, written out very much as he was in the habit of telling them. From the "ANECDOTE Of Dr. DODD" we learn:

> Dodd was an excellent companion, when he fell into such company (as he called it) whom he *could trust,* and I have heard him, after making all the old women cry at church in the morning, make his *trusty friends* laugh, as much in the evening by singing a song, of Adam and Eve going a journey, *and stopping in the land of nod, to have their horses shod,* a matter more excusable, in my opinion, than that of him and his wife dining *tete a tete,* at one tavern, in the most voluptuous manner, and supping in the same style, on the same day at another! but which I am assured they frequently

did. . . . Mrs. Wright, the wax modeller (a crazy-pated genius) modelled his head, as she informed me, and carried it to him under her pettycoats, in order to favor his escape by the use of it; a thing certainly (as he was circumstanced) not impracticable. His room was large and long, the fire was at the further end of it, and the entrance door opposite to it, at his fire side stood a large table covered with books, on a carpet; now as he was without irons, had eight or ten of his friends came in one after the other, so as to have all gone out together, he might possibly have gone with them, if he had dressed up a figure in his night gown, with Mrs. *Wright's head thereon,* for his keeper only appeared at the door when he rung the bell, & then, seeing his figure sitting at the table with his hat flapped, and his head reclined, he would not have regarded the number who went *out,* being *sure* he left his prisoner safe *within,* she said, Dodd had not courage to attempt it, nor am I clear she had resolution sufficient to have assisted him . . .[7]

But here the narrator is disingenuous and self-protective, for he had already admitted giving Dodd "advice not such as a *rational man* would have given," and receiving this pathetic reply:

> Dear Sir,
> I am *just at present* not very well & incapable of judging. I shall communicate your kind paper to my friends, my brother will be at Mrs. Porter's this evening; many thanks for your attention, — I rather think it would *do hurt* and be deemed a mob.
>
> <div align="right">Your's in great misery,
W.D.[8]</div>

So Dodd went to the gallows, June 27, 1777. Hapless efforts to save him persisted to the last. It is said that he had been equipped with a metal tube to enable him to breathe in spite of the strangling rope, that a heated carriage had been waiting to rush him to Dr. Percivall Pott for resuscitation — a story that carries us back to Dr. Chovet of the anatomical waxwork in Philadelphia. He, as a young practitioner in London, had pre-

pared such a device for a convict of his acquaintance, but the trick was exposed and Chovet, it was said, banished to the colonies as a result.[9] So often, wax and waggery have gone hand in hand. Another report tells of a wax figure that was to have been hanged instead of the clergyman.[10]

But all in vain. Dodd died, and the two conspirators next appear at the healing waters of Bath, where Thicknesse settled down to compose his *New Prose Bath Guide,* praising the talents and art of Mrs. Wright and according her a front place among the famous personalities of the town. There, as a result of having elsewhere in the *Guide* "told some tales out of school," he was swept away into other concerns — last seen trying to laugh away the threats of an angry mob surging around his door.[11]

With Platt free and Dodd as one more proof of royal malevolence, Patience remained, a Deborah in Israel. She must bring Franklin into London for the great fulfillment. July 1777 had gone by, but the dream was still intact. We can see it as a sort of magic-mirror image of an idea that existed in other, less impetuous minds. It was at this time that Horace Walpole touched on something much the same in a letter to his poet friend, William Mason. He had been contemplating "the flagrancy of a civil war" (as many Englishmen still regarded the effort to subdue America) and the worsening fortunes of the crown:

> The constitution might recover, the nation cannot: but though its enemies have miscarried in their attacks on the former, is there sense or virtue enough left to restore it, though the assailants have displayed such wretched despicable incapacity? unless sudden inspiration should seize the whole island and make it with one voice invite Dr. Franklin to come over and new-model the government, it will crumble away in the hands that still hold it.[12]

This was precisely the inspiration of Mrs. Wright. More — Franklin was now responding to letters from the waxwork. Warmed and thrilled, she opened her heart. Aware, perhaps, that she was not her persuasive best on paper, she began to think of crossing the Channel to press the issue face to

face, still faithfully determined "to Bring about the grand and most Extrordary Revolutions by the most unlikely means."

Pall mall waxwork
March 29th 177[8]

Honoured Sir

as Mr Platts historey, his marriage to my daughter and their return to america is already been Laid before you for your councill, assistance &c. The most sincer gratitude to god for making You the garduin angel of us, who are so far from our native Contry, notwithstanding I meet with the greatest politeness and sevility from the people of England yet, the distress which is already come and must follow to this once *great littel* Island gives me such pain I cannot content myself to Behold any more. I began with the Boston Port Bill and I have traveld through all the *difirent* ways of provdenc to Bring about the grand and most Extrordary Revolutions by the most unlikely means. That I now belive that all my romantick Education Joynd with my father old Lovells courage can be servisable yet farther to Bring on the glorious cause of sivil and religious Liberty. 5 years agoe I drempt a Dream Concerning Doctr Frankling. I wrote down sd Dream and told numer now ready today that all those wonderful Events would happen and as only one half is yet come to Pass I most solomly believe I shall live to see the other Part Compleated — Your Publick Entry to the Court of France is a prelude to the same honour done you at the Court of London with the addition of being the glorious delivrer &c. When the good god who govorns the world and rules in the heart of princes he raises up a Frankling to do his great work and that america should be honoured with her son Benjamin the youngest of his Fathers Famaly and the man whome I have been taught to look on with the highest hopes to my Contry. It has made me determind to make you a visit to take your Bosto to send to the Empror of germany, the Queen France and othr such Likeness as you shall aprove. Words cannot Express the honour your lettr

has done me, wherin you say you love me as well as ever which is saying mrs Wright has the Friendship of the greatest man in the whole World and her study has and shall be to deserve it by a faithful Eye to his honor and her Contry by paying due honour to the now great philosophe doctr Frankling, acknowledgd so by all the known Christian People.

I Intend seting out for France as soon as the *Hurly Burly* begins which must happen by mid sumer.

I shall bring some of my performanc with me and
 From the same old Patience Wright
The great love and Confidence I have in you joynd to my honest Intention to serve my Contry is a sufficient apology for this plain old Fashion Lettr from a good woman to the wisest man. My knowled[g]e of the false and shameful use of Polite Corespondanc givs me the boldness to write you from my heart
 and to tell you I am your Very humble
 and faithful servt.
remember the Faithful in times of troubel and the women in all ages have been found [in] Corospondanc very useful. Irland love you —— I have wrote to our old Friends this day. They are well, pr letter from a Admeral.[13]

In her thought of a "Bosto to send to the Empror of germany," Patience joined others who were spreading Franklin's likeness everywhere, shining the light of his benign diplomacy. He himself had noted at this time, with a touch of vanity, that his bas-relief portrait had gone by her request to the Empress Catherine of Russia, and news of that may have reached Mrs. Wright as well. Her plan to send the bust may have been suggested by William Lee, and certainly through Lee would reach its royal mark. He had been appointed by Congress commissioner to the courts of Berlin and Vienna, and was now on the Continent with Stephen Sayre as his secretary. By what means this pair was keeping in touch with the waxwork we do not know. Their adventures and misadventures would be many. Sayre was even thinking of making an informal mission of his

PATIENCE WRIGHT TO BENJAMIN FRANKLIN, MARCH 29, 1778

Predicting "most solomly" that "Your Publick Entry to the Court of France is a prelude to the same honour done you at the Court of London with the addition of being the Glorious delivrer &c."

"THE INVISIBLE JUNTO"

Political caricature of 1780 dedicated to Lord George Gordon and possibly, on the basis of theme and style, designed by Mrs. Wright and etched by John Williams ("Anthony Pasquin").

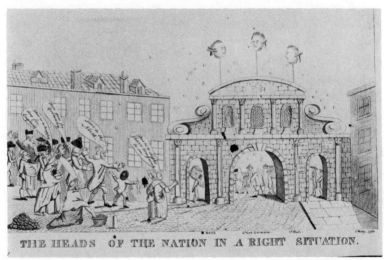

THE "RIGHT" SITUATION

Political caricature, May 1, 1780, attributed to John Williams, who was at the time apprenticed to the publisher, Matthew Darly. Mrs. Wright stands in left foreground, exclaiming, "This is a sight I have long wish to see."

own to St. Petersburg, having heard of the Empress's weakness for handsome men.[14] He was constantly in touch with Franklin and — Heaven knows — that idea of a portrait of Franklin for Catherine the Great may have been of his concoction.

Mrs. Wright seems never to have made a clear distinction between Frederick the Great and Joseph II — both "Germans," and that was that. The scene around her had changed. The clamorous activity of the American group in London had ended. Many had vanished, serving either Congress or the crown. She had less direct advice, more enemies, and fewer friends. American sympathizers spoke rarely, and with caution. Only she continued as before her bold, outrageous assertion that "dear America" could never be brought to heel, try as they would. This, to most Britons, was manifest absurdity — but then, into the stillness around her, came the news of Burgoyne's surrender of his army.

In Parliament Colonel Barré sneered at the failure of a plan of campaign "unworthy of a British minister and rather too absurd for an Indian chief."[15] Paris had had the news two days after London, December 4, 1777. Catharine Macaulay was there, but sent only a short note to Franklin, fearful of arrest on her return if she called.[16] Lord North dashed off orders to Paris to temporize by negotiation before the French could act. From Paris Franklin sent Jonathan Loring Austin, who had brought him the news of Saratoga, to consult with members of the Parliamentary opposition. Was the ministry in crisis? Would Lord Chatham at last take power? Even so, these two guardian angels would now have been hard put to it to agree. Pitt was adamant on the preservation of the empire he had created, and Franklin strongly committed to independence.

Franklin, Deane, and Arthur Lee set their signatures to the treaty with France on February 6, 1778. Two months later, in the House of Lords, Chatham made his last plea for such a peace as the Americans would have accepted readily before. Speech unfinished, he fell back into the arms of his friends, mortally stricken. It was a startling, strangely tragic moment, the thin figure in its scarlet robes a symbol of an ideal that would not surrender and could not go on. At his home on May 11, he

asked his son, another William Pitt, to read aloud to him from the Iliad the lines on the death of Hector. Later that day he died, his last words, "O! Save my country!"[17]

But for the disapproval of the King, the House of Lords would have attended his funeral in a body, and even then the motion lost by only one vote. His Majesty regarded the public obsequies and the monument in Westminster Abbey as "rather offensive to me personally."[18] He was greatly relieved, however, that an administration headed by Chatham had been averted, and that the war could go on under his personal guidance through Lord North. Chatham had been too long identified with the Englishman's personal and public liberties for any royal favor, even in death. The funeral, June 9, 1778, with all its pomp, was an opposition affair. Colonel Barré strode near the head of the procession, and very few of the courtiers were behind him. Horace Walpole saw it rightly as the end of an epoch. It drew a sharp line, he said, between the days of prosperity and of adversity.[19] The ideal of Chatham had passed from the plans of practical men and into the world of dreamers. Patience Wright saw this guardian angel laid away. She herself had a part in the ritual, and she herself was prepared to carry on.

In the great state funerals of the past, a life-size effigy of king or queen had been carried on the bier, and these preserved in the Abbey crypt as mementoes of departed worth. The custom was revived for Chatham. No effigy was carried in the procession, but one would be placed in the Abbey afterward to hold, for all who came by, a sense of the living presence of the Great Commoner. Whatever might be seen in grandiose marble in the nave would be matched, in the Chantry of the Chapel of St. John the Baptist, by this other and nearer recollection.

The wax figure, in the scarlet robes of a peer, was placed in the Chapel in 1779. It was Patience Wright's only public commission as an artist, and an acclaimed work from that day to ours. David Henry in his *Historical Description*, first published in 1783, describes the Abbey figures of Queen Elizabeth, William and Mary, and Queen Anne in their coronation robes, and then goes on:

But what eclipses the brilliancy of those effigies, is the admirable figure of the great Earl of Chatham in his parliamentary robes, lately introduced at a considerable expence. It so well represents the original, that there is nothing wanting but real life; for it seems to speak as you approach it. The eagerness of the connoisseurs and foreign artists to see this figure, and the satisfaction it affords them, justly places it among the first of the kind ever seen in this or any other country.[20]

After more than a century and a half, all the figures were cleaned under the supervision of the Victoria and Albert Museum. They were studied in detail both as portraiture and as examples of historical costume. Lawrence E. Tanner, Keeper of the Muniments and Library of the Abbey, reported the results in 1935. The figure of Chatham stood in the pose of an orator, a scroll of paper in the right hand. It was five feet eleven inches in height, but seemed smaller, stooping forward as Chatham, ill and seventy years of age, had done.

> The modelling of the face is most remarkable. The "eagle face," as Macaulay called it, with the prominent nose, sensitive and even humorous lips, and those magical eyes which no one could face when he was angry, are rendered with a skill which makes the effigy extraordinarily alive and impressive. It is, indeed, a masterly representation of the great Chatham, and perhaps comes nearer to the man himself than any of the existing portraits.

Tanner had compared the wax to the death mask of the Earl, and had found the resemblance "most striking and convincing." The hands, too, were remarkably realistic, "veined and tinted by coloured underslips, and with hairs on the surface." His technical description of the figure reveals to us how the people of the waxwork were put together:

> The head of wax is attached to the shoulders by cardboard strips. The trunk of wood has been cut and lengthened at the waistline; the shoulders are pieced out

with softened cardboard (set in glue) of papier-mâché consistency. The left leg is in one piece with the trunk, the right leg has been cut and turned outwards, and the thigh made up with small pieces of wood, held by string. The upper arms are carved to match the trunk to which they are fixed by large screws, but the forearms are of cardboard, glue, etc. The body is supported at the back by an iron which fastens to a wing screw in a cavity in the trunk.

As to the costume, the parliamentary robe is of the period, and according to tradition the one worn by the Earl at his last oration to the Lords. It is of red wool lined with silk and decorated with three wide horizontal stripes of gilt braid, headed with fur. The right side is open to the shoulder, the left looped up with black silk ribbon. The neck has white ribbon ties and a trimming of rabbit fur. There is a small turn-down collar at the back, and a small pointed hood. The personal dress is part genuine, part simulated — a coat of purple silk velvet, waistcoat and waistcoat sleeves of green watered silk, white linen shirt with sleeve ruffles of bobbin lace, linen stock, strips of black cloth to simulate breeches, white stockings with small figured clocks, black leather shoes with gilt buckles, and a curled wig of the period. Some of the pieces have been stiffened by mounting on paper, and on one of these the name "Miss Wright" appears, pointing to Phoebe as having had a share in this part of the work.[21]

Now it would be Phoebe's turn to take center stage. Young love had come to Elizabeth in from the perilous seas, and vanished with her out onto them again. Pretty Phoebe in love, young Joe in art, their mother her old bold indomitable self, would bring raised eyebrows and alarmed attention upon the waxwork as never before. The great Earl, the Great Commoner, the "gaurdin angel," William Pitt, with whom this mad course of intrigue had begun, was no more. But in his stead, not far away, Ben Franklin shone. Only Ben Franklin now could fulfill that dream of peace and glory for England and America.

Family Affairs

SAMUEL PERCY now dominated the field of portrait sculpture in wax — all small profiles, a guinea plain, a guinea and a half in colors. He had patrons by the hundred.[1] Few, if any, wanted likenesses life-size at fifty guineas. Patience Wright was famous still, perhaps more so than ever, but the waxwork was touched by desperation and danger. Graying, vigorous, voluble under the darkening clouds, she would age rapidly and die prematurely old. But a woman in her fifties is attracted to the young, and so were they to her. Youth, unruly, laughing, and assured, marks the waxwork of the war years. Phoebe and Joe are there, with young friends around them. Children are rather more ready to judge a conventional parent as eccentric than one who is filling their lives with an excitement of bold words and deeds, allies and enemies. Here were famous names, secret meetings and messages, envoys hurrying to and fro, long absences unexplained, long entries scratched into the "Jurnal of material Events," a gaudy mystery and peril in it all.

The young people could feel the gallantry of it, read truth in the garrulous self-importance. Joe, a carefree twenty-two, and Phoebe, seventeen, could take pride in a mother at war with the rulers of the nation and enjoy the éclat it brought them in their circle of young friends. One of the youngest, but a long-time habitué of the household, was John Williams, at seventeen a bright and bitter lad. He had left the Merchant Tailors' School after being punished for writing an epigram on one of the masters, and had then been apprenticed to Matthew Darly, engraver and painter of wall decorations.[2] Darly had engraved the furni-

ture designs for Chippendale's book, but is best remembered for his deft and pleasant caricature prints. He was a publisher too, and his shop window panes at 39 the Strand were filled with political satire and comic pictures — something much to young John Williams' taste, and Mrs. Wright the same. Yet the boy's métier was really the printed word, and he was headed toward a small place in English literature as "Anthony Pasquin," one of the most vitriolic and hated critics of England, of Ireland, and finally of America, where he ended his days.

For about three years now Patience had been making use of his facility with the pen in her far-flung correspondence. This comes out in a footnote to the sketch of John Hoppner in Pasquin's *Memoirs of the Royal Academicians*, 1796, where he praises Mrs. Wright's "strong and masculine understanding," and notes that "her house became the rendezvous for the Legislator and the Artist, and there I have often conversed with the late Lord Camden, Doctor Franklin, Mr. Garrick, Samuel Foote, Dr. Dodd, Mr. West, Silas Deane, &c." These names cover a range from 1775 to 1785 — and he adds:

> During the American War I wrote many letters to Mr. Hancock, Mr. Adams, &c. at the express desire and suggestions of this Lady, who maintained a correspondence, through me with the Chiefs of the Congress.[3]

Pretty Phoebe had a friend in Juliet Cozens, daughter of Alexander and sister of John Robert Cozens, imaginative landscape painters. Alexander was universally believed to be a natural son of Peter the Great. He was a teacher of art, and the Prince of Wales, later George IV, became one of his pupils. Juliet eventually compounded this lustre of noble blood by marrying Charles Roberts, claimant to an illegitimate connection with the Earls of Radnor.[4] Such pretensions fitted easily into the unreality of the waxwork world, and there was another with a glitter and promise all its own.

Phoebe, as Benjamin West's model for nymphs and shepherdesses, and Joe in the Royal Academy classes, had come to know the handsome art student, John Hoppner.[5] Of course

Patience, who missed no gossip, knew that he was widely believed to be an illegitimate son of the then reigning King of England.[6] As to her opinion in the matter, we only know that he was received into her home with favor, and no prejudice of parentage held against him.

Hoppner was the son of a waiting woman at court, and bore the name of a "German surgeon" who has never been identified. His mother was English, to judge by her given name, Mary Anne. The putative father was a twenty-year-old prince, held in seclusion at his mother's court, painfully amorous yet even more painfully eager to ascend the throne unencumbered by scandals such as had marked his grandfather's reign. The search for a queen followed Hoppner's birth, bringing at last the homely and dutiful Charlotte, who mothered his enormous family. John Hoppner was remembered by courtiers as a pretty child toddling about the Palace corridors, smilingly petted as "a little chance person."[7] He became a chorister at the Chapel Royal, and when his voice changed was entered at the Royal Academy. His mother had then been sent into the country, after accepting a bribe to use her influence with the King,[8] and he was living in the family of John Chamberlain, one of the royal pages who later became keeper of the King's medals and drawings. Benjamin West stood in an avuncular role, responding to his royal patron's interest in Hoppner's welfare and seemingly unaware of the complications that might follow from association with his other friends and protégés, the antimonarchical Wrights of Pall Mall.

In the public mind Mrs. Wright was still of one piece with Mrs. Macaulay — two antimonarchical women of the arts, in politics each with a religious zeal of her own. But what a contrast! One a free spirit, the other bound. Poor Catharine had been held impounded, frozen on a pedestal no less than the marble statue of her as Clio, Muse of History, which her aging admirer Dr. Thomas Wilson had set up under the domed rotunda of his London church. At Bath she lived like a vestal enshrined in Alfred House, Dr. Wilson's gift.[9] She had reached the age of forty-seven, a lined face heavily rouged and eyes

unlighted by any prospect of escape. Patience, young family around her, was out and about as she pleased, blustering and vociferous, taking hold of other lives in her bluff way, taking whole peoples into her warmly covert or boldly open protection, while "Kitty," as John Wilkes called her, ailing, discouraged, was alone among admirers.[10] Catharine, desperate, sought the advice of the fashionable Dr. James Graham, the "aerial physician" who had moved from London to Bath in 1777 with his "magnetic throne," electrified "celestial bed," and titillating lectures on subjects not discussed elsewhere in mixed company.[11]

In London, February 20, 1778, the *Morning Post* published a bit of caustic gossip blown in on the winds from Bath:

> Mrs. Wright the famous modeller in Wax, is here and we are informed that that lady, a native of America, Dr. Wilson, Mrs. Macaulay, and Dr. Graham — are to make a Partee Quaree to America early in the Spring, and that the Doctor proposes taking over Mrs. Macaulay's statue to be located on the very spot where Gen. Burgoyne piled his arms.

Outraged worshippers had been demanding the removal of the statue from Dr. Wilson's church.[12] As for Patience, she was riding high in that spring and summer at Bath — plays, the pump-room crowds, Mrs. Montagu and Mrs. Carter, Dr. Thomas Bowdler (like Dr. Dodd a popularizer of Shakespeare) and so many more, with endless gossip, artists, novel attractions. The only other waxwork to be seen there reproduced the severed head and right hand of Count Struensee, who had paid thus for being the Queen of Denmark's lover.[13] Macaulay went on her lonely way through all this and all that year until December. Then, as the news flashed over the nation, all the jubilant laughter of her enemies was turned upon her. She had married the famous quack doctor's younger brother, William Graham, aged twenty-one.[14] They made merry, too, at Dr. Wilson's grief and rage. The *Morning Chronicle* reported that she had written him an apology of sixteen pages — "She laments the impossibility, from the Doctor's age and infirmities, of his sup-

plying her cravings."[15] The lovers fled to rural seclusion, where William took orders in the Church.

With Mrs. Macaulay's great prestige cut down, powerful forces moved against Mrs. Wright. The handsome, haughty Earl of Bute was behind them, as Charles Willson Peale heard the story from West:

> And in a conversation with Lord Bute on the subject of the war, she told him that it was impossible for them to conquer America. In short her conversation was so pointed in favor of our independence, that Mr. West advised her to be more cautious of what she said, otherwise he did not know what would be the consequence, as petticoats would not protect her. And soon after she found it necessary to leave London and she went to France.[16]

From Bute, beloved mentor of George's student days, had come that immobile sense of duty, the hatred of Chatham, the American policy, hardened like concrete in the monarch's stodgy mind. The warning would go from Bute to West to silence this other American artist. Obviously, Mrs. Wright paid no attention to it. But her situation was different now. England and France were at war. Franklin was recognized at the French court as sole envoy of an independent United States, and that put his friends in London in a new light. There were rumors of a French invasion of Britain in the making. It came to the ears of William Strahan that Polly Stevenson of Craven Street had had a letter from Franklin promising to call upon her soon.[17] With a foreign army at his back? By what means we do not know, but the Pall Mall rooms were closed. Mrs. Wright retreated to a refuge on Leicester Square and from there wrote to Passy of her plan for a return to America by way of France, as Betsy and Ebenezer had done. But she would linger in Paris, hoping to repeat there her London successes of 1772. Some Englishman of late, observing her multiple activities, had credited her not with genius but with genii, and she herself was wearing the tag with satisfaction. France would see her genii. She was resilient, undefeated, full of love.

Lysle House No. 4 facing Leste field
March 14, 1779

Dear Sir /

I have moved from Pall mall with the full Perpose of mind to settel my afair and get Ready for my Return to america.

I shall take France in my way and call at Parris where I hope to have the Pleaser of seeing my old american Friends — and take off some of your cappatal Bustos in wax. England will very soon be no longer a pattron for artists. The Ingeneous must flye to the Land of Peace & Liberty. As I intend to make good use of my time while I stay at Parris I shall be hapy to meet with the Same Encouragment as I have meet with in England, (at my first coming before the unfortunat war).

I shall be glad before I set out to have your opinion. I beg the favr of you to Recomend my Performans and as you Know my abilities in taking Likeness in wax work, I am hapy to have the Pleasing Prospect of doing your Recomendation Honor by my Best performans. It is with the Right gratitud to my Friends and Perticerly to you I owe the grat Encouragment my Jenei meet in London, and now come to France Improved and in high spirits.

with the most faithful
and afectanat Servt to Comand
I am Honord Sir
yr old Friend
P. Wright

"I long to see you
"and love you more then
"Ever if I dont write to
"you it is not for want of
"good will but for fear of
"being troubelson" —
would to god you would sind for me —
my services are worthy of the Pleneypotentorey of america.
For my gardien Spirit
The great Philosopher and american Agent.[18]

The quotation marks embracing those few lines opposite her signature seem to have been put there to give a sort of vocal

emphasis to her distress at having had no reply whatever to so many urgent appeals. He answered promptly now, eager to forestall her coming, his tone affectionate and his advice wise. The bantering humor in his letter tells something of the terms of their friendship at an earlier day.

Passy, May 4, 1779

Dear Madam,

I received your Favour of the 14th of March past, and, if you should continue in your Resolution of returning to America, thro' France, I shall certainly render you any of the little Services in my Power; but there are so many Difficulties at present in getting Passages from hence, particularly safe ones for Women, that methinks I should advise your Stay till more settled Times, and till a more frequent Intercourse is established.

As to the Exercise of your Art here, I am in doubt whether it would answer your Expectations. Here are two or three who profess it, and make a Show of their Works on the Boulevards; but it is not the Taste of Persons of Fashion to sit to these Artists for their Portraits; and both House Rent and Living at Paris are very expensive.

I thought that Friendship required I should acquaint you with these Circumstances; after which you will use your Discretion. I am, Dear Madam

Your most obedient and most humble Servant,

B. F.

P. S. My Grandson, whom you may remember when a little saucy Boy at School, being my Amanuensis in writing the within letter, has been diverting me with his Remarks. He conceives, that your Figures cannot be pack'd up without Damage from any thing you could fill the boxes with to keep them steady. He supposes, therefore, that you must put them into Post-chaises, two and two, which will make a long train upon the road, and be a very expensive Conveyance; but, as they will eat nothing at the Inns, you may the better afford it. When they come to Dover, he is sure they are so like Life and Nature, that the Master of the Pacquet will not receive them on board without Passes;

which you will do well therefore to take out from the Secretary's Office, before you leave London; where they will cost you *only* the modest Price of Two Guineas and Sixpence each, which you will pay without Grumbling, because you are sure the Money will never be employ'd against your Country. It will require, he says, five or six of the long wicker French Stage Coaches to carry them as Passengers from Calais to Paris, and at least two large ships with good Accomodations to convey them to America; where all the World will wonder at your Clemency to Lord N——; that, having it in your Power to hang, or send him to the Lighters, you had generously repriev'd him for Transportation.[19]

So Patience, driven from Pall Mall, remained nonetheless in London. The authorities, ready as they may have been to expedite her going, could not forcibly deport her. Nor would she, as Billy Franklin was surmising, have taken the waxwork with her. Phoebe and Joe would have stayed with that, adding the new pieces their mother would send from France and, later, America. A new home base had been found at Lysle House in Leicester Square, grand mansion of an earlier day now let out to various tenants. The Square was not too far from Pall Mall, an attractive expanse of grass and gravel walks with a gilt equestrian statue of George I as its central feature. Sir Joshua Reynolds lived on one side and John Singleton Copley's house was on the other, with Hogarth's nearby, his widow still living there. But Patience was looking for something better, and still nearer to her old stand. She soon found it, a house in Cockspur Street, Charing Cross, with rooms for the waxwork below and residence above, right in a bustling neighborhood precisely to her taste.

From this better vantage point she could now share in newly rising tides of political excitement. With the turn of the year 1779 to 1780, high taxes and hard times had brought the opposition out from the city and into national prominence. County associations, notably that to the north in Yorkshire, were being formed to protest ministerial corruption and extravagance along with the burdens of an unpopular and unsuccessful war.

In Ireland a mustering of "Volunteers," ostensibly for defense against invasion, was assuming political power. Patience would keep a sharp eye on Ireland, liking the mettle of the people there and seeing also an object lesson of the oppression America would suffer if she submitted to the crown. A national association had driven James II from his throne. More than ever now, that "Glorious Revolution" was recalled, and Patience Wright more than ever, as she put it, "faithfully Employd in doing all the good I can."[20]

The old Society of Supporters of the Bill of Rights — a Chatham-Sawbridge affair which had been featured in the New York papers in the days of the waxwork there[21] — was replaced in 1780 by Major John Cartwright's Society for Constitutional Information. Its appeal to objective intelligence apart from party labels and party heroes united the liberal intelligentsia. Its purpose was to revive and publicize an awareness of liberty as it had existed among "our Saxon forefathers." The membership, led by Cartwright and Sawbridge, marched through the streets of Westminster behind a blue flag inscribed in white, "ANNUAL PARLIAMENTS AND EQUAL REPRESENTATION."[22] It was bidding fair, as the Major declared in responding to the members' toast, "to become a constellation of genius and patriotism."[23] Dr. Jebb, cofounder of the Society and another whom Mrs. Wright counted among her friends, put forward his plan for a representative assembly of the nation so authentic in character that it might declare the venal House of Commons dissolved and itself assume that place.[24]

Here a confident, buoyant mind could see just such a rising as Mrs. Wright had predicted to John Dickinson in 1775. A Declaration of Independence had not been enough, but a prolonged war now threatening the Channel Islands, Ireland, Gibraltar, even the homeland itself, and above all the ruinous rise of debt and taxation, had brought Lord North's administration near to fumbling chaos and had brought Cartwright, Price, Jebb, the friends of peace and hopers for reunion, to the forefront of a near-revolutionary movement.[25]

Within that movement, Franklin was warmly remembered

as the apostle of thrifty management and uncorrupted democracy. Its enemies, alarmed, returned to their hope that Franklin could be bribed, persuaded, respond somehow to the idea of peaceful reunion. William Eden, back from America and the Carlisle Commission's unsuccessful attempt to negotiate there, asked to be sent to treat with Franklin, but the King would have none of it.[26] James Hutton, London bookseller who figures in Franklin's "Craven Street Gazette" and who had kept in touch, urging peace, went to Passy but got only a ringing condemnation of the war policy.[27] Frederick Hervey, Bishop of Derry, reported optimistically after an interview that he believed Franklin to be dissatisfied with Congress and with France and quite ready to "contribute to a reunion of the Empire."[28] William Strahan, ever persistent, wrote his friend of a rumor that John Adams was coming to London to seek terms, and "urged BF that it would be a dishonor to have that done by any but himself."[29]

Meanwhile, in the councils of the Yorkshire Association, William Mason, to whom Horace Walpole had tossed his suggestion that the island "with one voice invite Dr. Franklin to come over and new-model the government," added to its platform a warning that the power of the crown "may soon prove fatal to the liberties of this country."[30] Parliament, April 6, 1780, with forty county petitions before it, surprised all by its famous resolution declaring that "the influence of the crown had increased, was increasing, and ought to be diminished."

Women had participated in those county meetings. That Mrs. Wright was present as a not entirely welcome observer at York or elsewhere is credible, though evidence of it may never be found. Certainly she was keenly aware of them, and that can be sensed in the boldness of the waxwork family as events moved up to their unexpected climax of storm and fury.

For now, riding the wave in his own way, comes that slender figure which might so well have reminded Patience of Robert Feke, gazing intensely from the pale thin face framed in loosely hanging hair. The joke in the House of Commons had been that it was split into three parties, Ministry, Opposition, and Lord

George Gordon. Then, suddenly, this near-nobody, so eager to identify his life and fortunes with the oppressed, had taken up a cause of enormous popular appeal and become himself a revolutionary force. Lord George stood for repeal of the Catholic Relief Act of May 15, 1778.

The Act itself was enlightened and long overdue, removing most of the disabilities imposed on Catholics since the reign of William III. However, when Lord George declared in an audience with the King that the "diabolical purpose of the Bill was to arm the Roman Catholics for the American war," he had, in a warped way, a point.[31] Catholics had been excluded from holding commissions in the army, and the ministry was backing the bill as necessary to recruiting soldiers for an unpopular war. The Quebec Act of 1774 had been similarly an anti-American measure, since it not only preserved the French Catholic establishment but added to it the western territories claimed by the seaboard colonies. This is what had been on Mrs. Wright's mind when she had assured Lord Chatham, June 27, 1774, that "Providenc sent you into this world to be on the Earth that Sattan should not be able to destroy the Protestant Religion nor ruin all america," and Mrs. Macaulay's *Address* of the next year had reiterated the idea more tangibly.

In Scotland a bill for repeal of the Catholic disabilities was pending, and a Protestant Association similar to the English reform groups had sprung up with startling rapidity to oppose it. Lord George was there, and saw its meetings overflow with zealots. There were riots in Edinburgh early in 1779, and under this threat the bill had been abandoned. With this victory in the north, a Protestant Association sprang up in London, growing with the magical speed of a conjuror's army. Documentation at this point is scant, but we may infer that the waxwork's "congregation" came into it in a body, and the "Christian soldiers" too. Meetings were held in Greenwood's "Great Room" in Haymarket and elsewhere as numbers rose beyond what any one hall could hold.[32] On November 12 Lord George Gordon was invited to become President, and for the next seven months would

be on the crest of a breaking wave that threatened even the life of the obstinate King.

Here James II and George III could be linked again more closely, alike in tyranny and Jesuitical intrigue. It is spelled out in a large caricature, *A Priest at his Private Devotions.* Here is George in monk's frock and with tonsured head kneeling at an altar of "The Holy Catholic Faith." Behind him the privy door stands open, revealing on its floor a litter of papers, identified as "Protestant Petitions for necessary uses." But now the Protestant Association was preparing a petition too formidable to be brushed aside. Signers were being enlisted everywhere, and Lord George was announcing, toward the end of May, that he would not present the document to Parliament unless accompanied to the House by a march of at least twenty thousand who had signed.[33]

And the waxwork? Two new caricatures were published in this month of May by Matthew Darly, both attributed here to young John Williams, Patience's secretary and Darly's apprentice. The draftsmanship in both is similarly crude and immature — far below the quality of Darly's own work. One, *The Invisible Junto,* is so replete with religious allusions of her own sort as, surely, to have been sketched out by Patience herself or else drawn to her explicit directions. The other, *The Heads of the Nation in a Right Situation,* can only be John Williams' simultaneous comment upon Mrs. Wright herself as a public figure of the moment.

The Invisible Junto is "Dedicated to the truly Honorable Lord G. Gordon,

> Though Knaves & Fools combine how light the Scale,
> But Truth & Liberty shall still prevail."

Pictorial elements and perspective have the disjointed character of a Patience Wright letter. A large balance dominates the scene, held up by a hand in a cloud from which come the warning words of Belshazzar's Feast, "Mene Mene Tekel Upharsin." One scale is weighed down to earth by the Holy Bible, Sidney on

Government, and a Cap of Liberty. The other, upraised, holds the King and Crown of England. Ropes reaching from it to the ground are unable to draw it down, though the words, "pull North," "pull Bute," "pull Mansfield," and "pull Devil" exhibit a determined effort to do so. His Majesty is labeled "K. Manassah," the ruler of Israel who had done evil in the sight of the Lord and followed the abominations of the heathen. To emphasize this accusation a stone pillar, center, is inscribed, "And he filled the Land with Blood," a reference of course to America, and a hand emerging from it points to the King. An inscription on a rock, left, refers us to "Kings, Chapter XXI," and "Daniel, Chapter IV," while a voice over a palace, right, informs us, "And Sodomites were in the Land." The allusions are all Old Testament, true again to waxwork taste in prophecy.

The Heads of the Nation in a Right Situation takes us from this land of fantasy back into the heart of London. It is dated May 1, 1780, though whether this is the precise day of publication or one appropriate to the action depicted in the print may be debated. We can imagine the subject being worked out in laughter at the waxwork with Patience herself joining in — "Wright" and "Right" and that other pun, long current among portrait artists, on the "taking off of heads." The scene is Temple Bar, where the heads of traitors had been exposed on spikes up until 1772, the year of Mrs. Wright's arrival. The picture shows three heads impaled, not easily distinguishable as to likeness, but identified as Lord North, Lord George Germain, and the Earl of Bute. Down below, center stage, is the robust matron of the waxwork joining with the men and boys in flinging stones, dirt, dead rats, and cats at the grisly relics above. She is following whatever missile she has just let fly with the words, "This is a sight I have long wish to see."

If this was the work of young John Williams, young Joseph Wright was not ready to be upstaged by his friend. Joe had his own caustic and defiant mood which has come down to us in a self-caricature etching. "YANKEE-DOODLE, or the American SATAN" is its title, with a slightly altered quotation from Pope:

Ask me what provocation I have had,
That strong antipathy Good bears to Bad.

The plate is further identified as "Jos. Wright ad speculum de-
lin." and "Pub. by Ebenezer Scalpp'em on the Banks of the
Ohio."[34] It is undated, but the youthful figure can be placed at
about this time when he was entering his first painting in the
annual exhibition of the Royal Academy.

His entry was a portrait of his famous mother. She was
shown modeling a head of King Charles I, but looking as she did
so toward the nearby heads of King George and Queen
Charlotte — the expression on her face making a clear connec-
tion between the actual fate of the one and the wished-for fate of
the others. It was a small canvas, and whoever reviewed entries
for the show must have approved it simply as a young artist's
filial tribute.[35]

Its political satire was not original with Joseph. Ever since
the 1760's, when Englishmen had sensed with alarm that the
new monarch valued royal prerogative above the constitution,
their minds had turned to the similar course, and fate, of
Charles. The anniversary of his execution was observed by the
royal family at divine service, but by many of their subjects with
feasting and fireworks. Oliver Cromwell was hero enough for a
Wedgwood and Bentley plaque. Horace Walpole had long had a
copy of the Magna Charta hanging on one side of his bed, and
the death warrant of Charles on the other, "as I believe, without
the latter, the former would by this time be of very little impor-
tance."[36] By 1780, with the King's unpopularity everywhere ap-
parent, there was no thought of his trial and execution, but
much of a return to the status of the earlier Hanoverian kings,
or even of a bloodless revolution and his retirement to his smal-
ler realm of Hanover. Joseph, therefore, painted his picture
knowing that its message would meet the approval of many. The
reviewer for the *London Courant and Westminster Chronicle* was
quick to observe his intention:

> 202. Mrs. Wright modelling a head in wax, *by J.
> Wright.* — This is a very striking likeness: the head, about

YANKEE — DOODLE, or the
American SATAN.

Ask me what provocation I have had
The strong Antipathy Good Bear to Bad ;
Ask me the Mahattan Sketch 'em on the Banks of the Ohio.

JOSEPH WRIGHT

Self-portrait etching of the *enfant terrible* of the Royal Academy,
c. 1780.

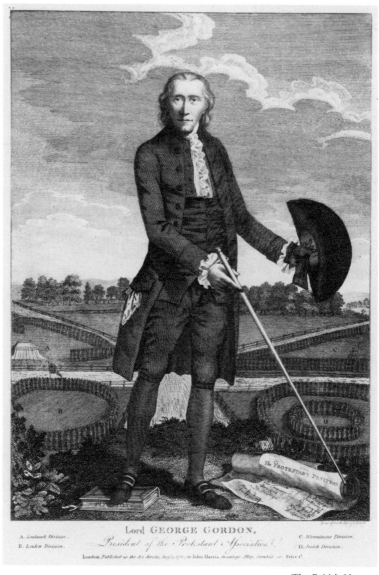

LORD GEORGE GORDON

"Drawn from the Life" in the summer of 1780, against a background of the Southwark, London, Westminster, and Scottish Divisions of the Protestant Association mustering on St. George's Fields for the march to Parliament.

which this famous modeller of wax is represented to be employed, has exactly the features of that *incorrigible tyrant, Charles* the First: two figures are painted as looking on, which seem designed as portraits, or rather *caricaturas*, of the *two first personages* in this kingdom. Should the instructive lesson which this piece appears calculated to convey, be *properly attended to by those whom it more immediately concerns*, and to whom perhaps it was directed, Mrs. Wright will merit the most magnificent rewards which royalty can bestow; and will gain the grateful and cordial applauses not only of her injured compatriots in America, but likewise of every honest well-wisher to the liberties of this kingdom, and to the glorious privileges of the pure and genuine constitution of England.[37]

The *Gazette* of May 16 added an epigram on the little painting and the pose of its subject:

> Wright on her lap sustains a trunkless head,
> And looks a wish — the King's was in its stead![38]

This was the "American SATAN's" first picture to be exhibited at the Royal Academy, and it would be his last.[39] It must have confirmed another exhibitor, Joseph Wright of Derby, in maintaining that "of Derby" as part of his name. Joe's painting would wound the kindly West, offend many others, and be a small part of those roaring events of the next few days which would bring a surging reaction of loyalty to the crown.

The ponderous might of the Protestant Association was on the march, with the wan and wraithlike Lord George Gordon at its head. The mammoth petition was ready. Tensions were building up in a way the town had never felt before. Would revolution or a "Pride's Purge" of Parliament be attempted? Always there was the hair-trigger threat of violence from the unfranchised hoi polloi so ready to become political partisans with sticks and tricks and flying stones.

Lord George was determined "to do nothing by halves." The King was asking the Commons for a new appropriation

with which to carry on the war, and the defeat of this was to be
an additional objective of the march. It tied the Protestant pro-
test so much the more firmly to peace and freedom.

June 2 dawned, the appointed day when twenty thousand
were to meet the President of the Association in St. George's
Fields to carry their petition to the House. Three times that
number came, sixty thousand strong, the London, Westminster,
Southwark, and Scottish Divisions, wearing the blue cockade,
marching through ominously rising summer heat behind the
flutter of their banners. They were well-dressed tradesmen for
the most part, holding their ranks in good order.[40] Was Pa-
tience's "congregation" among them, or the "Christian soldiers"
of Major Peter Labilliere? If so, all evidence of it has been oblit-
erated in the fire and frenzy that ensued. Young Frederic
Reynolds watched them pass and remembered how "They
talked of dying in the good cause, had lank heads of hair,
meagre countenances, fiery eyes, and they uttered deep ejacula-
tions."[41] They thought of themselves as daring martyrdom, risk-
ing a new Saint Bartholomew's, unaware that the Catholics
might be in even graver danger now than they.

The marchers were intent on good order. And yet in and
around them flowed a swirling current from the slums, many
waring a patch of blue, gathering to protest the hardships of the
times in their own way. Catholic Lord Bathurst was pulled from
his carriage, Lord Stormont's smashed to pieces — warning
thundergusts of a rising storm. The puritanical zealots vanished
as rogues and roguery, plunder and anarchy took over, day and
night. Homes of rich Catholics were wrecked, looted, and
burned. Newgate was set afire and the prisoners released.
Smoke and flame were everywhere. The mob, masters of Lon-
don, might have sacked the Palace had not a troop of horse
come at a clattering gallop through the smoke-filled streets to
defend it. The King watched the burning city from a window,
and his calm was praised as courage.[42]

Rather, it was the calm of a politician who sensed the value
of the event. His enemies, who thought only of peaceful revolu-
tion, would take the blame for this. Wild rumors were spreading

of opposition leaders heading the rioters in ragamuffin disguise. Young Frederic Reynolds saw a chimney-sweep "Earl of Effingham" shot to death and dashed home to tell his father of the tragedy, only to find the Earl safe in his drawing room. " 'This is my *third* death, Fred, during these riots. However, to cure you of your fright, and to prove to you I have some remnants of loyalty, here, my boy, take this *little portrait* of his Majesty,' at the same time giving me a guinea."[43] John Wilkes, once the idol of the London mob, was out, gun in hand, shooting into the crowd that threatened the Bank of England. The violence was the wilder, more terrible, for lack of leaders. It spilled out from London as far as quiet Bath, where Fanny Burney watched in horror as the Catholic Chapel blazed into the night sky.[44] Soldiery was mustered in full force at last, volleys of musketry crashing through the growling, smouldering uproar and followed by silence at last. By June 9, after eight days of fury and more than eight hundred deaths, it was over.

Lord George Gordon went to close imprisonment in the Tower on a charge of high treason. The ministry looked back upon the riots as a military victory and linked them to the glad news that came on June 15 — the capture of Charleston in America, with seven rebel generals and a rebel army of seven thousand men. Fearful, however, that any spark might light new fires, a handbill was posted forbidding "His Majesty's faithful Subjects to express their Satisfaction by Illuminations." Rigorous search was under way for ringleaders and conspirators "in the rebels' cause." Lord Hillsborough received a spy's report on the activities of a dangerous group "under the name of the american Club." Benjamin Bowsy, a prisoner turned informer for Alderman Thomas Wooldrige's benefit, "has made further discoverys, and informs me that a Mr. Lloyd a Gentn. of America & who lives in somerset street Portman square paid him and some others who were in the Mob one guinea each for their trouble, and of this he says that he hath several witnesses."[45] Incriminating bits were being culled from Lord George's papers — among them on a scrap of paper in his hand, touchingly characteristic: "All I desire is to find a safe harbor in the Affections of the

People, as they find me a true Pilot to their own Interests."[46]
Friendly John Greenwood's repeated visits to the prisoner in the
Tower lent color to the suspicions of an American plot.[47] John
the Painter was recalled, Benjamin Franklin named again as the
secret enemy behind it all.[48] Franklin accepted that onus
blandly, observing that "a taste of fire" was due those ministers
of the crown who had been burning towns in America.[49]

The reformers, so strong before the Gordon Riots, lost
much of their broad support. The county associations would be
under suspicion and harassment now, accusations of secret mili-
tary designs, of midnight orgies ridiculing Scripture.[50] By a firm
hand here and a few concessions there, the government could
get along. Parliament would adjourn in September sure of a
majority for continuing the war. Lord North's tottering adminis-
tration had gained two more years of life.

The reaction came even more quickly in the world of the
artists. Joe's portrait of his mother had been received with
amusement, but on June 7, in the midst of the havoc of the blue
cockade, the *Public Advertiser* printed:

A CARD

A Lover of Decency presents his Compliments to *Sir
Joshua Reynolds,* and is astonished to see in the Exhibition of
the *Royal Academy,* a Picture of Mrs. Wright modelling in
Wax the *Head* of Charles the First, attended by two Royal
Personages, who fill up the Back-ground, and are attentively
observing her Work. Such a piece in any public Exhibition
would be an Insult to Decency; in a Royal one, so protected
and encouraged by the munificence of its Founder, it adds
Ingratitude to Insult and Indecency. If the frantic Fanatic,
for whom it is executed, was Rebel enough to design it, and
pay for it, such a Piece certainly ought never to have ob-
tained a Place in the Exhibition of the Royal Academy at
Somerset Palace.[51]

Even Horace Walpole now expressed surprise at the
"lethargy of loyalty" which had permitted such a thing to occur
in an institution founded and fostered by His Majesty.[52] But the

Academy's President, Sir Joshua, could not have been held solely accountable. As the writer must have known, it was West, the American, who had been the friend of the Wrights all along, and West who was adding "Ingratitude to Insult and Indecency." His next interview at the Palace must have been a painful one for the gentle, kindly artist — unaware that worse, far worse, would be coming in the warmth and calm of the ensuing summer.

Henry Laurens, diplomatic envoy and former President of the Continental Congress, was captured at sea in August 1780 and lodged in the Tower of London. There, by chance and to the consternation of the warders, traitor Laurens met and conversed with traitor Gordon.[53] Lord George was brought to trial on February 5, 1781. Though he was acquitted, care would be taken to frustrate his return to politics, where he could still have been a power. He would be in Paris in the next year, but not before Patience herself had visited that city and tested the temper of America's new allies. She would be in touch as soon as means could be found with both Laurens and Gordon. But London was hostile and even unsafe. John Williams left for Ireland at this time, hoping as editor and writer to keep rebellious resentments simmering.[54] Mrs. Wright was much interested in Irish affairs, and he must have been one of her principal sources of information until obliged to decamp in 1784. But for herself the safest refuge and the best place in which to mature her plans was Paris — Paris and Franklin.

There could be no trouble about a passport. The King who had established her reputation with his patronage would be glad to be quit of the mad artist with her chatter and her dreams. But the final offense which roused his anger and must have hurried her departure again concerned poor West. It came out of the family life at the waxwork and, after a fashion, brought His Majesty into it. On July 8, 1781, John Hoppner and Phoebe Wright were married.

The bridegroom's pension from the crown was instantly withdrawn. There was an interview, the King and West. Again it must have been painful, with implications of ingratitude, disloy-

alty, the recollection of *Mrs. Wright Modelling a Head*. West presented a case for the withdrawal of the pension: Hoppner had not been exerting himself as he should, and needed the spur of necessity to bring his art to perfection.[55] This satisfied the King that he had acted only in the youth's best interest, but West must be the one to strike the blow. In that way Hoppner would be punished but the door still open to reconciliation.

West accordingly told Hoppner that he himself had advised putting an end to "the royal protection," and why — thus bringing upon himself the other's bitter and lasting resentment. Four years later Hoppner published an adverse criticism of West's work in a *Morning Post* review, and then came out with the whole story as he saw it, to justify his hostility:

> To give some color indeed to his actions he would insinuate he meant through sufferings to have made me an artist; but I rather think he meant when he threw me precipitately on the world, without interest, without money and with more than myself to provide for, that I should have sunk under the weight of my distresses; especially as at that time he could have had no grounds for supposing me capable of providing for myself, for from the little practice I had had in painting no hopes could have been formed of my being able to procure a subsistence by it.[56]

Only with his gradual progress toward success, he went on, had West grown "more civil." It was an unjustified grudge that was still rankling in the family as Hoppner's son told the story in 1869:

> At a very early age, in consequence of his marriage without King George the Third's consent, to my mother, and at the instigation of Mr. West, he was turned out into the street with half a crown in his pocket; West's hostility to him being thought the more iniquitous because he pretended to be a friend of my grandmother, an American like himself, and the reason he assigned for it being that young Hoppner was an idle fellow who would never do anything while the King supported him, and until he was forced by necessity to exert himself.[57]

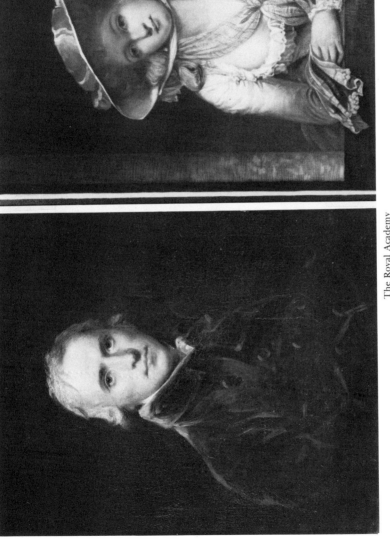

JOHN HOPPNER

Self-portrait of c. 1800, presented by Phoebe Wright Hoppner to the Royal Academy after her husband's death.

PHOEBE WRIGHT HOPPNER

Posed as "Sophia Western." Engraved by J. R. Smith after the painting by her husband.

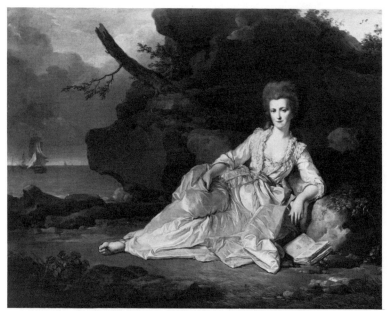

THE DUCHESS OF CHARTRES

Portrait by Joseph Siffred Duplessis at the Chateau de Chantilly.
Mrs. Wright's patroness during her visit to France is shown
awaiting the return of her husband as his ship sails against the
English, 1778. There followed the drawn battle off Ushant, July
27, in which the opposing fleet was commanded by another
Wright subject, Admiral Keppel.

The wedding which had triggered all of this emotional agitation had been celebrated at fashionable St. George's Church, Hanover Square. The entry in the Register is by the Reverend Richard Pitt, who had performed the ceremony:

John Hoppner of this Parish and Phoebe Wright of the Parish of St. James Westr. a Minor were married in this Church by License by and with the consent of Patience Wright Widow the Natural and lawful Mother of the said Minor this eighth day of July in the year 1781 By me Rd. Pitt, Curate.

And below:

This Marriage was solemnized between us ⎰ John Hoppner
⎱ Phoebe Wright

In the presence of ⎰ Peter Labilliere
⎱ Anne Juliet Cozens[58]

It would be pleasant to believe that of these two witnesses Juliet signed her name on behalf of all the young artists and their friends who had come, and that the other pews, rank on rank of them back to the rear of the nave, were filled by Major Labilliere's "Christian soldiers" and Mrs. Wright's attentive "congregation."

There was no wedding journey. Mr. and Mrs. Hoppner settled at once into rooms over the waxwork in Cockspur Street, two flights up, and would be living there for the next three years. As for Patience, she at last was away to France, bringing her genii to the rival power.

CHAPTER XI

Rendezvous in France

THINGS began to happen with a chance rencontre in Paris. In just this way, from the very first, new faces and new excitements had come into the life of Patience Wright. She was staying at the Hotel d'York, rue Jacob, on the Left Bank. It was a good hotel, and the one most patronized by Americans. Two years later, John Adams, John Jay, Henry Laurens, and Benjamin Franklin would meet in one of its rooms to sign the definitive treaty of peace with Great Britain, a fact still commemorated by a bronze tablet on its wall. Another guest arriving in this summer of 1781 was Elkanah Watson, aged twenty-three, fresh as the wind and handsome as a young god. He came of an old Plymouth, Massachusetts, family, kin to Tory Governor Hutchinson, but was himself heart and soul for independence. He had come to France with dispatches for Franklin two years before, had been studying the French language at Ancenis and Rennes, and was in Paris now on business of his own. He and his young French partner, Cossoul, had set up a mercantile house in the harbor town of Nantes, and expected to make their fortunes riding the golden wave of Franco-American amity.

Of all the memories of Patience Wright that have come down to us, Elkanah's are the richest. He had kept a journal which he recast in narrative form forty years later and which was published by his son long after that.[1] Yet all the events are vividly there, and with them still the gay carelessness of youth. He and Patience hit it off remarkably well, though he never really knew afterward how deeply involved he had become in the strange mad drama of the waxwork artist's prophetic dream.

She was now intent upon repeating in Paris the success she had had on first coming to London. He had breezed into town looking forward to two months of what he called "the elegant festivities of the city."

Giving orders from the balcony of the Hotel d'York, to my English servant, I was assailed by a powerful female voice, crying out from an upper story, "Who are you? An American, I hope!" "Yes, Madam," I replied, "and who are you?" In two minutes she came blustering downstairs, with the familiarity of an old acquaintance. We soon were on the most excellent terms. I discovered that she was in the habit of daily intercourse with Franklin, and was visited by all the respectable Americans in Paris. She was a native of New Jersey, and by profession a moulder of wax figures. The wild flights of her powerful mind stamped originality on all her acts and language. She was a tall and athletic figure; and walked with a firm, bold step, and erect as an Indian. Her complexion was somewhat sallow; her cheek-bones high; her face furrowed; and her olive eyes keen, piercing and expressive. Her sharp glance was appalling; it had almost the wildness of a maniac's.

The vigor and originality of her conversation corresponded with her manners and appearance. She would utter language in her incessant volubility, as if unconscious to whom directed, that would put her hearers to the blush. She apparently possessed the utmost simplicity of heart and character.

With the head of wax upon her lap, she would mould the most accurate likenesses, by the mere force of a retentive recollection of the traits and lines of the countenance; she would form her likenesses by manipulating the wax with her thumb and finger. Whilst thus engaged, her strong mind poured forth an uninterrupted torrent of wild thought, and anecdotes and reminiscences of men and events. She went to London about the year 1767, near the period of Franklin's appearance there as the agent of Pennsylvania. The peculiarity of her character, and the ex-

cellence of her wax figures, made her rooms in Pall Mall a
fashionable lounging-place for the nobility and distin-
guished men of England. Here her deep penetration and
sagacity, cloaked by her apparent simplicity of purpose, en-
abled her to gather many facts and secrets important to
"dear America" — her uniform expression in reference to
her native land, which she dearly loved.

She was a genuine Republican and ardent Whig. The
King and Queen often visited her rooms; they would induce
her to work upon her heads, regardless of their presence.
She would often, as if forgetting herself, address them as
George and Charlotte. This fact she often mentioned to me
herself. Whilst in England, she communicated much impor-
tant information to Franklin, and remained in London until
'75 or '76, engaged in that kind of intercourse with him and
the American government, by which she was placed in posi-
tions of extreme hazard.

I saw her frequently in Paris in '81; and in various parts
of England from '82 to '84. Her letters followed me in my
travels through Europe. I had assisted her at Paris; had
extended aid to her son at Nantes, and had given him a free
passage in one of our ships to America. Her gratitude was
unbounded. This son was a painter and artist of some emi-
nence, and in 1784 took a model of Washington's head in
plaster.[2]

Here we see how readily one could step into an intimate
personal relationship with the "Promethean Modeller," and
then quite as easily accept for gospel truth that highly question-
able legend of "important information" obtained at "extreme
hazard." Elkanah would learn more when he followed her to
London, but never the whole. In Paris, he was fascinated by her
self-assurance in the alien city.

Patience, of course, had gone promptly out to Passy to renew
acquaintance with her friend, the "garduin angel" of the na-
tions. Franklin introduced her to his neighbor, Mme. Helvétius,
widow of the Encylopedist and social philosopher, a deb-

onair lady with whom he had been enjoying a delightful intimacy. She was an aristocrat born and yet, like Patience, combined a lack of formal learning with an intelligent fondness for people. The two women discussed politics. Mme. Helvétius approved of Mrs. Wright's "principles."[3]

At Passy, perhaps at her first visit there, Patience modeled a new wax portrait of her great friend. There was trouble, late at night, walking back into the city with this head wrapped up in a napkin. Elkanah Watson was the first to learn of it:

> In returning in the evening she was stopped at the barrier, to be searched for contraband goods; but as her mind was as free as her native American air, she knew no restraint, nor the reason why she was detained. She resisted the attempt to examine her bundle, and broke out in the rage of a fury. The officers were amazed, as no explanation, in the absence of an interpreter, could take place. She was compelled, however, to yield to power. The bundle was opened, and to the astonishment of the officials, exhibited the head of a dead man, as appeared to them in the obscurity of the night. They closed the bundle without further examination, believing, as they afterwards assured me, that she was an escaped maniac who had committed murder, and was about concealing the head of her victim.
>
> They were determined to convey her to the police station, when she made them comprehend her entreaties to be taken to the Hotel d'York. I was in my room, and hearing in the passage a great uproar, and Mrs. W's voice pitched upon a higher key than usual, I rushed out, and found her in a terrible rage, her fine eye flashing. I thrust myself between her and the officers, exclaiming, "Ah, mon Dieu, qu'est ce qu'il y-a?" An explanation ensued. All except Mrs. W. were highly amused at the singularity and absurdity of the affair.

Elkanah, with high spirits and new prosperity bearing him on, ordered a wax head of Franklin for himself. He continues:

After it was completed, we were both invited to dine with Franklin, and I conveyed her to Passy in my carriage, she bearing the head upon her lap. No sooner in the presence of the Doctor, than she placed one head by the side of the other. "There!" she exclaimed, "are twin brothers." The likeness was truly admirable.[4]

Watson, it would seem, had begun to realize what a potential for gay deception lay in this art. He commissioned his own portrait in wax as well, and so was doubly provided for what the future might bring.[5]

We can never know how many of her "cappital Bustos" Patience Wright made in Paris, but Franklin, just as he had done in London in 1772, wrote letters to prominent people who might consent to pose for her. The Queen, whom she so confidently had expected to portray, was in confinement, to end with the birth of a Dauphin in October. Instead, he sent her to another great lady of the royal line, who publicly became her patroness and protector. Louise Marie Adelaide de Bourbon-Penthièvre, Duchesse de Chartres, in her twenties, blonde hair and pale blue eyes, a serious, intelligent face, posed for her portrait in wax. A replica would appear in the London exhibition, and then in an American one as well, in those later days attracting a new romantic interest.

The Duc de Chartres — after 1785 Duc d'Orléans — was an easy going Anglophile noted for his democratic principles and airs, and cordially hated for them by the Queen. His wife's fortune had made him the richest man in France. His role in the French Revolution as "Philippe Égalité" would end on the guillotine. The Duchess grew old in piety and splendor but, struck down by a book falling from its high shelf in her library, did not live to see her son, Louis Philippe, become King of France.[6] How this strangely fated couple fared with Patience Wright we do not know, beyond a later word of abrupt dismissal with which Mrs. Wright put the Duchess out of her mind much as she had Queen Charlotte. These patrons at least spoke English. By others, sympathetic as they were to all things American, Patience's blunt

heartiness and honest anger were not always understood. Some of the difficulties of the language barrier were described by the observant Mr. Watson:

> Sometime after my acquaintance with Mrs. Wright commenced, she informed me that an eminent female chemist of Paris had written her a note, saying that she would make her a visit at twelve o'clock the next day, and announced also that she could not speak English. Mrs. Wright desired me to act as interpreter. At the appointed hour, the thundering of a carriage in the court-yard announced the arrival of the French lady. She entered with much grace, in which Mrs. W. was no match for her. She was old, with a sharp nose, and with broad patches of ver-million spread over the deep furrows of her cheeks. I was placed in a chair between the two originals. Their tongues flew with velocity, the one in English and the other in French, and neither understanding a word the other uttered. I saw no possibility of interpreting two such volleys of words, and at length abruptly commanded *silence for a moment.*
>
> I asked each — "Do you understand?" "Not a word," said Mrs. Wright. "N'importe," replied the chemist, bounding from her chair, in the midst of the floor, and dropping a low curtsy, she was off. "What an old painted fool," said Mrs. W., in anger. It was evident that this visit was not intended for an interchange of sentiment, but a mere act of civility, — a call.[7]

"The chemist" was probably Mlle. Biheron, noted for her anatomical models in wax, a lady who spoke no English but had been Franklin's friend for many years. He may have introduced Patience also to the wife of his landlord, Donatien le Ray de Chaumont, as he did Joseph Wright a few months later. Whatever others there may have been, Patience was doing well enough to write back to Joe in London reporting high times and success.

Not so, however, in London. Phoebe answered that Joe must not be encouraged to believe that his mother was making a fortune for him. He was idling in her absence, taking the receipts from the waxwork and spending them at pleasure.[8] How Mrs. Wright replied to this we do not know, but she remained in France. She would hold her own in Paris for a year. New excitements were arising which would determine the course of Joe's career and her own. By the end of October Paris was ablaze with lamps and fireworks for the Dauphin's birth. Four weeks after, late in the night of November 19, Franklin received the news that Lord Cornwallis had surrendered his army to the allied forces of Washington and Rochambeau. This was the culminating hour — victory after six long and bloody years! Painters and sculptors everywhere thrilled to their expected role, to celebrate in art the heroes of this triumphant dawn. Joe must come to Paris to paint Franklin, whose portrait would now be wanted in countless homes of honest men. He could carry it home to America, and there paint one of Washington as well — make a life mask, too, from which could be made a waxwork figure of the victorious Commander-in-chief, an irresistible attraction at the London exhibition.

Joseph arrived at Paris in mid-December. He carried a letter, dated December 7, 1781, from Benjamin West to Jean Baptiste Marie Pierre, *"Premier Peintre du Roi,"* professor at France's Royal Academy.[9] West, heart of gold, had had it written for him in French and couched in the most flattering terms. *"Le Sieur Joseph Wrigth"* (his scribe had a difficulty with the name) *"jeune Americain de ma ville de Philadelphie"* intended to pursue the study of art at Paris, where *"Sa mère est protégée par la Duchesse de Chartres,"* and then to seek final perfection, as West himself had done, at Rome. Any favor shown to this promising youth would be as one to West himself. The letter was apparently never presented, since it remained among Joseph's papers and since, as would soon appear, further study was far from Joe's thoughts. He would paint portraits of Franklin and any other patrons he could find, and then head gloriously over the sea to victorious America.

He arrived at Paris armed also with a letter from the ebullient and indestructible Labilliere, dated from the "Temple of Liberty," December 8, 1781.[10] The Major commended "my ingenious, well principled, and approved American friend, Mr. Wright," and went on to report upon his own activity as a political reformer supporting annual parliaments with universal representation, the "only constitutional Majesty." He subscribed himself sententiously, "a christian watchman for Truth, D°. Soldr., D°. Actor, D°. Patriot, Cn. of the World." As an antidote to this lunatic pomposity, Joe had his picture, *Mrs. Wright Modelling a Head,* to bring out to Passy, and the story to tell.

Meanwhile in London King George — "Pharoah" in the language of Mrs. Wright, Major Labilliere, Thomas Paine, and other critics — had begun darkly to ponder "what my conscience as well as my honour dictates as the only way left for Me."[11] That would be abdication and retirement to his ancestral domain of Hanover. Sooner or later the rumor would come to Patience, through Polly Wilkes if no other. Miss Wilkes had written with much amusement to her father, then at Bath, January 3, 1782, "I have heard of a new print of a *Gentleman* going to Hanover, on Horseback, with his Lady behind him holding an infant, & several Children desiring their attention."[12]

It was not, however, until June or July 1782, with Joe ensconced at the Hotel d'York and Billy Franklin putting him in touch with prospective patrons, that Patience returned to London. There she heard again the rumors of impending crisis and change. The King had discussed abdication, drafted a message to Parliament, and ordered the royal yacht held in readiness for departure.[13] In Parliament meanwhile, Rockingham's brief ministry would end his power to control by bribery. On Rockingham's death, Lord Shelburne, reformer, would turn to Franklin with the idea of Anglo-American federation. He would not ask Franklin to "new-model" everything, but Patience was attending to that. Now was the time to "call all the wise honest hearted together," to summon their "garduin angel" across to Dover and to London. Franklin, preoccupied with the peace negotiations, paused to read:

London, July 30th, 1782.

Honor'd Sir —

afte my most hearty and sincer love to you and your grand son — friends &c.

I have the pleasure to tell you my hope is more fixt on you then Ever. My Inthuzasm encreases Evry day and from good authority can say my politicall Creed is well founded: you will be Very shortly Calld upon by the People — (Providence whome I trust) will Call all the wise honest hearted together and EXPOSE this shameful Condoctt of Wickedness: Our People are now in good Earnest to be Wise and use those powers god and nature has gave them: Now is the time for our great and good men to apeare in the behalf of a Ingured and opressd People and do Honor to themselves and to mankind. My Confidence in you and high Esteem for Mr. Wm Frankling together with the Courage, Condoct and wisdom of our good men belonging to the difrent societys: will oblige the devil to flye and then the authors of war will go also with him: and peace and plenty take Place. The Publick Funds is what keeps all back. Pray help our Credit: You can do it and give the good offic that help to the Bank So nessecary; A letter in its Credet and a line of Friendship to us will bring Thousands your Friends and make Peace on the most honourable terms to all nations. Our manufactorys are going off pr way of Ireland to america and the Loyal town of Manchester feals the *effects* of sound *Policy* abroad. We now are Easy. Things Work round to the grand Reform. Our old friend Strahn with others is a Patriot. It causes much chearful conversation to see inns and outs. This deferint hopes and fears while our great man thinks himself very safe in his Army with the art and deception of his Consort and his first servants &c. Ms Stephenson is well. Miss Huston sends her love to you and wishes much that I had calld on her to accompany me to Paris. You may see more of your old friends then you Expect if we dont prevent them by sending for you to DOVER as is Expected by me and others of strong Faith I have had the honor to see

and hope with good Reason. I beleve my arrivall in London was attended with good: As my opertunitys is great I find a disposition to speak proper truths.

I am very hapy to here by Mr whitford and others that my son is Painting your Portraite. We Expect a order from the Comon Councill very soon and so by the ordrs of the City or Part of them for your Picture to be Painted by Jos Wright and presented to those or to *whome* or *where* it may do most Honour. The perticulers are now in Contemplation. A few weeks will determine so Pleasing a Vote and so proper act at this time when all Parties seem to be more in their senses and Joyn with me in wishing to Shew all possable Testimonies of their Love and high Esteem to you by making Publick Declaration and gloring in ther doing Justice to great men. P. Wright[14]

Points of interest in Patience's letters are like objects floating by on a rapid stream. Picking them out from this epistle and fitting them into the pattern of other events, we see that the return to London has restored her "Inthusazm" for a grand reform of government. The Society for Constitutional Information and its sister organizations are active. The people, responding to God and nature, are ready to sweep monarchical trappings aside, and George III is to depart as quietly as James II had done. A purposeful message from Franklin is needed. The time for a triumphal entry into London and the fulfillment of her dream is at hand. He will be escorted by the faithful up from Dover to the city.

She now knows him too well, however, to feel sure that a great political upheaval with himself at the center of it is an idea well calculated of itself to lure him back. She recalls the happy past of Craven Street days — Margaret Stevenson and her daughter Polly, now the widow of Dr. William Hewson. Polly had visited Franklin at Passy, and later would go to Philadelphia to be near him. "Our old friend" William Strahan, too, is brought into the picture, as warm as ever toward peace and reconciliation. Caleb Whitfoord, witty Craven Street neighbor,

had been given a part in the current peace negotiations and was moving back and forth between Paris and London. As for Franklin's son William, former royal Governor of New Jersey, Patience was now both friend and partisan. Always for the underdog, she was pleading for reimbursement by America for the losses of the Loyalist refugees — again a cause to which William's father was cool.

That meeting at Dover, "expected by me and others of strong Faith," is mentioned in another letter as scheduled for the coming winter.[15] The waxwork is gaining favor again, with prominent people dropping in. Patience has her own view of the great, and her own way with them. To Joe, complaining from Paris of the behavior of the Duchess of Chartres, she writes with maternal concern:

> I am sorry for your sake that the Duchess forgot the character of her station, or her own character, in the affair of the two guineas. But I am so well acquainted with the world, that I am not disappointed. My dear son, *silence, patience, prudence,* industry, will put you above all those mean little minds, and teach you how to act when you become great.[16]

We must assume that Mrs. Wright was doing her best to cultivate these virtues in herself. It could not have been easy, with that vivid anticipation of climactic events as a constant pressure. Then, returning from Bath to London, she found news from France that Franklin was seriously ill. John Thayer, a pretentious young clergyman from Boston,[17] may have been the courier who brought the following cryptic dispatch from the waxwork to Passy:

> Honored Sir
>
> With the most sincere distress of mind I herd last [week?] from France you was ill and since [have] not had the good news of your Recovery. I beg mr Thare the Barer of this may give me the Early Intelligence of your helth and wellfare. My hopes are Placd high on your life health and

Situation. May almighty Ruler of Kings give you the bless-
ing of long life is the Prayer
> of dr Sir your Estemd Friend
> Patience Wright

London
> october 7th, 1782

My Dear Wm
With dificuly am silent. I returned from Bath where the
Spirit of the times made it very Entertaining being Com-
pany from all Parts &c. Would to god you was thir with
others now on their way to that blessed Water.

> mrs. Wright Respectful Complents to Doctr Bancroft
To hold him self Ready to meet us.[18]

As the postscripts to William Temple Franklin and Edward
Bancroft show, she expected them both to accompany the "gar-
duin angel" to London — Billy, intent upon the immediate
pleasures of Paris, and poor Bancroft, whose only concern at
this time was whether or not the new ministry would honor the
promises of the old and reward him with a pension for having so
sedulously played the traitor and spy. The "others" on their way
to Bath, "that blessed Water," included another who Patience
now felt sure would enter into her plans, Henry Laurens, the
wealthy former President of Congress.

Mr. Laurens made the journey only for rest and recupera-
tion after his grim imprisonment in the Tower, held, as Platt had
been, in the cold shadow of a traitor's death. Yet as President of
Congress he had been one to whom John Dickinson could write
frankly of an American return, not to subjection, but to the
empire, and in 1781 he had petitioned the King for special
consideration as one who had long sought "to preserve and
strengthen the ancient friendship between Great Britain and the
colonies."[19] His appointment to the Peace Commission in Paris
would be welcomed by the ministry as a moderate voice.

Patience's long letter of November 5, 1782, followed him

out from London to Bath and back again to London, as he was
preparing to depart for France on his mission.[20] Desiring as he
did to retain some confidence and trust upon both sides, he must
have broken the seal and read its message with alarm. It opened
by reminding him of their conversation in London in which he
had given her permission to write, and continued in terms that
implied some sort of agreement between them — himself ad-
dressed as a leading fellow-conspirator and urged to "save a
Sinking Land. It is in your Powr as now ther Councells are
divided . . . one man will drive a thousand and I trust in god you
and doct Franklin will be Calld upon by the People the moment
you write the sd letter. May you be Inspird to write is the Prayr
of thousands and the Prayr of the sinceer Friends to Religion
and Naturs god."

There was no signature, nor was one needed. The letter is
docketed, "Mr. W—— as supposed. 5th Novr. 1782. Recd.
12th." Her presence was there in every line, and his startled eye
would have caught that unsparing allusion to Britain's ruler —
something about bringing "a curse on mankind by flattering the
Pride and tyrony of a german Blockhead."

But there is method in it, too. She begins, in the frequent
pattern of her correspondence, by pouring out undercover in-
formation as a prelude to advice and guidance. Here she has a
small arsenal of five revelations:

1. Orders had gone secretly to the Hague to initiate a sepa-
rate peace with the Dutch.[21]

2. The cabinet had been split by a quarrel between Lord
Shelburne and Charles Lennox, Duke of Richmond — "such
high words as men of Honour must Resent and from which the
Duke must go out of office."[22]

3. Shelburne had increased the bounty for army enlist-
ments in Ireland.[23]

4. "A gentleman from Lanchester" (does she confuse Lan-
caster and Manchester, or is this her own melding of the Lanca-
shire towns?) had brought the ministry warnings of famine and
despair under which "if not stopt Imeadatly the people will take
the goverment into thir own hands."

5. (Her climactic point) "The merchnts a number of honest men most humbly hope, and wish; and Pray that Mr. Lawranc will actt as a mercht or as a man or as an american and as an Ambassador" and take up the cause of the "Truly to be pittied honest Part of mankind" against King and ministry.

"The People are much to be pittied. They are Bot and Sold with thir own money and now are told that america will not let Peace be made on any terms. . . . Great Pains is taken to give a Wrong opinion of you to the *French* to Dr Franklin also to the dutch"; but Franklin and Laurens must stand together for the "Rights of mankind," with the aid of all America. "A Seperat Peace is folly in Extreem. Sound the trumpet to your *tents o Isrell.*"

While these trumpets were sounding in Old England, Patience's friends across the Channel were feeling only the exuberance of victory. Elkanah Watson was gaily readying himself for a trip to London and from London through the English commercial cities. He had it in mind to set up an English branch of the prospering house of Watson and Cossoul. Since no treaty had yet been signed, Franklin had given him the protection of a minor diplomatic role as dispatch bearer. We have two accounts of his coming, one his own, and the other by Frederic Reynolds, son of a London lawyer long prominent in Lord Chatham's reform movement and an old friend of Franklin. Frederic, aged eighteen, had light-heartedly slipped out of England and into Paris without a passport — a lark, as he tells it, until his enjoyments were suddenly interrupted by the police, bursting into his room while he still lay abed:

> . . . an officer of the municipality, and two whiskered *gens d'arms* — O, thought I, old Cole is right; and I and my tour are both finished!
>
> I had again entered my bed; when, advancing close to me, the officer authoritatively demanded my passport; which, in course, not being able to produce, he exclaimed in a tone which gave me an universal palsy,
>
> "*Sacrebleu! — qui etes vous?*" —

So alarmed, and confused was I, by this abrupt inquiry, and their fierce manners, that all my little French vanishing, I was compelled to resort to my pocket dictionary for assistance. So long was this searching operation protracted (owing to my panic banishing the total recollection of one word, while I sought the succeeding,) that quite infuriated, one of the *gens d'arms* pointed his bayonet; while the officer stamped, and vowed, that unless I could give him immediate proof that I was no spy, he would take me on the instant to the Conciergerie —

This word roused all my faculties.

"*Je ne suis pas spy,*" I replied energetically; "*je suis Amerique! — non, stop, arretez,*" again recurring to my pocket ally! "*je suis, je suis Americain!*" —

"*Eh bien! mais le temoignage?*"

"*Quoi?*" again losing the scent.

"*Le temoin — l'evidence?*"

"*O l'evidence!*" I rejoined, with no more idea at first, who should evidence to the truth of my assertion, than they had who required it — "*L'evidence — oui, oui je comprends — wait un moment! l'evidence? ho! Docteur Franklin, Messieurs!*"

"*L'ambassadeur!*" cried the officer, "*cela fait autre chose donc.*"[24]

So then at once to Passy, where the necessary paper was obligingly obtained for him by one of the embassy secretaries, duly signed by Franklin, but for a week's duration only. That week passed swiftly and then, again in the shadow of the Bastille, he turned for help to handsome Stephen Sayre, a close friend and business associate of John Reynolds, his father. Sayre, experienced now in intrigue, proposed that Frederic go back to London disguised as Elkanah's valet. Elkanah's passport allowed him only his one servant, La Fleur. Doubtful as it seemed, he agreed to take the chance. The story then continues from Watson's book:

It was impossible to insert the name of Reynolds in my passport. There was no alternative but for him to pass as my

FREDERIC REYNOLDS

Of the "*Je ne suis pas* spy" adventure. Engraving after a portrait
by John Raphael Smith, 1803.

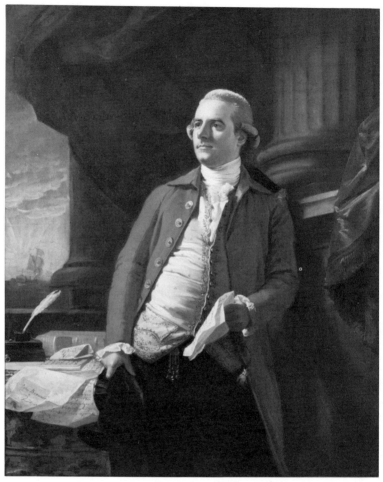

ELKANAH WATSON

Mrs. Wright's friend in a moment of triumph. He had just won a hundred-guinea wager, and heard King George acknowledge the independence of the United States. Painted by John Singleton Copley, London, 1783

servant and to associate with La Fleur. He was equipped as a servant, and he accompanied me in that capacity. Whilst La Fleur, however, was galloping along the road from Paris to Calais, Reynolds was snugly napping in the corner of my carriage. At Calais, whilst I was negotiating with the Commissioner for my passport to Dover, that of Dr. Franklin terminating at Calais, Reynolds was trembling in the courtyard, awaiting with La Fleur to be inspected and described. I succeeded in passing both as my servants, and marched to the wharf of embarcation through the streets, with each of my servants bearing a bundle, to screen Reynolds.

When we arrived at Dover, my brother traveller, to the wonderment of La Fleur, threw off the masque, and as he stood on British ground, seemed an inch taller. With me the case was reversed. I felt apprehensive in an enemy's country, and thought in turn I might want the protection of Reynolds, or of his powerful connections. Such are the vicissitudes of life![25]

Frederic, whose autobiography ties in so happily with Elkanah's, lived as he wrote, with gusto. The stage would be his métier and he would become the author of nearly a hundred plays, comedy for the most part. He is best remembered, however, for the success of *The Caravan,* a drama in which a trained dog leapt into a real pond to rescue a real child — and how the manager, Sheridan, had burst into the greenroom afterward with a jubilant, "Where is my Guardian Angel?"

"Mr. Reynolds has retired, sir."

"Pooh! I mean the dog-actor, the preserver of Drury Lane Theatre!"[26]

Here was a dramatic imagination matched by Frederic's friend, Elkanah. Elkanah had his head of Franklin, and was minded to have some fun with it. Mrs. Wright was away on one of her rounds of the shires, though he caught up with her repeatedly in his own tour through Liverpool, Leeds, Manchester, Sheffield, and the rest.[27] At Bath he renewed his acquaintance with Henry Laurens — a sad time for Laurens, who heard there

the news of the death of his son in the continuing American war.[28] Since Patience, pursuing her open and arcane preoccupations, would not have neglected so important a figure as a newly appointed peace commissioner, she may have been present with them — a mixed trio.

At Birmingham other mixed company appeared — Joseph Priestley, radical philosopher and innovative chemist; James Watt, inventor of the steam engine; and then, much to the young man's surprise, former Boston neighbors and kinfolk in a little coterie of Loyalist exiles, Hutchinsons and Olivers.[29] Back to London then, riding high, winner of a hundred-guinea wager, he celebrated by having his portrait painted in the large by Copley. He and the artist went to the House of Lords, December 5, 1782, to hear the King make formal acknowledgment of the independence of the United States, dined together afterward, and then the painter marked the occasion by adding an American flag to the ship dancing over the picture's background waves.[30]

Somewhere in the midst of these excitements (the chronology of the two autobiographies, both from later recollection, is not entirely clear), the wax head of Franklin came into play.[31] A first visit to the waxwork may have given Elkanah the idea — along with the constant rumors, in newspapers, by word of mouth, in Mrs. Wright's mad fancy, of Franklin's coming to London. Here was a chance to treat the old Craven Street coterie to a surprise. Frederic Reynolds tells the story. The scene is the London lodging of Elisha Hutchinson, son of the Governor and an uncle-in-law of Elkanah.

> Soon after my arrival from France, my father received an invitation from my travelling companion Mr. Watkins [*sic*], to dine with him at his uncle's house in the city. I also was invited, and as we read on the card that we were to meet amongst others the celebrated Dr. Franklin, who had suddenly arrived in England on a pacific mission, my father felt peculiarly gratified by the idea of once more shaking hands with the venerable patriot.

The important day being arrived, my father, as he descended from his carriage, eagerly demanded whether Doctor Franklin had arrived? The servant replied in the affirmative, and then added, that he was at that moment in the drawing room.

"Now, Fred," my father exclaimed, "you'll see what a reception I shall have." Up stairs he ran, and I, post haste, after him. On entering the room, we beheld the Doctor seated at a table near the fire with a large folio volume lying open before him. His dress, considering the time, and the occasion, appeared to us rather disrespectful; a large, wrapping, morning gown, slippers, nightcap, and spectacles.

However, this surprise was nothing to that which followed; for, when my father, with much self-satisfaction, exclaimed, "How do you do, Doctor?" he made not the slightest reply. "Probably you do not recollect me," rejoined my father, after a considerable pause, "my name is Reynolds." Again, neither answer, nor action. My father, checked and disappointed, strutted towards the window, expressing in rather an alto tone, his unlimited disapprobation of American manners.

I endeavoured to exculpate the Doctor by pointing out to my father how intent he was on his book; though, at the same time, I could not help wondering that he could see to read on a misty October evening, solely by the light of the fire. Yet the chief cause of my surprise was, that, during the whole time we had been in the room, I had never seen him turn over a single leaf; but such was my respect, I was afraid of approaching to a close inspection, lest I should give offence.

More visitors entered, and were received with the same contemptuous silence. All were whispering, and complaining together, when Mr. Watkins entered, and bowing respectfully to the Doctor, advanced towards us, and shaking us by the hands, loudly expressed his hopes that we had found his Excellency entertaining — "Not at all," was the

general reply, though in a low tone — "Indeed!" exclaimed
our host with assumed surprise; "then I must try if *I* cannot
make him entertaining," and rapidly approaching him, to
our sudden dismay, he seized his nightcap, threw it up to
the ceiling, knocked his spectacles from his nose, boxed his
ears, and then to prove that even dull Yankies can impose
on credulous cocknies, undid his garment, and discovered a
"Man of Wax."

"Yesterday, Gentlemen," said Mr. Watkins, "I pur-
chased this curious and extraordinary resemblance of our
illustrious friend, of Mrs. Wright, of Cockspur-street, for
fifty guineas; and I believe, gentlemen, you will all agree
with me, that I may venture to assert with Charles in the
School for Scandal, 'This is the first time the Doctor was
ever bought or sold.' "

Some laughed, some pouted, particularly my father,
however, all was soon forgotten and forgiven; Mr. Watkins
at last wholly re-establishing the general good humour, by
laughingly saying, "Having heard that a London dinner was
nothing without a lion, I thought it better to offer you even
a *waxen* one, than no lion at all."[32]

Then the return to France, the prospect of more fun crowd-
ing into that of rising prosperity and peace. Back in his office at
Nantes, Elkanah rounded out a business letter to William Tem-
ple Franklin by adding a personal request. It was Christmas Day,
1782.

> After this I have another favour to beg for myself — no
> less singular than impertinent, however when you have
> made full allowance for my Whim — I beg you'll say noth-
> ing of the matter, whether it be practicable or not. In short,
> I mean to beg a suit of your grandfather's Old Cloaths, that
> can never be of any service to him or any Body else — to be
> plain — Madam Wright, has fabricated (I think) a most
> striking likeness of him in Wax in my Possession — which I
> wish to sett up in my study — dressed in his own cloaths. If I
> can be gratified in this, pray be so polite as to write me, and

I will take the necessary means of having them conveyed forward.[33]

Gratified he was, and a more true-to-life reconstruction of the ambassador was quickly contrived, to try the thing out on the French.

> I had the figure placed in the corner of a large room, near a closet, and behind a table. Before it I laid an open atlas, the arm resting upon the table, and mathematical instruments strewn upon it. A handkerchief was thrown over the arm stumps; and wires were extended to the closet, by which means the body could be elevated or depressed, and placed in various positions. Thus arranged, some ladies and gentlemen were invited to pay their respects to Dr. Franklin, by candle-light. For a moment, they were completely deceived, and all profoundly bowed and curtsied, which was reciprocated by the figure. Not a word being uttered, the trick was soon revealed.
>
> A report soon circulated that Doctor Franklin was at Monsieur Watson's. At eleven o'clock the next morning, the Mayor of Nantes came in full dress, to call on the renowned philosopher. Cossoul, my worthy partner, being acquainted with the Mayor, favored the joke, for a moment, after their mutual salutations. Others came in, and all were disposed to gull their friends in the same manner.[34]

While these diversions were brightening provincial life, at Paris the original of the wax figure was engrossed in the parleys that would determine the future of the warring nations. Europe and America watched and waited. England still cherished a hope that the rupture with the lost colonies might not be absolute. France, intent upon weakening her ancient enemy, trusted that it would. France looked to Franklin to make it so, and London looked to Franklin hoping to see his old feeling for England and for Anglo-American entente revive. Just as Patience was reminding him of old friends, so the ministry had brought them in as negotiators. James Hutton wrote back to Lord Shelburne, January 26, 1783, with the good news of Franklin's intention of

coming to England on his way back to Philadelphia — news that may have reached Patience Wright, a wind across those smouldering, glowing hopes of Grand Re-entry and Revolution.

Like others in England, she knew little of how her countrymen were basking in the sense of victory after a long and bitter war. They were of no mind to yield any part of what they had won to a government headed by the King who had begun it, or to ministers who, even if liberal-minded, were traditional aristocrats. Parliamentary reform could not now remove the odium and distrust. Only a republic of Great Britain, rooted in the ancient liberties, might have restored the kinship broken by war, and this was for the dreamers of the "congregation" and the "Christian Armie."

No thought in those ranks of overthrow by force of arms — let the whole nation rise in peaceful revolution. Patience Wright read eagerly the signs of discontent and unrest in London, the shires, Ireland. Above all there was the rumor, still alive from day to day, of imminent abdication. That would be the moment! Her great friend was the one to precipitate it — the triumphal entry into London, the "garduin angel" borne through the streets in a shining, roaring welcome, a re-enactment in far more glorious style of the drama of 1688. Let only Dr. Franklin appear at Dover, as "Expected by me and others of strong Faith." The "congregation" and the "soldiers" were ready.[35]

In France, too, Elkanah was ready. He was as much aware as any of the tension and expectancy, of the concentration upon the wonderful old man at Passy as the genius of the hour. He would be returning to England that summer. He had his wax head, his authentic suit of clothes to round out the whole far better than before, his knack of adding motion to the image. All unaware of its creator's rising fervor of expectation, he was prepared to give the English admirers of the Doctor a stunning surprise.

CHAPTER XII

Billeter Square

ELKANAH had given Joe a free passage to America on one
of the Watson and Cossoul ships, the *Argo,* sailing from
France late in October 1782, an ill-fated voyage.[1] Pa-
tience, back in England, launched out on her roving tour of the
countryside. When she returned to her home over the waxwork,
only Phoebe and John Hoppner were there. It would be differ-
ent now. A daughter and a son-in-law with a rising star of their
own could impose some moderation — and also cushion those
shocks and sorrows which beset the dreamer of strong faith.

The young couple, wholly dependent upon her at first,
were soon advancing in the world. Hoppner had shown one
portrait at the Royal Academy in 1781, two and a genre piece
(*Girl with Salad,* Phoebe as model) in 1782, when his scene from
King Lear was awarded the gold medal.[2] In 1783 he exhibited
five portraits, among them Lord and Lady Lewisham, a begin-
ning of noble patronage.[3] Soon after, he moved into a comfort-
able house in Charles Street, St. James's Square, the fashionable
background necessary for a portrait painter. There he would
remain for the rest of his life. It had not been easy. A debt was
incurred, and for some years Phoebe helped to meet it by a skill
acquired at the waxwork, making all the clothes for the
family — husband, mother, and the children as they came.[4]

Their friend William Gifford comes early into this pleasant
story of rising fortunes. He has a place in literature akin to that
of Patience's young collaborator John Williams, a satirist also,
though with more restraint, sophistication, and success. He too
had known poverty and despair but, aided by a noble patron,

had graduated at Oxford in 1782, aged twenty-six, a scholar and a poet. He had come to London as tutor to Lord Grosvenor's son, Viscount Belgrave, and through him Lord Belgrave became a lifelong friend and patron of the painter. Gifford spread a romantic aura over John and Phoebe's home — "Selene," white-winged goddess of the moon, with her shepherd lover.[5]

The house in Charles Street had also the friendly good will of George Augustus Frederick, Prince of Wales, who was ever a champion of those who had dared to incur his father's displeasure — and who was moved as well, it was commonly said, by brotherly feeling.[6] The Prince would have been as pleased as Mrs. Wright by an abdication and retreat to Hanover, though they would have differed as to Dr. Franklin and a republic. As for the King, it was West, not he, who had to bear the young man's rancor. He could now relent, believing that his severity had indeed stimulated the errant youth toward becoming, as he was doing, one of the masters of British art. Charlotte Louisa Henrietta Papendiek, Assistant Keeper of the Wardrobe and Reader to Her Majesty the Queen, had known both John and Phoebe from the time when they had come to prepare a petition beseeching a restoration of the King's favor — a document engagingly decorated with portraits of the five princesses:

> . . . and during that time we had become intimate with him and his wife. She was a spirited, handsome woman, and being acquainted with Mr. Giffard, the tutor of Lord Belgrave, they were introduced through him to Lord Grosvenor, who took him by the hand. The Prince of Wales, the Duke of York, all the Whig nobility, and most of the leading people of the day sat to him, and in two years he had overcome all difficulty.[7]

The Queen, too, was gracious, and his popularity with opposition leaders — one of his best portraits was that of Dr. John Jebb, 1786 — was not held against him at court. His new relationship with the King combined filial piety with a rough, blunt impatience whenever the monarch (as he loved to do) declaimed about art.[8] Hoppner could be bitter and harsh, a trait perhaps caught from John Williams at the waxwork. When the new

friend, Gifford, published his *Baviad* and *Maeviad,* Williams promptly brought suit for libel, but at the trial it had taken only the reading of a few random lines of "Anthony Pasquin's" contrasting satirical style to bring a dismissal of the suit.[9] By that late day the French Revolution and the rise of Bonaparte had changed everything. The struggles of the American War out of which these turmoils had emerged then seemed as windblown and remote as the waxwork woman's web of conspiracy.

Mrs. Wright disappears from the London directories after 1782, and may have been living with the young couple in St. James's Square —[10] bringing with her into this milieu of socially accepted art and literature all of her republicanism, her hatred of the King, and all, as she put it, of "the old Quaker truths." There that aggressive intelligence and wild, marauding energy would be seen against the background of John and Phoebe's affection, would be tolerated and found amusing by the Whig habitués of home and studio. The Patience of this day is reflected in a portrait of her attributed to Hoppner, and certainly dating from very early in his married life, or even before.[11] Whether his or no, it hung in the house in Charles Street through his and Phoebe's lifetime. It is a full-length, seated, in a pose suggestive of Reynolds' *Mrs. Siddons as the Tragic Muse,* lips parted, eyes raised, and all around her shadow and cloud, mysterious shapes, a bird in flight. She is dressed in flowing lines appropriate to a sibyl, old rose with white lawn sleeves, white scarf, white veil about her hair, and a white apron billowing large across her lap. It is, no less, a picture of that under-the-apron modeling in progress, though the artist shows only one hand beneath it, the other poised at her side in an intense grasping gesture of the fingers that draws the eye downward toward what may be the painter's signature — a circle with cryptic markings that are now half-defaced by time.

This is Patience of the latter years, surrounding herself with a sibyline aura that was both provocative and self-protective. At the waxwork, or in Phoebe's decorous home, she was receiving the attention due to a gently respected oddity, and that speaks for the kindness of these people. They knew that she loved equally "Old England" and "Dear America." Her dream of a

new "Glorious Revolution" with a reunion of the empire had appeal. They commented pleasantly on her "romantic ideas," and she herself took up the phrase. She must have, as always, a sense of importance in affairs, and they gave it her.

It comes out in what remains of her far-flung correspondence. While Elkanah at Nantes was amusing himself with wax head and figure, she was confiding her hopes and fears to the real Franklin at Passy. Joseph, she wrote, February 22, 1783, had lost all his paintings in the wreck of the *Argo,* but had been rescued and reached Boston at last.[12] "These unhappy tidings makes me feel the Parent, and Joyne in Comforting them." Her "them" embraces both her Joe and Franklin's son William, who was in London petitioning for Tory indemnification. William's "health is bad looks old and Excites in me the old feelings of Friendship." Patience's championship of the Loyalists in their extremity is reflected in one version of her legend, which presents her not as the American spy but as the Tory refugee.[13]

Her letter closes with a prayer that "god wom I trust" preserve Dr. Franklin as a blessing to mankind, and then, restraints thrown aside, she opens her heart in a postscript:

> I hope to see you in Phila this summer as Human nature seems changd. I no longer Prophesie But only say time will bring all my Romantick Ideas Round and convince my Friends I am not MAD but speak the old Quaker truths.
>
> My daughter and husband is well. My health good my sperets rise and feal a Rightous Indignation at the parliment of England. They adopt the faults of george and Charlotte. As they pertake of ther sins they will also have their Plagues. I hope you will visit London. The great Joy will be expressd *mentioned* heretofore and a publick Entry into London; not only 2 hundred but 2 thousand to attend you. Major Labilliere is Ready with his Christian Armie, 7 thousand whom have not bowd down to george or Baal. My kind love to your grand son. I hope his experience and wisdom will make him a great minister. We all wait for the season to set out for america all the wise and prudent are going. Depend on the great fall of Publick Credit. Oh that

Bal must go before Pharoh will go to hanover. My daughter joyns me in love and Esteem. I hope you have health. Pleas to mention me to those who enquire after P. Wright.[14]

William Temple Franklin had been hoping to become his country's first Minister to Great Britain. Mrs. Wright's word on his "wisdom and experience" being equal to the task seems to spring from a doubt which was shared by others. John Adams would take the post instead. But in the meantime the *European Magazine and London Review,* March 1783, published a rumor that Dr. Franklin himself would be coming to the court of St. James's in this capacity.[15] It brought Mrs. Wright to the alert at once. The war was over, King and Queen too long on their thrones, Franklin too long away:

Ever honred Sir
 with the pleasing prospect of peace I Expected to see you arive in London with Public Entry and all my Romantick Idias fullfilld this winter. But to my mortification another year longer before Bag and Bagage is Exported to Hannove. We are Framing parliment Laws for traid and other Delays to Fill up the History of this Kings Reign. The honour the american heros have compleated by this peace has given me new spirit, health, and money is to come of course: and I no longer the old mad woman but "madam wright or the Ingenous mrs Wright from america who told us TRUTH." Now I have a field for my Politicall genii Joynd with my wax work which will do me some Credit if I keep within proper bounds. Experence the Exelent school master has taught me to folow Reason and let the world do as they please. I dont give up my hope of seeing you in London in a very short time. This day a Comitte of membrs of Prlmt Intend Calling out for Comitte of Safty — which if it takes Place it will astonish the Junto, and Restore the lost honor of that house. May you live to Enjoy all the Blessings of Health, peace and Liberty is the hearty prayr of
 dear Sir your faithfull Friend
. . . . P. Wright[16]
March 19, 1783.

Here again we catch an echo of the younger generation lecturing the old — "Politicall genii" and waxwork a credit only "if I keep within bounds." The Hoppners had good reason to be on guard. What was going on, with their own house as headquarters — a plot to put the Prince, their friend, on the throne of the father he despised? "Not only 2 hundred but 2 thousand to attend you," she had written in that letter of February 22. Whether this be numbers or numerology, it is at least safe to assume that the number of beating hearts had increased with the sense of crisis that hung over the land. The war was over, but enemies were still feared. It was just at this time that George Onslow delivered a speech in the Commons, much noted, to exonerate Lord North from blame. The defeat, he said, could be laid to those, even in that House, who had called Washington's army "our army," and its cause "the cause of liberty," who had constantly extolled Franklin and who, he went on, had not only exposed "the weakest parts of our government" but had sent that information to France. At this there were cries of *"By whom? Name! Name!"* — a demand the speaker evaded without withdrawing the charge.[17]

Mrs. Wright had a courier ready to deliver her letter of March 19, but William MacKinnon was delaying his departure in order to be able to bring Franklin news of the King's renewed struggle to retain his power.[18] Charles James Fox, his bitterest enemy, was to head an administration with Lord North as a passive colleague, and this the monarch could not stomach. It was an alliance sure to prolong rather than resolve the crisis — deplored as "unnatural" among Whigs and Tories alike. Here Mrs. Wright could see "the weakest parts" of the government exposed. Her news bulletin to Paris must surely have provoked conjecture, as it does today:

> Honoured Sir
> by the Desire of some of the honest membrs in Parliment this Inclosed proposals for a very useful paper (which is much wanted at the time). The news papers are so under the Direction of the Party of george, that no truth comes out

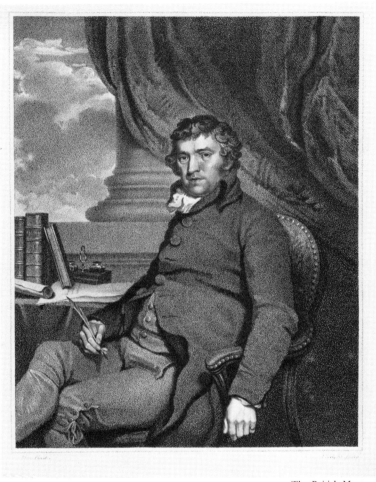

"ANTHONY PASQUIN"

John Williams, Mrs. Wright's confederate in secret corre-
spondence, seen as the embittered literary satirist of later life.
Engraving by J. Wright after Martin Arthur Shee.

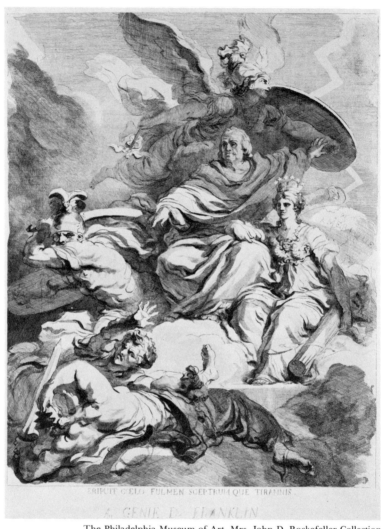

ERIPUIT CŒLO FULMEN SCEPTRUMQUE TIRANNIS

AU GÉNIE DE FRANKLIN

"AU GÉNIE DE FRANKLIN"

The French concept of Franklin as "garduin angel." Etching by
Marguerite Gérard after a design by Jean Honoré Fragonard.

to Inform the People. The People grone undr the tyrant and by assistance from america will through such useful papers open the way to truth. Mr Martain, Mr Evins and Councillor Lofft with others have set forward this weekly paper and by *Franks* and by *Friends* it will find its way through all Ranks of men.[19] Major Labilliere still is on his Hunt after the Enemies of truth as a Christian solder. He sends his love and Enjoys the prospect when you arive. Inclosed is note to you pr Friend who delayd his going. The Barer young Mac Kenning is to set out tomorrow, only waits Ld Surrys motion in the house Lords Respecting chusing a minister.[20]

I am now in Fashion. Several noblemen today calld at my house and I find a total *Ecliepted* or Darkness has sezd on Pharoh —

Pray help the Industrious honest hearted week English. Pity the people and send the Rebel to Power over to some Place where his mischevous Consort or Party can no longer destroy the peace and hapiness of mankind.

The Honourabl Part the French Court has acted and the Light from america has now opend the Eyes of England. They only want your help to set wisdom at work — which will bring Peace and hapyness to us again. I beg you for god's sake, for the sake of Reason Concarn Honour and the good of all men, write to the membrs Parliment or City membrs & Direct them to actt Honest to the articles of Peace.

My daughter Joyns me in most Respectful Complents to your grand son Wm Franklin, To madam Elvisious and others who know my principls. I am Dear Sir your most
<div style="text-align:center">faithful friend and very humbl svt</div>

march 21th 1783 Patience Wright

great talk of a Comitte of Safty &c. The men who is talkt of are Sir Cecil wray, mr Martin, mr Powis, mr Eliott or Eliss, 5 in numbr. If no Choice this day is made by the King the People proceed —[21]

all your old friends in England Rejoyce in the hope of
seeing you once more amongst them and thousands Fama-
lys Ready to Set out for america. Applications are making
Evry day for Passages or Information concerning the voyge
and for owners of Land and the mechanicks, traids men,
merchts, all Sorts opnly declare England is Ruind, they will
go to amcrica. This is thought one of the Reasons why no
minister and so long as no ministers no Emigration to amer-
ica &c. Kings Politicks.[22]

Emigration to America was indeed a disturbing factor, but
not enough to explain the "Kings Politicks."[23] Lord Shelburne
had resigned on February 24 and now, a month later, a year
after the first threats of abdication, the unhappy monarch was
refusing to accept an administration under Fox, and still pon-
dering a retreat to Hanover. It was said that he had at last
persuaded the Queen, though Horace Walpole thought she had
only judged it "wiser to humour a person in a passion than
contradict."[24] Five years before he had declared he would rather
lose his crown than wear it with Chatham as chief minister, and
now a far more hated enemy stood waiting. An angry Parlia-
ment was demanding that he act. "Ld Surrys motion," promised
on Friday when Patience wrote, came on Monday in the form of
a threat that the people would assemble "in all parts of the
kingdom" to obtain even more than "equal representation."[25]
Lord George Gordon had become again a shadowy influence,
and one night after the Earl of Surrey's speech mysterious
handbills were posted calling upon *the friends of Liberty to meet in
St. George's Fields on the 27th, when something would be proposed that
would amaze all Europe,"* and subscribed, *"Damn the King!"*[26]
On April 2 the King at last grudgingly accepted the Fox-
North coalition. Patience's courier was on his way with the
news — news, too, of that "Comitte of Safty," prepared, it would
seem, to see "Bag and Bagage" on their way to Hanover. Com-
mittees of Safety had launched the American Revolution, and
one can sense raised eyebrows, puzzled and incredulous, among
those who read her letter at Paris.

Puzzling too is her news that "Darkness has sezd on Pharoh." That, on the face of it, records an attack of the King's insanity five years before the recurrent condition became known to everyone in October 1788.[27] Yet there is no supporting evidence of this. George III had been for months under severe strain, humiliated by the failure of his imperial policy, by the near ruinous state of the nation, by the open contempt of his people, by the loss of his power, and, finally, by having to accept Fox as true head of the new administration. He was, enough said, "Ecliepted" and in darkness.

On April 2, 1783, the King accepted the new ministry, though determined to maneuver for its fall. It was a point from which rumors of abdication subsided, but, curiously, rumors of Franklin's coming sprang up. All through that April and May they persisted. Dr. Richard Price assured John Sargent it was true — "expected here *weekly* in a private, if not a Publick Character — the same thing was for a long time confirmed to me by that worthy man Mr. West, The King's Painter — but, at last, I hear I have been misled."[28] If West and Price believed it, so must Patience Wright. Would he come, or would he not? Her letters of these last two months sound no trumpets for a grand entry, although, presumably, the "Christian soldiers" were still in readiness. Note that she slaps the tag "Rebel" upon the monarch himself. It was "Dear America" who had been loyal to the spirit of "Old England."

Yet at the same time she was giving her heart and loud attention to the plight of the American Loyalists, sufferers themselves at the King's hands as she saw it. She wrote again to Franklin on their behalf, and with only an oblique allusion to the expectations of Labilliere and his forces:

Honord Sir

I had the pleasure to see your Son at my house governour Franklin and according to my custom I had a long chatt with him —— as I am now in Fashion at Court or in other words not in the same disgrace as while america was in Rebelion — wherefore now I can speak out such truths as

may be useful to the honest well meaning Rulers: who all own, they have not had truths laid before them.

the parliment is much divided with regard to the Loyalists and their Clames being *Just* on the King. It is thought the people will make him actt the honest Part by them: or make an Enquiry: which nothing he *fears* so much, for his *fears* of being calld to an account has been the cause of all the Delays in ministry and in acts of traid Repeal &c. Good Care is taken to keep up the spirits of the people and all Parties are *Decevd* and *Deceving* Each other, But nothing is Determind by any *Party* but to keep off Justice, or the *Retrospect:* Ld North has a promiss from all *Parties* to keep him his head. The Bank, the great Band of society, keep all together until you make us a visit nothing will be setteld.

the govenore looks well but old: and very prudent: and he being Chose by New Jersey will be considerd by us that forward the good Claim on the King: as much strengthing the Case of the people against his tyrannacall unjust treetment of all America: Friends and Enemies as their Case is now the subject of conversation.

I most heartly Joyne in seting this Case in the strongest light in favour of those well *meaning* honest men who now suffer for their Loyalty to the disgrace of Kings.

I hope those good opertunitys to unite all our force against tyrants, Knaves &c. will be now the business of all great good men and help the people out of their present dificultys. We still look up to you and are with the most sincer Inthuzam your faithful

Friend and very humbl servant the People

Joynd by esteem Patience Wright

The Prince Wails Calld on us Friday. Ld Dartmouth Ld Lusom with others Imploy my son-in-law to Paint their Portrits.[29]

Major Labilliere has his Christian Army almost Ready. He calls him self a Christian soldier.

[April] 28th 1783[30]

The Prince of Wales had called. Did Labilliere hesitate on that, his army now only "almost ready"? Uncertainties were everywhere. Parliament was debating the future of American trade, a matter watched by Elkanah Watson from Nantes, where the end of the war was ending the prosperity of Watson and Cossoul. Silas Deane had come to London with an eye on this issue too. Watson had met him at Ghent, learned how bitterly hostile toward his native country he had become, and had reported the fact to Franklin.[31] But Deane had a haven of sorts at the waxwork, where anyone who felt wronged, it would seem, could find sympathy and encouragement. In June another unfortunate found his way to Franklin bearing a brief note from the waxwork to reinforce his plea for help:

Honred Sir

Mr Mascall is on his way to Settel in Philadelphia. He was amongst the first men who wrote against the american war, and one of the first in the London association &c. His Stedy behaviour against the wicked medlurs of the ministry — and faithful in the Cause of *The Rights of the People* — Brot on a Suffering and percecution from Lords mansfield and other men in Power which has deservedly Recomended him to the favour of america.

mr mascall has a Knowledge of Phisick, Brot up an appotacary — Cymist &c, has a strong understanding, Knows the laws of England, has read men and Books, and been useful in the Cause of america and Intends spending the remainder of his days in that Contry of Peace and Liberty —

I am Sir with the higest Esteem
your faithful Friend and humbl servnt
Patience Wright

London June 19th 1783
To doctr Franklin[32]

This was the last she would write to her great friend, envisioned for so long as "garduin angel" of the people. What

ended that rapport? Was it that the treaty of peace, concluded
on September 3, 1783, wiped out her hopes for reunion? Or was
it because Franklin had ignored those appeals to him to come,
those preparations for the march up from Dover, the entrance
into the city, the triumph of her dream? There had been re-
peated crises when all signs were auspicious, the people aroused,
the tyrant in dismay - - most of all in this very year, between
February and April — and he had not come. It must have been
in some measure all of these things, but there is an irresistible
temptation to point to one small incident as the thrust into the
bubble of her dream, the sharp edge that cut the cord of friend-
ship.

Watson came into town in this summer, his promising
commercial career in ruins but with high spirits undiminished,
his wax head and its accompanying suit of clothes ready at hand.
His lodgings were away on the other side of London, remote
from Palace and Pall Mall but deep in the world of business and
finance. Billeter Square, crowded and small, is in the old heart of
London not far from the Tower. Once the quarter of the belyet-
ers, or bell-founders, it was a tiny residential district of brick
houses built earlier in the century, but surrounded by small
shops and ancient buildings, many dating from before the Great
Fire. Here Elkanah set up, as he called it, his "bachelor's hall."
One of his first acts before sallying forth into the town was to set
up his figure of Benjamin Franklin at a window, the sage appar-
ently gazing down with reflective interest into the little square
below.[33]

There it could remain by day, but in the evenings there was
fun to be had with the figure. Again we have two accounts,
Elkanah's for one, and for the other, this time, that of his Tory
relative, Elisha Hutchinson, whose diary dates the incident it
describes, August 25, 1783:

> Mr W. has a striking likeness of Dr Franklin by Mrs. Wright
> in wax, and another which was designed for himself, but
> there is want of resemblance: they being dressed, and [in a]
> sitting posture in the room, would deceive the nicest dis-

cernment at first entrance, and everyone at first is led to speak to them.[34]

From this terse account we can perceive what the other makes amply clear — that Elkanah's humor was not endearing him to his friends. A counterfeit of Franklin's presence was not something one could impose upon others as a joke. For the incident which he himself describes we also have a date, though he does not give it. He tells us only of three gentlemen from Boston, one of whom he calls "Mr. B.," bearing letters of introduction from Franklin's old friend the Reverend Dr. Samuel Cooper, but their identity and date of arrival can be guessed. On July 19, 1783, Dr. Cooper wrote two letters of introduction, one for Oliver Brewster and one for Benjamin Austin, Jr.[35] They were, he told Franklin, young gentlemen of excellent character who were embarking for England, after which they would travel in France. The third Bostonian is unidentified. Since it may be supposed that Brewster and Austin arrived in late August, the date must be very close to that given by Elisha Hutchinson.

Elkanah places it only in general terms, "after the peace of '83." He goes on to explain that the figure at his window had been recognized — an interesting reflection upon how well Franklin was remembered in London. It was attracting excited attention, and Elkanah ordered his man to take it down. Already, however, the word had gotten about, and one of the morning papers broke the news that Dr. Franklin had come, unannounced, to London. This was read by the new arrivals from Boston, who begged at once to be allowed to call and present their letters:

> In the interval, three Boston gentlemen who were in the city expressed a wish to pay their respects to the Doctor. I desired them to call in the evening, and bring their letters of introduction, which they had informed me they bore, expecting to see him at Paris. I concerted measures with a friend to carry the harmless deception to the utmost extent on this occasion. Before entering, I apprised them that he

was deeply engaged in examining maps and papers; and I begged that they would not be disturbed at any apparent inattention. Thus prepared, I conducted them into a spacious room. Franklin was seated at the extremity, with his atlas, and my friend at the wires. I advanced in succession with each, half across the room, and introduced him by name. Franklin raised his head, bowed, and resumed his attention to the atlas. I then retired, and seated them at the farther side of the room.

They spoke to me in whispers: "What a venerable figure!" exclaims one. "Why don't he speak?" says another. "He is doubtless in a reverie," I remarked, "and has forgotten the presence of his company; his great age must be his apology. Get your letters, and go up again with me to him." When near the table, I said, "Mr. B——, Sir, from Boston." The head was raised. "A letter," says B——, "from Doctor Cooper." I could go no further. The scene was too ludicrous. As B. held out the letter, I struck the figure smartly, exclaiming, "Why don't you receive the letter like a gentleman?" They were all petrified with astonishment; but B. never forgave me the joke.[36]

It is probable that young Mr. Austin, whose identity is entirely concealed in the story, was even more resentful. He would return from Europe full of ideas and live out his life as one of the most vigorously contentious characters ever known upon the ever lively stage of Massachusetts politics. It seems safe to assume that the "friend" at the wire was the dramatist-to-be, Frederic Reynolds.

What we are not and shall never be told is the effect of that item in the morning paper upon Patience Wright. This must be left to the imagination. Word of the excitements at Billeter Square might never have reached her, but the little announcement in cold print emphatically would — if not read by herself at once, others would surely come running with it to the waxwork, astonished that she, Franklin's friend, had not known. The "congregation" would see it, the Major and the "Christian

soldiers." All of those whom she had been preparing over so long a time for that triumphal entry would wonder, and perhaps darkly, how this had come about. The newspaper stated that Franklin was staying "at an American merchant's" in Billeter Square.[37] Did they hurry to the place to see for themselves? Was it to stop such clamor that Mr. Watson "found it necessary," as he says, "to contradict the report" in another issue of the paper?

In all the possible conjecture, one thing is sure. The joke was on Mrs. Wright. She "of strong faith" who had prophesied great things, had predicted the public entry through cheering throngs, the toppling of the throne, must face the cold truth of this ripple of excitement created by one of her own wax heads. She wrote no more to Franklin and, from what evidence survives, made no further boast of his friendship nor calls upon it. This was the end of the dream.

General Washington and Master Billy

THIS was the end of the dream. Franklin's friendship for her had given her a public importance, now melted away. If all those preparations for his entry into London had had any effect upon the developing crisis, it could only have been to raise an alarming portent of what the fall of the monarchy might bring with it. The myth of her influence was gone, though Franklin himself continued in the news. In mid-October of 1783 his intention of visiting England in the spring for a final leave-taking was reported.[1] Two weeks later came word that the Doctor had been "sent for to America, in order to have his Advice in making a Code of Laws for the better Government of the United States."[2] None of this brought, as it once would, hearty words from the waxwork.

Prophetic inspiration comes with the authority of a power beyond the self, a loftier light and will. Pity the one who has proclaimed it to eager believers, when the power fades. The self, exalted in its coming, is bruised and shriveled in its loss. In her art we read of wildly inspired modeling, but not one new work is recorded. There will be no grand entry and new dawn for England, yet lightning still must flash from what cloud remains, and now, like a gingerly given consolation prize, a new arrival in London brought new prospects of "doing good." John Adams, America's first envoy to the Court of St. James's, was an old acquaintance of younger days. He came in November. The London papers were full of the treaty of peace and its terms. The touchy business of adjusting the old nation and the new to coexistence had begun.

Adams, as most Americans did, sought her out at once. She was away at the time on one of her many calls through the town — devastated to have missed him — overjoyed when young John Quincy Adams appeared and carried back her welcoming note, "a token wrote from the heart of a old frend."[3]

John Adams' cordiality gave promise that women could still be useful in grand events. Joe was safe in America, lightening a great burden of worry and bringing within her reach a new source of usefulness and éclat — the possibility of adding to her gallery the greatest guardian angel of the day. Joe had cut a lively course down from Boston to home ground in New Jersey, where he found Washington encamped with his army at Rocky Hill, near Princeton, waiting for the last British forces to withdraw from New York. He had lost his portrait of Franklin and that wonderful piece of his mother in the shipwreck, but proceeded at once to demonstrate his skill as a painter with a portrait of the General. As for the life mask his mother so much desired, this, alas, was botched. Washington agreed with reluctance to submit to the process, and then, with Mrs. Washington's sudden entrance, her cries of alarm, and his own muffled laughter, the plaster was broken in its hurried removal. Joe was able, later, to model both a bas-relief and a bust.[4] His mother, meanwhile, hearing something of the activity at Rocky Hill, wrote to Washington in gratitude, December 8, 1783:

Honered Sir

My Friends Write to me from America that Joseph Wright (my Son) "has Painted a Likeness and also moddeled a Clay *Busto* of general Washington which will be a very great honour to My Famaly."

I most heartily thank my god for sparing my life to see this hapy day — — I joyne with all my friends in the pleasing prospect that Posterity will see, and behold the Statue of the man who was apointed by his Contry, and the Voice of the Enlightened Part of mankind to be the great general to save the Liberties of the Christian Religion and Stop the Pride of old England. — and by his truly great and noble

Example in all human Vertues he has Restord *Peace* on Earth, *good will* toward mankind —

Truly hapy are you Sir to have the greatful thanks of all Europe — with the Prayis of the Widow and the Fatherless — you have my most greatful thanks for your kind atention to my Son in taking him into your Famaly to encourege his genii, and giving him the pleasing opertunity of Taking a Likeness that has I sincerly hope, gave his Contry and your Friends Sir, Satisfaction —

I am Impatient to have a Copy of what he has done that I may have the honour of making a model from it in wax work. It has been for some time the wish and desire of my heart to moddel a Likeness of generel Washington. Then I shall think my self arivd at the End of all my Earthly honours and Return in Peace to Enjoy my Native Contry

I am Sir with gratitude and Respect

your very humble Servnt

Patience Wright[5]

It may be conjectured that she entrusted this missive to Elkanah Watson for delivery.[6] That would account for its requiring a whole year to reach Mount Vernon, and also explain a direction the conversation took in one of the pleasantest pictures we have of the victorious commander relaxing at home. Elkanah had been in London when Patience wrote. He left in March 1784 for a tour of the Low Countries, returned again to London, and finally embarked for home on August 21. Just before sailing he spent an evening with Granville Sharp, founder of the Association for the Abolition of Negro Slavery, who had been a warm friend of America throughout the war. Learning that he intended to visit General Washington, Sharp put together a set of his own writings for delivery to the great man.[7] Elkanah had already established credentials at Mount Vernon. When the news of Yorktown had reached Nantes, he and his partner had employed the nuns there to embroider a Masonic apron upon which, along with the rest, conjoined French and American flags were emblazoned, a gift which Washington had acknowledged with fraternal and affectionate gratitude.[8]

"Just as we had done dinner," the General noted in his diary for January 19, 1785, "a Mr. Watson, late of the House of Watson & Coussoul of Nantes, and a Mr. Swift, Merchant in Alexandria, came in and stayed all night."[9]

"I found him at table with Mrs. Washington and his private family," as Elkanah continues the story, "and was received with the native dignity and urbanity so peculiarly combined in the character of a soldier and eminent private gentleman. He soon put me at ease, by unbending in a free and affable conversation."[10]

Elkanah confessed that "I felt an unaccountable diffidence as I came into the presence of this great man." To make it worse, he had caught a miserable cold, with cough, on the journey down from New England. But "free and affable conversation" came easily to young Mr. Watson, and one has the impression that each unbent to the other. They had interests in common. Watson had made himself an authority on canals in England and on the Continent, an expertise which would figure in his later career in New York. Washington was at this time directly involved in development of the Potomac River by canal.[11] It was a serious topic, of value to both. On the lighter side, they had Mrs. Wright.

Watson had his stories of the lady chemist, the head in the basket at the Paris gate, the Mayor of Nantes, "Franklin" in London nodding over his atlas. The General matched these with his story of Joe and the life mask. We have the tale as Elkanah remembered it long after:

> Among the many interesting subjects which engaged our conversation in a long winter evening (the most valuable of my life), in which his dignified lady and Miss Custis united, he amused us with relating the incident of the taking of this model. "Wright came . . ." the General remarked, "with the singular request, that I should permit him to take a model of my face in plaster of Paris, to which I consented, with some reluctance. He oiled my features over; and, placing me flat upon my back upon a cot, proceeded to daub my face with the plaster. Whilst in this ludicrous attitude, Mrs.

Washington entered the room; and, seeing my face thus overspread with the plaster, involuntarily exclaimed. Her cry excited in me a disposition to smile, which gave my mouth a slight twist, or compression of the lips, that is now observable in the busts which Wright afterward made." These are nearly the words of Washington.[12]

In another recollection Elkanah writes of "a peculiarity in his smile which seemed to illuminate his eye; his whole countenance beamed with intelligence, while it commanded confidence and respect —"

> The gentleman who had accompanied me from Alexandria left in the evening; and I remained alone in the enjoyment of the society of Washington for two of the richest days of my life. . . . I found him kind and benignant in the domestic circle, revered and beloved by all around him; agreeably social, without ostentation; delighting in anecdote and adventures, without assumption; his domestic arrangements, harmonious and systematic. His servants seemed to watch his eye, and to anticipate his every wish; hence, a look was equivalent to a command. His servant Billy, the faithful companion of his military career, was always at his side. Smiling content animated and beamed on every countenance in his presence.

"Delighting in anecdote and adventures," the General nonetheless waved aside all allusions to his part in the war. Good talk and laughter so shared bring a bond of sympathy, and the young man remained through after years enormously touched by the memory of that night:

> We sat a full hour at table, by ourselves, without the least interruption, after the family had retired. I was extremely oppressed with a severe cold and excessive coughing, contracted from the exposure of a harsh winter journey. He pressed me to use some remedies, but I declined doing so. As usual after retiring, my coughing increased. When some time had elapsed, the door of my room was

gently opened; and, on drawing my bed curtains, to my utter astonishment, I beheld Washington himself, standing at my bed-side, with a bowl of hot tea in his hand.[13]

Watson departed in the morning and his host continued the work of the day before, "arranging the walk, etca.," and grubbing out the undergrowth "in my Pine Grove on the margin of Hell hole."[14] On Sunday, January 30, Washington found time to pen a reply to Mrs. Wright:

> Madam: By what means it came to pass, I shall not undertake to devise; but the fact is, that your letter of the 8th. of December 1783, never got to my hands until the 12th. of the same Month in the year following. This will account for my not having acknowledged the receipt of it sooner; and for not thanking you as I now do, before, for the many flattering expressions contained in it.
>
> If the Bust which your Son has modelled of me, should reach your hands, and afford your celebrated Genii any employment, that can amuse Mrs. Wright, it must be an honor done me. and if your inclination to return to this Country should overcome other considerations, you will, no doubt, meet a welcome reception from your Numerous friends: among whom, I should be proud to see a person so universally celebrated; and on whom, Nature has bestowed such rare and uncommon gifts.[15]

He wrote with the courtesy due a woman whose fame as artist and patriot had been well known long before that young man had come by and added a new dimension to her "genii." One can sense amusement behind the deferential terms, while longing to know what else the General may have heard of rumor or truth. Had that military information from Lord Dartmouth's office reached him? Or any of those papers sent hidden in wax heads to Rachel Wells? Could he have connected her in any way with her cousins and friends of the Culper Ring? That is unlikely indeed, but Washington had given much care to his secret service in the war, guarded their identities then and later, remembered and recompensed. The legend of Patience Wright

the spy had begun to flower by 1785. Imagine him puzzling over it for a moment, a smile, stroking his nose with the quill before dipping it again.

How well Mrs. Wright had kept in touch with Long Island and New York in her far-flung correspondence we shall never know. Platt had been one direct link. Another, whose fate may have added much to her worry over Joe's absence at sea, had been Joshua Townsend, grandson of her uncle of the same name and a cousin of the Townsends of the Culper Ring. Joshua, a sailor lad aged nineteen, had come to the waxwork in October 1776. She and he had taken tea together while he told her of his plans to ship aboard a British whaler. That was the last to be heard of him, though she helped in the search made after the war, inquiring, advertising. The trail seemed to lead to a press gang of the Royal Navy and finally a story, unconfirmed, of his escape from a warship in one of the West India islands.[16] It was one more iniquity at the door of the tyrant.

As for Pharaoh's overthrow, that hope may have returned briefly now, though within four months it would be roughly stricken out forever. John Adams' arrival and friendly greetings in November 1783 may well have prompted other dreams. One read in the papers of his attending a meeting of the Revolution Society to commemorate the accession of William III.[17] Her note of welcome eagerly declares her willingness to "wait home from any other *pleasure Engagement or Business*" in order speak again with "the man who has undr god saved his Contry."[18]

That longing to return to America had come again, but again the excitements of London politics were soon absorbing all attention. The Fox-North coalition met defeat in Parliament on December 17. It was a crisis engineered in part by the King, who on the next day appointed William Pitt, a younger son of the Earl of Chatham, his First Lord of the Treasury. This new William Pitt, aged twenty-four, had been only briefly in Parliament. He was "Master Billy" to the Whigs, and they derided the "backstairs" management by which he had come to terms with the throne. He held on precariously until, on March 25, Parliament was dissolved — to be followed by one of the most memor-

able, most uproarious of all British elections, April 1 to May 17, 1784.

Long in advance, all England was in a seething fury of anticipation, and Patience's own district of Westminster most of all. Westminster was the most democratic constituency, the most hotly contested, the storm center. Charles James Fox led the Westminster Whigs. Against him stood the revived Tory party with Pitt at its head. Pitt and Fox alike had spoken for reform and opposed the American war. With either the long personal rule of George III would be ended, but with Pitt on terms far more acceptable to His Majesty. It was full of ominous import, confusion, and change, a "whirling about of parties," as Patience explained it to a newly arrived American, and "no knowing who were Whigs and who Tories."[19] She might have had some feeling for the attractive young son of the "gaurdin angel," the King's enemy of ten years before, but Fox was the hero of the populace, the King's enemy of the moment, the boon companion, too, of John Hoppner's friend and patron the Prince of Wales. The list of Hoppner's portraits makes clear his stand with Fox and the Prince, a Whig bias his children and grandchildren tried later to disclaim.[20]

Squibs and caricatures came like leaves blown on the first gusts of the storm, lightening its rages with laughter. Here and there among them are allusions to wax or waxwork, guarded, indelicate, dangling ideas too obvious to partisan minds to need elaboration. The unique "No. 1" of *The Court and City Magazine* catalogues an exhibition of art in various forms, including wax figures, but particularizes a painting:

> 5. Patience on a Monument, by Mr. W. Pitt. — This piece is tolerably finished; and such a painting seems much wanted to terminate the Treasury *vista*.[21]

Patience, a famous town character now, declared her sentiments as everyone else was doing — but in her own oblique style. She set up her waxen image of the father of the King's candidate in the window of the waxwork, looking out into Cockspur Street upon the throngs of people passing between Pall

Mall and the Strand. The throngs could look through the glass and catch the eye of the founder of their lost empire, pride, wisdom, and dignity, a guardian angel rejected. This from the woman who had told them "the TRUTH," though she no longer prophesied. It was a reminder of past greatness, of an unbending will that might have held America and Britain together as one. It was a rebuke to youth and vainglory and backstairs intrigue. It was there, watching, into the terrible night of February 28, 1784.

Pitt's adherents the while were intent upon bringing him splendidly, resoundingly, into prominence. "The Grocers' Company," we read in the *Morning Herald* of February 24, "have waited on Mr. Pitt to offer him the freedom, and have invited him to dine at their hall. . . . Great preparations are making for the reception of the young premier." And then, ironically, on the morning of February 28:

A PROCLAMATION!
Make way for the GROCER'S COMPANY!
PITT and PREROGATIVE for ever!
Bless the Lords of the BEDCHAMBER!
The Sweet Liberty Boys!
BACK STAIRS and SECRET INFLUENCE for ever! Hurra!

The young premier was to go in grand procession on that Saturday from Westminster to the great hall of the Guild in London to be accorded all the honors the livery could bestow, an entertainment, it was reckoned, costing a thousand guineas. And on it came, magnificent — horsemen, carriages, marching citizens, a military band of music, filling the street, flowing along as the friendly *Daily Advertiser* describes it, "amidst the Acclamations of applauding thousands" through "one continued Scene of Joy." Banners waved above the rumbling drums, the jubilant fifes and horns, and on Ludgate Hill the ladies of the Court cheered it shrilly forward, their muffs and hats emblazoned with *"Pitt forever; Liberty and our Country."*[22] It was such a scene as Patience Wright had imagined, so often and so long, in dream and hope, coming in from Dover with her "Doctr Frankling" in the great coach at its center.

Thomas Rowlandson immortalized it all in caricature, *MASTER BILLY'S PROCESSION TO GROCERS HALL.* Here the celebrants move by, reduced to ridicule. Master Billy, riding in a little cart drawn by children, is precisely opposite the "WAX WORK," the long white plume in his hat just touching its sign. A spectator leaning out of a window of the "LORD CHATHAM" inn comments, "Very like his Father." Another, from an upper window in the house of "Tommy Plumb, Grocer to his MAJESTY," cries, "O what a charming YOUTH." Flags flutter in the winter wind and the crowd shouts, "Pitt and Plumb Pudding for ever, Huzza!"

The sumptuous dinner, steaming dishes and flowing wines, carried the affair at the Hall well into the dark hours of the night, while outside the waiting citizenry prepared for the "illumination" intended to light the celebrants back to Westminster. Friends of Pitt would have candles in their windows — and enemies too, if they did not want the glass broken. The time went by, and seemed to have passed. But then, rumbling and grumbling from afar, they came. True to the rule by which political fanfare brought riot and mayhem in its wake, the day's real peak was reached in those small dark hours toward midnight on that march back from Grocers' Hall. His rowdy henchmen had taken the horses from Master Billy's coach and were drawing it themselves in the midst of a swirling drunken throng. "Lawless riot and unchecked outrage" were taking over. The city's big paving stones were torn up and flung with crash and thud and rattle of falling glass, defiant yells of triumph bearing the tumultuous pack along.[23] Ground floor lights were not enough. No window without a light would be spared if stones could reach it. The Foxite *Morning Herald* best tells the tale of the battle and destruction moving along the Strand toward Cockspur Street, the waxwork, and Pall Mall.

PROCESSION of Mr. PITT from GROCER'S HALL

Sky rockets being let off, as a signal to apprize the hired rabble, which joined at the different places of rendezvous appointed, the gates of the Hall Court were thrown open, about eleven o'clock, when out sallied Mr. Pitt, drawn by a

set of persons who had been permitted to partake of the good cheer provided for their employers, and headed likewise besides the unthinking many, by several servants in liveries, and other stout fellows, some with bludgeons about half the size of a constable staff, and others with flambeaux, and indeed many with both. They had passed on breaking every person's windows who possessed spirit enough not to light up candles, to honour a man who is attempting to deprive them of that liberty their ancestors have for ages past so nobly struggled for and handed down to them, till they came opposite to St. Clement's Church in the Strand, when it occurred to the writer, on seeing about half a dozen coal-porters daring enough to assert the cause of freedom, in defiance of such an host, of the few miners of Dalecarlia, who were so eminently assisting the great Gustavus Vasa in procuring liberty to Sweden. These were immediately attacked by a party of Mr. Pitt's vanguard, with brick-bats and stones, who, though numerous, were kept at bay for some minutes, with only the dirt the gateway afforded, till the grand guard was called to the attack, who inhumanly knocked down many innocent persons, acting only as spectators of the courage of those few brave fellows. From thence they proceeded on, committing the same depredations without the least interruption, till they reached Brookes's where a gentleman, who had been witness of their lawless proceedings, desired the chairmen to take care of their chairs, or they certainly would be broke; but the vanguard of the rioters being so near as not to permit them to have time to move their chairs into a place of safety, they resolved to defend them, provided they were attacked: these words were hardly spoken, but the attack commenced against Brookes's, and several glasses of the chairs were demolished. The chairmen no longer able to bear seeing their property destroyed, and their persons insulted, broke some of the poles of the chairs with which they armed themselves; the attack now ceased till Mr. Pitt arrived opposite, when a general halt was made for the whole cavalcade to be

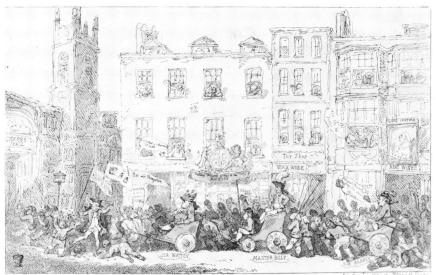

MASTER BILLY'S PROCESSION

The younger William Pitt, hauled through the streets in a baby carriage under the banner "KING'S MEN," moves past the "LORD CHATHAM" and the "WAXWORK." Caricature of March 8, 1784, by Thomas Rowlandson.

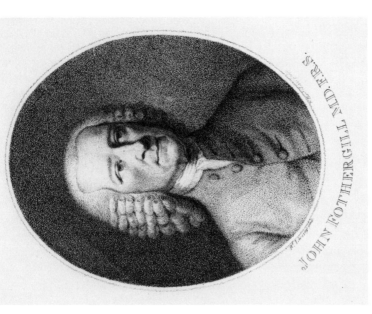

DR. JOHN FOTHERGILL

The bust by Patience Wright made for a niche in the library of Dr. John Coakley Lettsom.
Left, as painted by Richard Livesay and engraved by Francesco Bartolozzi, 1786.
Right, copy by William Jones, c. 1845, presumably a cast of the face with remodeled wig and costume.

witness of the sport. But alas! Their triumph was soon over, for no sooner had they begun the attack, but they were attacked in their turn by about twenty of the justly incensed chairmen, and as soon, if possible, took to their heels, and left the coach with Mr. Pitt and Lord Chatham directly facing Brookes's, and which came in for a full share of the pelting materials, flying from one side of the way to the other, and upon a lighted flambeau falling into the coach that was aimed at the chairmen by one of Mr. Pitt's servants, the prerogative party retreated down the back stairs precipitately, and took shelter in the Maccaroni, and the coach then for some minutes became the sport of both parties. During this, the other coaches wisely turned tail, and took different routs; a suspence then for a short time induced Mr. Pitt's forces to rally, and to draw up the coach for him to get in, which he no sooner accomplished, but the cry of Pitt forever was heard again, and being accompanied with a volley of stones, mud and sticks, directed at Brookes's, which were felt by many of the spectators, particularly Col. North and Mr. O'Burne, they were again attacked in their turn, and on their retreating, Mr. Pitt was once more obliged to alight, just as the coach reached White's; and soon after had the mortification to see a party of his ruffians skulking away with the shattered coach. After this there was a kind of parley; several Noblemen and Gentlemen going from White's to Brookes's, and from Brookes's to White's; during which Mr. Fox came to Brookes's in a chair, his house having been rendered uninhabitable by all the windows being broke, and no doubt, by a party hired on purpose for that service, as they seemed unconnected with the rest of the rabble, and by the house being situated in a remote place, where the cavalcade was not to pass. But it is happy for the cause of freedom and the nation, that he did not seem to have received any hurt.[24]

It is understandable that the procession may have been delayed so long that Patience, on guard at the waxwork, had lost all

expectation of its coming by. She may have been one of those with "spirit enough" to place no lights, or she may have taken them down — but when the warning came she hurried with candles to windows just as the wild tide surged by. They gave her no grace. The story of what occurred must have come from Patience herself, perhaps to Joe or Elizabeth, and then to the pages of the *New-York Packet:*

> Among the numerous depredations committed by Mr. Pitt's mob during his midnight progress from London to Westminster, the attack made on Mrs. Wright's windows was particularly violent, and attended with strong circumstances of inhumanity. This lady is well known to the ingenious world for her very curious display of wax figures: On the first call for lights, while she was endeavoring to place some candles on the sash frames, a brick was thrown in, which narrowly missing her own head, knocked down that of the Earl of Chatham, whose waxen representation stood near her. It is not a little singular, that though the room was full of many respectable and great characters, not a bust received any material injury except that of the noble Lord in question, who was demolished by the friends of his son.[25]

A few days later the polling began, to roll on through more than six frenzied weeks. In Westminster, armies of ruffians were mustered to terrify opposing voters, Admiral Lord Hood's sailors for Pitt, Irish chairmen for Fox. Elkanah Watson saw some of it, awestruck as a climactic battle raged through Covent Garden Square.[26] Ladies were out in such force and allure that Elisha Hutchinson tells us "some people have proposed that it should be called the Ladies' Parliament."[27] Flower of them all, the beautiful Georgiana, Duchess of Devonshire, was trading kisses for votes for Fox. Fox won Westminster by a narrow margin, but the new Parliament as a whole was Pitt's and its majority found ways to deny him his seat.

So ended a decade momentous for Britain and America. The King was on his throne and this new William Pitt would

refashion the broken empire around it. "Pharoah," no longer able to buy his own majority in the legislature, would linger on into those darkened later years, with his chosen premier dominating British history through most of them. But at the waxwork the "gaurdin angels" were no more, the "Inthusazm" of strong faith and hope had been shattered like the glass and wax, beyond repair.

"I Must Kiss You All"

HERE they were in London at war's end, still with the bright promenade of Pall Mall between them, Patience and King George. If she was losing touch with reality, so was he. Both had been wholly committed to a cause and stood proof against the mounting evidence of failure. He was the last English king to assert the right of royalty to rule. She was a spark of seventeenth-century England blown back to the mother island from the west — just such a zealot as had denied the sacredness of royal blood in the earlier reign. He had before him those last long years of darkness, she a shorter span filled by pretense, playing a game of secret statecraft, of "doing all the good I can." Gone was the brash, blunt honesty of young womanhood. She found pleasure in being, or seeming, devious. These years recall the games played at Bordentown so long before with little people who were not really people, that world within the world of Tryon, Quaker meeting, the village street and store.

Each, entering on this decline, had the deferential gentleness of friends. They created a supporting drama, a semblance of truth. For Patience there was no rejection, no isolation, no laughter. John and Phoebe's circle accepted the political activity with bland concern. They would even enlist her aid or carry a dispatch. Wherever an artist of such unusual panache might grace an occasion, she was invited. Richard Cumberland came upon her soon after the war at one of Elizabeth Robinson Montagu's parties. Mrs. Montagu liked to bring authors and artists together, but she enjoyed people of all sorts, down to the little

chimney sweeps of the city, for whom she gave a picnic every May Day on her front lawn, roast beef and plum pudding. She was older than Mrs. Wright, in her sixties now — an intelligent face, as Sir Nathanael Wraxall observed it, marked by "something satirical and severe, rather than amiable or inviting. She possessed great natural cheerfulness and a flow of animal spirits; loved to talk, and talked well on almost any subject."[1]

She was much admired for her book defending Shakespeare from Voltaire's attack. In 1781 Dr. Samuel Johnson's indifferent opinion of Lord Lyttelton's poems had brought "a declaration of war against him from Mrs. Montagu," to his chagrin.[2] Lord Lyttelton's portrait was at the waxwork, and it may well have been Mrs. Montagu who first commissioned it. "Nothing feminine about her," Wraxall says, reminding one of Colonel Barré's estimate of Mrs. Wright's "masculine understanding." Both women held strong opinions and were quick to defend them. "Sir," Dr. Johnson said, with Fanny Burney, Elizabeth Carter, and Hannah More in mind, "Mrs. Montagu does not make a trade of her wit; Mrs. Montagu is a very extraordinary woman: she has a constant stream of conversation, and it is always impregnated; it has always meaning."[3]

This comment was made on May 15, 1784, which must have been just about the time when Richard Cumberland, strolling through the rooms at Portman Square, found both Mrs. Wright and Samuel Johnson in one of them — though not, understandably, in the give-and-take of conversation. Cumberland, popular playwright, had been absent for some time in Spain on a government mission, and now came in from his home at Tunbridge Wells expecting surprises. He had no idea who the heavyset woman in the black cloak might be, sitting by a fireplace with her feet up on the fender (in order, of course, to bring more warmth to the wax), her hands busily at work on something out of sight under her apron. Puzzled and amused, he sat down nearby. She, also amused, had her eyes brightly fixed upon him, her hands still moving rapidly over that something out of sight. It might be, he guessed, a pillow or cushion of some sort. At last she was ready, still challenging his curiosity.

"You have heard of the Witch of Endor," she said. "I am a descendant of that old lady's, and can raise the dead as well as she could."

With this she swished her apron aside and there, looking up at him from her lap, was a face which Richard Cumberland had known well. But General Robert Monckton, soldier of the French and Indian War, wounded at Wolfe's great victory on the Plains of Abraham before Quebec, Governor of New York, and then at last a Member of Parliament, had been dead for two years and more.

"You know this brave fellow, I perceive," says Patience, pleased, as ever, by the look of surprise and admiration. "England never owned a better officer. He was my hero, and every line of his face is engraved on my heart."

The incident comes to us in the first edition of *The Observer,* published by Charles Dilly, 1785 —[4] sketches of London characters under fictitious names, some of which had kept everyone, up to Queen Charlotte, guessing.[5] General Monckton appears only as "the father of Calliope." The little picture of Mrs. Wright is almost the only word we have of her at this late date as an artist in wax. It supports what Elkanah Watson asserted, that she could model an accurate likeness from memory alone —[6] though Monckton's portrait, made from life, was at Cockspur Street, and this one therefore could not have been entirely a new creation from memory.

Richard Cumberland moved away from his Witch of Endor into a nearby group "who had collected themselves round a plain, but venerable, old man." This, by Horace Walpole's identification of *Observer* characters, was Samuel Johnson, enjoying himself in these surroundings to the full but with scant attention, one may be sure, for the waxwork game by the fireplace. It was the last year of his life, and very nearly the last of hers.

Dr. Johnson had once undertaken to confound Catharine Macaulay's republican and "leveling" principles by insisting that her footman sit down to dinner with them.[7] But that had been some twenty years before. Catharine and her new husband were now on their way to America, where they spent ten days as

guests at Mount Vernon.[8] Washington was pleased to find him-
self and the great lady in agreement as to political foundations
for the newborn nation, though her brother, John Sawbridge,
had little hope now of seeing his democratic ideals realized in
Britain. Dr. Graham, her brother-in-law, had closed his "Tem-
ple of Health and of Hymen" in Pall Mall, a disappointment to
the children who had enjoyed shooting pellets at the patients
coming to find surcease on the "celestial bed."[9] Old Dr. Thomas
Wilson had died at Bath during the furor of the famous election,
and had been laid away with an excess of funereal pomp long
remembered.[10] In London it was a time of balloons — Count
Zambeccari, and Vincent Lunardi in the entourage of Neapoli-
tan ambassador Prince Caramanico, and François Blanchard
soaring aloft with Mademoiselle Simonet beside him in the bas-
ket. Even Frederic Reynolds had a spurt at it.[11] Balloons
brought everyone a sense of progress, upward, away from solid
earth. Bemused by the whirl and excitement of it all, another
young fellow, William Dunlap, son of a New York businessman
and ostensibly a student of Benjamin West, was deserting art for
theatre and giving most of his attention to the sights and pleas-
ures of the town. He stopped by to see the famous waxwork
woman. She was, as he told it, "called Sybilla, for which there was
some foundation, as she professed sometimes to foretell political
events, and was called the Sybill." Though he was then "too
young and careless to observe her minutely," he recalled "the
expression of her eye . . . and an energetic wildness in her man-
ner. While conversing she was busily employed modelling, both
hands being under her apron."[12]

From this it would seem that Mrs. Wright was then putting
on her Witch of Endor act for all and sundry who dropped in at
the waxwork. Dunlap was remembering the scene from a dis-
tance of nearly fifty years. Another New Yorker gives us a more
minute view written on the spot. Chief Justice William Smith, a
man of poise and careful judgment, was in London as a Loyalist
refugee, though in his balanced opinion the American position
on independence had much to sustain it. She put on no sibyl act
for him, and in his diary we have a revealing glimpse of the

face-to-face Mrs. Wright, provocative, challenging, giving out information that caught the attention of others and startled them into giving information in return. Smith saw no "Sybilla," but an outrageous gossip of dangerously wide range:

April 12, 1784

 I went according to a pressing Invitation & Promise to Tea at Mrs. Wright's the famous Worker in Wax. She is a great Rattle for her Native Country of America and is much visited for a Talent in Wax Likenesses. She hears a great deal and sometimes leaks Secrets, being of Character that Invites to Incaution.

 I find that Staats Morris & some others hurt in America by the British want to Commence Suits here, and that they wish to get at Orders supposed to have been issued for spoil there by the King and by the King only.[13] She charged me with Secrecy upon a Subject I ridiculed. I told her what was done was the Natural Effect of War and the Perpetrators indempnified by Act of Parliamt, thus the Idea of the Kings Order was doubtless without Foundation.

 I got from her that Lord Buchan of Scotland is in Town intending for America with Scotch Emigrants & come to take Leave of the King.[14] He is Brother to Erskine the Counsellor for Lord George Gordon & who is thrown out of Parliament by the Dissolution.[15] She says the Earl of Buchan is going to purchase Lands in Jersey.

 She has it also that the King is intent upon prohibiting the Commercial Intercourse of the Colonies with the West India Islands to increase the Miseries of the Continent and thus compel them to ask for a Reunion. She speaks very disrespectfully of the King, says he holds Councils frequently at Night without Ceremony and that it is now a Part of his Plan to keep up a good force in Nova Scotia and Canada & a Naval armament to watch the Trade of America with the Islands, That the King pities the Loyalists but attributes to their Counsels & advice the late fatal War & says tho' they are to be helped they can't be satisfied and he wished the Nation rid of their Importunities.

I ask'd her where she got all this from. She said she often saw Parliament Men & many who went to Court, and wanted me to fix a Day to be at her House to meet some of them.

She said to several who wanted American Information that they could get it from me, but they replied in Terms she did not chuse to repeat to me. I ask'd whether they were Whiggs or Tories. She evaded & said in the Whirling about of Parties there was no knowing who were Whiggs and who Tories.

I am confirmed by this that I observed a prudent Course in avoiding mixed Companies for or agt. the Court; one knows not who is to be trusted.

She concieves me to be anti American, & come home for Promotion. I told her I disapproved the War & the Separation as destructive of both Countries & that I came for the Education of my Son. She seemed perplexed, and at the ruined State of America distressed, but said America was compelled to a Separation. I took great Care to prevent her having any Handle for malevolent Representations, for she has more Art than is generally imagined & by that Means and her Imploymt. much opportunity for Mischief. She is a great Enthusiast both in Religion & Politics with a Vanity greatly inflated by the Rank of the Visitors her Genius draws about her.[16]

Mrs. Wright's former resolve to eschew prophecy was now slipping away, as we see in Smith's next encounter. Again it was reunion. She had begun to share the expectation of some Englishmen that the United States would not do well alone, and would soon wish for a return into the Empire:

June 14, 1784

The Whig Americans & those here who have abetted them often refer to Mrs. Wright's (the Worker in Wax) who is a Chatterer without guard & yet acquires by her Zeal and Inquisitiveness more Information than she should be trusted with. The Language held by her within a few Days is a Condemnation of the Violence & Perfidy of the Colonies

of late and an Approbation of the Honesty of Englishmen in general; a Prediction that there would be a Change in America soon & a Recal of the Loyalists if they did not boast of their Foresight of the Wretched Condition of the Colonies on the grand Severance from the Mother Country; that therefore she wished me in particular to allow Merit to the Leaders who perceived that I should be speedily called Home: such her Strain to my Brother James last week.[17]

This comes from better Heads than her own & probably arises from the Dread of the Leaders Laurens & others that a Miserable People may be set up agt. them as the Authors of the Public Ruin. They have Cause for it, and Laurens and Jay will certainly not find their Return a welcome one.[18]

Wishful thinking had been from the first a failing of the American Tory exiles, and here it appears again. Hearing later that Benjamin West had reported Jay and West as now holding the King in high estimation, Smith toys with a thought of the American Peace Commissioners, John Adams too, as willing to stake their fortunes in "the Scheme of restoring the Empire."[19] It would almost seem as if he too had been caught up in the flow of Mrs. Wright's loquacity — that torrent of allegation from supposedly authentic sources flowing from a woman of, as he himself had put it, a "character that invites incaution."

John Adams' cordiality in his brief stay of the autumn before seems also to suggest incaution. He would not be exposed to that danger, however, on his return, with Mrs. Adams at his side. Mrs. Adams and her daughter — the two Abigails — arrived from Boston in July 1784, just after the great election. John would hurry back from the Continent and sweep them over to Paris for a round of social pleasures — three short, plump figures in a gay and alien world — before returning to London to take up his duties as American minister.

Mrs. Adams had filled a page of her journal during a fine day at sea with reflections on America and the arts, noting, "The 3 most celebrated painters now in Britain are Americans Mrs.

Wright, Mr. Copely and Mr. West." Wright's name was later stricken out, either an immediate second thought or perhaps after the visit made, on arrival, to the American artists.[20] The mother and daughter, squired by William Stephens Smith and Charles Storer, secretaries-to-be of the new legation, went first to Copley's house to see his full-length portrait of John Adams, then to "Mr. Copley's Exhibition," admission one shilling, "Explanation gratis." It was featuring *The Death of Lord Chatham* and *The Death of Major Peirson,* two of Copley's finest subject pieces.[21] His show had now been moved into the "Great Room" in Haymarket, John Greenwood's place, formerly the scene of so much political activity, and only a short walk from the wax-work.[22]

"From thence," the elder Abigail wrote to her sister, "I went to see the celebrated Mrs. Wright, Messrs. Storer and Smith accompanying us. Upon my entrance, (my name being sent up,) she ran to the door, and caught me by the hand; 'Why, is it really and in truth Mrs. Adams? and that your daughter? Why, you dear soul you, how young you look. Well, I am glad to see you. All of you Americans? Well, I must kiss you all.' Having passed the ceremony upon me and Abby, she runs to the gentlemen. 'I make no distinction,' says she, and gave them a hearty buss; from which we would all rather have been excused, for her appearance is quite the slattern. 'I love everybody that comes from America,' says she; 'here,' running to her desk, 'is a card I had from Mr. Adams; I am quite proud of it; he came to see me, and made me a noble present. Dear creature, I design to have his head.' "

Such freedom of behavior and expression did not please the lady from Boston. The passage is a striking revelation of both women, Abigail and the aging artist in wax. Each had her own distinct peculiarities, and some observers might have found Mrs. Wright's the more endurable, and more interesting. Yet if Abigail reports correctly, Patience's autobiographical patter had certainly grown threadbare with repetition — " 'There,' says she, pointing to an old man and woman, who were sitting in one corner of the room, 'are my old father and mother; don't be

ashamed of them because they look so. They were good folks;'
(these were her figures in wax-work;) 'they turned Quakers, and
never would let their children eat meat, and that is the reason we
were all so ingenious; you had heard of the ingenious Mrs.
Wright in America, I suppose?' In this manner she ran on for
half an hour. Her person and countenance resemble an old
maiden in your neighborhood, Nelly Penniman, except that one
is neat, the other the queen of sluts, and her tongue runs like
Unity Badlam's. There was an old clergyman sitting reading a
paper in the middle of the room; and, though I went prepared
to see strong representations of real life, I was effectually de-
ceived in this figure for ten minutes, and was finally told that it
was only wax."[23]

The "old clergyman" must have been the *William Gostling* of
1776. Patience's intention as regards Mr. Adams, to "have his
head," was never carried out so far as we know. Abigail would
have seen to that. In Abigail's eyes, Patience was at a double
disadvantage — the liberties she took so readily with gentlemen,
and her long friendship with Benjamin Franklin, of whom the
Adamses had never entertained an entirely cordial opinion. It is
to be noted that in Paris, soon after, Abigail took an identical
view of Anne Catherine de Ligniville d'Autricourt Helvé-
tius — holding her up to scorn for her "careless, jaunty air," her
"dirty" clothing, and her manners toward Franklin, and even
John, that were familiar beyond endurance.

Franklin had promised, Abigail wrote, that she would meet
in Mme. Helvétius "a genuine Frenchwoman, wholly free from
affectation or stiffness of behaviour, and one of the best women
in the world. For this I must take the Doctor's word; but I should
have set her down for a very bad one, although sixty years of
age, and a widow."[24] Patience and this other widow had hit it off
very well. They had each the same spirited disregard for formal
conventions, the same warm acceptance or testy rejection of
others. Neither had any pretension to learning, nor could spell
correctly, but they were alike in spirit if a world apart in
background. One can appreciate Franklin's amusement in
bringing two such together. But Abigail the elder was "highly

disgusted," and Abigail the younger even more prim with an, "Odious indeed do our sex appear when divested of those ornaments, with which modesty and delicacy adorn them."[25]

When the trio returned to London to make ready for their presentation at court and the beginning of official duties, the feeling of the ladies toward Mme. Helvétius had been modified somewhat by having met her again in her own home with the memory of her distinguished husband and her royal lineage in evidence.[26] Unfortunately, they would have no contact with the Hoppner household to offset their prejudice there, while the conspicuously secret political activities of the waxwork would be frequently forced upon their attention. Lord George Gordon, too, had reappeared upon the scene and, lacking others, found hearty allies in Mrs. Wright and Major Labilliere. He was under surveillance as a dangerous character, and Patience's breezy comment that the London police have "all the folly without the abilities of the French" suggests a sympathy based upon experience.[27] Lord George was seeking an international role for his Protestant Association: muster the soldiers and sailors made idle by the Peace of Paris, and let them reinforce the Protestant Dutch in their war against the Catholic Emperor Joseph of Austria. When the Dutch ambassador refused to join him in a demonstration march to the Palace, his Lordship dressed himself in a Dutch uniform and led the parade — presumably with the Major and Christian soldiers behind him.[28]

On the morning of Sunday, June 5, 1785, the celebrated Mrs. Wright sat down to splash out a letter to Mr. Adams who, these conspirators hoped, would prove more cooperative than the Dutchman. Apparently she could not recall his Christian name, but no matter. A dash would do. The Major was waiting with a sheaf of documents to show the American minister, and this was to be his introduction. Perusing her screed, we see that Mrs. Wright still conceives herself at a crisis point in history, and however confused her intention, it is still impelled by love — by that maternal protective instinct toward "a Ingured people — the Eyes of the world is on the present moments." She is also politician enough to present Labilliere with John Jebb's charita-

ble estimate of him. Dr. Jebb, physician, Fellow of the Royal
Society, dominant leader of England's strongest radical group,
the Society for Constitutional Information, was a man greatly
and justly admired by Adams.[29]

"Mrs. Wrights most Respectfull Complents to her
Friend —— Adams Esqr &c. —" the lady wrote, "and has the
pleasuɪ to deliver to him those papers — from Major Labilliere
presented by him to Mr Adams Esqr as a worthy Charatcker, on
whos Condoct and Sentiments much Depends toward bringing
Justic and good goverment to a Ingured people. the Eyes of
the world is
on the present moments - - - - ⎫
 ⎬ forgiven blood . . ."
The house of Ahab must not be ⎭

This obscure and unsettling allusion is followed immediately by
the reassurance that many friends are at hand, ready to assist in
the "glorious work" of establishing peace and free trade. She
summarizes the new Pitt administration as "this gunto" with a
spate of confused name-dropping, Scriptural references linking
the wars of Israel and the King of England, and tops off with Dr.
Jebb, who, with "other worthy tryd Friends to America Can
testifie how active a part major Labilliere has taken in the Cause
of that Contry and the Extrordanry pains to set truth before the
Solders — 'not to fight against their Consciences the Cause of
america was the Cause of god' with love to mrs adams I am with
the highst Esteem your and my Contrys faithful friend and very
humbl Srvt Patience Wright."[30]

So the Major sallied forth, probably only to deliver some of
his own writings, now carried about with him and passed out by
hand. He was approaching that stage of progressive dementia
which would reach its climax in that weird interment at Box Hill.
On the same day and with similar intentions, Lord George Gor-
don converged upon Adams. In order to keep the public aware
of great matters in progress, he inserted a report of the meeting
in the next day's *Advertiser:*

Yesterday Lord George Gordon had the Honour of a

long conference with his Excellency John Adams (honest John Adams), the Ambassador of America, at the hotel of Mons. de Lynden Envoye extraordinaire de Leur Hautes puissances.

Mrs. Adams sent a clipping of this to Thomas Jefferson at the legation in Paris, with her explanatory note:

> This is true, and I suppose inserted by his Lordship who is as wild and enthusiastic as when he headed the mob. His Lordship came here but not finding Mr. Adams at home followed him to the Dutch Ministers. The conversation was curious, and pretty much in the Stile of Mrs. Wright with whom his Lordship has frequent conferences.[31]

Abigail may have intended this as a warning to the new man at Paris, anticipating that Patience would soon be in touch with him also. So she would. The letter is one of those printed by William Dunlap in his *History of the Rise and Progress of the Arts of Design in the United States.* It had remained, therefore, among her papers, either as a copy or because never sent. It shows Patience in better possession of her faculties, even if we allow that Dunlap clarified the prose somewhat in his transcription:

> London, at the wax-work, Aug. 14, 1785.
> Honoured sir: — I had the pleasure to hear that my son Joseph Wright had painted the best likeness of our HERO Washington, of any painter in America; and my friends are anxious that I should make a likeness, a bust in wax, to be placed in the state-house, or some new public building that may be erected by congress. The flattering letters from gentlemen of distinguished virtues and rank, and one from that general himself, wherein he says, "He shall think himself happy to have his bust done by Mrs. Wright, whose *uncommon talents,* &c. &c." make me happy in the prospect of seeing him in my own country.
> I most sincerely wish not only to make the likeness of Washington, but of those *five* gentlemen, who assisted at the

signing the treaty of peace, that put an end to so bloody and dreadful a war. The more public the honours bestowed on such men by their country, the better. To shame the English king, I would go to any trouble and expense to add my mite in the stock of honour due to Adams, Jefferson, and others, to send to America; and I will, if it is thought proper to pay my expense of travelling to Paris, come myself and model the likeness of Mr. Jefferson; and at the same time see the picture, and if possible by this painting, which is said to be so like him, make a likeness of the General. I wish to consult with you, how best we may honour our country, by holding up the likeness of her eminent men, either in painting or wax-work. A statue in marble is already ordered, and an artist gone to Philadelphia to begin the work. This is as I wished and hoped.[32]

Here we find Patience far more accurately aware of events in the art world than on the political side. She is minded to do in wax a Treaty of Peace group such as West had begun on canvas. She had heard of Charles Willson Peale's full-length of Washington sent to Thomas Jefferson in Paris as the model for a marble statue commissioned by the state of Virginia —[33] and that Jean Antoine Houdon, entirely unwilling to do the work from a painting, was on his way to America to carry it out from the life. This information had come to the London embassy in Jefferson's letter of July 7, and obviously she must have learned it there. Very well. On her mettle now, Mrs. Wright proposes to go to Paris, there to model Jefferson from the life, Washington from the picture. Understandably, we hear no more of this. Houdon was in London briefly on his return journey at the end of the year, and conceivably might have stopped in at Cockspur Street to see how a form of portrait sculpture not altogether unlike his own was carried out in wax.[34]

In the same ship that brought Houdon to America, Franklin had returned from France. It had stopped at Southampton long enough for his last meeting there with his son and a few old friends. At his arrival home after all those years the

bells rang, throngs gathered to welcome him and then elect him governor of their state — a reception, warm and triumphant, such as had been planned for him in London, but passed by.

London, under the balloons and gaiety, faced turmoil at home and abroad as the young Pitt labored to bring the shattered empire together in a new integrity. There was rumor enough at large to keep the waxwork busy, and the legations at London and Paris may be imagined making what they could of the sometimes authentic, often garbled reports, freely seasoned with Old Testament lore. There was unrest, as ever, in Ireland, and at home, even in London, warnings of rebellion against the taxes that must pay for the war —[35] all of interest to Mrs. Wright. John Adams seems to have turned her over to young Abigail's fiancé, Secretary William Stephens Smith. Patience continued to haunt the embassy, though Lord George, disillusioned, drifted away from the Adams circle. Toward the last he was spreading a report that Mr. Adams was in the pay of the French king.[36]

It was Jefferson who in a small way succeeded Chatham and Franklin as Mrs. Wright's "gaurdin angel" of the oppressed. She put him in touch, if nothing more, with at least one connection of interest. William Wenman Seward, Secretary of the Association of Irish Merchants at 74, Haymarket, opened trade negotiations on October 25, adding respectfully, "We have been indebted to Mrs. Wright of Cockspur street for the present opportunity of forwarding this."[37] Another set of dispatches went to Paris in December, when William Gifford left for the Continent as Lord Belgrave's tutor and traveling companion. It is pleasant to think of Mr. Jefferson's meeting with the pair, and the exchange of views that may have occurred — an attractive young nobleman with a satirical poet for mentor. Hoppner had once good-naturedly compared Gifford to a toad — short and portly, large expanse of yellow waistcoat. Gifford, rigidly conservative, never approved of his friend's Whig bias.[38] It was from this pair that Mr. Jefferson received Mrs. Wright's revelations of George III's plan to make one of his sons King of America, and an alliance between Britain and the "Allgree pirots."

Jefferson was even then concerned in the matter of a treaty with the North African corsairs. The dispatch of most immediate interest to him would have been the letter from Henry Bowles, December 12, 1785, replying to Mrs. Wright's request for information on Irish commerce and the tobacco trade, in which smuggling had become prevalent. Enclosed also was a letter of similar purport from John Bourne to John Adams, December 4, but entirely in Patience's hand, and as confused in language and orthography as if it had been her original composition. Another enclosure, a terse request for a hogshead of tobacco from John Keys, "Venerable Founder of the Constitutional Whigg, Grand Lodge of England," is dated from No. 3 Charles Street (near the Hoppner residence), December 9. This she has docketed with a small drawing of a man, perhaps intended as an identifying portrait of the Venerable Founder.[39]

Two covering letters from Patience came with all this, one of them revealing all her coy zest for the game:

London Decemb. 15th. 1785

Honred Sir

In Mr. Smiths absence the politicall afairs of Irelands traid with *america* was transacted with great sucksess wonderfully brott forward by gentlemen who from principl have acted with the same *spirit* which first brot forward the Independence of the America states and all other *Revolutions* in *Church* and States of all Nations. You will see by their letters to me and other Circumstances of prudence that they are perfectly well acquainted with mankind and the true and only way to accomplish so grand and extensive a plann of usefull traid for a new Empire — and to take Miss Ireland under their cear. She has now Court paid to her traid by her mother England but afraid of her being free and Independent to Run off with a *frenchman*. When we see them We believe Truths that at a Distance is incredible to human Reason. Experenc maks men wise, practice maks perfect. As I been 8 years faithfully Employd in doing all the good I can, I have the pleasure to lay in your way to

forward to where you best can serve your Contry and man-
kind. I have the honor to be with due Respect your old
faithfull

P. Wright

And the other with her air of secret-agent mystery in full swing:

> Some Respectable gentlemen who have been great sufferers
> by the American War have aplyd to Mr Adams for leve to
> traid to and from all the Contending powers —
> P W is requested to Inform *Micajah* that Report says a
> Nother War with America and prays him to Direct his an-
> swer P. W.
> mr gifford sits of for paris, and will take with him any Let-
> ters or parcells to paris —
> I here Mr Smith returnd pray let him see those letters di-
> rected to me as Every thing sent to Deborah is proper for
> *him* to COUNTER ACT the Fooly of Mitehinall [Whitehall?]
> Council —[40]

Could they have been coming back to her now from that
secret world of her childhood? These are not code names of a
spy. She is building a make-believe world of Bible people:
Micajah, who said, "As the Lord liveth, even what my God saith,
that will I speak," and against whom the wicked King had cried,
"I hate him; for he doth not prophecy good concerning me, but
evil."[41] Micajah, the son of Imlah — an echo of the Imlay name
of long before. And she herself is Deborah, prophetess, "who
judged Israel at that time" —

> . . . until that I Deborah arose, that I arose a mother in
> Israel.
> They chose new gods: then was war in the gates: was
> there a shield or spear seen among forty thousand in Israel?
> My heart is toward the governors of Israel, that of-
> fered themselves willingly among the people. Bless ye the
> Lord. . . .
> Awake, awake, Deborah: awake, awake, utter a song.[42]

In the Charles Street home she had comforts never known before, but nothing could bring back the quick, sure perception, the excitement and admiration so vividly alive in the old wax-work. The end now was near. She would live to see only two of Phoebe's five children, all to be christened in honor of eminent patrons of their father. The eldest, a son, deferentially if oddly named Catherine Hampden Hoppner, born on April 24, 1784, was joined on January 9, 1786 by another boy, Richard Belgrave.[43] Belgrave Hoppner, it is interesting to note, would grow up to be a minor celebrity in art and letters. As a friend of Lord Byron he spread rumors deeply offensive to Shelley, whom he referred to in writing under the code name,"Shiloh" — a strange reverberation from the waxwork he had never known.[44] Patience, turned sixty in 1785, was failing fast. The waxwork, it would seem, had been taken from her.[45] She had no dominion any more in London, yet knew that "dear America" still honored her name. Washington himself would welcome her there.

It must have been in the midsummer of 1785, with the news of Franklin's homing voyage, that she wrote to her sister of her thought that a little land near Bordentown might be given her, as land was being given to the soldiers who had fought the war. Rachel, ill and aging too, penned a letter to Franklin, unsigned, but bringing into it a hint that it came from a Member of Congress. One senses again the truant playtimes in that strangely peopled realm of the little girls in white — secrecy, "Inthusazm," hidden paths and moments, all under the clouded sky of Tryonite beneficence.

Robert McKean, a Bordentown boy, son of Thomas Mc-Kean, Congressman and Chief Justice,[46] delivered the letter to the house in Franklin Court:

Hond Sr
 I take the Liberty to Mention a taxt of Scripture which has often

Ecclesiastes 9th 15th
 Caim into my Mind since Peace Commencd Consarning ye

Poor man that deliverd the Sity yet this Poor man was never Considered.

it has bein often Asked me and other of our older members if aney thing has bin don for Mrs Wright. Mr Pain[47] has bin Considrd why not Mrs Wright. Mr Hancock & others of our oldest members allways alowd that her inteligence was the best. We Recevd them by the hand of her sister wells who found them in ye wax heads she then sent to her &c. &c. By her Last Latters she Cant be Content to have her bons Laid in London.

Now Sir as your Station togather with your good Principels it is Easey to mention this as one word from your Honour will go quit[e] as fare as is Nesseserey jest to mention this that she mite not be forgt as the poor man was that deliverd the Sity. We that was first in Congress Remember well her faithfull Atention to us in that Perilous hour —

I am advancd in years and have bin Confind to my Rum Ever sence your arivell or I should have waited on you in Person & Living at a Considrebell distance That its not bin Posabell for me.

She writes that she should Chuse to Lay her bons in the mannah — or near Pennsberry. Collonell Carbright maid purchs of the whole mannah at the begining of the war.[48] Now my desire is that Congress would give her a Lott of ground ther. I am very Sencebell that he is very Intemeat with the fameley & was fond of her before she Left america & I am Sartan that he thinks more of you Sir then he does of an angel. Therefor I verely think that was mr frankland to ask mr Carbright for the Price of a Lott of Land their it would Com verey Low & cost Congress but a trifell, but I am apt to think that if it was for mrs wright That he would make her a Present of it. He has maid her Sister Rachel wells a Present of a Lott in Bordentown to build her a Museum on a few months Past. He seems to be Much of a gentelman. His Losses this war has bin grate verey considrebell indeed. I Must bag That you will Excuse my Naim as I

am Singel and Therefor it may be thought to be a selfish
Request by those that dont know me nor my Station
> Their is small Confisticated Estates proper
> > in this Case we are not Confind
decbr ye 16th 1785
> your atention to her & her fameley
> has much Encouraged my Expectations[49]

New York had given Thomas Paine a confiscated Loyalist
estate at New Rochelle. His place at Bordentown was mistakenly
supposed to have been a similar gift from New Jersey. Colonel
Joseph Kirkbride was just such a man as would have given the
aging Rachel Wells a lot in town for her waxwork "Museum."
His huge estate included most of the old Pennsbury Manor
lands. After the burning of his home by British raiders he had
settled in Bordentown, where he would long be remembered as
a striking figure, tall, erect, cocked hat, and military air —
"high-minded and gallant, the soul of honor and a sincere Chris-
tian, he was one of the noblest men that Bordentown ever pos-
sessed."[50]

Time and again, through all those London years, Patience
had longed for the land of "peace and liberty," and now for a
final resting place near the great river, the Manor, the old West
Jersey home. While Rachel was attending to that, she kept up
her work of political information unabated and unsparingly.
She had been out once more to the American embassy when,
suddenly, the end came on February 25, 1786 — marked by a
line in the death notices in the London *Morning Post* of March 1:

> Saturday. Mrs. Wright, of Charing-cross, the cele-
> brated modeller in wax.

Obituary writers cocked their heads and dipped their pens
for English, then Scottish, then American papers. The news in
New York's *Daily Advertiser,* May 16, gives us a glimpse of her
passing lacking from the others. It may have been written by
Joseph, who had just settled in the city; or Elizabeth Platt, who
may have been there with her waxwork; or, very likely, the
long-suffering Ebenezer:

MRS. PATIENCE LOVELL WRIGHT. It is with the utmost regret that we acquaint the public with the death of the celebrated American, Mrs. Wright, occasioned by a fall in returning from a visit to our ambassador, Mr. Adams — America has lost in her a warm and sincere friend, as well as one of her first ornaments to the arts — Those brave fellows who during the late war were fortunate enough to escape from the arms of tyranny and take sanctuary under her roof, will join us in lamenting her loss; whilst her attachment to America, and her generous and indefatigable attention to the prisoners in distress will render her regretted and her memory revered by her country.

Horace Walpole jotted a note in his "Book of Materials": succinctly, "Mrs. Wright from America, who modelled in wax as large as life & in colours, died in feb. 1786."[51] He, at least, set down the simple record of her first claim to fame. Elsewhere, the legends of patriotic fervor and clever espionage grew rapidly, crossed the ocean to flower again in the land of her birth. She had built her own monument of fable, of great usefulness in grand events, so pretentious that it obscured all else. The March number of *The European Magazine* leads off with what would become a cornerstone of the Wright legend. This, rather than any recollection of his own, is the source from which William Temple Franklin drew his account of Mrs. Wright the spy.

Mrs. Wright, the celebrated modeller in wax. She was one of the most extraordinary characters of the age, as an artist, and as a profound politician: in an early period of life she gave strong indications of a singular talent for taking likenesses in wax, and did not fail to take heads of some of the leading Americans, at the commencement of the American contest, in which her family became much injured. At rather an advanced age she found herself greatly distressed by the ravages of the civil broils occasioned by the councils and instruments which the Minister of England employed, and the old lady, both distressed and enraged, quitted her native country with a determination of serving it in Britain.

She added to the most famous Americans the heads of the English most distinguished at that time for opposition to Lord North's measures; and as her reputation drew a very great variety of people of all ranks to see the marvellous productions of her ingenuity, she soon found out the avenues to get information of almost every design which was agitated or intended to be executed in America, and was the object of the most entire confidence of Dr. Franklin and others, with whom she corresponded, and gave information during the whole war. As soon as a general was appointed to go out to mount the tragi-comic stage in America, from the Commander in Chief to the Brigadier, she instantly found some access to a part of the family, and discovered the number of troops to be employed, and the ends of their expatriotic destination. The late Lord Chatham paid her several visits, and was pleased with the simplicity of her manners, and very deep understanding. She took his likeness, which appears in the Abbey of Westminster; and though she had been in France, and much caressed by the political geniusses of that kingdom, yet at the end of the war she was so singularly attached to England, that she was constantly employed to enforce forgiveness among her country people, whom she advised for the future to look to England in preference to France for trade and alliance.[52]

It is a pity that so many of us are remembered as in our later years when frustrations are replacing purpose. Patience Wright is fortunate, after a fashion, in that she has lived on not as she was at the last but in her bold front of earlier days. Both the nations she loved claim her as their own, and both the *Dictionary of National Biography* and the *Dictionary of American Biography* stress the role of clever espionage. Understandably, to her American family she was the mettlesome, intrepid heroine of Independence, while those in England took a gentler view.

Phoebe, on the defensive, was always ready to show General Washington's letter to her mother, where, as Joseph Farington noted, "He expressed His esteem for her in strong terms."[53]

Among her children and grandchildren Joseph became "a young American of great abilities and good family who with his mother and three sisters had sought a refuge in England at the outbreak of the American War. His mother was a very clever woman whose sound judgment and talents caused her often to be summoned to His Majesty's presence when desiring her counsel in affairs of moment."[54]

Far across the ocean at the time of her death, a young American poet composing an epic of his native land praised wax as "livelier" than marble, and ranked hers among the foremost names in art:

> See Wright's fair hands the livelier fire controul,
> In waxen forms she breathes the impassion'd soul;
> The pencil'd tint o'er moulded substance glows,
> And different powers the unrival'd art compose.[55]

Joel Barlow could then have seen her work only as it appeared in Rachel Wells' exhibition. He came to England in 1792, formed friendships with Effingham, Cartwright, Price, and others who had known Patience, and may have seen *The New Wonderful Magazine* of 1793 with its revival of the *London Magazine*'s high praise.[56] From someone he heard a description of Mrs. Wright in the act of artistic creation, and in the later expanded version of his poem gave it a couplet:

> Grief, rage and fear beneath her fingers start,
> Roll the wild eye and pour the bursting heart . . .[57]

But the famed waxwork of Pall Mall had vanished long before. When the young German novelist Sophie von LaRoche toured London in September 1786, taking in all the well-known sights, galleries, and museums, the only waxwork she saw was at the Abbey — and there was no one to tell her who had made the piece that caught and held her attention:

> Likewise Queen Mary, Elizabeth and others are in full dress, as also the great Lord Chatham in parliamentary attire. A slim figure and fine features, quite different from

anything I might have imagined from his works and activities; for I should have pictured him very serious. This image stresses rather the greatness of his mind, and that the planning and execution of important matters were but trifles to him.[58]

Today it is still to the crypt in Westminster that one must go to see the artist through her work — the authentic talent, the warm heart which caught that shadow of a smile, and within it all her feisty fidelity to "the old Quaker truths" of fairness, equality, and love.

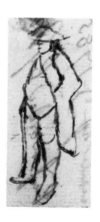

MYSTERY MAN

Sketch by Patience Wright

(See page 216)

THE WAXWORK

PATIENCE WRIGHT brought wax sculpture in the round to prominence as a portrait art in a way unknown before or since. Wax effigies for state funerals were a tradition inherited from ancient Rome and earlier, but the nearest thing in private portraiture was the occasional polychromed terra-cotta, such as Roubiliac's *Colley Cibber* at the British National Portrait Gallery, with its removable terra-cotta cap. A life-size wax with hair, glass eyes, and real clothing could exceed even that in realism, though lacking the monumentality of a more permanent material.

But for occasional news items and visitors' recollections, her *oeuvre* would be almost unknown today. The total must have been small, even though possibly twice as many as are listed below. Like other artists, she kept a matrix version from which later orders might be filled, and several are known only through replicas that came to America. Those which found a place in Rachel Wells' rooms went from Philadelphia to Bordentown c. 1785. Colonel Kirkbride's "Museum" never came into being, and at Rachel's death in 1795 her thirty-three figures were willed to her brother, John Lovell. How he disposed of them is unknown. Some may have come to Elizabeth Platt, who was in Philadelphia with her Ebenezer in 1780, after which, quoting William Dunlap, "Mrs. Platt made herself well-known in New-York, about the year 1787, by her modelling in wax." Dunlap himself had returned from London to New York in that year, and it is safe to assume that the waxwork advertised from 1785 to 1788 as at No. 100 Queen Street, "the house formerly oc-

cupied by Mrs. Wright," was Elizabeth's. Some of its subjects were certainly from the London exhibition — the King and Queen, the Prince of Wales, Lord North, and the Duchess of Orléans. There also were Patience's old friend, Dr. John Rodgers, along with Bishop Samuel Provoost and the Reverend Dr. John Henry Livingston. With this steady company Elizabeth had a *Nun at Confession, Moll, a Madwoman,* and *The Story of Bell and the Dragon* in the métier of Rachel Wells, while the influence of Mrs. Salmon appears in the fact that *Moll,* recalling the Fleet Street *Mother Shipton,* was so contrived as to strike angrily at anyone who came too near. Elizabeth closed her show in 1788, but the pieces reappear, 1789, under the aegis of Daniel Bowen, veteran seafighter who had been a prisoner of war in England, where he might conceivably have seen the London waxworks. Elizabeth died at Bordentown in 1792, making her sister Sarah her principal heir and Aunt Rachel her executor. Bowen's advertisement in the *New York Columbian Gazetteer* honors her memory by featuring a portrait of "Mrs. Platt, the late celebrated American Artist in Wax Work." After that, though Bowen went on and Ebenezer is glimpsed, no further Wright subjects are seen.

CATALOGUE

The following sources are cited by number. The dates are of first mention of the piece rather than origin.

(1) *New-York Gazette, or The Weekly Post-Boy,* June 10, 1771.

(2) *London Chronicle,* July 4–7, 1772.

(3) Diary of Henry Marchant. Typescript, Library of the American Philosophical Society.

(4) *New-York Gazette and The Weekly Mercury,* November 9, 1772.

(5) *New-York Gazette and The Weekly Mercury,* February 15, 1773 (London news dated December 1, 1772).

(6) Horace Walpole to the Countess of Upper Ossory, February 11, 1773.

(7) *New-York Journal,* March 17, 1774 (London news dated January 10, 1774).

(8) *The Diary of John Baker, Barrister* (London, 1931), p. 313, May 16, 1775.

(9) Letters of William Forster, October 7, 1773, January 11, 1775, February 24, 1776, quoted in Friends' Historical Society, *Journal,* Vol. 20, pp. 95–96.

(10) *London Magazine, or Gentleman's Monthly Intelligencer,* Vol. 44 (November 1775), p. 555.

(11) *Gentleman's Magazine,* Vol. 46 (May 1776), pp. 214–215.

(12) London *Morning Chronicle,* May 7, 1776.

(13) John Adams to Abigail Adams, Philadelphia, May 7, 1777.

(14) *European Magazine and London Review,* Vol. 9 (March 1786), p. 210.

(15) *New-York Daily Advertiser,* June 11, 1788.

(16) *New-York Weekly Museum,* October 3, 1789.

(17) Philadelphia *Pennsylvania Packet,* July 8, 1790.

PORTRAITS

AMHERST, JEFFREY, LORD, 1717–1797.

A letter from Edward Mason to Amherst, August 4, 1772 (Amherst Mss., Kent Archives Office) asks if he can give a sitting to

a Mrs. Wright who has come from America expressly for the purpose of making a wax figure of him.

BARRÉ, ISSAC, c. 1726–1802.

> *Bust.* (9), 1773; (10).

CHARTRES, DUCHESSE DE, 1753–1821.

> *Bust or figure.* Benjamin West to M. Pierre, December 7, 1781 (Historical Society of Pennsylvania), introduces Joseph Wright: "*Sa mère est protégée par la Duchesse de Chartres.*" In (16), (17) as "The Duchess of Orleans, of France, elegantly dressed."

CHATHAM, WILLIAM PITT, EARL OF, 1708–1778.

> *Bust.* (8), 1775; (10), (11), (12).

> *Figure.* (13), 1777. Replica of above sent to Philadelphia probably in 1775. (16), (17).

> *Figure.* Replica of above. Commissioned 1778; placed in Westminster Abbey 1779.

COLDEN, CADWALLADER, 1688–1776.

> *Bust.* (2), 1722; (3), April 6, 1772. Probably made at "Spring Hill" near Oyster Bay, c. 1771–1772; brought to London 1772.

CUMBERLAND, HENRY FREDERICK, DUKE OF, 1745–1790.

> *Bust.* (11), (12). 1776. *See* GLOUCESTER.

DE LANCEY; *see* WATTS.

DICKINSON, JOHN, 1732–1808.

> *Bust or figure.* (1), 1771.

DINGLEY, ROBERT, 1709–1781.

> *Bust.* (10), 1775.

DODD, WILLIAM, 1729–1777.

> Philip Thicknesse's account of Mrs. Wright's proposal to rescue Dodd from the gallows by substituting her wax portrait arranged as a figure seated in the Newgate cell where he received visitors has been cited, as also John Williams' inclusion of Dr. Dodd among the waxwork habitués whom he had met there.

> An example of the *London Magazine* engraving of Mrs. Wright has been found, with a penciled identification of the bust on her lap as that of Dodd.

EFFINGHAM, THOMAS HOWARD, EARL OF, 1747–1791.

> *Bust.* (11), May 1776, (12).

FOTHERGILL, JOHN, 1712–1780.

> *Bust.* Fothergill, Quaker physician and philanthropist, was a warm ally of Benjamin Franklin in seeking to prevent the American War, and then one of those who turned to Franklin in a hope

of reconciliation. Franklin's experiments in electricity had been first published, 1751, by his advice and with a preface by him. Famous in London (even to being another one of those parodied on stage by Foote), he shunned portraiture as a vanity, and it was his protégé, the younger and equally successful Dr. John Coakley Lettsom, who commissioned Patience Wright to make the bust. — Richard Hingston Fox, *Dr. John Fothergill and His Friends. Chapters in Eighteenth Century Life* (London, 1919), p. 420.

The portrait was probably made c. 1773–1774, but was unrecorded until after its subject's death. At "Grove Hill," Camberwell, Lettsom's lavish suburban estate, its library was divided into sixteen sections, with busts of appropriate figures over each. The *Fothergill* presided over Medicine and Botany. Most of these patron saints were of an earlier day, and the only ones possibly by Mrs. Wright were *John Wesley* (Tracts and Pamphlets), *Dr. Percevall Pott* (Surgery and Chemistry), and *Benjamin Franklin* (Natural History).

A print of the *Fothergill* was published in Lettson's *Memoirs of John Fothergill* (London, 1786) as a stipple engraving by Francesco Bartolozzi. The bust itself was cast or copied c. 1845 by the Welsh sculptor William Jones, and from this at least three casts were made.

Figure. (17). Presumably from a replica of the bust brought to America by Elizabeth Platt.

FRANKLIN, BENJAMIN, 1706–1790.

Bust. (3), April 6, 1772. The first work made on arrival in London, March 1772.

Figure. (4), 1772; (13). Replica of the above made for the New York exhibition and later shown in Philadelphia. This or a replica may have passed from Rachel Wells to Elizabeth Platt, and from her to Daniel Bowen whose advertisement, *Columbian Gazetteer,* New York, October 10, 1793, includes, "Dr. Benjamin Franklin sitting at a table with an Electrical apparatus."

Head and figure. Made at Paris, 1781, for Elkanah Watson and shown by him as a figure at Nantes and London. The head was broken, many years later, at Albany, New York — Watson, *Men and Times of the Revolution* (New York, 1857), p. 140. Presumably a replica was made for the London exhibition.

GARRICK, DAVID, 1717–1779.

Noted in (2), 1772, (3), and (4), November 9, 1772, as unfinished. The work seems to have been interrupted by Garrick's

departure for the country, where he is described in a letter from John Wilkes to his daughter, August 8, 1772 (British Museum, Add. Mss. 30,879) as very painfully ill.

GEORGE III, 1738–1820.

Bust. (4), 1772, "several eminent Personages, and even his Majesty himself, have condescended to sit several times." (8), (9), October 7, 1773, has been "lately sent for by the King." (10), (11), (12).

Figure. (15), 1788. Replica of above, either from Rachel Wells or brought to America by Elizabeth Platt. (16), (17).

QUEEN CHARLOTTE, 1744–1818.

Bust. (7), 1774; (8), (10), "Her Majesty, particularly expressive." (11), (12).

Figure. (15), 1788. Replica of above, either from Rachel Wells or brought to America by Elizabeth Platt. (16), (17).

GEORGE AUGUSTUS FREDERICK, PRINCE OF WALES, 1762–1830.

Figure. (15), 1788. Presumably a replica of a bust made in London, c. 1774. (16), "habited in cloaths which were presented by the King." (17).

GLOUCESTER, WILLIAM HENRY, DUKE OF, 1743–1805.

(9), January 11, 1775. William Forster's, "Well, I think also the D. of Gloucester," may be in error for another brother of George III. *See* CUMBERLAND.

GOSTLING, WILLIAM, 1696–1777.

Figure. (11), 1776; (12).

HALL, WESTLEY, 1711–1776.

Figure. (8), 1775. Hall, an eccentric clergyman who had married a sister of John Wesley, was active in the Methodist movement yet secretly hostile to its leaders. His views ranged widely, in doctrine to deism, in morals to polygamy. In later life he lived at Bristol, and the portrait was probably made there.

HANWAY, JONAS, 1712–1786.

Bust. (10), 1775; (11), (12).

HUNTINGDON, SELINA HASTINGS, COUNTESS OF, 1707–1791.

Figure. (7), 1774. Founder of the sect of Calvinistic Methodists known as "The Countess of Huntingdon's Connection," of which George Whitefield, her chaplain, became so eloquent an advocate in Britain and America. Like Mrs. Macaulay and Mrs. Wright, she had homes both in London and at Bath, where her "tabernacle" was situated.

KEPPEL, AUGUSTUS, VISCOUNT, 1725–1786.

Figure. (17), 1790. Presumably a replica of a bust in the London exhibition. The portrait of the bold and popular admiral, a strong opponent of the American War, was probably made with those of other like-minded Members of Parliament, c. 1774. However, Keppel came into special notoriety after the indecisive battle of July 27, 1778, when an officer politically opposed to him failed to obey an order, making possible the escape of the French fleet. His figure was small ("Little Keppel" to the sailors, in affection), and his face disfigured by a broken nose.

LIVINGSTON, JOHN HENRY, 1746–1825.

Figure. (16), 1789; (17). Portraits of three prominent clergymen of New York City, Livingston, Provoost, and Rodgers, appear in the collection which Daniel Bowen acquired from Elizabeth Platt. They may have been Platt originals. All, however, were present in New York, 1770–1772, and active in the movement toward independence, making it probable that they were by Mrs. Wright.

LOVELL, JOHN, died 1762.

Figure. (9), January 11, 1775. William Forster describes the figure of Mrs. Wright's father as wearing a long white beard and white hat, and as finished "a few days since." (10).

LOVELL, PATIENCE TOWNSEND.

Figure. (8), 1775, mentions the figure of Mrs. Wright's mother as "reading and stooping." (10).

LOWTH, ROBERT, 1710–1787.

Figure. (17), 1790, as "the late Bishop of London." Portly and affable, a high-ranking churchman who won John Wesley's friendly approval, he became Bishop of London in 1777. In the House of Lords, December 1778, he declined to vote on General Clinton's proclamation threatening to lay waste America with fire and sword, and the portrait may have been made in response to this.

LYTTELTON OF FRANKLEY, GEORGE LYTTELTON, FIRST BARON, 1709–1773.

Bust (?). (6), 1773. Lord Lyttelton, author and politician, died suddenly, August 22, 1773. Lord Hervey has been quoted on his appearance: "His face was so ugly, his person so ill-made, and his carriage so awkward, that every feature was a blemish, every limb an encumbrance and every motion a disgrace." And Horace Walpole on his character: "He had sense and uncommon learning for a

peer." Mrs. Wright may have been introduced to him by Lord Chatham or by Benjamin West, other of whose sitters appear among her works.

MACAULAY, MRS. CATHARINE, 1731–1791.

Figure. (3), July 7, 1772, "She is now doing . . . Mrs. Macaulay." (6), (8), (10). The figure was probably posed with pen in hand and the volumes of her *History of England,* and may be reflected in the contemporary china figurine.

Figure. (4), 1772; (5), (13). Replica of above, sent to New York, and then with Rachel Wells in Philadelphia.

MONCKTON, ROBERT, 1726–1782.

Figure. (7), 1774. General Monckton had been second in command to Wolfe at Quebec, and later Governor of New York. He was in Parliament during the war, an inactive supporter of the administration. Mrs. Wright may have been introduced to him by Benjamin West, who had painted his portrait.

Head. Replica of the above, described by Richard Cumberland, *The Observer* (London, 1785), p. 222.

NORTH, FREDERICK, LORD, 1732–1792.

Bust. (8), 1775; (11), (12).

Figure. (15), 1788. Replica, presumably sent to Rachel Wells and later included in the exhibition of Elizabeth Platt.

ORLÉANS, DUCHESSE D'. *See* CHARTRES.

PENN, THOMAS, 1702–1775.

Bust. (5), 1772, "is now making." Received by the Pennsylvania Assembly as the gift of Lady Juliana Penn, September 24, 1773, with covering letter from Mrs. Wright, June 24, 1773.

PITT, WILLIAM. *See* CHATHAM.

PLATT, ELIZABETH WRIGHT, died 1792.

Figure. Probably by Rachel Wells or a self-portrait, but possibly the work of the artist's mother, this piece is recorded in Daniel Bowen's advertisement, *Columbian Gazetteer,* New York, October 10, 1793.

POWNALL, THOMAS, 1722–1805.

Bust. (8), *London Chronicle,* Dec. 4–7, 1773. Probably made on the recommendation of Benjamin Franklin.

PROVOOST, SAMUEL, 1742–1815.

Figure. (16), 1789; (17). This portrait, with those of two other clergymen, Livingston and Rodgers, may be an original work of Elizabeth Platt on her return to New York after the war, or may have been made by Mrs. Wright while living there, 1770–1772.

Provoost returned from study abroad and became assistant rector of Trinity Church in 1770. (8) records the figure of "a clergyman who used to dispute in America with Whitefield" in the London exhibition, May 16, 1775. This could not be Livingston, who was too young, or Rodgers, a Whitefield convert, but Provoost had preached strongly against the evangelical enthusiasm of White-field's followers.

RODGERS, JOHN, 1727–1811.

Figure. (16), 1789; (17). Like the portraits of Livingston and Provoost, this may be a work of Mrs. Wright while in New York, 1770–1772, or made there by Elizabeth Platt after the war. Mrs. Wright, by her long and friendly letter to him, was certainly well acquainted with the subject.

SAWBRIDGE, JOHN, 1732–1795.

Figure. (13), 1777, in the exhibition of Rachel Wells, Philadelphia. It must certainly have been a replica of a bust or figure made in London. Sawbridge had been painted by Benjamin West at about the time of Mrs. Wright's arrival from New York, in the costume of a Roman tribune, typifying his personal and public integrity as steadiest spokesman of the opposition to political corruption and the American War. He was a brother of Catharine Macaulay (q.v.).

TEMPLE, RICHARD GRENVILLE-TEMPLE, EARL, 1711–1779.

Bust. (10), 1775; (11), (12). Earl Temple was the brother-in-law and political ally of the Earl of Chatham, a friend and supporter also of John Wilkes.

THOMPSON, EDWARD, 1738?–1786.

Bust. (10), 1775.

WASHINGTON, GEORGE, 1732–1799.

No evidence has been found that a life mask was sent by Joseph Wright to his mother, as intended, and a figure of Washington added to the London exhibition. Washington does appear, however, (15), (16), (17), among the figures shown by Elizabeth Platt in New York and acquired by Daniel Bowen.

WATSON, ELKANAH, 1758–1842.

Head. Probably made in Paris, 1781. Noted in the diary of Elisha Hutchinson, August 25, [1783], as quoted in Thomas Hutchinson, *Diary and Letters* (London, 1883–1886), Vol. 2, p. 367.

WATTS, MRS. JOHN (ANNE DE LANCEY), 1723–1775.

Figure. (6), 1773. Made in New York, probably at the same time as the portrait of her kinsman, Cadwallader Colden. She was

the wife of a wealthy New York merchant, connected by marriage with socially prominent English families.

WESLEY, JOHN, 1703–1791.

Wesley was asked to pose, but his diary note, London, January 24, 1774, leaves the issue in doubt: "I was desired by Mrs. Wright, of New York, to let her take my effigy in waxwork. She has that of Mr. Whitefield and many others, but none of them, I think, comes up to a well-drawn picture."

WEST, BENJAMIN, 1738–1820.

Bust. (8), 1775.

WHITEFIELD, GEORGE, 1714–1770.

Figure, replica of original by Rachel Wells. (1), 1771, New York; (2), 1772, London. The Rachel Wells original was probably made in Philadelphia, May 1770. Whitefield died near Boston, September 30, 1770. Mrs. Wells then presented her figure or a replica to Whitefield's "orphan house academy," Bethesda College, Georgia, which was destroyed by fire, June 1773.

WILKES, JOHN, 1727–1797.

Bust. (10), 1775; (11), (12).

WILSON, THOMAS, 1703–1784.

Bust. (10), 1775; (11), (12).

WRIGHT, ELIZABETH, *See* PLATT.

UNNAMED SUBJECTS

A DEAD CHILD.

(10), 1775.

HOUSEMAID.

Figure. (6), 1773.

INDIAN CHIEF.

Figure. (9), January 11, 1775; (10).

INDIAN WOMAN.

Figure. (10), 1775.

DRAMATIC PIECES

MURDER OF ABEL BY CAIN.

Attributed in the *New-York Mercury,* August 5, 1771, to both Rachel Wells and Patience Wright.

TREACHERY OF DELILAH TO SAMSON.

> Attributed as above, *New-York Mercury,* August 5, 1771.

RETURN OF THE PRODIGAL SON.

> Attributed as above, *Pennsylvania Chronicle,* September 9–16, 1771.

QUEEN ESTHER, AHASEURUS, AND MORDECAI.

> (10), 1775.

NOTES

CHAPTER I: *Amazing Art and Deep Design*

1. Small wax profiles of the type made in London by Isaac Gosset (1713–1799) have been attributed to Patience Wright, as have a smaller number of paper silhouettes, but with no primary supporting evidence.

2. The most precise contemporary description is that of Charles Willson Peale in his manuscript autobiography, Peale Papers, American Philosophical Society: "She untaught, made portraits in wax by a most extraordinary manner, holding the wax under her apron she moddled it into the features of the Person sitting before her! This account we had from Mr. West, with whom she was very intimate." — Typescript, p. 102.

3. CF. Elkanah Watson, *Men and Times of the Revolution; or, Memoirs of Elkanah Watson, including his Journals of Travels in Europe and America, from the Year 1777 to 1842, and his Correspondence with Public Men, and Reminiscences and Incidents of the American Revolution. Edited by his Son, Winslow C. Watson* (second edition, New York, 1857); see especially pp. 137–138, where he describes how "by the mere force of a retentive recollection of the traits and lines of the countenance, she would form her likeness, by manipulating the wax with the thumb and finger. Whilst thus engaged her strong mind poured forth an uninterrupted torrent of wild thought, and anecdotes and reminiscences of men and events." Described also by Richard Cumberland, *The Observer* (London, 1785), p. 222.

4 Corey Ford, *A Peculiar Service* (Boston and Toronto, 1965), explored all surviving evidence of espionage activities around New York during the Revolution, but found nothing to indicate information coming from the London waxwork. He considered it a possibility, though a very unlikely one. (Letter to the author, January 19, 1966.)

CHAPTER II: *Wisdom's Dictates*

1. *Oyster Bay Town Records. Published by Order of the Town* (New York, 1916–1940), Vol. 3, p. 712; Vol. 5, pp. 93–94.

2. *Ibid.*, Vol. 3, p. 709; Mary Lovell Rhodes and Thomas D. Rhodes, *A Biographical Genealogy of the Lovell Family* (Ashville, N.C., 1924), pp. 207–208.

3. *Oyster Bay,* Vol. 5, p. 94.

4. Henry Wilder Foote, *Robert Feke, Colonial Portrait Painter* (Cambridge, 1930), pp. 28ff; W. Phoenix Belknap, "The Identity of Robert Feke," *Art Bulletin,* Vol. 29 (1947), pp. 201–207.

5. Louise Fargo Brown, *The Political Activities of the Baptists and Fifth Monarchy Men in England* (Washington, 1912), pp. 1–2.

6. Only one author has summarized PW's story of her life as she repeated it to waxwork visitors: Philip Thicknesse, *New Prose Bath Guide for the Year 1778* (London and Bath, 1778), pp. 51–53.

7. Thomas Chalkley, *A Journal, or Historical Account of the Life, Travels and Christian Experience of . . . Thomas Chalkley* (Philadelphia, 1754). The original manuscript is at the Historical Society of Pennsylvania.

8. *Ibid.*, from the manuscript, p. 56.

9. *Ibid.*, printed, p. 171.

10. *Ibid.*, p. 170.

11. George William Cocks, *History and Genealogy of the Cock-Cocks-Cox Family* (New York, 1914), map.

12. Tryon, *Way to Health* (London, 1691), p. 140; *ibid.* (London, 1697), pp. 54–55, 83–84, 260–261.

13. Tryon, *Knowledge of a Man's Self* (London, 1703), p. 503; *Way to Health* (1697), p. 259.

14. *Friendly Advice . . . By Philotheus Physiologus* (London, A. Sowle, n.d.)

15. *The Countryman's Companion; or a New Method of Ordering Horses & Sheep so as to Preserve them both from Diseases and Casualties* (London, A. Sowle, 169?).

16. Both now at Library Company of Philadelphia.

17. Benjamin Franklin, *Autobiography* (New Haven and London, 1964), pp. 63, 87–88.

18. *Oyster Bay,* Vol. 5, pp. 97–100, 636–637; Vol. 6, pp. 94–99. From the sale of the homestead at this time and the evidence of John Lovell's presence at Oyster Bay in 1725, the year of PW's birth, it is assumed that she was a native of Long Island and not of New Jersey as previous biographers have stated. The year of birth, 1725, is given by William Dunlap, who had access to family records,

in his *History of the Rise and Progress of the Arts of Design in the United States* (New York, 1834), Vol. 1, p. 132.

19.　　Rhodes, *op. cit.,* pp. 153–154, names John, Elizabeth, Patience, Martha, Mary, Sarah. Rachel, Deborah, Rezine, and Anne are recorded in the probate records, *New Jersey Archives,* 1st ser., Vol. 38, p. 404.

20.　　Thicknesse, *loc. cit.*

21.　　Tryon, *Some Memoirs of the Life of Mr. Tho. Tryon, late of London, Merchant* . . . (Philadelphia, 1761), pp. 61–62.

22.　　E. M. Woodward and John F. Hageman, *History of Burlington and Mercer Counties, New Jersey* (Philadelphia, 1883), p. 457.

23.　　Margaret Townsend Tagliapietra, *Townsend-Townshend, 1066–1909* (New York, 1909), p. 83.

24.　　Tryon, *Wisdom's Dictates: or, Aphorisms and Rules, Physical, Moral, and Divine, for Preserving the Health of the Body, and the Peace of the Mind* . . . (London, 1691), pp. 145, 149.

25.　　Tryon, *A New Method of Educating Children* (London, 1695), pp. 30–31.

26.　　Tryon, *Way to Health* (1697), pp. 156–157.

27.　　Dunlap, *op. cit.,* Vol. 1, p. 132.

28.　　John Galt, *The Life and Studies of Benjamin West* (Philadelphia, 1816), pp. 66–75. Even with West's authority cited, no American could accept this. Dunlap, Vol. 1, p. 42, dismisses it with a joke.

29.　　Woodward and Hageman, *op. cit.,* pp. 455–457.

CHAPTER III: *A Husband, Rich and Old*

1.　　Philip Gosse, *Dr. Viper. The Querulous Life of Philip Thicknesse* (London, 1952).

2.　　Thicknesse, *loc. cit.*

3.　　John F. Watson, *Annals of Philadelphia* (Philadelphia, 1891), Vol. 1, p. 538; more moderate estimates, pp. 346, 352.

4.　　Nicolle de la Croix, *Géographie Moderne* (Paris, 1780), Vol. 2, p. 371.

5.　　Tryon, *The Planter's Speech to his Neighbors & Country-Men of Pennsylvania, East & West Jersey, and to all such as have Transported themselves into New-Colonies for the sake of a quiet retired Life. To which is added, The Complaints of our Supra-Inferior Inhabitants* (London,

1684), p. 24; a further source in Ecclesiastes, 9:8, "Let thy garments be always white, and let thy head lack no ointment."

6. *Pennsylvania Gazette*, March 25, 1742; *The Papers of Benjamin Franklin* (New Haven and London, 1959–), Vol. 2, p. 357.

7. Roberts Vaux, *Memoirs of the Lives of Benjamin Lay and Ralph Sandiford* (Philadelphia, 1815), pp. 28–29.

8. *Ibid.*, pp. 25–27; Benjamin Rush, *Essays, Literary, Moral and Philosophical* (Philadelphia, 1806), pp. 296–301.

9. E. P. Richardson, "William Williams. A Dissenting Opinion," *American Art Journal*, Vol. 4 (1972), pp. 10–13.

10. Benjamin Lay, *All Slave-keepers that keep the Innocent in Bondage, Apostates Pretending to lay Claim to the Pure & Holy Christian Religion; of what Congregation so ever; but especially in their Ministers, by whose example the filthy Leprosy and Apostacy is spread far and near; it is a notorious Sin, which many of the true Friends of Christ and his pure Truth, called Quakers, have been for many Years, and still are concern'd to write and bear Testimony against; as a Practice so gross & hurtful to Religion, and destructive to Government, beyond what Words can set forth, or can be declared of by Men or Angels, yet lived in by Ministers and Magistrates in* America. The Leaders of the People Cause them to Err. *Written for a General Service, by him that truly and sincerely desires the present and eternal Welfare and Happiness of all Mankind, all the World over, of all Colours, and Nations, as his own Soul.* (Philadelphia: Printed for the Author, 1737).

11. *Pennsylvania Gazette*, May 7, 1761.

12. William Wade Hinshaw, *Encyclopedia of Quaker Genealogy* (Ann Arbor, 1936–), Vol.3, p. 475.

13. Marriage date given from documents in his possession by Dunlap, *op. cit.*, Vol. 1, p. 132. A Wright family, including Joseph Wrights, was among the first settlers of Oyster Bay, related to Lovells and Townsends and with them involved in the migration from Long Island to West Jersey.

14. Will of Richard Wright, "of Burlington City, Gentleman," October 4, 1755. *New Jersey Archives*, 1st ser., Vol. 32, p. 371; will of Joseph Wright, mentioning "my late father, Richard Wright," Register of Wills, County of Philadelphia, 1769, No. 277; Woodward and Hageman, *op. cit.*, p. 276, cite the family as prominent Quakers, established on the Delaware in 1677.

15. Woodward and Hageman, *op. cit.*, pp. 455–457.

16. Hugh and Nella Imlay, *The Imlay Family* (Zanesville, O., 1958),

pp. 47–48, 183; F. Dean Storms, *History of Allentown Presbyterian Church, Allentown, N.J.* (Allentown, 1970), pp. 86n, 306–310; *New Jersey Archives,* 1st ser., Vol. 24, p. 419; Vol. 27, pp. 235–236; Vol. 28, pp. 90–92.

17. Gilbert Imlay, *The Emigrants, &c. or the History of an Expatriated Family, being a Delineation of English Manners, &c. Volume 1* (London, 1793); *Dictionary of National Biography.*

18. Will of Patience Wright, Surrogate's Court, County of New York.

19. Recorder of Deeds, Philadelphia, Deed Book 17, p. 465.

20. *New Jersey Archives,* 1st ser., Vol. 24, p. 102.

21. *Ibid.,* Vol. 22, p. 254.

22. Recorder of Deeds, Philadelphia, Deed Book I 12, p. 20.

23. *New Jersey Archives,* 1st ser., Vol. 39, p. 147.

24. *Pennsylvania Archives,* 2nd ser., Vol. 8, marriages at Christ Church, Philadelphia, Mary Wright to Manuel Eyre, January 8, 1761; Lydia Wright to Jehu Eyre, December 28, 1761, p. 293.

25. Peter D. Keyser, "Memorials of Col. Jehu Eyre," *Pennsylvania Magazine of History and Biography,* Vol. 2 (1879), pp. 296–297, 417.

26. *New Jersey Archives,* 1st ser., Vol. 35, p. 17; Vol. 39, p. 200; *Pennsylvania Magazine,* Vol. 22 (1898), pp. 131–132; *Genealogical Magazine of New Jersey,* Vol. 22 (1947), pp. 37–38, tracing the Anderson line from Long Island.

27. *New Jersey Archives,* 1st ser., Vol. 35, p. 178.

28. *Ibid.,* Vol. 30, p. 172; Vol. 33, p. 140.

29. In the *Pennsylvania Gazette,* October 27 and November 17, 1757, proposals were published for a new edition of Tryon's *Way to Health, Long Life and Happiness,* in "neat octavo" at seven shillings sixpence. Apparently subscribers did not meet the cost and the book was never printed. It may be surmised that John Lovell had promoted this effort and, with its failure, issued the smaller volume.

30. *New Jersey Archives,* 1st ser., Vol. 33, p. 259.

31. Deed, John Lovell to John Lovell, Jr., September 18, 1756, recorded May 5, 1762; Archives and History Bureau, New Jersey State Library.

32. Howland Delano Perrine, *The Wright Family of Oyster Bay* (New York, 1923), p. 91, listing the children but in error as to the identity of their father; Dunlap, *op. cit.*

33. Register of Wills, County of Philadelphia, 1769, No. 277.

34. Eli Field Cooley, *Genealogy of Early Settlers of Trenton* (Trenton, 1883), p. 295.

CHAPTER IV: *The American Waxwork*

1. Shippen to Franklin, May 14, 1767. *The Papers of Benjamin Franklin* (New Haven and London, 1959–), Vol. 14, pp. 148–149.

2. William Snow Miller, "Abraham Chovet: An Early Teacher of Anatomy in Philadelphia," *Anatomical Journal*, Vol. 5 (1911), pp. 147–171.

3. Miller, pp. 158–159, citing *Pennsylvania Journal*, October 12, 1774, and *Pennsylvania Gazette*, November 30, 1774. Chovet's models figure in a dispute between Drs. William Shippen, Jr., and Thomas Bond, described by Whitfield J. Bell, Jr., *John Morgan, Continental Doctor* (Philadelphia, 1965), p. 158.

4. John C. Fitzpatrick, ed., *The Diaries of George Washington* (Boston and New York, 1925), Vol. 3, p. 226. Later history of the models is noted in *Pennsylvania Magazine of History and Biography*, Vol. 63 (1939), p. 329.

5. Samuel Johnson, *Idler*, No. 45, February 24, 1759.

6. John Cuthbert Long, *Mr. Pitt and America's Birthright. A Biography of William Pitt the Earl of Chatham* (New York, 1940), p. 504; J. C. Long, "Patience Wright of Bordentown," New Jersey Historical Society, *Proceedings*, Vol. 79 (1961), pp. 118–119. The original source for Long's statement that the waxwork was launched with Hopkinson's encouragement has not been found, but all attendant circumstances support it.

7. George Francis Dow, *The Arts and Crafts in New England, 1704–1775* (Topsfield, Mass., 1927), pp. 288–289; *South Carolina Gazette*, Charleston, August 13, 1737.

8. Colden's portrait by Matthew Pratt, painted in 1771 at about the same time as Mrs. Wright's, is illustrated in William Sawitzky, *Matthew Pratt, 1734–1805* (New York, 1942), frontis.

9. "Pd. for my Sisters Seeing the wax works 2/," diary of C. W. Peale, Philadelphia, October 5, 1776. Peale Papers, American Philosophical Society. Washington, *Diary*, Vol. 2, p. 87n, at Williamsburg, November 16, 1772, "By Cost of seeing the Waxwork, 7s 6d," is almost certainly Rachel Wells on tour without her sister.

10. George C. D. Odell, *Annals of the New York Stage* (New York,

1927–1949), Vol. 1, p. 155; Rita S. Gottesman, *The Arts and Crafts in New York, 1726–1776* (New York, 1938), pp. 391–392.

11. John Warner Barber and Henry Howe, *Historical Collections of New York* (New York, 1842), pp. 454–455.

12. Morton Pennypacker, *General Washington's Spies on Long Island and in New York* (Brooklyn, N.Y., 1939), p. 103; Tagliapietra, *op. cit.*, p. 73.

13. Corey Ford, *op. cit.*, gives the story in definitive detail, and John Bakeless, *Turncoats, Traitors and Heroes* (Philadelphia and New York, 1959) in its larger setting.

14. *New-York Gazette; and the Weekly Mercury,* August 5, 1771.

15. *Dictionary of American Biography,* Lindley Murray (1745–1826), grammarian, Presbyterian turned Quaker. Son of a successful New York merchant, he had gone to Burlington, N.J., for his schooling and may have first met PW there.

16. *Ibid.,* William Goforth, son of a prominent New York physician of the same name.

17. *Ibid.,* John Bowne (c. 1627–1695), Quaker leader. The Bowne mansion near Oyster Bay is described in Barber and Howe, *op. cit.,* pp. 453–454.

18. Michael Joseph O'Brien, *Hercules Mulligan, Confidential Correspondent of General Washington* (New York, 1917); Walter Barrett, *The Old Merchants of New York City* (New York, 1863), pp. 365, 410.

19. Bakeless, *op. cit.,* p. 240.

20. *Ibid.,* pp. 345ff; O'Brien, *op. cit.,* pp. 85, 95, 99–100, 164, 252–253; Ford, *op. cit.,* pp. 164, 196.

21. Bakeless, *op. cit.,* p. 358; Ford, *op. cit.,* p. 314.

22. O'Brien, *op. cit.,* pp. 121–122.

23. *Pennsylvania Chronicle,* February 3–10, 1772; with news of sailing, *Boston News-Letter,* February 13, 1772.

CHAPTER V: *London by Storm*

1. Jonathan Boucher, *Reminiscences of an American Loyalist, 1738–1789* (Boston and New York, 1925), p. 143.

2. "I have this day received your kind letter by Mrs. Wright. She has shown me some of her Work which appears extraordinary. I shall recommend her among my Friends if she chuses to work here." — Carl Van Doren, ed., *The Letters of Benjamin Franklin & Jane Mecom* (Princeton, 1950), pp. 135–136.

3. Henry Marchant, Diary, April 6, 1772; typescript, Library of the American Philosophical Society.

4. John Thomas Smith, *Nollekens and His Times* (London, 1828), Vol. 1, p. 175; John Ashton, *Social Life in the Reign of Queen Anne, taken from Original Sources* (London, 1919), pp. 212–213; Rosamond Bayne-Powell, *Eighteenth Century London Life* (London, 1937), pp. 166–167; E. Beresford Chancellor, *The Pleasure Haunts of London during Four Centuries* (London, 1925), pp. 294–296; Edward Walford, *Old and New London* (London, 1887–1893), Vol. 1, pp. 45–46; Henry Benjamin Wheatley, *London Past and Present* (London, 1891), Vol. 3, p. 206; E. J. Pyke, *Biographical Dictionary of Wax Modellers* (Oxford, 1973).

5. Chancellor, *loc. cit.*

6. Henry Angelo, *Reminiscences* (London, 1828), Vol. 1, pp. 401–402; Henry Wilson, *Wonderful Characters, comprising Memoirs and Anecdotes of the Most Remarkable Persons of Every Age and Nation.* (New York, 1834), pp. 280–281.

7. Pyke. *op. cit, passim.*

8. Marchant, Diary, July 7, 1772.

9. *Pennsylvania Chronicle,* September 9–16, 1771.

10. John Williams ("Anthony Pasquin"), *Memoirs of the Royal Academicians* (London, 1796), p. 92.

11. Walpole to Countess, February 11, 1773, in Wilmarth S. Lewis and A. Dale Wallace, eds., *Horace Walpole's Correspondence with the Countess of Upper Ossory* (New Haven, 1965), Vol. 1, p. 98.

12. Edward Mason to Amherst, August 4, 1772, Amherst Mss., Kent Archives Office.

13. PW to Lady Pitt, repeating request, May 11, 1774, Chatham Papers, Public Record Office, London.

14. *London Magazine, or Gentleman's Monthly Intelligencer,* Vol. 44 (1775), p. 556. Dunlap, *op. cit.,* Vol. 1, p. 134, adds, "She has likewise been called Sybilla, for which there was some foundation, for she professed sometimes to foretell political events, and was called the Sybill."

15. *New-York Gazette,* November 9, 1772; Gottesman, *op. cit.,* pp. 392–393.

16. L. H. Butterfield, ed., *Diary and Autobiography of John Adams* (Cambridge, 1961), Vol. 1, p. 360.

17. Both John and Abigail Adams wrote to Macaulay in admiration; Mary Wollstonecraft, *Vindication of the Rights of Women* (London,

1792), p. 130 declared her "the woman of the greatest abilities, undoubtedly, that this country has ever produced."

18. Lucy Martin Donnelly, "The Celebrated Mrs. Macaulay," *William and Mary Quarterly,* ser. 3, Vol. 6 (1949), p. 176.

19. Tryon, *Knowledge of a Man's Self* (London, 1703), pp. 398–399.

20. *New-York Gazette,* February 15, 1773, gives last reference to 30 Great Suffolk Street as of December 1, 1772; *London Chronicle,* December 4–7, 1773, gives Pall Mall; and John Baker, *Diary of John Baker, Barrister* (London, 1931), p. 313, specifies Chudleigh Court as of May 1, 1775.

21. The arrival of the children is undocumented; *London Magazine,* 1775, p. 556, describes them as having been in London long enough to show their developing talents.

22. There is no further contemporary mention of a Franklin bust till the new likeness, 1781.

23. *The Papers of Benjamin Franklin,* Vol. 14, p. 310; Vol. 15, p. 54.

24. *Pennsylvania Magazine of History and Biography,* Vol. 8 (1884), p. 433; Vol. 15 (1891), p. 122.

25. John W. Jordan, ed., "A Description of the State House, Philadelphia, in 1774," *ibid.,* Vol. 23 (1899), p. 418.

26. Franklin Papers, American Philosophical Society.

27. Lewis Einstein, *Divided Loyalties. Americans in England during the War of Independence* (Boston and New York, 1933), pp. 295–297.

28. Watson, *op. cit.,* p. 118.

29. Friends' Historical Society, *Journal,* Vol. 20 (1923), p. 95.

30. Mrs. Cromarty, "Notes taken from Mamma's Anecdotes and from Uncle Belgrave's Letters," The British Library, Add. Mss, 38, 510.

31. Ernest Fletcher, ed., *Conversations of James Northcote, R.A. with James Ward on Art and Artists* (London, 1901), p. 154.

32. Dunlap, *op. cit.,* Vol. 1, p. 135.

33. C. C. Sellers, *Benjamin Franklin in Portraiture* (New Haven and London, 1962), p. 70.

34. Frederic Reynolds, *The Life and Times of Frederic Reynolds* (London, 1826), Vol. 1, p. 249.

35. Nathaniel William Wraxall, *Historical Memoirs of My Own Time* (Philadelphia, 1837), p. 196; *Dictionary of National Biography.*

36. Franklin to PW, May 4, 1779, in Albert Henry Smyth, ed. *The Writings of Benjamin Franklin* (New York, 1905–1907), Vol. 7, p. 304.

37. William Forster to his sister Eliza, 10th month, 7th, 1773. Friends' Historical Society, London.

38. Emily J. Climenson, ed., *Passages from the Diaries of Mrs. Philip Lybbe Powys of Hardwick House, Oxon.* (London, 1899), p. 153.

39. Smyth, *op. cit.,* Vol. 9, p. 583.

CHAPTER VI:

"Women Are Always Usful in Grand Events"

1. PW to Franklin, March 29, 1778, Franklin Papers, American Philosophical Society. Her statement, "5 years agoe I drempt a Dream," puts the date reasonably close to January, 1774. Her further statement that she had put the dream in writing and told many persons of its prophecy that Franklin would yet be honored by all as their "glorious delivrer" fits this occasion better than any other.

2. PW to Franklin, March 7, [1777]. *Ibid.* Search for the missing "Jurnal" continues.

3. Tryon, *A Treatise of Dreams and Visions . . . By Philotheus Physiologus* (London, 1689). "Some Dreams," Tryon avers, pp. 50–51, "are by courteous Visits of good Angels," while also, "It sometimes pleases Almighty God, in a special and extraordinary manner to reveal his secrets to those that fear him in Dreams, which are more usually called Visions."

4. William Forster, Feb. 24, 1776, quoted in Friends' Historical Society, *Journal,* Vol. 20 (1923), p. 96.

5. PW to John Dickinson, April 6, 1775, Historical Society of Pennsylvania.

6. *Public Advertiser,* London, June 22, 1766, quoted in John C. Miller, *Origins of the American Revolution* (Boston, 1943), p. 210.

7. Forster to John Birkbeck, Jr., April 30, 1774, Friends' Historical Society, London.

8. John C. Long, *Mr. Pitt and America's Birthright. A Biography of William Pitt the Earl of Chatham, 1708–1778* (New York, 1940), p. 529. Basil Williams, *The Life of William Pitt* (London, 1913), Vol. 2, p. 301, emphasizes his belief "that the errors of the ministers had often been due to their not obtaining the best information from America, and he was resolved not to make that mistake himself."

9. Even Benjamin West, far less voluble than PW, had trouble, confessing to his cousin Peter Thomson, the conveyancer who had drawn Joseph Wright's will in 1769, "I dont like writeing — its as

deficult to me as painting would be to you." Letter of February 23, 1772, Historical Society of Pennsylvania.

10. Chatham Papers, Public Record Office, London.

11. Of the firms cited here, *Kent's London Directory,* 1774, lists Champion and Dickason; Lane, Son and Fraser; and Henry and Thomas Bromfield. Jack M. Sosin, *Agents and Merchants. British Colonial Policy and the Origins of the American Revolution* (Lincoln, Neb., 1965), pp. 174ff., gives a larger view of the situation and Chatham's other informants.

12. The names are rattled off with assurance that his Lordship knows them all: William Lee, Stephen Sayre, Edward Dilly (the more politically inclined brother of Charles), Robert Murray. Edward and John Green, merchants, appear in *Kent's Directory,* but there are other possibilities, including George Green of Boston, living in London.

13. Sayre to Chatham, May 24, 1774, Chatham Papers.

14. Addressed "To Right Honorable Lady Chattam at Hays," Chatham Papers. May 11, 1774, was a Wednesday, not Thursday as dated.

15. *London Chronicle,* March 28, 1775, quoted by John Hampden, *An Eighteenth Century Journal, being a Record of the Years 1774–1776* (London, 1940), p. 162.

16. PW to Franklin, March 7, [1777], "Suffer me to troubel you with my Scraps of papr as I formely did in Craven Street," Franklin Papers.

17. Chatham Papers. Mr. "Grear" is not identified.

18. Sayre to Chatham, July 9, 1774, Chatham Papers.

19. Historical Manuscripts Commission, *The Manuscripts of the Earl of Dartmouth* (London, 1887, 1895, 1896).

20. Rachel Wells to Benjamin Franklin, December 16, 1785, Franklin Papers.

21. *Manuscripts of the Earl of Dartmouth, op. cit.,* Vol. 2, pp. 178, 284, 371.

22. *Ibid.,* pp. 284, 371, shows the matter of the petition still open a year later, though PW's prediction seems to have been sound.

23. Major General Sir William Draper (1721–1787), who had married Susannah, daughter of Oliver De Lancey, was in the news at this time as second in command of the reinforcements leaving for America. Susannah was a niece of Mrs. John Watts, whose portrait PW had brought from New York to London.

24. The Quebec Act, June 1774, supported by William Murray, Earl of Mansfield; John Stuart, Earl of Bute; and Wills Hill, Viscount Hillsborough.

25. William Tryon of the Foot Guards, formerly Lieutenant Governor of North Carolina, transferred to New York, leaving there for London, April 1774, and now returning, June 1775.

26. American Philosophical Society.

27. Peter Force, ed., *American Archives, Fourth Series* (Washington, 1837), Vol. 1, pp. 771–772.

28. Hugh Percy (formerly Smithson), soldier, later Duke of Northumberland, represented Westminster in the Commons from 1763 until his succession to the peerage in 1776. His marriage to a daughter of the Earl of Bute had brought him into the inner circle of the court, though he opposed its war policy. He was in Boston and covered the retreat from Concord, April 1776. He retired from the American service in 1777 with the rank of lieutenant general.

29. PW's allusion to the "Quakers' " military force in Pennsylvania is apparently ironic. No Roman Catholic bias appears in the career of General Thomas Gage, other than leniency toward the subject population in Canada while stationed there. His father, an Irish peer, had abjured Catholicism, but reverted late in life, and his younger son was similarly guided by practical considerations.

30. Chatham Papers.

31. Diary of Edward Thompson, the British Library, Add. Mss, 46, 120; Edward Thompson to John Wilkes, April 21, 1773, *ibid.,* 30, 871; songs, *ibid.,* 45,580 f. 13.

32. Williams, *op. cit.,* Vol. 2, p. 305.

33. "Journal of Josiah Quincy, Jun., during his voyage and residence in England from September 28, 1774, to March 3, 1775," Massachusetts Historical Society, *Proceedings,* Vol. 50 (1916–1917), pp. 433–471.

34. Bernard Bailyn, *The Ordeal of Thomas Hutchinson* (Cambridge, 1974), p. 318.

35. Quincy, *op. cit.,* pp. 440–441.

36. *Ibid.,* pp. 438, 468.

37. *Ibid.,* p. 444.

38. James Boswell, *Life of Samuel Johnson, LL.D.* (Chicago, London, Toronto, 1952), p. 318. The date was May 15, 1776. On March 9, 1775, Charles Dilly had sent Quincy a copy of *Taxation No Tyranny*

by "Court Pensioner Dr. Samuel Johnson"; Quincy, *op. cit.,* p. 490.

39. Quincy, *op. cit.,* pp. 469, 494.

40. Stillman to PW, Boston, November 13, 1774, printed in full in "Letters to Josiah Quincy, Jr.," Massachusetts Historical Society, *Proceedings,* Vol. 50 (1916–1917), pp. 475–476. Samuel Stillman (1737–1807) had lived in Bordentown for two years before settling in Boston as pastor of the First Baptist Church; *Dictionary of American Biography.*

41. Quincy, *op. cit.,* pp. 456–461.

42. *London Chronicle,* March 28, 1775; Strahan to Franklin, June 7, 1775; *Manuscripts of the Earl of Dartmouth, op. cit.,* Vol. 2, p. 310.

43. Friends' Historical Society, *Journal,* Vol. 20 (1923), p. 95.

44. The Protestant Dissenting Deputies (two representatives chosen annually from each member congregation) met regularly to protect their civil rights. Chatham had spoken strongly in their behalf, 1772, in response to an appeal from Richard Price. Their minutes, Guildhall Library, London, do not record PW's visit.

45. Admiral John Montagu (1719–1795), just returned from three years in command of the North American Station.

46. A similar association of American churches had been in touch with the Protestant Dissenting Deputies in London, 1769, through PW's friend, John Rodgers, to oppose the appointment of an American bishop: Bernard Lord Manning, *The Protestant Dissenting Deputies* (Cambridge, England, 1952), pp. 421–422. *Manuscripts of the Earl of Dartmouth, op. cit.,* Vol. 2, pp. 219, 224, gives opinions of John Vardill and other clergy of New York and New Jersey in favor. William Tryon to Lord George Germain, New York, December 25, 1776, believes the present crisis the opportunity for firm establishment of the Episcopacy beginning with New York; Historical Manuscripts Commission, *Report on the Manuscripts of Mrs. Stopford-Sackville* (London, 1910), Vol. 2, p. 53.

47. PW's warning is directed against Loyalists at Philadelphia who had not broken sharply with supporters of the Congress. The position of the Reverend Dr. William Smith of the College of Philadelphia had been reported to Lord Dartmouth, also Joseph Galloway as "discreet and well intentioned," and Governor John Penn as making the best of "a very unpleasant" position; *Manuscripts of the Earl of Dartmouth, op. cit.,* Vol. 2, pp. 359, 242, 308.

48. Historical Society of Pennsylvania. Benjamin Franklin, who carried the letter, arrived at Philadelphia May 5, 1775.

49. The arrival of Captain McCulloch at Philadelphia, June 7, 1775, is reported in William Duane, ed., *Extracts from the Diary of Christopher Marshall* (Albany, 1877), p. 29; also, *Manuscripts of the Earl of Dartmouth, op. cit.,* Vol. 2, pp. 314–315. Possibly the bearer was William McCulloch, privateersman during the war.

50. PW is aware that the guilds and trading companies forming the Livery of London were the strongest element of political power in the city. The petition to the House of Lords "against an unjust and inhuman Bill, which has passed the House of Commons, entitled, 'A Bill to restrain the Trade and Commerce of the Province of Massachusetts Bay, &c.' " had been considered at the Guildhall, March 14, 1775, with Lord Mayor Wilkes in the chair. A copy of the call, in *Manuscripts of the Earl of Dartmouth, op. cit.,* Vol. 2, p. 281, is annotated in William Lee's hand, "In consequence of this Summons, the Corporation drew up and presented a strong petition to the House of Lords, which with the resolution of the Bill of Rights Society shows the disposition of the people of London with respect to America more strongly than any thing I can say."

51. Placing the Earl of Hertford, Lord Chamberlain of the King's Household, in conjunction with the radicals of the Common Council might have struck the recipient of this letter as odd. His son was supporting Lord North in Parliament. However, his brother, Field Marshal Henry Seymour Conway, steadily opposed the American war.

52. Sir Jeffrey Amherst to Lord Dartmouth, April 5, 1775, with list of artillery in North America, "to which may be added six light three-pounders ordered to be shipped for Boston"; *Manuscripts of the Earl of Dartmouth, op. cit.,* Vol. 2, pp. 285–286.

53. Gilbert Barclay, Scottish merchant, settled in Philadelphia, where he married Anne Inglis in 1761. He had been aboard the *Polly* as supercargo when she arrived with her consignment of tea, December 25, 1773, and returned to London with the ship. He reported to William Strahan from Philadelphia, September 5, 1775, that he was well accepted by members of Congress, had assisted in composing the conciliatory petition to the King, "and if commissioners are appointed to settle differences hopes to be of further service"; *Manuscripts of the Earl of Dartmouth, op. cit.,* Vol. 2, p. 371. Later, without tar or feathers, he returned to Scotland.

54. The De Lanceys of New York, married advantageously in Eng-

land, had been helpful to PW on her coming in 1772. She is now hostile, but six years later, when American Loyalists appeared as neglected sufferers because of the war, she became their partisan.

55. Letters of Joseph Galloway and Joseph Reed are indeed in Lord Dartmouth's papers. Reed's letters dispute the authority of Parliament to tax in a friendly, conciliatory tone, hardly justifying PW's suspicions. De Lancey letters are there, and others from Chief Justice William Smith of New York, whom PW or her informant apparently confuses with Dr. William Smith of Philadelphia. The informant has not been identified.

56. Charles Fitzroy (1737–1797), Colonel of the King's Own Dragoons, Member of Parliament from 1759 until 1780, when he was raised to the peerage as first Baron Southampton. He was not as outstanding a friend of America as those with whom PW associated him, Thomas Pownall, John Sawbridge, and Isaac Barré.

57. The petition of the Livery to the King, with Lord Mayor Wilkes' speech, April 3, 1775, would be printed in the *Pennsylvania Gazette* of June 7, perhaps from the newspaper sent by PW.

58. PW seems to have the impeachment of Chief Justice Peter Oliver by the Massachusetts House of Representatives in mind, and, in these breathless instructions, to expect a bill of particulars against Governor Hutchinson upon which he will be brought to trial in England.

59. Historical Society of Pennsylvania.

60. George III to Lord North, April 11, 1775: "I am sorry Howe seems to look so much on the command in New York as the post of confidence, as I think Burgoyne would best manage any negotiation." John Fortescue, ed., *The Correspondence of King George the Third from 1760 to December, 1783* (London, 1928), Vol. 3, p. 202.

61. Worthington Chauncy Ford, ed., *Letters of William Lee, 1766–1783* (New York, 1968), Vol. 1, pp. 128–129, 137–138, 140.

62. *Manuscripts of the Earl of Dartmouth, op cit.,* Vol. 2, p. 281. *Journal of Josiah Quincy* shows William Lee warning against Dr. Smith and others at the same time and in similar terms as PW, evidence that the two shared sources of information.

63. Force, *op. cit.,* Vol. 2, pp. 306–308.

64. Smyth, *op. cit.,* Vol. 6, pp. 311–312.

65. Chatham Papers.

66. Dunlap, *op. cit.,* p. 135.

CHAPTER VII: *"The Promethean Modeller"*

1. Friends' Historical Society, *Journal,* Vol. 20 (1923), p. 96.

2. Henry J. Cadbury, "Did Woolman Wear a Beard?," *Quaker History,* Vol. 54 (1965), pp. 111–114.

3. Jonas Hanway, *Letters on the Importance of the Rising Generation of the Labouring Part of our Fellow-subjects* (London, 1767), p. 123.

4. William Thomas Whitley, *Artists and Their Friends in England, 1700–1799* (London and Boston, 1928), Vol. 1, p. 157.

5. John Baker, *The Diary of John Baker, Barrister* (London, 1931), p. 323.

6. Catharine Macaulay, *An Address to the People of England, Scotland and Ireland on the Present Important Crisis of Affairs* (Bath, 1775), p. 31.

7. Baker, *loc. cit.*

8. Louis de Loménie, *Beaumarchais and His Times. Sketches of French Society in the Eighteenth Century from Unpublished Documents* (London, 1856), Vol. 3, pp. 110–131.

9. Julian P. Boyd, "The Remarkable Adventures of Stephen Sayre," *Princeton Library Chronicle,* Vol. 24 (1941), pp. 51–64.

10. Sayre to Lady Chatham, September 5, 1787, Chatham Papers.

11. Boyd, *op. cit.* Stephen Sayre, *The Trial of the Cause of an Action brought by S. Sayre, Esq. against William Henry, Earl of Rochford* (London, 1776).

12. Sayre, *op. cit.* Peter Labilliere, *Letters to the Majesty of the People* (London, 1784), p. 40n.

13. Stan V. Henkels, Catalogue No. 1297, April 6, 1922, item no. 471, West to C. W. Peale, February 10, 1775: "It is a subject I would dwell long on, but prudence and the times will not permit my saying anything. . . . I hope my countrymen will act with that wisdom and spirit which seems to have directed them as yet."

14. The article, by an unlikely but remotely possible conjecture, may have come directly from the waxwork, by the pen of very young John Williams ("Anthony Pasquin"). The writer's "Promethean," to be taken in the sense of "daringly original," recalls the sobriquet given Franklin for his early experiments with electricity, "a new Prometheus," seizing for mankind the fire of heaven.

15. W. S. Lewis, Grover Cronin, Jr., and C. H. Bennett, eds., *Horace Walpole's Correspondence with William Mason* (New Haven, 1955), Vol. 2, p. 133; letter dated April 21, 1781.

16. *Gentleman's Magazine,* Vol. 46 (1776), pp. 214–215; *Morning Chronicle and London Advertiser,* May 7, 1776.

17. Reynolds, *op. cit.,* Vol. 1, p. 228n.

CHAPTER VIII: *"Hearty Love and Confidence"*

1. Franklin Papers, American Philosophical Society; printed in Edward Everett Hale, *Franklin in France* (Boston, 1887), pp. 149–150.

2. Ross S. J. Hoffman, *The Marquis. A Study of Lord Rockingham, 1730–1782* (New York, 1973), p. 340.

3. Sellers, *op. cit.,* pp. 109–112, 120.

4. Richard Hingston Fox, *Dr. John Fothergill and His Friends. Chapters in Eighteenth Century Life* (London, 1919), p. 351.

5. PW to Thomas Jefferson, December 15, 1785. Jefferson Papers, Library of Congress.

6. William Bell Clark, "John the Painter," *Pennsylvania Magazine of History and Biography,* Vol. 63 (1939), pp. 1–23.

7. *Ibid.,* pp. 2–4; Thomas Hutchinson, *Diary and Letters* (London, 1883–1886), Vol. 2, p. 144, relates "that Bancroft had told 20 of his friends what John the Painter said to him, and he supposed him to be a spy employed by the government."

8. London, *Gazetteer and New Daily Advertiser,* March 8, 1778.

9. *London Magazine,* Vol. 47 (1777), p. 115.

10. Hutchinson, *op. cit.,* Vol. 2, p. 142, PW to Franklin, March, 1777, Franklin Papers.

11. Burton J. Hendrick, *The Lees of Virginia* (Boston, 1944), p. 289. The spy was the mysterious Major John Thornton. He was in England in December 1777 as Franklin's agent to give aid to American prisoners of war and almost certainly interviewed Mrs. Wright in the course of that business.

12. To Juliana Ritchie, January 19, 1777. Albert H. Smyth, ed., *The Writings of Benjamin Franklin* (New York, 1905–1907), Vol. 7, p. 569.

13. The British Library, Add. Ms. 34,413, f. 422 and 423; Lewis Einstein, *Divided Loyalties. Americans in England during the War of Independence* (Boston and New York, 1933), pp. 11, 393, 414.

14. Charles Platt, Jr., *Platt Genealogy in America* (New Hope, Pa., 1963), p. 93. The family was centered at Huntington, near Oyster Bay, and had connections in Burlington, N.J. Ebenezer was a

cousin of Jeremiah Platt (1744–1811), son of an earlier Ebenezer, and described by Helen Burr Smith, "A Portrait by John Mare Identified: 'Uncle Jeremiah,' " *Antiques,* Vol. 103 (1973), pp. 1185–1187.

15. Rita S. Gottesman, *The Arts and Crafts in New York, 1726–1776* (New York, 1938), p. 159. An advertisement in *The Kentucky Gazette,* Lexington, August 4, 1792, documents Ebenezer's later return to "Watch and Clock Making."

16. Elizabeth Wright to Benjamin Franklin, February 13, 1777. Franklin Papers; Ebenezer Smith Platt, Memorial to the Congress of the United States, March 6, 1780, National Archives, Papers of the Continental Congress, No. 41, VIII, folio 100; *Colonial Records of the State of Georgia,* Pt. 1, pp. 463–465; Pt. 2, pp. 32–35.

17. Memorial, *op cit; Parliamentary Register . . . 14th Parliament, 3d Session,* Vol. 6 (London, 1775–1780), pp. 244–245.

18. "The Deane Papers," *Collections of the New-York Historical Society for 1886,* Vol. 1, p. 486.

19. Franklin Papers, with additional letters of PW and E. S. Platt.

20. *Parliamentary Register, loc. cit.* when, four days later, John Wilkes brought Platt's case into the debate of suspension of Habeas Corpus.

21. Captain Wickes' report of his captures, February 14, 1777, urging an exchange of prisoners, is printed in Hale, *op. cit.,* pp. 114–115. Ruth Y. Johnston, "American Privateers in French Ports," *Pennsylvania Magazine,* Vol. 53 (1929), pp. 359–361, gives "Weeks" as a common variant. Similarly, "Frankling" was not a PW solecism.

22. Franklin Papers.

23. Sir Basil Keith, R.N., Lieutenant Governor of Jamaica, and Admiral Clark Gayton, with the ships in which Platt was a prisoner.

24. Wilkes' speech is printed in *Parliamentary Register,* 1777, Vol. 6, pp. 239ff. The pamphlet, Viscount Bolingbroke's *The Idea of a Patriot King,* 1749, had contributed to the determination of George III to establish royal authority above party lines. It must have been well known to Franklin and certainly misjudged by PW.

25. Sir Charles Asgill, banker and Lord Mayor, father of the Captain Charles Asgill later taken prisoner at Yorktown and for a time under sentence of death in retaliation for the murder of an American prisoner, Captain Huddy.

26. Richard Grenville-Temple, first Earl Temple (1711–1779),

Lord Chatham's brother-in-law, is a somewhat more reasonable suggestion of someone with whom to open negotiations than Lord George Germain (1716–1785), general and secretary of state, a stalwart of the Tory administration.

27. Cf. I Kings, 19:18, "Yet I have left me seven thousand in Israel, all the knees which have not bowed down unto Baal . . ."

28. Equating Franklin's coming to London with the conquest of the Midianites (Judges, 7:17–22) by the blowing of a trumpet and raising a shout.

29. Franklin Papers.

30. Benjamin Franklin to Thomas Cushing, May 1, 1777, Library of Congress.

31. Franklin Papers.

32. Peter Labilliere, *Letters to the Majesty of the People* (London, 1784), pp. 28–29n, 33; Labilliere to Benjamin Franklin, December 8, 1781, National Archives; Biography in *Gentleman's Magazine,* Vol. 70, Pt. 2 (1800), p. 693; Francis P. Labilliere, "History of a Cevenol Family," *Proceedings of the Huguenot Society of London,* Vol. 2 (1889), p. 336; John Timbs, *English Eccentrics and Eccentricities* (London, 1875; reissue, Detroit, 1969), pp. 164–165.

33. PW to John Adams, June 5, 1785, Adams Papers, Massachusetts Historical Society. Labilliere "set truth before the Solders — not to fight against their Consciences."

34. Labilliere, *Letters,* p. 40n.

35. Christopher Hibbert, *King Mob. The Story of Lord George Gordon and the London Riots of 1780* (Cleveland and New York, 1958), p. 170. Lectures, debates, art exhibitions at Greenwood's "Great Rooms," No. 28, Haymarket, were announced frequently in the newspapers.

36. Whitley, *op. cit.,* Vol. 2, pp. 31–33.

37. Illustrated, *Antiques,* Vol. 106 (1974), p. 603. Apparently as a member of the "Friendly Brothers," a social and benevolent society.

38. The meeting that followed is reported in *Parliamentary Register . . . 4th Session of the 14th Parliament* (London, 1775–1780), Vol. 8, pp. 7ff., with Wilkes declaring Howe's retreat from Boston "an absolute flight, as much so, sir, as that of Mahomet from Mecca," and denouncing the "succession of ministerial falsehoods," Burke predicting Burgoyne's failure, and Barré calling for an "olive

branch to the Americans before they become utterly irreconcile-
able to Great Britain."

39. Franklin Papers.

40. Platt to Wilkes, July 23, 1777, British Library, Add. Mss, 30,872.

41. *Journals of the Continental Congress, 1774–1789* (Washington, 1904–1937), Vol. 8, p. 676.

42. Catherine M. Prelinger, "Benjamin Franklin and the American Prisoners of War in England during the American Revolution," *William and Mary Quarterly,* 3rd ser., Vol. 32 (1975), pp. 261–294.

43. Franklin Papers.

44. Prelinger, *op. cit.,* p. 264; Mary Wilkes to John Wilkes, January 3, 1778, The British Library, Add. Mss, 30,879.

45. London *Gazetteer and New Daily Advertiser,* January 30, 1779, announcing also expected ending of collections as of January 12; *ibid.,* March 2, 1779, announces reopening.

46. Thornton to Franklin, October 4, 1777, offering to take any commission, however hazardous, and December (?), 1777, reporting back from London, Franklin Papers.

47. PW to Benjamin Franklin, March 29, 1778, Franklin Papers.

48. Prelinger, *op. cit.,* pp. 282–283.

49. Gottesman, *op. cit.,* p. 385.

CHAPTER IX: *A Guardian Angel Laid Away*

1. L. H. Butterfield, ed., *Adams Family Correspondence* (Cambridge, 1963), Vol. 2, pp. 235–236.

2. Rachel Wells to Benjamin Franklin, December 16, 1785, Franklin Papers.

3. PW to Thomas Jefferson, August 14, 1785; printed in Dunlap, *op. cit.,* Vol. 1, p. 135.

4. Percy Fitzgerald, *A Famous Forgery, being the Story of "the Unfortunate Dr. Dodd"* (London, 1865); Edwin Eliott Willoughby, " 'The Unfortunate Dr. Dodd.' The Tragedy of an Incurable Optimist," ms., Dickinson College Library.

5. Philip Thicknesse, *A Year's Journey through France and Part of Spain* (Bath and London, 1777). His interest in undercover work appears in his earlier *Treatise of the Art of Decyphering and of Writing in Cypher* (London, 1772), though we have no evidence that PW, too spirited and forthright for such devious arts, had read it.

6. John Nichols, *Literary Anecdotes of the Eighteenth Century* (Carbondale, Ill., 1967), p. 360.

7. Thicknesse, *Memoirs and Anecdotes* (London, 1788), Vol. 1, pp. 225–228.

8. *Ibid.*, pp. 223–224.

9. "The Autobiography of Peter Stephen DuPonceau," *Pennsylvania Magazine of History and Biography,* Vol. 63 (1939), p. 325.

10. Bernard O'Donnell, *The Old Bailey and its Trials* (New York, 1951), pp. 114–115.

11. Thicknesse, *Memoirs,* Vol. 2, pp. 234ff.

12. Lewis, Cronin, and Bennett, eds., *op. cit.,* Vol. 1, p. 394. Christopher Wyvill, a central figure in the British reform movement, consulted Franklin directly, and Franklin's "The Justice of Disfranchising the smaller Boroughs in England," sent from Passy in June 1785, is printed in Wyvill's *Political Papers* (York, 1794–1806), Vol. 3, pp. 362–367.

13. Franklin Papers; the letter is erroneously docketed "1777." The admiral is not identified.

14. Hendrick, *op. cit.,* p. 250.

15. *Parliamentary Register . . . 14th Parliament, 4th Session,* Vol. 8 (London, 1775–1780), p. 97.

16. Macaulay to Franklin, December 8, 1777, Franklin Papers.

17. As reported by Lord Camden, *Westminster Magazine,* Vol. 6 (1778), p. 228.

18. King to Lord North, quoted in J. C. Long, *Mr. Pitt and America's Birthright* (New York, 1940), pp. 533–534.

19. Lewis, Cronin, and Bennett, eds., *op. cit.,* Vol. 1, pp. 394–395.

20. Henry, David, *An Historical Account of the Curiosities of London and Westminster* (London, 1785), p. 51.

21. Lawrence E. Tanner, "On Some Later Funeral Effigies in Westminster Abbey," *Archaeologia,* Vol. 85 (1935), pp. 196–197.

CHAPTER X: *Family Affairs*

1. Pyke, *op. cit.,* pp. 103–105.

2. Smith, *op. cit.,* Vol. 1, p. 382n; "John Williams (1761–1818)" in *Dictionary of National Biography* and *Dictionary of American Biography.* Algernon Graves, *The Society of Artists of Great Britain, 1760–1791. A Complete Dictionary of Contributors and their Work* (London, 1907), and Henry Angelo, *op. cit.,* Vol. 1, pp. 298, 310–311, 314, 316, both

confuse "Anthony Pasquin" with another John Williams, painter and engraver, who exhibited in London, 1770–1775. Two others of the name, connected by marriage with Benjamin Franklin, come into the story of Revolutionary activity and intrigue. *Manuscripts of the Earl of Dartmouth, op. cit.,* Vol. 2, p. 427, records a printed prospectus of a new political paper, *The Fall of Britain,* November 9, 1776, projected by Theophilus Stephens, John Williams, and Charles Thompson.

3. John Williams ("Anthony Pasquin"), *Memoirs of the Royal Academicians* (London, 1796), p. 92. None of this correspondence has been firmly identified in surviving papers. Its existence may be accepted on the ground that "Pasquin's" plain statements as fact are less open to doubt than his critical innuendo and defamation.

4. Whitley Papers, British Museum; A. P. Oppé, *Alexander and John Robert Cozens* (Cambridge, Mass., 1954), pp. 2–4.

5. Dunlap, *op. cit.,* Vol. 1, p. 135; Joseph Farington, *The Farington Diary,* ed. James Grieg (New York, 1923–1928), Vol. 1, p. 84, quotes Hoppner's statement that he had known Phoebe "several years" before they were married.

6. The belief was current throughout Hoppner's life, and has been studied with detachment by his biographers, particularly Horace P. K. Skipton, *John Hoppner* (London, 1905), pp. 2–7, 13. William McKay and W. Roberts, *John Hoppner* (London, 1909), p. xiii, cite as convincing the baptismal record of April 8, 1758, without a surname; the attentive interest of the royal family; and the mother's receipt of bribes to use her influence with the King. Farington, *op. cit.,* quotes, and accepts, Hoppner's statement that his father was a German surgeon. "Pasquin's" innuendo that Hoppner encouraged belief in his royal parentage seems unsupported. It would certainly have damaged his good standing at court. Against the evidence pointing to a liaison between the young prince and an English girl stands the known purity of the King's personal life, reinforced by his confession to his mentor, Lord Bute, c. 1759–1760, of "a daily encreasing admiration of the fair sex, which I am attempting with all the phylosophy and resolution I am capable of to keep under. I should be ashamed after having so long resisted the charms of those divine creatures now to become their prey." Quoted in full in Romney Sedgwick, ed., *Letters from George III to Lord Bute, 1756–1766* (London, 1939), pp. 36–37.

7. J. E. Hodgson and F. A. Eaton, "The Royal Academy in the Last Century," *Art Journal* (New Series, London, 1891), pp. 344–345.

8. *Annual Register* (London, 1773), p. 118.

9. Manfred S. Guttemacher, "Catharine Macaulay and Patience Wright," *Johns Hopkins Alumni Magazine,* Vol. 24 (1935–1936), p. 312.

10. Donnelly, *op. cit.,* p. 186.

11. Angelo, *op. cit.,* Vol. 1, pp. 127–128.

12. Sculptor, John Francis Moore. Described and illustrated in Donnelly, *op. cit.,* p. 183, Pl. III. Now in the Town Hall, Warrington, England.

13. Thicknesse, *New Prose Bath Guide,* p. 53.

14. The marriage took place December 17, 1778. Mary Wilkes, January 6, 9, 1779, regretted that Kitty had made herself "so ridiculous," but was vastly amused by her father's account of the match. The British Library, Add. Mss, 30,879.

15. *Morning Chronicle,* February 9, 1779.

16. Charles Willson Peale, Autobiography, typescript, p. 103, Peale Papers, American Philosophical Society.

17. Thomas Hutchinson, *Diary and Letters* (London, 1883–1886), Vol. 2, p. 274: August 27, 1779 — "Called upon Mr. Strahan. He says Mrs. Bl[o]unt who I took to be Mrs. Stevenson's daughter, or Stevens, the woman at whose house Dr. Franklin lodged many years, received about two months ago a letter from him, in which he says he hopes to see her at her hut in Kensington. Preparations were then making in France for an invasion, and his hopes must be founded upon the success of it."

18. Franklin Papers.

19. Library of Congress.

20. PW to Thomas Jefferson, December 10, 1785, Jefferson Papers.

21. As in *New-York Gazette and Weekly Mercury,* June 10, 1771, filling p. 1.

22. Herbert Butterfield, *George III, Lord North and the People, 1779–80* (London, 1949), pp. 350–351; 311.

23. Frances Dorothy Cartwright, *The Life and Correspondence of Major Cartwright* (London, 1826), Vol. 1, p. 143.

24. H. Butterfield, *op. cit.,* p. 192.

25. Eugene Charlton Black, *The Association. British Extraparliamentary Political Organization, 1769–1793* (Cambridge, 1963), tempers Butterfield's picture of a crucial confrontation of "the People *versus* the King" (H. Butterfield, "The Yorkshire Association and the Crisis of 1779–80," *Transactions of the Royal Historical Society,* 4th ser., Vol. 29 [1947], p. 69). The political power of the reformers lay in their

alliance with the country gentry, whose ideals were far more limited. But in the view of a Patience Wright on one side, or alarmed partisans of the King on the other, the dangers were very real.

26. Bonamy Dobrée, ed., *The Letters of King George III* (New York, 1968), p. 130.

27. Franklin to Hutton, February 1, 1778, quoted in Gerald Stourzh, *Benjamin Franklin and American Foreign Policy* (Chicago, 1954), p. 190.

28. Hervey to Lord George Germain, August 4, 1779, Historical Manuscripts Commission, *Report on the Manuscripts of Mrs. Stopford-Sackville of Drayton House, Northamptonshire* (Hereford, 1910), Vol. 2, pp. 135–136.

29. Hutchinson, *Diary,* January 12, 1780, Vol. 2, p. 324.

30. H. Butterfield, *op. cit.,* p. 200.

31. Hibbert, *op. cit.,* p. 49.

32. *Ibid.,* pp. 186–188.

33. The Protestant Petition exists only in a court copy at the Public Record Office. PW cannot be identified by handwriting, may have been one of the many to use an alias, or might have been with one of the religious groups subscribing as a body, such as "the Protestant Congregational Church called Independents." Of her religious affiliation we have only the word of John Hoppner, January 25, 1796, "Her father was a rigid Quaker but she became a Protestant." — Farington Diary, typescript of ms., British Museum.

34. Alexander Pope, *Epilogue to Satires,* Dialogue 2, "Ask you what Provocation I have had? / The strong Antipathy of Good to Bad." *Ad speculum delineavit,* "Drawn at the mirror." The print is discussed by Edgar P. Richardson, "Four American Political Prints," *American Art Journal,* Vol. 6 (1974), pp. 42–44.

35. No. 202 in the exhibition catalogue, "Mrs. Wright Modelling a head in wax." By Joseph Wright, "at Mrs. Wright's, Cockspur Street, Haymarket." Unstarred, indicating that it was not for sale and, by implication, commissioned for some patron. Joseph Wright to William Temple Franklin, August, 1782, "I had a great notion of making it [a portrait of Benjamin Franklin] the same size as my mother's, or the other little one you saw," Franklin Papers.

36. H. Butterfield, *op. cit.,* p. 388.

37. *London Courant and Westminster Chronicle,* May 3, 1780.

38. Whitley Papers.

39. Joseph Wright was represented in the exhibition of the Society

of Artists, also in 1780, by No. 304, "Portrait of a Gentleman," possibly his portrait of Major Labilliere from which a mezzotint was made.

40. *Parliamentary Register . . . 6th Session of the 14th Parliament* (London, 1780), Vol. 17, p. 721, June 2, 1780; Hibbert, *op. cit.,* p. 56.

41. Reynolds, *op. cit.,* Vol. 1, pp. 124–125.

42. *Ibid.,* pp. 130–131.

43. *Ibid.,* pp. 129–130.

44. Joyce Hemlow, *The History of Fanny Burney* (Oxford, 1958), p. 141.

45. Public Record Office, London, SP 37.21.

46. Film of Gordon Papers, Public Record Office. Courtesy of Eugene Charlton Black.

47. Hibbert, *op. cit.,* p. 180.

48. Richard B. Morris, *The Peacemakers. The Great Powers and American Independence* (New York, 1965), pp. 84–85.

49. Franklin to Benjamin Vaughan, June 15, 1780, Library of Congress.

50. A. M. W. Stirling, *Coke of Norfolk and His Friends. The Life of Thomas William Coke, First Earl of Leicester of Holkham* (London and New York, 1912), pp. 126–127.

51. *Public Advertiser,* No. 1424, June 7, 1780, p. 2. A further echo appears in a note on No. 202 in the Royal Academy catalogue of 1780 in the Anderson Collection, British Museum: "*Mrs. Wright modelling the Head of Charles the first* & their Majesties contemplating it! this woman was afterwards found to be a spy of the American Congress."

52. Lewis, Cronin, and Bennett, eds., *op. cit.,* Vol. 2, p. 33.

53. Morris, *op. cit.,* p. 264.

54. *Dictionary of National Biography:* to Ireland about 1781, returning to London as an editor of the *Morning Herald.*

55. Mrs. Cromarty, "Notes taken from Mamma's Anecdotes and from Uncle Belgrave's Letters," The British Library, Add. Mss, 38,510; Whitley, *op. cit.,* Vol. 2, pp. 42–43.

56. *Morning Post,* July 2, 4, 1785. John Williams, recently returned from Ireland, had joined Henry Bate Dudley as editor of the *Morning Post* in 1784, and the paper then began a series of art exhibition reviews written by "artists of abilities and judgment." Whitley, *op. cit.,* Vol. 2, pp. 30–52.

57. Whitley, *op. cit.,* Vol. 2, pp. 42–43.

58. Marriage Register, St. George's, Hanover Square.

CHAPTER XI: *Rendezvous in France*

1. Elkanah Watson, *op. cit.;* cf. Chapter 1, note 6.
2. *Ibid.,* pp. 137–138.
3. PW to Franklin, March 21, 1783, Franklin Papers.
4. Watson, *op. cit.,* pp. 140–141.
5. Thomas Hutchinson, *Diary and Letters* (London, 1883–1886), Vol. 2, p. 367.
6. J.-F. Michaud, *Biographie Universelle* (Paris, 1843), "Orléans."
7. Watson, *op. cit.,* pp. 139–140.
8. Dunlap, *op. cit.,* Vol. 1, p. 312.
9. Historical Society of Pennsylvania; printed in *Pennsylvania Magazine of History and Biography,* Vol. 32 (1908), pp. 17–18.
10. National Archives, Washington, D.C.
11. Sir John Fortescue, ed., *The Correspondence of King George the Third, from 1760 to December, 1783* (London, 1928), Vol. 5, p. 391.
12. Mary Wilkes to John Wilkes, January 3, [1782]. The British Library, Add. Mss, 30,879. The date of the letter is fixed by its reference to the "account of Admiral Hyde Parker's success being generally believed." Hyde Parker's battle with the Dutch fleet was fought August 5, 1781. No copy of the print has been found.
13. *The Last Journals of Horace Walpole during the Reign of George III from 1771–1783. With Notes by Dr. Doran* (London and New York, 1910), Vol. 2, p. 494. Bonamy Dobrée, *op. cit.,* p. 154, places the King's undated message of abdication in March 1782, and Fortescue, *op. cit.,* Vol. 6, p. 316, in March 1783.
14. Franklin Papers.
15. PW to William Temple Franklin, c. July–September 1782, *loc. cit.*
16. Dunlap, *op. cit.,* Vol. 1, p. 313.
17. Carl Van Doren, *Jane Mecom* (New York, 1950), pp. 172–176.
18. Franklin Papers.
19. Richard B. Morris, *The Peacemakers. The Great Powers and American Independence* (New York, 1965), p. 265.
20. Laurens Papers, South Carolina Historical Society. Laurens had just received the King's consent to recuperate at Bath from his imprisonment (Correspondence, Laurens and Thomas Townshend, Public Record Office, London, HO 42).
21. "Seartan and *privet* orders are gone to the Hague or Dutch to try for a Seperate peeace." The secret mission of Paul Wentworth to

the Netherlands had ended, unsuccessfully, six months before, a matter of great interest to Laurens but of which he may have known as much as PW at this time (Morris, *op. cit.,* p. 254).

22. Waxwork gossip on a well-known difference of temper and opinion. Edmund George Petty, Baron Fitzmaurice, *Life of William, Earl of Sheburne, afterwards First Marquess of Lansdowne* (London, 1912), Vol. 2, pp. 303–304, describes the acrimony, and the general wish of the Whigs that one would be shot and the other hanged for it.

23. Stagnant trade and heavy taxation had brought hardship and discontent to the Lancashire industrial towns which were unrepresented in Parliament. Manchester's only recourse was by petition or such warnings of coming violence as this — which reached a bloody climax there in the Peterloo massacre of 1819.

24. Reynolds, *op. cit.,* Vol. 1, pp. 222–223.

25. Watson, *op. cit.,* pp. 165–166.

26. *Dictionary of National Biography.*

27. Met PW "in various parts of England from '82 to '84." — Watson, *op. cit.,* p. 138.

28. *Ibid.,* p. 199.

29. *Ibid.,* pp. 179–182. Elisha was a son of Governor Thomas Hutchinson, who had died at the time of the Gordon Riots. He had married Elkanah's aunt, Mary Oliver Watson, a granddaughter of Chief Justice Peter Oliver. The Chief Justice's son, Dr. Peter Oliver, was also in the Birmingham group.

30. *Ibid.,* pp. 202–203.

31. Reynolds dates the first high jinks with the wax head of Franklin "soon after my arrival," that is, September 1782, but places it in the London home of Elisha Hutchinson, whom Watson met in Birmingham a month later. Hutchinson's diary, difficult to date precisely, seems to put the incident in August 1783. Yet Watson was then dressing his figure in Franklin's own clothes, while in the incident described here he had only a dressing gown. One may conclude therefore that the invitation to John Reynolds came at this time, and that Frederic Reynolds is confusing it with the later occasion with the Hutchinsons.

32. Reynolds, *op. cit.,* Vol. 1, pp. 246–249.

33. Franklin Papers. The suit of clothes came to the Massachusetts Historical Society as Watson's gift. There a lady curator informed the author that it had once given proof of Franklin's having been a

dirty old man, the coat collar being saturated with a greasy substance.

34. Watson, *op. cit.,* pp. 141–142.

35. PW to Franklin, July 30, 1782, Franklin Papers.

CHAPTER XII: *Billeter Square*

1. Watson, *op. cit.,* p. 138; PW to Franklin, February 22 and March 17, 1783, Franklin Papers.

2. Algernon Graves, *The Royal Academy of Arts; a Complete Dictionary of Contributors and their Work from its Foundation in 1769 to 1904* (London, 1905–1906); Allan Cunningham, *The Lives of the Most Eminent British Painters* (London, 1879), Vol. 2, pp. 288.

3. Viscount Lewisham, son of the Earl of Dartmouth, and at this time Lord of the Bedchamber to the Prince of Wales.

4. Farington, *op. cit.,* Vol. 1, p. 84; Mrs. Cromarty, "Notes," *op. cit.*

5. Mrs. Cromarty, *ibid.;* McKay and Roberts, *op. cit.,* p. xviii.

6. Skipton, *op. cit.,* pp. 33–34. Hoppner was appointed, 1789, "Portrait Painter to the Prince of Wales."

7. Charlotte Louisa Henrietta Papendiek, *Court and Private Life in the Time of Queen Charlotte, being the Journals of Mrs. Papendiek, Assistant Keeper of the Wardrobe and Reader to Her Majesty* (London, 1887), Vol. 1, pp. 232–233

8. Edward Dutton Cook, *Art in England* (London, 1869), p. 262, cites Hoppner's maintaining his admiration of Reynolds in the face of the King's dislike. Farington, Grieg, ed., Vol. 1, p. 104, describes Hoppner's angry impatience while listening to the King discourse critically on art. Conversely, Farington Diary, typescript, British Museum, quotes Hoppner as of February 8, 1800, on "the extreme good nature of the King of which he said, 'I am the proof, for though I had been wrong in my conduct to his Majesty, yet he entirely overlooked it, and always checks me if I allude to it.' "

9. *Dictionary of National Biography,* "William Gifford"; Skipton, *op. cit.,* pp. 86, 89.

10. PW's letter of March 19, 1783, placing William Franklin in Suffolk Street "a few doors from me," came from the waxwork, and it would appear that she was as much there as with Phoebe.

11. An attribution to Joseph Wright, though with only his *Benjamin Franklin* for comparison, is possible.

12. Carl Van Doren, ed., *op. cit.,* p. 217.

13. Mrs. Cromarty, "Notes."

14. Franklin Papers.

15. *European Magazine and London Review,* Vol. 3 (1783), p. 165, the writer giving no credit to the rumor, "and should be sorry ever to see him in that situation."

16. Franklin Papers.

17. *The Parliamentary Register . . . 2nd Session of the 15th Parliament* (London, 1782), Vol. 6, p. 453.

18. William Mackinnon, Jr., son of an Antigua planter, carrying a letter also from Benjamin Vaughan, wrote Franklin of his arrival at Paris, April 9, 1783. Franklin Papers.

19. James Martin, independent reformer in Parliament; Thomas Evans, publisher of the *Morning Chronicle* and *London Packet;* and Capel Lofft, a founder of the Society for Constitutional Information, whom Boswell describes as "a zealous Whig" and praises for his liberality and knowledge.

20. In the Commons, not the Lords.

21. Sir Cecil Wray, M.P. for Westminster, President of the Society for Constitutional Information and a strong opponent of the American War; James Martin; Thomas Powys, supporter of economic reform; either Edward or Sir Gilbert Eliot; Welbore Ellis.

22. Franklin Papers.

23. Public Record Office, London, HO 42, pp. 234–235, 378, 450–451, with evidence that Benjamin Franklin and French agents were promoting the emigration of skilled artisans to America.

24. *The Last Journals of Horace Walpole during the Reign of George III from 1771–1783. With Notes by Dr. Doran* (London and New York, 1910), Vol. 2, p. 494.

25. *Parliamentary Register . . . 3rd Session of the 15th Parliament* (London, 1783), Vol. 9, pp. 511, 539.

26. *Last Journals of . . . Walpole, op. cit.,* Vol. 2, p. 505.

27. Ida Macalpine and Richard Hunter, *George III and the Mad Business* (London, 1969), presents the first complete study of the case. The King's correspondence makes clear that such an attack in 1783, if suffered at all, must have been brief.

28. John Sargent to Franklin, June 1, 1783, American Philosophical Society.

29. The Earl of Dartmouth and his son, Lord Lewisham.

30. Franklin Papers.

31. Watson, *op. cit.,* pp. 207, 213; 151–152.

32. Franklin Papers. Mr. Mascall appears at a meeting of the free-holders of Middlesex, September 26, 1775, delivering a vigorous "harangue" against the King's American policy. — Peter Force, ed., *American Archives. Fourth Series* (Washington, 1837), Vol. 3, p. 785.

33. Watson, *op. cit.,* p. 142.

34. Thomas Hutchinson, *Diary and Letters* (London, 1883–1886), Vol. 2, p. 367.

35. Franklin Papers.

36. Watson, *op. cit.,* pp. 142–143.

37. *Ibid.,* p. 142. Extensive search of extant papers has not yet un-covered the newspaper items.

CHAPTER XIII: *General Washington and Master Billy*

1. *London Chronicle,* October 18–21, 1783.

2. *Daily Advertiser,* November 1, 1783.

3. Adams Papers, Massachusetts Historical Society.

4. Dunlap, *op. cit.,* Vol. 1, pp. 313–314; Fiske Kimball, "Joseph Wright and His Portraits of Washington," *Antiques,* Vol. 15 (1930), pp. 35–39.

5. Washington Papers, Library of Congress. Joseph Wright did make a bust in the round, completed December 1784, but whether a cast was received by his mother in London is unknown.

6. A probability, though if so Washington misdated the time of its arrival by a few days in his reply.

7. Watson, *op. cit.,* p. 267.

8. *Ibid.,* pp. 156–157.

9. Fitzpatrick, ed., *op. cit.,* Vol. 2, p. 336.

10. Watson, *op. cit.,* p. 278.

11. Washington was president of the canal company, their main topic of conversation, and Watson made a survey of the proposed route after leaving Mount Vernon. — *Ibid.,* pp. 280–282.

12. *Ibid.,* pp. 138–139.

13. *Ibid.,* pp. 278–280.

14. Fitzpatrick, ed., *op. cit.,* Vol. 2, p. 337.

15. John C. Fitzpatrick, ed., *The Writings of Washington* (Washington, 1931–1944), Vol. 28, pp. 44–45; original in the British Library, Add. Mss, 12,099.

16. Peter L. Santvoord, "The Frantick Rebel," *Long Island Forum,* Vol. 28 (1965), pp. 69–70.

17. *Daily Advertiser,* November 6, 1783.

18. Adams Papers.

19. L. F. S. Upton, ed., *The Diary and Selected Papers of Chief Justice William Smith, 1784–1793* (Toronto, 1963), Vol. 1, p. 54.

20. Edward Dutton Cook, *Art in England* (London, 1869), p. 263.

21. *No. 1. The Court and City Magazine, or Universal Repository of Knowledge and Entertainment,* "A work entirely new with copper-plates elegantly coloured," appeared July 1, 1784, as a satirical echo of the election.

22. *Daily Advertiser,* March 1, 1784.

23. *Morning Chronicle,* March 1, 1784.

24. *Morning Herald,* March 1, 1784. Of the clubs named, Charles James Fox had been a conspicuous member of both Macaroni and Brooks's. White's and Brooks's sustained a Whig and Tory rivalry and hence the humor in the parley, back and forth. The clubs were in the fashionable part of Westminster and near where the procession would have ended.

25. *New-York Packet,* May 27, 1784.

26. Watson, *op. cit.,* pp. 217–218. It was reported to the King as "of a very serious nature." One of the "peace officers" seeking to disarm the rioters armed with "bludgeons and cleavers" had been killed. — A. Aspinall, ed., *The Later Correspondence of George III* (Cambridge, 1962), Vol. 1, p. 58. Watson contrasts the affair to the "silent dignity" of an American election. However, if Patience Lovell had been in Philadelphia in 1742, she had seen something much the same as sailors from the British warships tried to intimidate opponents of the Governor's party.

27. Hutchinson, *op. cit.,* Vol. 1, p. 318.

CHAPTER XIV: *"I Must Kiss You All"*

1. Nathanael William Wraxall, *Historical Memories of My Own Time* (Philadelphia, 1837), p. 65.

2. Boswell, *op cit.,* pp. 462, 465.

3. *Ibid.,* p. 532.

4. Richard Cumberland, *The Observer* (London, 1785), p. 222. The copy at the Lewis Walpole Library contains Horace Walpole's iden-

tifications of guests at the party: Mrs. Wright, Dr. Johnson, Mrs. Siddons.

5. *Diary and Letters of Madame d'Arblay (1778–1840), as Edited by her Niece Charlotte Barrett, with Preface and Notes by Austin Dobson* (New York, 1904–1905), Vol. 3, p. 71.

6. Watson, *op. cit.,* pp. 137–138.

7. Boswell, *op. cit.,* p. 127.

8. Fitzpatrick, ed., *Diaries of Washington, op. cit.,* Vol. 2, pp. 381–383; Guttemacher, *op. cit.,* p. 313.

9. Frederic Reynolds, *op. cit.,* Vol. 1, pp. 153–154.

10. *Bath Chronicle,* May 6, 1784.

11. Edward Wedlake Brayley, *Londiniana* (London, 1829), Vol. 2, pp. 161–162; *Public Advertiser,* December 13, 1784; diary of Sir Richard Clark, Guildhall, London, April 3 to May 7, 1785.

12. Dunlap, *op. cit.,* Vol. 1, p. 134.

13. Staats Long Morris (1728–1800) of Morrisania, New York, British soldier and Member of Parliament, 1774–1784, was a half-brother of Gouverneur Morris and consort of the Dowager Duchess of Gordon.

14. David Steuart Erskskine (1742–1829), eleventh Earl of Buchan. He did not emigrate, though a warm friend of America who was in correspondence with Washington and others.

15. Thomas, first Baron Erskine (1750–1823), brother of the Earl of Buchan. Attorney for the defense of his cousin Lord George Gordon in 1781, Member of Parliament 1783–1784.

16. Upton, ed., *op. cit.,* Vol. 1, pp. 53–54.

17. Dr. James Smith is described by John Adams as a troublemaker suspected of being a spy. — L. H. Butterfield, ed., *Diary and Autobiography of John Adams* (Cambridge, 1961), Vol. 4, pp. 74–75.

18. Upton, *op. cit.,* Vol. 1, pp. 86–87.

19. *Ibid.,* pp. 149–150.

20. Butterfield, ed., *op. cit.,* Vol. 3, p. 165.

21. Abigail Adams, journal letter to her sister, July 24, 1784, in *Letters of Mrs. Adams, the Wife of John Adams, with an Introductory Memoir by her Grandson, Charles Francis Adams* (Boston, 1840), pp. 227–228.

22. London *Morning Herald and Daily Advertiser,* June 4, 1784.

23. *Letters of Mrs. Adams, op. cit.,* pp. 228–229.

24. To Lucy Cranch, Auteuil, September 5, 1784, *ibid.,* pp. 252–254.

25. Katharine Metcalf Roof, *Colonel William Smith and Lady. The Ro-*

mance of Washington's Aide and Young Abigail Adams (Boston, 1929), p. 61.

26. *Ibid.,* p. 85.

27. PW to Thomas Jefferson, August 14, 1785, quoted in Dunlap, *op. cit.,* p. 136.

28. Hibbert, *op. cit.,* p. 212.

29. Carl B. Cone, *The English Jacobins. Reformers in Late Eighteenth Century England* (New York, 1968), p. 68n.

30. Adams Papers, Massachusetts Historical Society.

31. Jefferson Papers, Library of Congress; Julian P. Boyd, ed., *The Papers of Thomas Jefferson* (Princeton, 1950–), Vol. 8, p. 180.

32. Dunlap, *op. cit.,* Vol. 1, pp. 135–136; Boyd, *op. cit.,* Vol. 8, pp. 380–381.

33. Painting now at the Fogg Museum of Art, Harvard University; statue in the capitol, Richmond, Virginia.

34. Abigail Adams to Thomas Jefferson, December 20, 1785, Boyd, *op. cit.,* Vol. 9, p. 115; Roof, *op. cit.,* p. 114.

35. Diary of Sir Robert Clark, Lord Mayor, Guildhall, London: June 14, 1785, suspicious characters resisting tax on retail shops; July 29, "combinations in the coal trade"; September 2, anonymous warnings of "great Danger."

36. Robert Watson, *The Life of Lord George Gordon: with a Philosophical Review of his Political Conduct* (London, 1795), pp. 64–65.

37. Colonial Williamsburg, Inc.; Boyd, *op. cit.,* Vol. 8, p. 673.

38. Mrs. Cromarty, "Notes," The British Library, Add. Mss, 38,510, pp. 263–265.

39. Jefferson Papers; Boyd, *op. cit.,* Vol. 9, pp. 100–102.

40. *Ibid.,* Vol. 9, p. 102. "Mr. Smith" is William Stephens Smith of the American legation.

41. I Kings, 22:8.

42. Judges, 5:7–12.

43. Thomas Trevor, Viscount Hampden (1746–1824) married in 1768 Catherine Graham (1749–1805), whose portrait was painted by Hoppner. Belgrave's baptism honored the patrons of his father and father's friend, Gifford.

44. Leslie A. Marchand, *Byron. A Biography* (New York, 1957), Vol. 2, pp. 714, 757, 799, 875–876. Phoebe was in the background through her long widowhood, living with Belgrave or others of her children. Late in life she intervened with William Gifford in an effort to spare John Keats the anguish of the *Quarterly Review*'s derisive attack. Another son, Wilson Lascelles, shone briefly as his

father's successor in the studio, but died insane, a burden on her last years.

45. Less than a week after PW's death, the waxwork's first advertisement appeared in the London *Morning Post,* inviting "the Nobility, Gentry and the Public," at "Two Shillings each Person," from ten until six. The figures were "newly dressed," indicating that some new management had taken over, perhaps weeks or months earlier.

46. Thomas McKean (1734–1817) married Mary, daughter of Joseph Borden of Bordentown.

47. Thomas Paine.

48. Colonel Joseph Kirkbride, 1731–1803.

49. [Rachel Wells] to Benjamin Franklin, December 16, 1785, Franklin Papers.

50. Woodward and Hageman, *op. cit.,* p. 472.

51. Lewis Walpole Library, Farmington, Connecticut.

52. *European Magazine and London Review,* Vol. 9 (1786), p. 210. Reprinted in *The Scots Magazine,* Vol. 48 (1786), pp. 154–155, with a circumspect deletion of the phrase, "the Minister of England employed." This obituary is the source of William Temple Franklin's affirmation of PW's success as a spy (W. T. Franklin, ed., *The Works of Dr. Benjamin Franklin in Philosophy, Politics and Morals* (Philadelphia, 1808–1818), Vol. 6, p. 87n) — ignoring the actual correspondence which, as his grandfather's secretary at Paris, he must have seen.

53. Diary of Joseph Farington, typescript, p. 526. British Museum, Dept. of Prints and Drawings.

54. Mrs. Cromarty, "Notes," quoted in James Grieg, ed., *The Farington Diary. By Joseph Farington, R.A.* (New York, 1923–1928), Vol. 1, p. 84n.

55. Joel Barlow, *The Vision of Columbus* (Hartford, 1787), p. 210–211.

56. James Woodress, *A Yankee's Odyssey. The Life of Joel Barlow* (Philadelphia and New York, 1958), pp. 120–124.

57. Barlow, *The Columbiad. A Poem* (Philadelphia, 1807), p. 312. It is a couplet which, conversely, might be taken as descriptive of the Rachel Wells *oeuvre.*

58. Clare Williams, ed., *Sophie in London, 1786. Being the Diary of Sophie von LaRoche* (London, 1933), p. 118.

INDEX